# The Garland Library of the History of Art

One hundred and fifty-two articles in fourteen volumes

*Editorial Selection Committee*

**James S. Ackerman**

**Sumner McKnight Crosby**

**Horst W. Janson**

**Robert Rosenblum**

# Volume Nine

# Seventeenth Century Art in Flanders and Holland

*Garland Publishing, Inc.,*
*New York & London*

*1976*

## Library of Congress Cataloging in Publication Data

Main entry under title:

Seventeenth century art in Flanders and Holland.

    (The Garland library of the history of art ; v. 9)
    Includes bibliographical references.
    CONTENTS: Janson, H. W. Preface.—Jaffe, M. Rubens
sketching in paint.—Held, J. H. Le roi à la ciasse.—
Slive, S. Notes on the relationship of protestantism to
seventeenth century Dutch painting. Realism and symbolism
in seventeenth-century Dutch painting. ₍etc.₎
    1. Art, Flemish—Addresses, essays, lectures.
2. Art, Modern—17th-18th centuries—Flanders—
Addresses, essays, lectures. 3. Art, Dutch—Addresses,
essays, lectures. 4. Art, Modern—17th-18th centuries—
Netherlands—Addresses, essays, lectures. I. Series.
N5300.G32 vol. 9 ₍N6969.F5₎ 709s ₍759.9492₎ 76-14071
ISBN 0-8240-2419-2

**Printed in the United States of America**

# Contents

# Preface

*The Garland Library of the History of Art* has grown from a project that had its beginnings a decade ago. At that time the Bobbs-Merrill Company, which for many years had been producing offprints of articles from scholarly and scientific journals for instructional use, decided to add the history of art to its roster. It invited four scholars—James Ackerman, Sumner McKnight Crosby, Robert Rosenblum, and the undersigned—to serve as an editorial committee charged with the task of selecting an initial list of about 200 articles. With the aid and advice of numerous colleagues, the committee in the course of the following two years completed its assignment, which impressed all its members and consultants as of eminent educational value. Bobbs-Merrill set about clearing permissions with the authors and publishers concerned, but eventually decided to drop the project. The members of the editorial committee, however, were encouraged to look for another publisher who might want to take it over. By then five years had passed, and the first signs of the coming recession were clouding the prospects for new ventures such as this. Nevertheless, the committee persisted; after several time-consuming false starts, the project finally found a home with the Garland Publishing Company, which now had to do the job of clearing permissions all over again. In the process, the original list inevitably underwent some shrinkage: a few authors and journals proved untraceable, others withheld permission for various reasons. Still, the main body of the original list remains intact. Garland decided to reprint these outstanding contributions to scholarship not only in pamphlet form but to gather them in a series of cloth-bound volumes for reference use in libraries, thus making them available to institutions that do not own the original periodicals and permitting those that do to substitute *The Garland Library of the History of Art* for these precious and often irreplaceable research materials on student reserve shelves. The editorial committee is about to reconstitute itself and to resume its work, for during the years that have passed since the compilation of the first list, many additional articles of great scholarly value and educational usefulness have appeared and will, as time goes on, be added to the *Garland Library*. We invite suggestions from our colleagues for these future volumes, which will be keyed to the present set of fourteen. Areas of the history of art not now represented in the set, such as Pre-Columbian or Primitive art, may well be added if there is enough demand for them. Meanwhile, we trust that the series will prove as important to our common enterprise as we believe it to be.

H.W. Janson

*May, 1976*

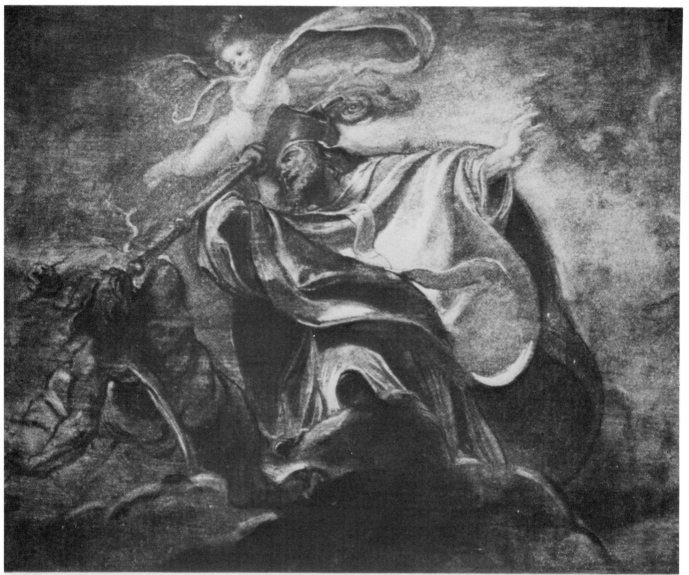

(1)

Sketching for church decorations: Rubens' *St. Gregory* [above],
19 by 24½ inches, is the model for one of 38 huge panels in
the Baroque ceiling of the Antwerp church of St. Charles
Borromée (newly acquired by the Albright Gallery in Buffalo,
from E. & A. Silberman). *Elias* [below], 12½ by 17 inches,
is another sketch for that ceiling, destroyed by fire in 1718.

CURTIS BAER COLLECTION, NEW YORK

*By Michael Jaffé*

# RUBENS'
# SKETCHING
# IN PAINT

*The enormous growth of interest in the more informal revelations of Rubens' genius is confirmed by recent additions of a number of his oil sketches to U.S. public collections. ARTNEWS has commissioned Michael Jaffé, among the most penetrating of the newer Rubens scholars, to analyze the functions of the sketch in Rubens' art. His points are here illustrated mainly by works in America.*

Less than fifty years after Rubens' death, in 1681, Roger de Piles observed of him in the *Dissertation sur les ouvrages des plus fameaux peintres:*

"He had so great a practice in every aspect of his art that he painted quite as much as he drew. Hence one sees almost as many little pictures by his hand as the full-scale ones, of which they are the first thoughts and sketches. Of these sketches some are only very lightly suggested while others are more or less finished, according to how far he had clearly in mind what he had to do, or was in the mood to work. Of some even he made use in their original form; and wherever he had studied objects from nature that he had to represent in a large work, he made changes only as he found them appropriate."

De Piles was qualified to speak. He was a close friend of the Duc de Richelieu, himself a great collector of Rubens paintings; and he was the enthusiastic correspondent of Philip Rubens, who had known his uncle, Peter Paul, in life. After three centuries, this account of the central activity in Rubens' artistic production needs little elaboration beyond illustrating a few of the uses to which he put his astonishing powers of creating form and of organizing complex designs, directly in paint. His habit of doing so was not only imitated by his immediate followers in Flanders, within their limited resources of hand and eye; it was of considerable profit to Velásquez as well as to Van Dyck, in the seventeenth century and to Fragonard, in the eighteenth; it was emulated by the most vigorous of nineteenth-century masters, by Baron Gros and Géricault, and, above all, by Constable and Delacroix. Indeed the Delacroix copy of Rubens' sketch for the *Miracle of St. Benedict* hangs today in the Brussels Museum as companion and tribute to the original.

Rubens in Italy had made his way first to Venice where, only six years after the death of Tintoretto, some knowledge of his methods, despite family secrets, could be gleaned from his still undispersed shop. He might well have seen some of the preparatory sketches which Tintoretto had painted for his large canvases. Moreover, Federigo Barocci—another master whose art was to be important to the young Rubens, later in Rome—customarily made small color trials to adjust his harmonies before attempting any full-size work. From the example of the lightning Tintoretto and the deliberate Barocci, Rubens took suggestion. He must have been ambitious almost from his first Italian years to organize one day a studio in Antwerp whence should proceed quantities of monumental-scale paintings to match in the North the scale and grandeur of Renaissance art which he was studying in Venice and Rome. This enormous purpose could never be realized unaided. He had therefore established, by 1605 at latest, the foundation of a lifelong habit to paint sketches, first as models for clients; then, after his return to Flanders, also to convey his style of thinking to assistants, or to be reproduced in engravings which would advertise to all Europe his powers in

Sketching for sculpture: Rubens' device to modify his brilliant white gesso grounds—diagonal charcoal streaking—is visible in the actual-size detail [above], as is the black crayon underdrawing of the sleeve. The detail is from *St. Norbert Triumphing over the Heretic Tanchelm* [below], oil sketch for a large marble statue.

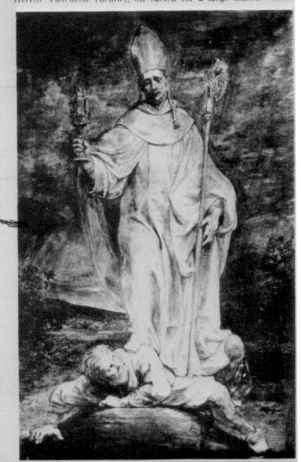

(2)

Sketching for landscape: From his small *Landscape with Farm* [above], Rubens incorporated the motif of his own residence in his larger *Sunset Landscape* [right], which was in his studio till his death.

design; and, always as the spirit moved him, to give painted life to the swift run of his ideas. Without the sketches the magnitude of his achievement is inconceivable. They are small works in inches only, the means by which he developed and taught to others his rich pictorial language, and so enlarged the vision of an age.

## Sketching for church decorations

Nowhere is this quality more abundantly evident than in the models he prepared to the order of the Antwerp Jesuits for the ceiling of their Church of St. Charles Borromée. The thirty-nine little sketches on panel of this series were at the same time guides for his assistants—Van Dyck being especially named among them in the contract—to execute the over-life-size canvases that were to be set in cofferings far above the spectators in the nave. The *St. Gregory Nazianus* and the *Prophet Elias* are two of the finest of these (see p. 34). The foreshortening of the figures is adjusted, after the comfortable Venetian manner, to suit a 45-degree angle of view from below. The violence of their actions is free of empty rhetoric but as [Continued on page 64]

(3)

Sketching for large canvases: Rubens' highly finished sketch, *David and Abigail* [below], actually simplified in the huge version by him and an assistant, ca. 1630 [lower right], also served for an engraving [right].

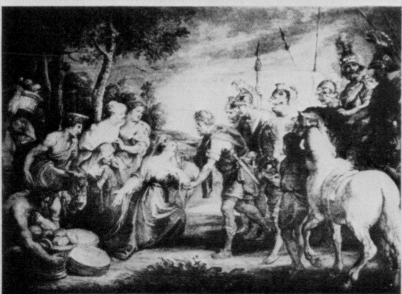

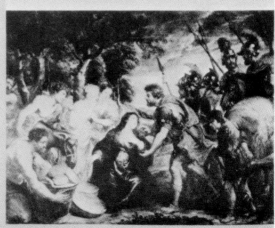

Sketching within his pupils' canvas: Rubens gave a finishing touch to *The Gathering of the Manna* [left], ca. 1625, a full-scale tapestry design (16 feet high) mostly painted by assistants, by his inserting a female figure [detail below] in the middle distance near the center of the picture with the economy of stroke of his small sketches.

(4)

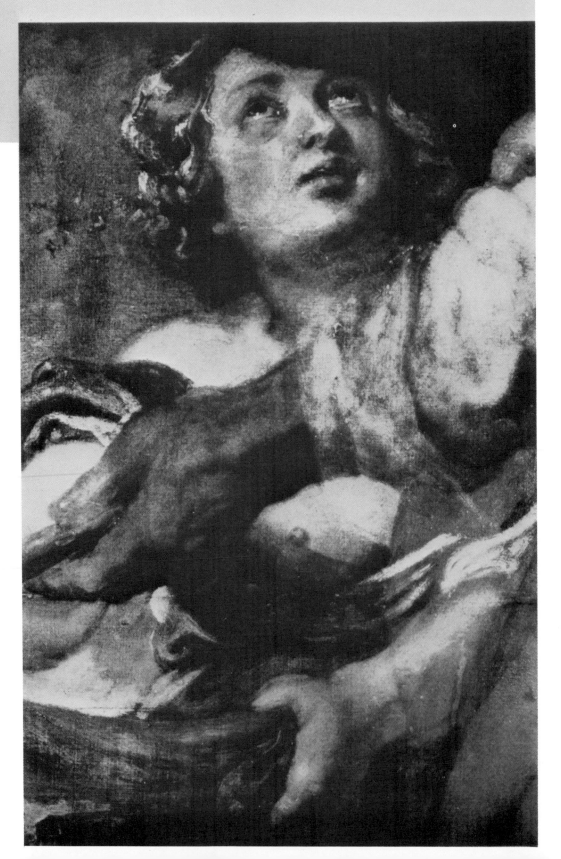

magniloquent as anything on the grand scale. "Small works of this kind," as Rubens himself wrote, "succeed better on panel"—to paint on whose smoothly prepared surface demands a direct, *alla prima* technique which fitted his quickness of hand and spirit. The translucency of the film of oil paint, allied to his open brush work, has made these works more luminous with time. The color is essentially simple. A rub of raw umber establishes a warm half-tone. A black cloud is set against the gold car for greater brilliance in the *Elias*, which beyond that has only the rose red of the prophet's dress and the creamy white of his horses to its making. In the *Gregory*, the gold glows sumptuously in the saint's struggle with an almost monochrome evil; the pretty pink flesh of the putto above gives airiness and softer light. Such things are readily appreciated at sight. "*Een schets van den prophet Elias opgevoert, van Rubbens*"—"A sketch by Rubens of the prophet Elias being borne aloft"—appears in the inventory of Herman de Neyt two years after the artist's death. This and the *Gregory* are amazing outbursts of that *furia del pennello*—the "impetuous brush"—which Bellori recognized in Rubens. They have been rightly prized from the first.

### Sketching for sculpture

In contrast to the swirling choreography of *St. Gregory* repulsing the winged demon is the statuesque posture of St. Norbert trampling the prone heretic Tanchelm [p. 35]. This imperious sketch, in grisaille but for the green stockings of Tanchelm, some accents of color lightly pasted on mitre, crozier and monstrance, the flesh tones, and rose flushes in the slate-grey sky, is indeed the model for a sculptor. The finished marble was to stand with two other figures above the high altar of St. Michael's Abbey in Antwerp, for which a magnificent *Adoration of the Magi* was painted in 1624 by Rubens himself. Thus, by his skill to vary his sketching technique to the requirements of different media of expression, he could control a complete scheme of decoration. Doing so, he gave a fresh twist to the mediaeval practice of Flemish painters to paint figures in grisaille, looking like statues ready to leave the sculptor's shop to be tinctured and gilt. His favorite device of diagonally streaking the surface of the panels with charcoal, shows in the detail of St. Norbert's sleeve [p. 35]. This broke the steady reflection from the white gesso, gave increased play of the colors in the drapery, and, beneath flesh tones, produced an optical effect to rival nature, of the warm to cool alternation of light on

skin. The detail also shows under-drawing of the folds in black chalk, which is exceptional: yet he allowed himself perfect freedom when he came to determine the final shape of them in paint.

### Sketching for large canvases

The concurrence between sketch and finished work is not often so exactly determined. The composition of *The Meeting of David and Abigail* exists in two versions: a sketch (unfortunately known to the present writer only from a photograph); and a large canvas involving fewer figures in a simpler arrangement which abandons the admirable *repoussoir* of horse and groom to bring the history nearer to the front plane [p. 36]. A pentiment in the finished gallery picture—which was actually a present to De Piles from the Duc de Richelieu—shows that a piece of red cloak originally hung from David's arm, as it does in the sketch. Its execution with nearly life-size figures is, in subordinate elements such as the lancers and porters, the work of an assistant of Rubens, probably Panneels. The principal group, however, is splendidly Rubens' own. Although the simplification of design argues that the sketch preceded the canvas, it was the sketch which provided the model for the engraver, and was presumably therefore the composition with which Rubens was best satisfied at the time. Indeed, the large picture may well have been commissioned some time later, on the basis of the engraving [p. 36].

### Sketch to be engraved, woven

A sketch designed solely for the engraver, such as the learnedly involved *Allegory in Honor of the Franciscan Order and of the Spanish Royal House*, seems dry by comparison [p. 65]. There Rubens best reveals his characteristic touch in the crisp delineation of portrait heads and in the live rhythms of the lightly brushed banderoles. His spirit was cramped by this kind of work.

A great deal more to his taste must have been the commission in 1621 from Louis XIII of France to prepare twelve sketches for tapestries illustrating the history of the Emperor Constantine, the classic prototype of Most Christian Majesty. The design of *The Vision of Constantine* [p. 66], in keeping with Rubens' personal renaissance of the antique, is based on the *Allocutio* type of relief—which shows Roman commanders addressing their troops—as much as on the treatment of the theme in the Vatican Stanze. Of the general approbation with which these panels were received by the learned critics of Paris we know from Peiresc; and canvases from them later became treasures of the Orléans

Sketch for engraving: Rubens' involved *Allegory of the Franciscan Order* [above] was closely followed in Pontius' print [below].

(6)

Collection. The handling of the *Vision* is as spirited and free as the interpretation. Colors are clearly indicated as a guide to the weavers. But the study is less elaborate than, for example, the models for the *Achilles* series about ten years later, where even color and arrangement of the ornamental borders are fully determined as an integral part of the conception. Another stage in the task of designing for tapestry is represented by the full-scale and full-color cartoons for *The Triumph of the Holy Sacrament*. The original set was woven in Brussels to the order of the Governess Isabella-Clara-Eugenia and, on their completion in 1628, presented to the convent of the Barefoot Carmelites near Madrid. The execution of the huge canvases was left mostly to assistants; but for example *The Gathering of the Manna* [p. 37] shows in the detail of the Israelite woman with skirts outspread, how Rubens would insert at the last moment, to suit his eye, a complete figure in the composition. She is an idea sketched on the heroic scale with the same brilliant economy of paint which characterizes his little sketches on panel.

### Sketching for festival décor

Besides tapestry and, of course, stained glass, the monumental pictorial expression of the North—where there was neither fresco nor mosaic—had been restricted before the advent of Rubens to theatrical staging. His own nature was congenial to the invention of shows and triumphal arches; and his most spectacular achievements of this kind were the tremendous decorations for the state entry into Antwerp of the Cardinal-Infante Ferdinand. Between November 1634 and April 1635 Rubens made scores of designs for the histories, allegories and single figures involved in this lavish advertisement to the new Governor of the impoverishment of his province and its chief port. In addition to surveillance of the work and virtually every painter in the city was brushing away at the scenery he had designed Rubens undertook, less than a month before Ferdinand was expected, a triple expansion of the principal arch, the extra fields of which were to be painted by his own hand. Comparison of the brilliantly suggestive sketch for one of these, *The Meeting of the Cardinal-Infante and King Ferdinand of Hungary on the Field of Nördlingen* [p. 67], with that of the *David and Abigail* [p. 36] shows the resolution of a comparable problem in the solemn meeting of many figures. Here is not

Sketching for tapestry: The Gobelin tapestry for Louis XIII [below] was from Rubens' small *Vision of Constantine* [above], 1621.

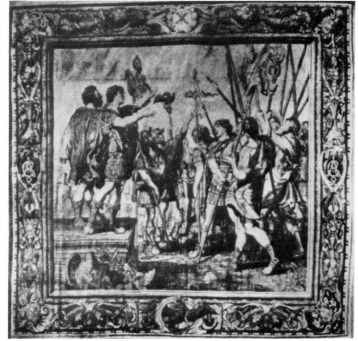

(7)

only the continuous development of his pictorial ideas, which extends far beyond the refreshment of particular motives, but also his much greater freedom of handling when painting simply to clarify at speed the elements of his own inspiration.

### Sketching for landscapes

The meeting of the royal captains on the eve of victory shows Rubens in his grand public manner. Within a few years he painted also his private vision of the world in *The Sunset Landscape* [p. 36]. "Nothing equals the landscapes of Titian and of Rubens," wrote Delacroix: "Those of the latter are the most admirable for the imagination. None of the studied detail which makes a mere portrait of landscape. *But all the grandeur and bounty of nature.*" By the golden illumination of a late afternoon sky, flocks wind over the land near Steen to the sound of the shepherd's pipe. This pastoral poetry of Flanders is attuned to the song of the Venetian idylls. Yet behind this noble elegy to the autumnal countryside lies a tender lyric. In

the breath of paint which is Rubens' sketch from nature, called *Landscape with a Farm* [see p. 36], we look not, as in the larger picture, at sunset and land and man and beast orchestrated into a universal harmony, but instantly to the very eye of the day star as he sinks with the myriad fleeting colors of the light. It is a single chord of beauty heard once and not again.

and this perhaps marks the low point in appreciation of Rubens generally. After the chill of the Greek Revival, a warm and live feeling for the strength of his sketches returned. In them the magic of Rubens may work again for us as it did for the Romantics, Fromentin and Delacroix and Burckhardt; and we may feel that by each sure gesture observed in them, now violent, now gracious,

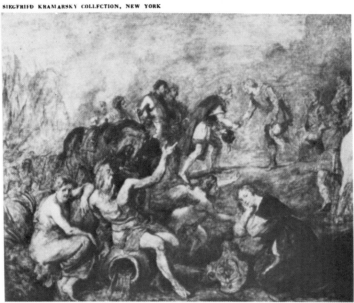

Sketching for festivals: Rubens' *Meeting of the Cardinal-Infante and King Ferdinand* was for a triumphal arch celebrating the latter's entry in Antwerp, 1635.

During the lifetime of the painter, Charles I of England kept Rubens' first model for the Banqueting Hall ceiling in his own chamber at Whitehall. There it kept company with Raphael's *St. George*, Leonardo da Vinci's *St. John* and the other choicest small pictures of the Royal Collection. The inventories of the Antwerp collectors during the seventeenth century list not only numerous sketches by Rubens himself, but many more made by other painters after his own, so desirable was the possession of any work by which to know something of their own Apelles. The sale catalogues of the next century show that the keen taste for a Rubens sketch never disappeared; and we have, as testimony, Watteau's words of envious admiration after visiting a collector. Charles Towney, the noted connoisseur of antiquities in the late eighteenth century, did indeed let pass his chance to buy the design of *The Triumph of Bacchus* as, for him, its conception strayed from the authority of the sarcophagus relief of that subject in the Borghese Collection;

we can approach more closely to the artist himself.

The sketches which he painted lie indeed at the core of our understanding of his whole artistic production. Early in his working life, and in his maturity when no client or assistant was immediately involved, he made use also of rapid pen jottings to lay compositions on paper. In his last years, however, this development of traditional Renaissance practice, and his own more essential one of interposing chalk studies from life between the sketch and the finished work, by which he gave a vital reincarnation to his conceptions, both seem to have lapsed from his habitual method. The persistent growth of his mastery of paint, which has never been rivaled, and his skill to develop a whole conception with a few strokes of the brush, supplanted those more restricted methods by which a painter draws. Proceeding from the full freedom of his powers, these late sketches seem like the last bright halations of an artistic apotheosis.

# "LE ROI À LA CIASSE"

## JULIUS S. HELD

### I

WITH the *Mona Lisa*, the *Sistine Madonna*, and the *Nightwatch*, the portrait of Charles I in the Louvre belongs to that handful of pictures with which virtually everybody is familiar (Fig. 1).[1] It has been reproduced endlessly, from the engravings of the late eighteenth century to the halftones of modern school books. It appears with the same monotonous regularity in treatises on the history of England as in books on Flemish art. Charles Sterling called it, with a polite bow to Fromentin, "perhaps the most beautiful portrait by Van Dyck,"[2] and Mme Bouchot-Saupique spoke of it as "une des plus parfaites expressions de la peinture de toute une époche."[3] One should certainly expect that all the aspects of the picture had been thoroughly explored and that little is left for the modern critic except to share in the universal admiration which the portrait seems always, and deservedly, to have enjoyed.

Surprisingly, the literature on this famous work is rather skimpy. Although the picture has been described many times, these descriptions, by and large, are brief and sometimes misleading, and there are some questions that have never been asked at all.

In the present study I want to discuss some aspects of the interpretation of the work, to make suggestions as to its meaning and possible sources, and to indicate tentatively what may have been the reasons for its enduring popularity. No new contribution will be made to its date, generally accepted as 1635. No new finds have been made in archives. The considerable effect which the picture has had on contemporary and later artists such as Dobson, Sustermans, Quellinus, Carreño, Reynolds, Gainsborough, Goya, C. W. Peale, and even Prud'hon would form the theme of a separate and different investigation.

(9)

1. Louvre, no. 1967 (Inc. no. 1236). Canvas, 272 x 212 cm. Inscribed on a stone at the lower right (Figs. 1a and 1b): CAROLVS · I · REX · /MAGNÆ BRIT · /ANNIÆ · &C and A · VAN DIICK · F. Ex coll: Comtesse de Verrue; Marquis de Lassay; Comte de La Guiche; Madame du Barry; King Louis XVI (1775). According to Mme Jacqueline Bouchot-Saupique (*La peinture flamande du XVIIe siècle au Musée du Louvre*, Brussels, 1947, p. 70) there exist more than thirty copies of this work. It was engraved by Robert Strange in 1782 (and rendered in many unimportant engravings and wood-engravings afterwards). Strange's engraving bears the following text: "Carolo I.<sup>mo</sup> MAGNAE BRITTANNIAE REGI, &c. / Jacobus Hamiltonius, Marchio ab Hamilton, Sacri Stabuli Comes, adstat./ E Tabula Antonii Vandiick Equitis, 8 pedes et 9 digitos alta, 6 pedes et 10 digitos lata, in Pinacotheca Regis Christianissimi conservata. Antonius Vandijck Eques pinxit. Robertus Strange delin.ᵗ atque sculpsit A.D. 1782." As far as I can see, Strange is the first source to identify the equerry with the Duke of Hamilton. On his authority virtually all writers have accepted this identification. Only Paul G. Konody and Maurice W. Brockwell (*The Louvre*, London, 1905) identified the equerry with M. de Saint-Antoine. This view is clearly untenable since the attendant in the Louvre portrait is obviously a different person from de Saint-Antoine whom Van Dyck portrayed in an equestrian portrait of the same kind at Windsor (G. Glück, *Van Dyck*, Stuttgart-Berlin-London, 1931, p. 372). The identification of the equerry with Hamilton, however, is also open to serious doubt. James Hamilton, First Duke of Hamilton (1606-1649), was one of the great nobles of Charles' reign and heir to the throne of Scotland. Though he

was closely allied with Charles from childhood, it is highly unlikely that he would have been included in a portrait of the king in the role of an equerry. It is true that in 1628, upon the death of Buckingham, he was appointed Master of the Horse (as well as gentleman of the bedchamber and a privy councillor). The Master of the Horse, far from being charged with holding the horse for the king on an outing, is actually "the third great officer in the British court. He has the management of all the royal stables and breed horses, with authority over all the equerries and pages, coachmen, footmen, grooms, etc. In state cavalcades he rides next to the sovereign" (*The Century Dictionary and Cyclopedia*, V, New York, 1906). There is not the slightest indication of high rank in Van Dyck's painting in the figure behind the king, indeed, half hidden by the King's horse. Furthermore, there is no compelling physiognomic likeness between the equerry in Van Dyck's painting and the features of Hamilton as we know them from D. Mijtens' portrait of 1629 in the National Gallery at Edinburgh (H. Gerson, *Van Geertgen tot Frans Hals*, Amsterdam, 1950, fig. 160) and Van Dyck's portrait in Hamilton Palace (Glück, *loc.cit.*, p. 463). Despite Strange's explicit statement, I believe the identification of the equerry with Hamilton must be abandoned. For the time being, both the equerry and the page who carried the king's cloak must remain anonymous. (Charles Sterling informed me in a letter that he, too, has come to this conclusion. He also kindly supplied me with photos of the inscriptions.)

2. Catalogue of the Exhibition "Rubens et son temps," Paris, Musée de l'Orangerie, 1936, no. 31, pp. 57-58.

3. *Op.cit.*, p. 70.

W. H. Carpenter was the first to identify the painting with one called "Le Roi à la Ciasse" and listed in a memorandum of 1638, presumably drawn up by Van Dyck himself.[4] Although this identification has never been formally challenged, it has not been accepted by *all* writers. Charles Blanc makes no reference to it;[5] he describes Charles as "promenading in the woods." Guiffrey quotes the title but then goes on speaking of "the elegant simplicity of everyday dress."[6] Fromentin, Heidrich, Friedländer, Delen, Robb, Waterhouse, and Baldass completely ignored the old title,[7] as do most authors of books and catalogues on the collections of the Louvre.[8] M. Rooses put the words "Le Roi à la Ciasse" into quotation marks and parentheses,[9] thus indicating that he considered it a traditional label without serious significance. Michiels was the first to make use of the identification suggested by Carpenter, and his description, one of the longest in the literature, deserves to be quoted in full:

> It appears as if the monarch had lost his way during the hunt and, tired from a long ride, and not knowing where he was, dismounted from his horse. Two pages behind him hold the noble beast. The trees at the edge of the forest spread their shadows over the group. In the distance one sees the waves of a tranquil sea and a boat that moves away with full sails. The features of the hapless monarch express the moral weakness and the martial courage which formed in him such an interesting mixture. He looks at the beholder in an exquisite attitude, the right hand resting on the pommel of a large cane, the left hand on his hip. One might say that the artist foresaw the flight of the monarch and the hours of anguish which he had to pass at the shore of the Channel searching with his eyes for a vessel of rescue which could take him to France. Alas! the winds carry away that last hope. The sails become smaller and will soon disappear in the haze of the horizon.[10]

With the last passage Michiels alluded to an eighteenth century opinion according to which the Louvre canvas illustrates the flight of Charles I. In the print of the painting that accompanies a chapter in F. A. David's *Histoire d'Angleterre*, the picture is actually entitled "Charles I. se sauve d'Amptoncourt."[11] Realizing that it was hardly possible for Van Dyck, who had died in 1641, to depict an event that took place in 1647, Michiels admitted that the old view had been erroneous. Yet he evidently could not free himself from sentimental associations caused by his knowledge of the later events of the King's life.

(10)

A reference to the King's fate indeed is one of the leitmotifs in descriptions of the Louvre canvas. Charles Blanc had struck this note when he said of his promenading gentleman that he carried with himself "sa mauvaise fortune et ses rêveries,"[12] a mood extending to the horse which "l'oeil morne et la tête penchée *semble se conformer à sa triste pensée.*" Even the old

4. William Hookham Carpenter, *Mémoires et documents inédits sur Antoine van Dyck* . . . , Antwerp, 1845 (translated by Louis Hymans) pp. 66-67. While it is generally assumed that it was the king himself who crossed out Van Dyck's valuation of £200 and instead wrote £100 on the margin, Margaret Goldsmith (*The Wandering Portrait*, London, 1954, p. 39) avers that the corrections show the hand of Bishop Juxon, the Lord Treasurer.

5. Charles Blanc, *Histoire des peintres de toutes les écoles*, École flamande, Paris, 1868, "Antoine van Dyck," p. 16. Needless to say, all earlier discussions of the portrait—as for instance that of John Smith, *Catalogue Raisonné*, III, London, 1831, p. 39—make no reference to hunting at all.

6. Jules Guiffrey, *Sir Anthony van Dyck*, London, 1896, pp. 193-197.

7. E. Fromentin, *Les peintres d'autrefois*, Paris, 1876, p. 141; Ernst Heidrich, *Vlämische Malerei*, Jena, 1913, p. 75; Max J. Friedländer, *Die niederländischen Maler des 17. Jahrhunderts*, Berlin, 1923, p. 322, no. 129; A. J. J. Delen, *Antoon van Dijck*, Antwerp, 1947, p. 54; D. M. Robb, *The Harper History of Painting*, New York, 1951, p. 509; E. Waterhouse, *Painting in Britain*, London, 1953, p. 48; L. Baldass, *Gazette des Beaux-Arts*, L, 1957, p. 270.

8. Armand Dayot, *Le Musée du Louvre*, Paris, 1912;

Louis Demonts, *Catalogue des peintures*, III, Écoles flamande, hollandaise, allemande et anglaise, Paris, 1922, p. 6; Eduard Michel, *La peinture au Musée du Louvre*, Paris, n.d., pp. 90-95; Georges Lafenestre, *Le Louvre*, Paris [1947], I, p. 27; R. Huyghe, *Art Treasures of the Louvre*, New York, 1951, p. 162.

9. Max Rooses, *Art in Flanders*, New York, 1914, p. 231 (fig. 429).

10. Alfred Michiels, *Histoire de la peinture flamande*, VII, Paris, 1869, pp. 349-350. Large sections of this description were taken over verbatim by Michiels in his book on Van Dyck, first published in 1880 (2nd ed., 1882, p. 390). He eliminated, however, the sentence beginning "The features of the hapless monarch . . ." and inserted instead the following: "Les traits du malheureux souverain ont une expression remarquable de mauvaise humeur; dans son dépit, son oeil reste froid, morne, sans éclair de la haine et des fortes résolutions: il souffre, il souffrira encore . . . , il ne se vengera pas!" And after the sentence that ends "the left hand on his hip" ("la main gauche sur la hanche") he mentions the horse: "Son cheval, la tête basse, gratte du pied la terre avec impatience."

11. Vol. II, Paris, 1786, p. 141, pl. XXVIII.

12. See note 5.

notion of Charles' flight echoed in Blanc's text when he spoke of the ship which approaches the shore "comme pour emmener un fugitif." (In his description of the Windsor portrait Blanc described Charles' face "serious and melancholy as always" and continued: "I do not know if the knowledge of history contributes to it, but one is persuaded to distinguish in the pallid features of this prince harbingers of his tragic destinies.")[13] Louis Gillet found Charles' expression in the Louvre painting both "rayonnante et triste."[14] E. Schaeffer, though taking a stand against romantic extremes, felt nevertheless that the King looks "mit nachdenklicher Melancholie in die abendliche Landschaft."[15] Glück, too, describes Charles as looking out from the picture "mit fast trauriger Miene."[16] For Fierens-Gevaert Charles was a "souverain nostalgique,"[17] and Delen climaxed it all when he said: "Ces yeux tristes et ces lèvres minces et austères disent tout le mystère de l'angoisse dévorante, du sombre pressentiment dans l'âme de ce roi fastueux mais malheureux qui bientôt [!] devrait expier sa faiblesse par la mort."[18]

The "gloomy" school of interpretation of the Louvre canvas (and occasionally of other portraits of Charles by Van Dyck) is too persistent a phenomenon not to require an explanation. Delen's phrase "ces yeux tristes," indeed, is strangely reminiscent of a famous line in Robert Browning's *Strafford* (ii, 2) where Charles is described as "the man with the mild voice and the mournful eyes." Browning's image of the physical make-up of the King was probably derived from many portraits, the one in the Louvre surely among them; yet it is more than likely that he visualized him with "mournful eyes" because his mind was conditioned by two factors: One was the pervasive tendency of Romantic poetry and art to see a special beauty, if not a mark of distinction, in a melancholy bearing. Géricault's melancholy artist (Paris) and Delacroix's troubled Michelangelo (Montpellier) are as characteristic for this trend as Byron's *Sardanapalus* or Matthew Arnold's *Empedocles on Etna*.[19] The second factor, bearing more specifically on the theme of Van Dyck's portrait, was the revival of a tendency to stress Charles as a tragic figure.

(11)

It may be useful to remember that from the moment of his trial and execution Charles had been portrayed in diametrically opposed patterns. Those who were in sympathy with the Commonwealth referred to him as a tyrant who had fully deserved his fate. But to those who felt that monarchy was the only guaranty of a lawful government and who abhorred democracy, he became the "Royal Martyr" (or the "blessed," or "glorious" one) and his execution—in the often repeated words of Edward Hyde, first Earl of Clarendon—the "execrable murder."[20] Five churches were dedicated to "King Charles the Martyr," and, in December 1660, Parliament passed a bill ordering the annual observation of his death as a day of fasting and penance.[21]

13. Blanc, *op.cit.*, p. 14.

14. Louis Gillet, *La peinture, XVIIe et XVIIIe siècles*, Paris, 1913, p. 100.

15. Emil Schaeffer, *Van Dyck*, Stuttgart, 1909, p. xxxii.

16. Gustav Glück, *loc.cit.*, pp. xliii-xliv.

17. H. Fierens-Gevaert, *Van Dyck*, Paris (n.d.), p. 94.

18. *Loc.cit.*, p. 54. It is significant for this trend of interpretation that Max Rooses, who, in marked contrast to other nineteenth century scholars, describes Charles in the Louvre portrait as a "prince aimable, heureux et frivole"! (*Les chefs-d'oeuvres de la peinture de 1400 à 1800*, Paris [n.d.] I, p. 53), could not help introducing a "sad" interpretation into his analysis of the equestrian portrait of Charles, now in the National Gallery. Perhaps under the influence of Blanc's description of the Windsor portrait, cited above, he says that Charles "seems to turn his large listless eyes instinctively towards heaven with a tired and melancholy expression as if he were reading in the clouds his fateful end" (*Geschiedenis der antwerpsche Schilderschool*, Ghent, 1879, p. 480). Pol de Mont, finally, speaks of "les enfants mélancoliques du roi" with references to the portraits by Van Dyck of Charles' children (*Antoine van Dyck*, Haarlem [1906], Introduction). To him,

however, almost all of Van Dyck's figures appear melancholy ("Quelle mélancolie dans les traits de tous ces visages") but it is a "mélancolie souriante" which makes him think of Alfred de Musset and Heinrich Heine.

19. See also note 18.

20. Edward, Earl of Clarendon, *The History of the Rebellion and Civil Wars in England*, Oxford, 1826, VI, pp. 235-236. For the strong religious aspect of this worship of Charles' memory see, for instance, Luke Milbourne's Sermon preached at the Parish-Church of St. Ethelberga's in 1719 on the anniversary of Charles' death which begins thus: "The Day is now return'd which has been set apart for many Years by Publick Authority, in which *Three guilty Nations* should in a more eminent manner humble Themselves before Almighty God, the terrible Avenger of the Blood that, next to the Crucifixion of the incarnate Son of God, the Sun ever look'd on, the impious Murder of *Charles* the First, once the lawful Sovereign of these Kingdoms, of precious and ever Blessed Memory." Luke Milbourne, *Ignorance and Folly put to Silence . . .* , London, 1719.

21. J. G. Muddiman, *Trial of King Charles the First*, Edinburgh and London [1928], pp. 188-189.

The services of the day were printed in the book of Common Prayer where they remained until 1859.

During the latter part of the eighteenth century the controversy had quieted down, but in the early nineteenth there was a strong revival of interest in the problems of the English revolution and the figure of Charles I. Various factors combined in this development. One was evidently the French Revolution, which again posed the problem of royal absolutism and popular representation, and in which again a legitimate monarch had been executed. One of the leading historians, and eventually a most powerful politician, François Guizot (1787-1874), whose father also had been a victim of the guillotine, published the first two volumes of his *Histoire de la Révolution d'Angleterre* in 1826-1827. In his preface he frequently coupled the two revolutions, discussing their similarities and differences and summing up with the significant statement "that the first would never have been thoroughly understood had not the second taken place."[22] Although aiming at an objective view, his basically conservative attitude (which after 1830 made him "the most determined foe of democracy")[23] is easily noticed in his account. He strongly attacks Brodie, the author of a *History of the British Empire*, who "fully participates in all the prejudices, distrust, and anger of the bitterest puritans . . . while, to the faults and crimes of his party, he is wholly blind."[24] Guizot's detailed and often moving account of Charles' ordeals, trial, and death quickly became the standard text for Continental as well as English readers.[25]

Two years after Guizot's book there appeared the first volume of a five-volume biography of Charles I by Isaac D'Israeli, the father of the future Prime Minister.[26] D'Israeli, too, criticizes earlier historians unfriendly to Charles, among them Brodie ("a Scotch covenanter") and Mrs. Macauley ("a commonwealth lady") whose *History of England* had appeared in the years between 1763 and 1783 and had been partially translated into French by Mirabeau. For D'Israeli, Charles is a figure of tragic dimensions, comparable to the classical Oedipus.[27] There is more than rhetoric in his words when he sums up his introduction by saying: "Humiliated by fortune, beneath the humblest of his people, the King himself remained unchanged; and whether we come to reproach, or to sympathise, something of pity and terror must blend with the story of a noble mind wrestling with unconquerable fate."[28]

In 1813 the remains of Charles I were discovered in the tomb of Henry VIII in St. George's Chapel, Windsor. An account of this discovery was written on April 11 by Sir Henry Halford, the distinguished physician, and published in 1831;[29] the *New York Mirror* of October 22, 1831, reprinted the text with a woodcut of the King's head, under the heading "Curious Discoveries." Although the corpse was immediately reinterred, a lock from Charles' head was sent like a "relic" to Sir Walter Scott who placed it in his "musaeum."[30] The discovery of Charles' body too, may have contributed to bringing back into focus the pathetic end of the Stuart prince.

For the revival in some quarters of the old cult of Charles I, credit must be given to the growth of a historic Romanticism closely associated with the conservative trends of the age. Scott himself, though not sympathetic to Charles, had helped to make the age of the cavaliers appealing to the

22. F. Guizot, *History of the English Revolution of 1640*, translated by William Hazlitt, New York, 1846, p. xv.

23. *Encyclopaedia Britannica*, 11th edition, New York, 1910, XII, p. 706.

24. Edinburgh, 1822, p. xxii.

25. It is highly characteristic of Guizot's increasing conservativism that the relative objectivity of his attitude towards the English Revolution and Charles' execution gives way to a strongly partisan view in his *Discours sur l'histoire de la révolution d'Angleterre*, of January 1841, published in the 1850 edition of his *History of the English Revolution*. On p. 35 of that *Discours* we find this revealing passage: "Et ce qu'on n'eût osé tenter contre le moindre des Anglais, on le faisait contre le roi d'Angleterre, contre le chef suprême de

l'Église comme de l'État, contre le représentant et le symbole de l'autorité, de l'ordre, de la loi, de la justice, de tout ce qui, dans la société des hommes touche à la limite et réveille l'idée des attributs de Dieu!"

26. I. d'Israeli, *Commentaries on the Life and Reign of Charles the First, King of England*, London, 1828-1831.

27. V, p. 472.

28. *Ibid.*, I, p. 7.

29. The report was reprinted in Sir Henry Halford's *Essays and Orations*, London, 1842, p. 333.

30. H. J. C. Grierson, *The Letters of Sir Walter Scott*, London, 1932, III, p. 264. The letter is dated May 3, 1813, and is addressed to Scott's daughter.

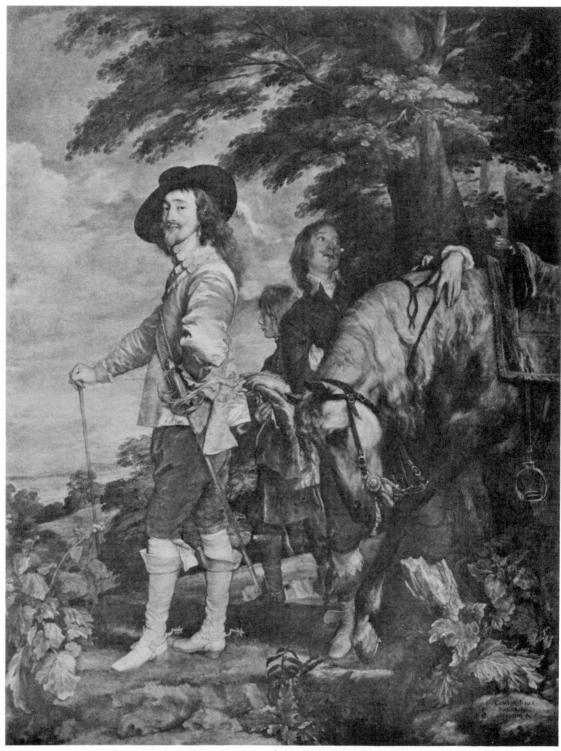

1. Van Dyck, *Le Roi à la Chasse* (Portrait of Charles I). Paris, Louvre
(photo: Alinari)

1a and 1b. Details of Fig. 1

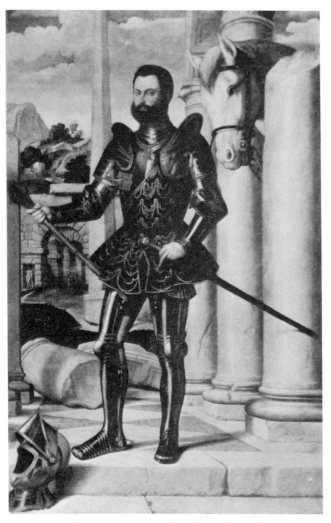

2. G. B. Moroni, *Portrait of a Man in Armor* (1563)
New York, Samuel H. Kress Collection

3. British School, *Portrait of Henry Frederick, Prince of Wales* (1603)
New York, Metropolitan Museum of Art

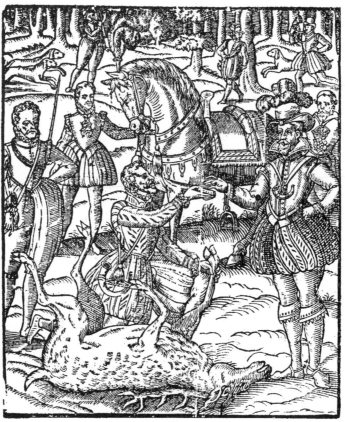

4. *The Breaking Up of the Deer* (Woodcut from the 1611 edition of
Turbervile's *Booke of Hunting*)

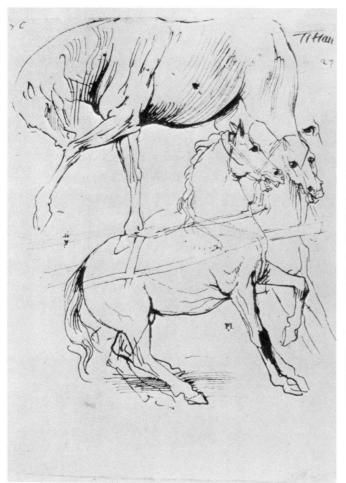

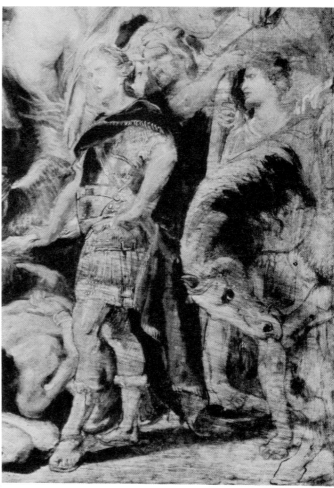

5. Van Dyck, *Drawing of Horses*. Chatsworth House, Sketchbook

6. Rubens, *Emperor Constantine* (detail from *Roma Triumphans*, sketch) The Hague, Mauritshuis

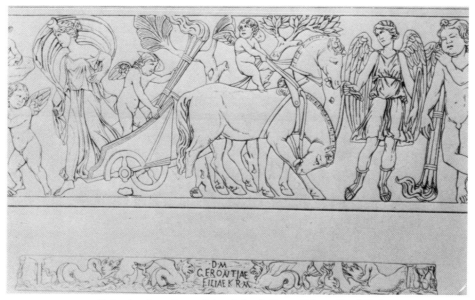

7. Endymion Sarcophagus (after Robert), Rome, Palazzo Rospigliosi

9. Edward Bower, *Charles I at His Trial*. Edinburgh, National Portrait Gallery of Scotland

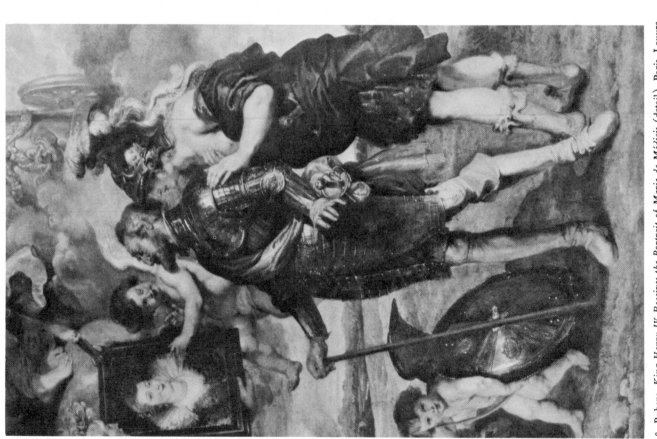

8. Rubens, *King Henry IV Receives the Portrait of Marie de Médicis* (detail). Paris, Louvre

imagination (George Borrow called it later the "Jacobite Nonsense" of Scott). Plays about Charles had occasionally been written before, but in the early nineteenth century there was a sudden outburst of such dramatizations.[31] In 1818 Shelley began to think about a play on Charles I, but he left only a fragment when he died in 1822. In 1828 a tragedy about Charles was written by E. Cobham and two years later a German, E. Kaiser, also wrote a *Trauerspiel* with Charles as hero. This was followed in 1834 by a "historical tragedy" about Charles by Mrs. M. R. Mitford, in 1840 by another German *Trauerspiel* by Frans Bermoth, and in 1846 by the Reverend Archer T. Gurney's play *King Charles the First*. If we add to these Browning's *Strafford*, first produced in 1837, we find that in the space of twenty-two years no less than seven tragedies were planned or produced in which Charles figured prominently. After 1850 the number of plays dedicated to Charles' life declined, but six more were written between 1873 and 1908.[32]

Poets and novelists, especially those who for political or religious reasons leaned towards a conservative attitude, revived the very terms under which Charles had been venerated before. When Princess Charlotte died in 1817, Robert Southey devoted to her a *Funeral Song* in which he also evoked the memory of Charles ". . . whose tragic name / A reverential thought may claim. / That murder'd Monarch. . . ."[33] In 1828 (the year in which d'Israeli's book came out) the Reverend John Keble, who is credited with having started the Oxford Movement, added a poem about "King Charles the Martyr" to his *Christian Year*, the incredibly popular book of spiritual poetry that in Keble's lifetime alone saw ninety-five editions.[34] In this poem he apostrophized Charles with the frequently quoted lines: "Our own, our royal Saint"; and the Reverend Mr. Gurney again used the phrase "Royal Saint" in his play. The Tractarians indeed seem to have kept faithfully the solemn annual observation of Charles' death.[35]

How many more pious or sentimental references to King Charles may be found in early and mid-nineteenth century literature is impossible to say. A characteristic example, listed in Amy Cruse's book, is the passage from M. Yonge's *The Heir of Redclyffe* where its hero, Sir Guy Morville, says about the King: "How one would have loved him, loved him for the gentleness so little accordant with the rude times and the part he had to act—served him half like a knight's devotion to his lady-love, half like devotion to a saint."[36] And finally we should not forget the romantic pictures, distributed in innumerable prints, which showed some of the pathetic moments of the King's life, one particularly touching being his taking leave of his children.

Thus we see that in the beginning of the nineteenth century Charles once again assumed in many quarters a tragic and romantic aspect and that the emotional appeal of his fate was further strengthened by the significance his struggle had for the conservative political forces of the period. It is likely, therefore, that the "gloomy" interpretations of the Louvre portrait of Charles by Van Dyck, and occasionally of other portraits of the monarch, appearing as they do among art historians shortly after the middle of the century, reflect a climate of opinion that had been formed in various political, literary, and religious circles during the preceding years.

## II

Most modern writers do accept the identification of the King as being at the hunt, no matter how melancholy he may appear to them.[37] At first glance the painting itself hardly justifies this

(17)

---

31. See Reinhard Fertig, *Die Dramatisierungen des Schicksals Karls I. von England*, Diss., Erlangen, 1910.

32. Fertig lists dramas about Charles by W. G. Wills (1873), Arthur Gray Butler (1874), the first author to rescue Cromwell from the villain's role, Peter Lohmann, a German (1875), Mariano Aureli, an Italian (1875), and finally Siegfried Heckscher, a German (1908). Whether it is more than coincidence that four plays on Charles were published between 1873 and 1875, following by only a few years the deposition of Napoleon III and the establishment of a French Republic in 1871, I am unable to say.

33. Robert Southey, *The Poetical Works*, New York, 1850, p. 787.

34. *The Christian Year* appeared first in 1827. The Poem on Charles I was added to the third edition.

35. See Amy Cruse, *The Victorians and Their Books*, London, 1935, p. 34. I owe Mrs. Horace W. Chandler the reference to this book.

36. Cruse, *loc.cit.*, p. 52.

37. Besides Guiffrey, Schaeffer, Fierens-Gevaert, Sterling,

confidence. While Charles' costume is such as could conceivably have been worn by the King when hunting, it is most unlikely that it can be shown to have been worn *only* at such occasions. The evidence seems almost to point in the other direction: a walking cane does not seem to be a proper piece of equipment for a hunter; the silk jacket is rather unsuitable for the rough business of the hunt.[88] The equerry who holds the horse's bridle and the page who carries the King's mantle are surely normal company for a monarch on any outing undertaken on horseback, and nothing in their outfit or equipment supports the thesis that we have before us an incident of the hunt. There is no reference anywhere to other hunters, to hounds, or to the prey itself. Nor is there any indication that the King has been separated from the rest of the company. Nothing seems to be further from the mind of the monarch, as we see him in Van Dyck's painting, than the pursuit of the stag.

Should we then give up the old theory that the painting in the Louvre is indeed the same picture that in the memorandum of 1638 figures as *Le Roi à la Ciasse*? I do not think so. It is necessary, however, to examine the question from a somewhat different angle.

Considering that it was painted at a time when painting in general, and portraiture in particular, were still apt to follow established patterns—though with variations—the Louvre painting of Charles I represents a rather unusual type. While the picture of a gentleman standing near his horse became common in later times, there are not many iconographic antecedents for Van Dyck's picture. The patterns of courtly portraiture, as found in the works of Titian and Rubens, did not include a formula comparable to Van Dyck's. The picture is not only more informal than the established types of state portraiture, but it combines elements which were normally not seen together in this way.

Where a horse is present, the model is likely to sit on it; when he is on foot, he may have near him a dog, a member of his family, or a dwarf, but not a horse or a retinue like that seen in the Louvre canvas. A painting by G. B. Moroni, now in the Kress collection, is the only Italian example known to me in which a full-length figure is portrayed with a horse standing near him (Fig. 2). Yet the similarity goes no further. The setting is completely different; of the horse, only the head is seen, appearing between the columns at the right. The man is in full armor and his stance is fairly conventional—and quite different from that of King Charles. No reference to Moroni's portrait is found in Van Dyck's Italian sketchbook. It is not very likely that Van Dyck ever saw it; in the genesis of the Louvre portrait, at any rate, it probably had no part.[39]

More important, I believe, is an English picture which exists in two versions, the better of which is in the Metropolitan Museum in New York (Fig. 3). (The other is in Hampton Court.) Painted in 1603, it shows Henry, Prince of Wales (1594-1612), at the age of nine standing triumphantly over the body of a dead stag. In the literature about this picture, there is some confusion as to what exactly is shown; one author said it is Henry represented cutting the throat of a stag.[40] Another describes Henry as "drawing" a sword, to cut off the stag's head.[41] Cust sees

Glück, and Bouchot-Saupique, whose works have been listed before (notes 2, 6, 15, 16, 17), we might mention further G. F. Waagen, *Handbuch der deutschen und niederländischen Malerschulen*, Stuttgart, 1862; Jos. van den Branden, *Geschiedenis der antwerpsche Schilderschool*, Antwerp, 1883; H. Knackfuss, *A. van Dyck*, Bielefeld-Leipzig, 1902; Lionel Cust, *Anthony van Dyck*, London, 1905; Paul G. Konody and Maurice W. Brockwell, *The Louvre*, London, 1910; F. M. Haberditzl, in Thieme-Becker, *Allgemeines Lexikon der bildenden Kunst*, X, 1914, p. 268; Willi Drost, *Barockmalerei in den germanischen Ländern*, Wildpark-Potsdam, 1926; Frank van den Wijngaert, *Antoon van Dyck*, Antwerp, 1943; Antonio Muñoz, *Van Dyck*, Novara [1941]; Leo van Puyvelde, *Van Dyck*, Brussels, 1950; Ernst H. Gombrich, *The Story of Art*, London, 1950.

38. Mme Bouchot-Saupique (*op.cit.*, pp. 28 and 70) calls the outfit unequivocally a "costume de chasse."

39. The manner in which the horse is introduced next to a man in armor in Moroni's picture is reminiscent of renderings of St. George, such as the one in Pisanello's well-known painting in London. (I owe this observation to Professor Millard Meiss.)

40. Thomas Pennant, *Some Small Account of London*, 4th ed., London, 1805, p. 97. Pennant was speaking about the picture in Hampton Court. The Reverend James Dallaway in his notes to Walpole's *Anecdotes* (II, London, 1826, p. 7) repeats this statement.

41. The Reverend James Granger, *A Biographical History of England from Egbert the Great to the Revolution*, 3rd ed., London, 1779, I, p. 337.

the prince "about to give the *coup de grâce* to a wounded stag."[42] Helen Comstock[43] and Mrs. Elizabeth E. Gardner[44] alone of all authors described Henry correctly as sheathing his sword, but Miss Comstock gives a rather fanciful description of the scene and Mrs. Gardner cannot free herself from the notion of the *coup de grâce* which Henry supposedly has just administered.

To interpret correctly what goes on we only have to read the pertinent passage in the English edition of *Turbervile's Booke of Hunting*.[45] Speaking about "the Englishe manner, in breaking up the Deare" the author says (p. 134):

> . . . oure order is that the Prince or chiefe (if so please them) doe alight and take assaye of the Deare with a sharpe knyfe, the whiche is done in this manner. The deare being layd upon his backe, the Prince, chiefe, or such as they shall appoint, commes to it: And the chiefe huntsman (kneeling, if it be to a prince) doth holde the Deare by the forefoote, whiles the Prince or chief, cut a slyt drawn alongst the brysket of the deare, somewhat lower than the brysket towards the belly. This is done to see the goodnesse of the flesh, and howe thicke it is.—This being done, we use to cut off the Deares heades. And that is commonly done also by the chiefe personage. For they take delight to cut off his heade with their woodknyves, skaynes or swordes, to trye their edge and the goodnesse or strength of their arme. [The head is then used to reward the hounds.]

If one examines the picture in the Metropolitan Museum more closely, one sees, although hidden under merciful retouches, a big gash in the deer's neck. This is certainly not a *coup de grâce* for a wounded animal, but a blow inflicted upon the dead deer in accordance with the customs of the hunt. Prince Henry, still a very young boy, after all, is satisfied with having opened by his blow the deer's neck. He is now indeed sheathing his sword, leaving the complete severing of the head to others. That the severing of the head was the ritualistic climax of the hunt of the stag (which in itself was the noblest—and most formalized—of all the hunts)[46] may be seen also from a woodcut in the English translation of Turbervile, here shown from the 1611 edition, where a prince has replaced—on a separate wood block—the princess who figured there originally; this is clearly a reflection of the change from the times of Queen Elizabeth to those of James I (Fig. 4). In this woodcut the prince receives from a kneeling gentleman the knife with which he cuts the stag's neck. It is quite possible that this plain woodcut served as the model for the painting of Prince Henry. The kneeling companion holding on to the stag, the horse in the background, held by the prince's equerry, the presence of hounds, and the reference to hunting in the background are sufficient to establish a connection between the works.

As far as I see there is no evidence that there existed a tradition of such hunting portraiture before 1603, which makes the influence of the woodcut on the painting all the more likely; between 1603 and 1635 (if that is the date of Van Dyck's picture) there were painted at least two more works that show variations on the theme of the prince at the hunt. In 1617 Paul van Somer painted his *Anne of Denmark* (1574-1619) at Hampton Court, in which the Queen stands in a landscape in front of her horse which is held by a Negro groom; she is surrounded by hunting dogs but she is not herself engaged in hunting.[47] In 1626, George Geldorp painted the portrait of William the Second (Earl of Salisbury) at Hatfield, showing the spurred and booted gentleman in a landscape with a tiny stag hunt depicted in the distance.[48]

References to hunting are found in all these pictures, but they become successively weaker.

42. *The Walpole Society Annual*, III, London, 1913-1914, p. 28.

43. *The Connoisseur*, CVI, July, 1940, p. 28.

44. *Bulletin of the Metropolitan Museum of Art*, January, 1945, p. 113.

45. London, 1576; published in a second edition in 1611, and republished from this later edition in Oxford, 1908. There is some question as to whether Turbervile really was the author of the book that goes under his name. The answer to that question, however, has no bearing on our subject since the paragraph cited above was added by the English translator.

46. See W. R. Halliday, *A Short Treatise of Hunting by Sir T. Cockaine*, Oxford, 1932 (Introduction).

47. See C. H. Collins Baker and W. G. Constable, *English Painting of the Sixteenth and Seventeenth Centuries*, Florence-New York, n.d., plate 37.

48. *Ibid.*, plate 43.

While they have virtually disappeared from Van Dyck's work, it can still be considered as a late representation of those portraits "à la chasse." Like them it shows the King on foot, out of doors, in a partly wooded setting. The groom with the horse standing behind the prince was a feature also in the hunting portraits of Prince Henry and Queen Anne. It is perhaps pertinent in this connection to point out that King Charles was the brother of Prince Henry (whose premature death alone forced Charles to take on the burden of rule) and the son of Queen Anne. Their portraits were of course constantly before Van Dyck's eyes. Thus it is easy to understand why he should have referred to his own picture as *Le Roi à la Chasse*, no matter how little it still retained of this context. To a noticeable degree, his painting does continue an established tradition and the commission may well have specified that the King should be rendered as he would appear at a hunt. However that may be, we must admit that Van Dyck played down the reference to the hunt as an activity involving exercise, manipulation of weapons, and contact with hounds, let alone with dead animals. Instead, he stressed nobility of appearance, and princely superiority. In view of these facts, it is appropriate to ask whether there were not other influences which contributed in the genesis of the painting. While the idea of the work may well have been derived from the English portraits discussed before, it is clear that there is no trace of any *formal* dependence. The unmistakable elegance and dignity of the picture—especially as regards the attitudes of, and the compositional relationship between, king and horse—have no parallel in the local tradition.

## III

(18)

It has long been observed that for the pose of the horse Van Dyck made use of a motive which he had found in a work by Titian.[49] He drew the horse in one of the most beautiful pages of his Chatsworth sketchbook where it is indeed inscribed with the word "Titian" (Fig. 5). His actual source may have been a drawing, as Adriani says,[50] but could just as easily have been one of the several versions of Titian's *Adoration of the Magi*, examples of which are in the Prado, in the Escorial, the collection of Arthur Sachs, and the Ambrosiana. What precisely the horse is doing in this pose had been interpreted in different ways, such as pawing the ground, licking or rubbing the knee, or chasing a fly; it certainly is not "kneeling down to allow the royal rider to dismount."[51] More important for our purpose is the observation that in Titian's picture the horse's motion is not only suggestive of a homage to Christ paid by the noble creature but that its erstwhile rider, the first king, who kneels in front of it, is evidently a portrait of a sixteenth century nobleman, though no one, apparently, has identified the model.

Moreover, it has been suggested by Fischel that the pose of the horse is not even Titian's own invention but has a still nobler derivation.[52] It is, indeed, of classical origin. As far as we know, it appeared first on the West Frieze of the Parthenon, where the horse's head nearly touches the ground. Fischel thought that the source for Titian may have been a classical *carneol* such as he found in an example preserved in the Antiquarium in Berlin, in which a single horse is shown in a similar pose. He overlooked another possibility which involves a more readily accessible work. A horse in a very similar pose is attached to Selene's chariot in sarcophagi illustrating the myth of Endymion.[53] A characteristic example, possibly the very one Titian had studied, was later embodied in the façade of the Casino Rospigliosi, built in 1607 (Fig. 7).[54] The horse, according to Robert, "impatiently rubs his mouth against his leg, and seems to paw the ground."

49. See O. Fischel, *Tizian, Des Meisters Gemälde*, Stuttgart and Leipzig, n.d., p. 227.

50. Gert Adriani, *Anton van Dyck, Italienisches Skizzenbuch*, Vienna, 1940, p. 41, no. 27.

51. D. M. Robb, *op.cit.*, p. 509. Miss Du Gué Trapier in a recent article (*Burlington Magazine*, XCIX, 1957, p. 270)

thinks that Charles "is ready to mount his white horse."

52. *Amtliche Berichte aus den berliner Museen*, XXXIX, 1917, pp. 6off.

53. See Carl Robert, *Die antiken Sarkophag-Reliefs*, III, Berlin, 1897, pls. XII, XIV.

54. *Ibid.*, no. 39, p. 59.

One could also think that it chafes against the bit. The winged figure acting as groom is called *Aura* by Robert but other interpretations have also been proposed.

It hardly needs stressing that an artist like Rubens was not likely to pass up a motif which, hallowed through its appearance on classical sarcophagi, had the additional sanction of having been used in a famous composition by Titian. As a matter of fact, the horse bending down appears in several of his compositions: It figures in the *Meeting of Abraham and Melchisedec*, one of the tapestries celebrating the Triumph of the Eucharist, designed for Isabella Clara Eugenia during the years 1625-1627;[55] with some modifications we see it also in the beautiful sketch of Briseis returned to Achilles which recently entered the Detroit Institute of Art (designed probably towards 1630).[56] The most important example for our purposes, however, is found in one of the scenes of the Constantine cycle which dates ca. 1622-1623. It is easy to see that all the main formal elements of Van Dyck's picture already occur in the composition which is generally called the *Triumph of Rome*. In this composition Constantine stands near the right edge in the role of the victor, followed by his horse and a groom who is holding it. The arrangement of the Louvre canvas is particularly close to the Constantine group as it appears in a sketch which was formerly in the Cook collection and now belongs to the Mauritshuis at the Hague (Fig. 6). I believe it is safe to say that while the general idea of rendering Charles "à la ciasse" came probably from a local tradition, the precise formal pattern was borrowed from Rubens' composition. Van Dyck was surely familiar with it even though he was already in Italy when Rubens painted the sketch. It is, above all, the relationship of the horse to the prince that is strikingly similar, a relationship in which the action of the horse—whatever its functional meaning—has been subtly employed to enhance the stature of the prince. In Titian's *Adoration of the Magi*, the bending down of the horse had only echoed the humble *proskynesis* of its master. With Rubens, and with Van Dyck who followed him, the horse's reverence brings out the grandeur of the monarch. It is interesting to see how Van Dyck developed this idea even further than Rubens had done. Not only the horse, but the attending figures are shorter than the King (who, as we know, was no more than five feet five inches tall). And whereas in Rubens' sketch the Emperor is encumbered from all sides, in Van Dyck's canvas Charles stands clearly outlined against the open sky. Overhead, the branches of the trees form a veritable baldachin.

(19)

In taking over his basic compositional idea from Rubens' work, Van Dyck must have intended to incorporate into his painting the idea of triumph inherent in this design. Van Dyck's picture is certainly closer to those of military commanders overlooking a battlefield from an elevated vantage point than those of gentlemen taking their melancholy thoughts to the woods and fields. Charles admittedly seems to have little in common in his appearance with Rubens' Roman Emperor. Instead of being sheathed in armor he is dressed in soft and comfortable clothes. Where Constantine held a thunderbolt in his right hand—itself a symbol of apotheosis—Charles holds a cane. Yet in the hand of a seventeenth century cavalier a cane is more than a mere utilitarian object. As late as the nineteenth century the walking stick distinguished the middle-class gentleman from the lower bourgeois or the worker. It is amusing to see that even though he is sitting down on the ground, one of the picnickers in Manet's *Déjeuner sur l'Herbe* still holds on to his cane. Max van Boehn, in his book on accessories of fashion, devoted a whole chapter to the history of the walking stick, a descendant of the rods "the earliest symbols of sovereignty."[57]

55. For this series see Victor H. Elbern, "Die Rubensteppiche des kölner Domes," *Kölner Domblatt*, 1955, p. 43 (available as "Sonderdruck").

56. See Jan-Albert Goris and Julius S. Held, *Rubens in America*, New York, 47, no. 70.

57. Max van Boehn, *Modes and Manners, Ornaments* . . . , London, Toronto, 1929, ch. IV, pp. 94ff. (tr. from: *Das Beiwerk der Mode*, Munich, 1928, p. 97). For the meaning of rods in general and specifically the pastoral staff as the symbol of "authority of jurisdiction and rule" see A. Welby

Walking sticks as objects of fashion make their appearance among the dandies of late feudal society, such as Charles V of France and King René. For a long time they remained the exclusive property of the upper classes, gradually becoming objects of great luxury. Costly canes grew fashionable precisely in the early seventeenth century. Louis XIV "never showed himself in public without a cane" and what is more, he put so much stress on this sign of distinction that commoners were forbidden to carry them. In the eighteenth century this rule was relaxed (it had, of course, never applied in other countries) and gentlemen began to make collections of canes. According to Van Boehn, Rousseau had 40, Voltaire 80, and Count Brühl all of 300 canes, some with matching snuff boxes.

Henry IV of France "seems to have owned the first stick which could be classed as an article of luxury."[58] This is of considerable interest in our connection because it is in a portrait of this king by Rubens that we find one more analogy to Van Dyck's portrait of Charles I. If we compare the Louvre portrait of Charles with Rubens' King Henry in the picture of the Medici series where he receives, and examines with rapture, the portrait of his future Queen (Fig. 8), we see an undeniable similarity in the way in which each holds a slender walking stick in his extended right hand. The King in Rubens' picture has been divested of his helmet and shield to express the idea that in this moment the power of love supersedes the cares of war (specifically the war Henry was then conducting against Savoy). Yet the presence of the various gods, and especially the personification of France, who, standing behind the King, shares in his admiration, makes it clear that here—as in all parts of the Medici cycle, the hero is rendered not as a private person but as the head of a state.[59] It is evident that in this context a cane that is no more than a walking stick would hardly have been given such prominence.

(20)

Charles I was obviously fond of canes, perhaps precisely because they combined conveniently princely dignity with comfort. That he adopted the fashion to wear a cane early may be seen from a portrait of the King by Daniel Mytens, painted in 1629, long before Van Dyck's arrival in London. Now in the Metropolitan Museum of Art, it portrays the King in full-length. Though wearing riding boots, he stands indoors near a table on which are placed demonstratively the royal insignia of crown, scepter, and orb. The inscription underscores the formal character of the portrait by citing Charles' full title, not omitting his role as "Fidei Defensor." The King wears a sword at his side, and his right hand rests on a long, slender cane.

Charles' liking for canes as objects befitting both a monarch and a cavalier, throws a curious light upon an incident that happened at the very end of Charles' life. From contemporary records in writing, as well as from one version of the painting by Edward Bower,[60] we know that Charles came to his trial carrying a cane (Fig. 9). This in itself is highly significant, since it is known that in his behavior Charles stressed deliberately the notion of royal prerogative and refused to recognize the authority of the court. Bower's painting depicts the King with his hat on, in accordance with the records which tell that Charles declined to take it off lest the gesture be construed as a sign of respect towards his judges. In his hand he holds the cane, a slim plain rod with a knob, made, according to most reports, of silver. During the first day of the trial (January 20), when "Mr. Cook, solicitor for the Commonwealth . . . offered to speak . . . the King, having a staff in his hand, held it up and laid it upon the said Mr. Cook's shoulder [another source says it

Pugin, *Glossary of Ecclesiastical Ornament and Costume*, London, 1868, pp. 212ff. See also Du Cange, *Glossarium mediae et infimae Latinitatis*, I, Graz, 1954, pp. 515-518, "Baculus."

58. *Ibid.*, p. 107.

59. See Otto Georg von Simson, *Zur Genealogie der weltlichen Apotheose im Barock*, Strasbourg, 1936, *passim*. For the classical sources of this figure, see F. M. Haberditzl, *Jbh. d. kunsthist. Samml. des allerhöchsten Kaiserhauses*, XXX, 1912, p. 257.

60. There are two versions of Bower's portrait. One is in the collection of the Duke of Rutland at Belvoir Castle, the other in the National Portrait Gallery of Scotland at Edinburgh. It is only the latter that shows Charles holding the cane; in the portrait at Belvoir Castle his left hand is placed against his hip. On the basis of the photographs the Belvoir Castle portrait appears to be superior in quality. If the Edinburgh picture is a second version, or even a copy, the addition of the cane and its prominent place furnish striking evidence for the importance which this object had assumed during the trial.

was the arm] two or three times, bidding him 'hold.' "[61] Then, as another witness continues, "the head [of the staff] being Silver happen'd to fall off, which Mr. Herbert . . . stopp'd to take up, but falling on the contrary side, to which he could not reach, the King took it up himself. This by some was look'd upon as a bad Omen."[62] A contemporary magazine reports, after telling that the knob fell off, that "he stooping for it, put it presently into his pocket. This it is conceived will be very ominous."[63] A fourth witness tells "that the King himself thought the accident a bad omen, and that it was suspected that Hugh Peters had tampered with the cane."[64] (Hugh Peters is generally considered to have played a sinister role in the proceedings; he alone of all the regicides made a very miserable figure when he was to be executed in 1660.)

That Charles chose to bring the staff with him in the first place, and that he used it when he tried to stop the solicitor from presenting his charges, is suggestive of the fact that to him the cane represented one of the objects that signified his dignity and commanded respect. Still more revealing is the immediate reaction of all witnesses to the strangely meaningful incident of the falling knob. It surely would have been noticed even if the cane had been no more than an insignificant accessory of dress. But that Charles was disturbed enough to stoop to pick it up; that foul play was hinted at; that practically everyone saw in it an omen—all this seems to reinforce what we have assumed before: that to Charles and his contemporaries the cane was still invested with compelling associations of authority. In the light of what happened a few days later, the incident of the falling knob of a cane took its place among those symbolical portents, those signs in the sky and weird phenomena on earth, which to former ages had announced the doom of great kings.

Summing up, then, one can say that in Van Dyck's portrait of Charles I elements of two types of portraiture of historical personalities have been combined: On the one hand it is derived from the English type of the prince at the hunt, a tradition linked with behavior patterns of Renaissance nobility as embodied in the many treatises on the gentleman and his appropriate pastimes.[65] On the other hand it is connected with the concept of the absolute monarch symbolizing the State and the power conferred upon him as its head. Charles appears in it both as the *cortigiano* and the *principe*. Indeed, it is the skillful blending of these two different elements that gives to the Louvre portrait its unique character and has contributed to its enduring success. Van Dyck created in it a new iconographic type which was followed by countless imitations. It certainly expresses well—as has always been felt—the character of Charles I, who also aimed at blending the two spheres of the cavalier and the monarch, though with less happy results. The only author who (perhaps without being aware of all the iconographic ramifications) expressed this idea with enviable lucidity is Ernst Gombrich. His one modest sentence is surely far and away the most penetrating comment on the picture that hitherto has been written. The picture, he says, "shows the Stuart monarch as he would have wished to live in history: a figure of matchless elegance, of unquestioned authority and high culture, the patron of the arts, and the upholder of the Divine Right of Kings."[66]

(21)

In the oeuvre of Van Dyck, at any rate, the picture represents the high watermark of sensitive historical interpretation. His other portraits of Charles I are much simpler in their meaning and, in general, adopt patterns which had become standard for royal portraiture, such as the equestrian portrait where the horse serves only as a grand base for the elevation of the ruler.

BARNARD COLLEGE

61. J. G. Muddiman, *op.cit.*, p. 77.

62. *Memoirs of the two last years of the Reign of that unparallel'd Prince, of ever Blessed Memory, King Charles I. by Sir Thomas Herbert and others*, London, 1702, p. 115.

63. Muddiman, *op.cit.*, p. 77 (quoted from *The Moderate*, a periodical published by Mabbot).

64. This was reported by Sir Philip Warwick, cf. Muddiman, *op.cit.*, p. 77.

65. See Ruth Kelso, *The Doctrine of the English Gentleman in the Sixteenth Century* [Univ. of Illinois Studies in Language and Literature, xiv], Urbana, 1929. For the doctrine current in England at the time of Charles I see Henry Peacham, *Compleat Gentleman* (1622; republished from the enlarged edition of 1634, with an introduction by G. S. Gordon, Oxford, 1906).

66. Gombrich, *op.cit.*, p. 302.

# NOTES ON THE RELATIONSHIP OF PROTESTANTISM TO SEVENTEENTH CENTURY DUTCH PAINTING[1]

*By* SEYMOUR SLIVE

IN 1932 the Czech writer Karel Čapek published a short volume entitled *Obrázky z Holandska*[2] which contains many excellent observations about life and culture in The Netherlands. He lists, for example, seven ways in which the bicycle has affected the Dutch character. He notes that a Dutch street is really an interior—nothing more than a passage used by a number of neighbors in common—and that is why it is so neat and tidy. Čapek also remarks on Dutch painting. According to him most Dutch painters worked seated, and this affected their work. Make an excited man sit down and immediately he drops his heroics. Nobody can preach sitting down. The seated Dutch painter scanned things closely and dallied with details. If Čapek were an art historian he probably would have coined the word *Sitzmalerei*. He did, however, note that Vermeer painted his figures from the angle of vision which German photographers call *Bauchperspective*.

Čapek states that the Dutch masters painted small pictures for their small houses. No cathedral altars, for Calvinism stripped the Dutch churches; no palace frescoes, but only such things as a slaughtered duck or a worthy uncle on the mother's side. Painting was hounded out of the cathedrals and found its way into the kitchen, the tavern, the world of clodhoppers, shopkeepers and charitable societies. And so, Čapek concludes, as a result of the Reformation there arose a Dutch art which was secular and bourgeois.

Now, of course there is nothing original about the causal relationship made by Čapek between Protestantism and seventeenth century painting. Most of us take the connection for granted. Eighteenth century writers, however, did not. For example, Samuel Ireland, best known as the author of *Graphic Illustrations of Hogarth,* never mentions the subject in his remarks on Dutch painting in his travel book *A Picturesque Tour through Holland, Brabant and Part of France,* published in 1790[3] for the express purpose of surveying the various productions of art in order to give a critical review of the merits of those worthy a connoisseur.

(23)

*3*

Garland Publishing, Inc./545 Madison Avenue/New York, N.Y./10022

Ireland's approach is biographical. Sometimes it is almost possible to hear him thumb through his Houbraken for material. His criterion for mentioning an artist was the place he was in at the time he wrote. When in Leiden he discusses the artists born there; when he is in Rotterdam he is concerned with the artists of that town, and so on. Ireland is at his best when he reports his first-hand experiences; although when he tells us that Amsterdam can be seen from the tower of St. Lawrence in Rotterdam[4], we have good reason to doubt his accuracy. He deplores a Dutch production of Hamlet which he saw in Amsterdam because when Hamlet starts at the appearance of his father's ghost in the impassioned scene between Hamlet and his mother, Hamlet's wig was made to jump, by means of a concealed spring, from the seat of his distracted brain.[5] The material Ireland gives us on painting is more conventional. Like Reynolds and most eighteenth century travelers, he found Bartholomeus van der Helst's group portrait in the Stadhuis in Amsterdam of the *Civic Guard Celebrating the Peace of Munster* more interesting than Rembrandt's *Night Watch*. He does not give the latter picture a title; he simply states, after some discussion of Van der Helst's painting: "In the same apartment is a charming picture by Rembrandt."[6]

<span>(24)</span>

In one passage Ireland gives a hint of the tremendous shift in the appreciation of Dutch painting which will take place during the nineteenth century. He objects to the high finish in Adriaen van der Werff's works which "sometimes becomes hardness, and impresses the mind more with the idea of ivory than of animated flesh: and there is in general too much coldness in the effect of his pictures."[7] On the very next page he praises the squareness of penciling and freedom of touch of Hondius. Not many years later, Sir George Beaumont, who was a much more sensitive critic than we are led to believe if we are only familiar with the dictum attributed to him that "a good picture like a fiddle should be brown," wrote his objections to *Feinmalerei* in a letter written in 1807:

> I know few things more unpleasing in a picture than too great smoothness: there are no objects in nature perfectly smooth, except polished objects and glass; all other objects are varied by innumerable lights, reflections and broken tints: perhaps no man ever understood this better than Rembrandt; and it is this which renders his drag, his scratch with the pencil stick, and his touch with the palette knife, so true to nature and so delicious to an eye capable of being charmed by the treasures of the palette: and it is the want of this, which renders Wouwermans and other painters of high excellence, in other respects, comparatively insipid.[8]

4

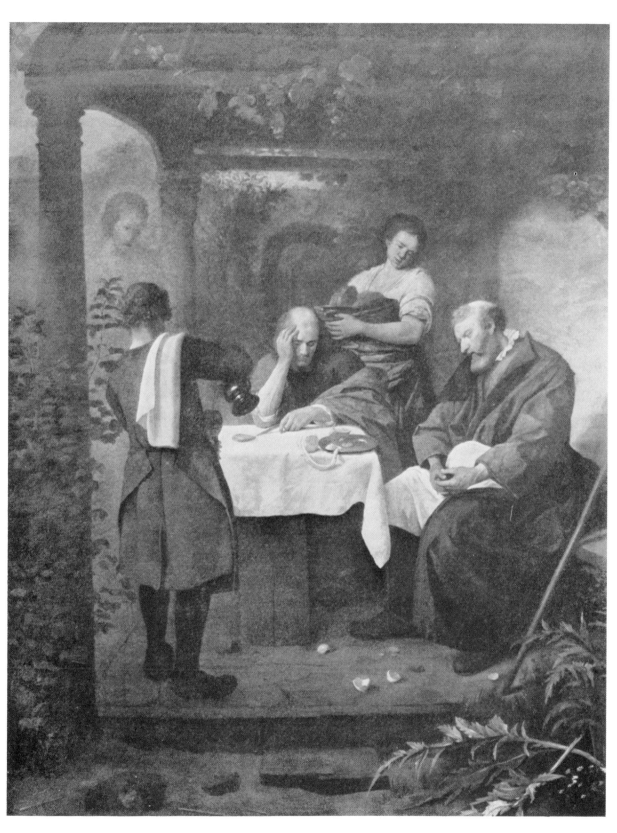

(25)

*Fig. 1.* JAN STEEN, *Christ at Emmaus*
*Amsterdam, The Rijksmuseum*

After the middle of the nineteenth century, and particularly after the impressionists began working, many more artists and critics voiced their preference for broken and varied brush work. This was one of the things which led to the fabulous shift in the reputation of Frans Hals, who was hardly mentioned during the eighteenth century, and who, by the end of the nineteenth, was ranked second only to Rembrandt.

Ireland and Beaumont, like other eighteenth century critics, took greater delight in what we would call problems of connoisseurship than those of cultural history. Eighteenth century critics more frequently tried to describe wherein the peculiar excellency of an artist consisted, than considered issues such as the relationship of environmental factors to Dutch painting. Occasionally their narratives on Dutch art are interrupted with remarks on religious or political history in order to demonstrate that painting instructs as well as delights. An anonymous author of an eighteenth century Baedeker for Holland put it neatly and typically when he wrote that mere descriptions are too dry:

> ... when not attended with important Circumstances and historical Facts relating to them: To look on and gaze only, is too narrow an Employment for an intelligent Being; to reflect upon, and improve from the Objects that occur, is the proper Exercise of the rational Mind.[9]

(26)

This author's own text, however, is only sprinkled with unconnected historical observations.

Hegel, it seems, was the first to attempt to show systematically that there was a connection between the social, economic and religious conditions in The Netherlands and the pictures made there, when, in the 1820's, he briefly structured in his *Vorlesungen über die Aesthetik* the national conditions which were operative when Netherlandish painting swung from the representation of traditional devotional pictures to portraiture, landscape, still-life and genre subjects.[10] Schnaase, Kugler, Burckhardt, Thoré-Bürger, Blanc, Fromentin, Taine, Bode—the list is a very long one— expanded the theme from their individual points of view. The passages cited from Čapek demonstrate how commonplace the ideas are in our time. Generalizations about the connection between freedom of conscience, independence, democracy and popular government in The Netherlands and seventeenth century Dutch painting, came easily to nineteenth century writers of every political persuasion. Loud echoes of the generalizations are found in contemporary handbooks and monographs published on Dutch art, and many are still in the unrefined state

they were in when they were first articulated. Their crudity can be pointed up if we examine the one which in its most extreme form considers The Netherlands' greatest period of painting her reward for becoming Protestant.

We all agree that there is a connection between Protestantism and seventeenth century Dutch painting. Our agreement is tantamount to pontificating that art is not created in a vacuum. How much do we really know about Protestantism in The Netherlands during the seventeenth century? What percentage of the population of the Northern Provinces remained Catholic and for how long? How fundamental was the effect of conversion upon the work of former Catholic painters? What was the relative strength of various Protestant sects, and what was the nature of, and how effective was their control of the artist? What do we know about the spiritual revival around 1650 which is reflected in the works of Rembrandt and in lesser men such as Metsu, Eeckhout and Jan de Bray? These and other questions must be considered, and if possible answered, and then examined in relation to other social, economic, political and intellectual factors before we can safely establish a relationship between the art and the religion. The task is a particularly difficult one because of the methodological problem of establishing coincidence, or cause and effect relationships between works of art and social, intellectual and psychological realities, and because available evidence is meagre and obscure. However, some material has been brought to light which is worth reviewing.

(27)

First of all, there is the fact, which has not yet entered the mainstream of contemporary art-historical thought, that the Calvinists were a small minority in the Northern Provinces in 1609 when the truce with Spain was signed. Peter Geyl and other Dutch historians have recently shown that the idea that the Dutch people spontaneously deserted from Catholicism to Calvinism at the beginning of the seventeenth century is a myth. The myth was created by nineteenth century historians like Motley, who assumed that the division of the Lowlands into the Dutch and Belgian Netherlands was the end of an inevitable historical process, and that differences in the national character of the Dutch and Flemings predestined them by their very nature to become separate nations adhering to Calvinism or Catholicism. It has been shown that the split in the Lowlands was principally the result of military and geographic considerations and not of a *Rassengemeinschaft*. The rivers brought a stalemate in the war with Spain which was confirmed by the Truce of 1609. In the year 1609 it is not possible to speak of a Protestant north and a Catholic south. The final result of Catholicism in the south, and Protestantism in the north, resulted

*6*

from the course of the Eighty Year War; it was the result, not the cause of the split.[11]

Thus, during the first decades of the seventeenth century when the Dutch painters were creating their Golden Age of painting, the United Provinces were not as Protestant as is commonly believed. Although the Catholic religion was suppressed and Catholic churches were purged of their altars and seized for the Reformed as soon as a town fell, the Protestantization of the United Netherlands was a slow process, particularly in the country districts. More artists remained Catholic than is generally known. The precise number is difficult to establish because a record of baptism, marriage or burial in a Reformed church is not necessarily proof of Protestantism; the place where these rites were performed was sometimes prescribed by the municipal authorities. Jan Steen, for example, was a Catholic and was buried in the Protestant church of St. Pieter in Leiden. Steen's father-in-law Jan van Goyen was also a Catholic. Mention of these two painters indicates that the Catholic artists were not limited to Honthorst, the Bloemaert family, and others of the Utrecht school whose connection with Rome is evident from their choice of subjects.

The Utrecht painters were not the only seventeenth century Dutch Catholic artists who painted religious pictures; we tend to forget that Steen made about sixty. To be sure, Steen treated most of his religious themes like genre subjects, and many contain humorous, and some scatological incidents; if his religious pictures are judged by the criteria employed by the tribunal which tried Veronese, or by academic rules, they are condemned. There are exceptions. One is Steen's *Christ at Emmaus,* now in the Rijksmuseum, Amsterdam (Fig. 1), which ranks with the most devout interpretations of the passage from St. Luke. Instead of showing the moment when Christ reveals himself to wide-eyed and gesticulating disciples, as Caravaggio, Rubens, the young Rembrandt and other Baroque artists did, Steen represented the scene after the Revelation. Christ is still present as an apparition. A disciple, not Christ, is the center of Steen's symmetrical composition. The boy servant pouring wine, who has his back turned toward us, is as unaware of the onlooker as he is of what has just occurred. He is a foil for the praying disciple on the right. The maid behind the disciples senses the mystery, and the half-peeled lemon on the table, the crumbs and broken egg shells on the floor, which are Steen's constant props for banquets and brawls, in this case lend credibility to a miracle.

Convincing evidence has recently been brought forward by P. T. A. Swillens

which indicates that Vermeer was a Catholic.[12] Swillens points out that when Vermeer and his wife mentioned deceased relatives they used the term *zaliger* (sainted) which was used by Catholics—Protestants used the term *wijlen* (the late); there is no evidence of the baptism of his eleven children, thus they were probably baptized in secret, in a hidden Catholic church; he was married in Delft, but there is good reason to believe that a Catholic wedding ceremony was performed in Schipluyden; Vermeer's wife came from a Catholic family; and finally, the number of paintings with Roman Catholic subjects listed in the inventory made of Vermeer's effects in 1676 after his death. Swillens also agrees with A. J. Barnouw's identification of Vermeer's so-called *Allegory of the New Testament,* now in the Metropolitan Museum (Fig. 2), as a representation of the *Catholic Faith.*[13] Barnouw wrote that this picture was based upon Cesare Ripa's description of "The Faith":

> The Faith is also represented by a Lady who seated and looking tenderly pensive holds a Chalice in the right hand, resting with her left on a Book which lies on a firm cornerstone, i.e., *Christ,* having the World under her feet. She is dressed in Sky-blue, with a carmine overdress. Under the corner-stone a Snake lies crushed, and Death with his arrows broken. Nearby lies an Apple whereby Sin is caused. She is crowned with Laurel leaves, for a sign that we conquer through Faith. Behind her hangs a Crown of Thorns on a nail . . . In the background Abraham has been placed, where he is going to sacrifice his Son.[14]

(29)

Vermeer did not follow Ripa's text to the letter: the chalice is not in the woman's right hand; she is not crowned with laurel; the Bible is not on the corner-stone; the Crown of Thorns does not hang on a nail; and a *Crucifixion*[15] has been placed in the background instead of *Abraham's Sacrifice.* Two other changes must be noted: the woman wears a white dress instead of the sky-blue gown and carmine overdress prescribed by Ripa, and a Crucifix with a Corpus Christi has been introduced into the picture. Ripa's description of the "Catholic or General Faith" prescribes that a woman clothed in white must be represented;[16] on the basis of this Barnouw concluded that Vermeer intended to show the "Catholic Faith," not "Faith." Swillens adds that the introduction of a Crucifix, which is not mentioned by Ripa, also points to this intention.

Adriaen van de Velde was another Catholic artist. His rare religious pictures are seldom seriously considered by students of Dutch art.[17] They suffer from the prejudice that seventeenth century Dutch artists—except for Rembrandt—were apes of nature who could only paint the faces, genre scenes, landscapes

*8*

or still-lives which were before their eyes. Hofstede de Groot wrote: "Apart from his landscapes with figures and a few pictures of cowsheds with cattle, Adriaen van de Velde produced little that need be taken into account in estimating his artistic importance. His scenes from the Passion do not in the least add to his reputation."[18] W. Martin criticized Van de Velde's *Annunciation,* now in the Rijksmuseum (Fig. 3), for using the formulae of Bolognese academic painting.[19] Thanks to the brilliant historical studies written by Denis Mahon,[20] "Bolognese academic painting" is no longer an opprobrious label and we are now able to look at Adriaen van de Velde's *Annunciation* with new spectacles.

Adriaen van de Velde's father and brother, both called Willem, were also Catholic, as were Jan Anthonisz. van Ravesteyn, Adriaen Hanneman, Pieter Nason, Cornelis Saftleven, Claes Moyaert, Pieter de Grebber; the still-life painters Willem Heda, Willem van Aelst and Justus van Huysum and his son Jan; Gillis Hondecoeter and his son Gysbert; Rembrandt's brother-in-law Wijbrand de Geest; the Italianate painters Jan Baptist Weenix, Claes Berchem and his father-in-law Jan Wils, Carel du Jardin and probably Philips Wouwermans. Thomas and Willem de Keyser were Catholic and so was their father Hendrik de Keyser, who was called upon in 1603 by the Reformed to build the South Church in Amsterdam; in 1614 he was commissioned to make the monument for William of Orange in Delft and in 1620 began the West Church in Amsterdam.[21]

It is also important to note that there was not an iron curtain between the north and south Lowlands during the seventeenth century. During the twelve-year truce there was easy communication between them and ample evidence can be given to prove that when hostilities were resumed in 1621, contact did not cease. Prints, of course, went back and forth even more readily than painters and their pictures. As late as 1630 Constantin Huygens, the diplomat, poet and discerning art critic, who applauded Rembrandt's talent when the painter was in his early twenties, made no distinction between artists who worked in the north and south Lowlands. When he listed the great history painters of his day in his autobiography he cited those of Antwerp along with the painters of Amsterdam, Utrecht and The Hague, and he called all of them great painters of The Netherlands. When he wrote of the greatness of early seventeenth century Netherlandish landscape painters, who lacked nothing in order to show the warmth of the sun and the movement caused by cool breezes, he mentions, among others, Jan Wildens, a painter of Rubens' school, in the same

(30)

9

breath with the Haarlem painter Esaias van de Velde, whom Wolfgang Stechow has called the founder of Dutch seventeenth century landscape painting.[22]

However, let there be no misunderstanding. In spite of contact between the painting done in the north and south, nobody—not even the diehard twentieth century irredentists who still fight for a unification of the Greater Netherlands—would deny that during the first half of the seventeenth century the painters of the United Provinces developed a style and iconography which without hesitation can be called Dutch. And although the Protestantization of the northern Netherlands did not take place overnight, and painters as important as Steen, Van Goyen and most probably Vermeer were Catholic, it would be absurd to maintain that seventeenth century Dutch art was Catholic. But on the other hand, in view of available evidence, who can state how significant the sects of the seventeenth century Protestant church were in forming Dutch painting, particularly if some aspects of what we call Dutch in painting —an interest in the effects of space and light, a concern for landscape and interiors, and the special reticence which, in the works of the greatest Dutch artists is transformed into a searching introspection, and in those done by the less talented reflects apathy and phlegm— can be traced back, with extreme caution, to fifteenth century Netherlandish painting?[23] The grays between these black and white positions have yet to be measured.

(31)

Huizinga, as always, summed up the matter when he wrote that the foreigner who wants to understand seventeenth century Dutch history usually runs on the assumption that the Dutch republic was an undisputed Calvinist state and country. He added, Dutchmen know better. Was Calvinism the mainspring of Dutch culture? Did it form the spirit or was it only the salt and yeast? Whoever works with these matters, he concluded, works with absolutely immeasurable quantities.[24] We can conclude that this is not disconcerting to art historians who constantly attempt to measure the absolutely immeasurable.

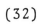

(32)

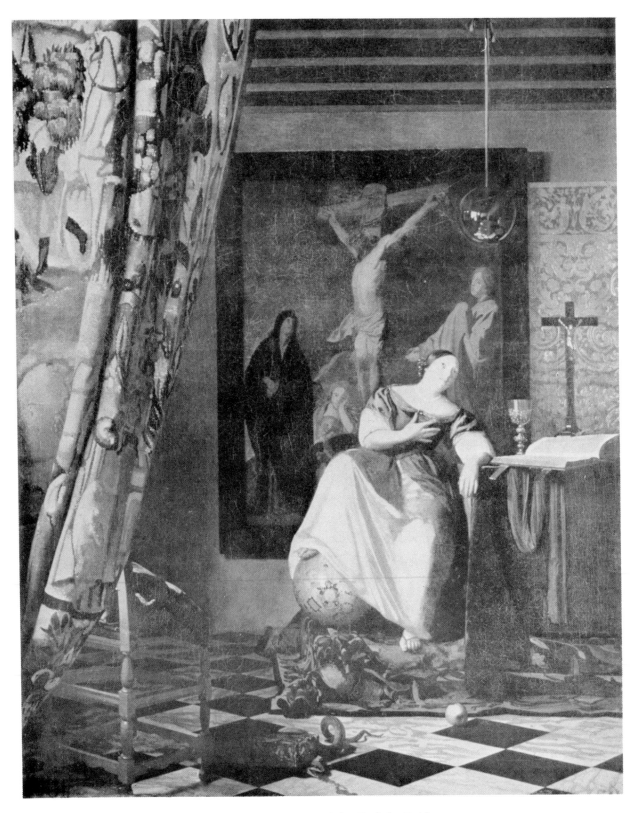

*Fig. 2.* JAN VERMEER, *The Catholic Faith*
*New York, The Metropolitan Museum of Art*

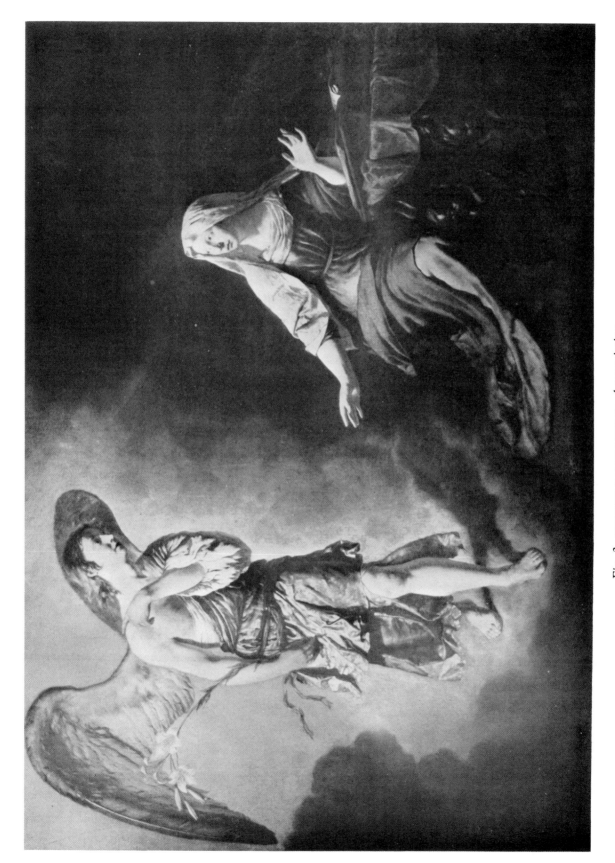

*Fig. 3.* ADRIAEN VAN DE VELDE, *Annunciation*
*Amsterdam, The Rijksmuseum*

(33)

12

[1] A slightly shorter version of this essay was read at the Baroque session of the College Art Association Meeting in New York, 1955.

[2] Karel Čapek, *Obrázky z Holandska*, Prague, 1932. The English translation by Paul Selver, *Letters from Holland,* London, 1933, was used for this paper; the remarks on painting are found in the chapter called "Old Masters," pp. 75-84.

[3] References in this paper are to Samuel Ireland, *A Picturesque Tour Through Holland, Brabant, and Part of France Made in the Autumn of 1789,* 2nd ed., with additions and an entire new set of copper-plates in aquatinta from drawings made on the spot, London, 1796, 2 vols., with added engraved title pages dated 1795.

[4] *Ibid.,* p. 27 f.

[5] *Ibid.,* p. 132. William Henry Ireland, the son of Samuel, inherited his father's interest in Shakespeare, and devoted his talent and energy to forging Shakespeare manuscripts; see the *Dictionary of National Biography,* edited by Sidney Lee, 1908, X, 469 ff.

[6] Ireland, *op. cit.,* p. 145. Reynolds did not find the *Night Watch* "charming". He wrote that he did not think that this picture deserved its great reputation and "that it was with difficulty I could persuade myself that it was painted by Rembrandt; it seemed to me to have more of the yellow manner of Boll [*sic*]. The name of Rembrandt, however, is certainly upon it, with the date, 1642. It appears to have been much damaged, but what remains seems to be painted in a poor manner." On the other hand, Reynolds found Van der Helst's group portrait "perhaps, the first picture of portraits in the world, comprehending more of those qualities which make a perfect portrait than any other I have ever seen . . . Of this picture I had heard before great commendations; but it as far exceeded my expectation, as that of Rembrandt fell below it"; Sir Joshua Reynolds, "A Journey to Flanders and Holland in the Year 1781," in *The Literary Works of Sir Joshua Reynolds,* edited by Henry William Beechey, London, 1890, II, 197.

[7] Ireland, *op. cit.,* p. 36 f.

[8] Beaumont sent the letter to Sir David Wilkie; see Allan Cunningham, *The Life of Sir David Wilkie,* London, 1843, I, 135-136. Beaumont's sentences are also cited with delight by Sir Edmund Head in the edition of Franz Kugler, *A Handbook of the History of Painting,* translated from the German by a Lady, London, 1846, which he edited. Head adds, *ibid.,* p. 258: "No man can look at a Vanderwerf, or a Carlo Dolci, with their surfaces like a newly japanned teaboard, without feeling the truth of these observations."

[9] *A Description of Holland: or the Present State of the United Provinces, wherein is contained, a particular Account of The Hague and all the Principal Cities and Towns of the Republick, with their Buildings, Curiosities . . . ,* London, 1743, p. viii. The anonymous author acknowledges that some critics may maintain that Dutch painting did not achieve the grand and sublime style of painting. He, however, does not think that Dutch painting is second rate; see *ibid.,* pp. 239-241. Since this book seems to be rare (it is not listed in J. N. Jacobsen Jensen, *Reizigers te Amsterdam, Beschrijvende Lijst van Reizen in Nederland vóór 1850,* Amsterdam, 1919, or in Jensen's *Supplement* published in 1936), the favorable appraisal of the state of engraving and painting in Holland which it contains is worth quoting at length:

'Statuary is cultivated with Success in *Holland.*

"But Painting and Engraving have attained their final Maturity there. One would think it hardly possible to carry those beautiful Arts to a higher Degree of Perfection.

"*London* and *Paris* are at this Day, as formerly, obliged to *Holland* for almost all their good Engravers. A greater Variety of good Prints are no where to be seen. Few Books are printed there without a fine Copper Plate for the Frontispiece. The *Dutch* have so great a Taste and Passion for good Prints and Cuts, that they do not care what Money they bestow upon them; so that many Books are thrown into the Form of Folios or Quatros only for the sake of adorning them with Copper Plates.

"The *English* are beginning to come into this fine Taste. *Hogarth's* Burlesques have been very well received for several Years past by a great Part of the Nation; and the Heads of the Kings, Queens, and most eminent Personages of *Great Britain* and *Ireland,* taken from original Paintings and other authentick Monuments, with admirable Judgement and Art, shew how agreeable farther Improvements of that kind would be. But hitherto the ingenious Engraver is no where in so great Esteem as in the United Provinces.

"The same may be said of the Painter. There is not an ordinary Burger's House, that is not plentifully furnished with such good Pictures, as would adorn the Houses of the Gentry in other Countries. The *Dutch* excel in every part of this noble Art: In Flower, Fruit, and Fish-pieces; Insects, and Flies, which have actually deceived Spiders; Ships, the Sea, Storms, and Shipwrecks; the Seasons, and particularly the Winter, and the Diversions upon the Ice; Tables spread with a Dutch Dinner of Fish, Hung-beef, Butter, Cheese, Grapes, other Fruits, and a Glass of Wine; burlesque Pieces; as a jovial Company at their Cups, a Country Wedding,

(34)

*13*

a Quaker's Meeting; Night-pieces, in which they have followed *Bassin,* but are now Models for others to imitate. None, in my Opinion, have come up to them in Drapery. Some have thought, that the *Dutch* Schools have copied Nature and the Humours and Foibles of Men with great Success, but that they have failed in the Grand and Sublime of Painting. It must however, be owned, that none have exceeded them in Battle-pieces, and very few in Portraits and Histories. If their Works have any Fault, it is perhaps in their being too much laboured. The minutest Part of their Paintings is as much finished as the principal Figure; whereas other Masters usually exhaust their whole Art and Genius on the principal Figure, leaving the rest neglected and unfinished. The *Dutch* colouring in general is very beautiful, and the Painting so smooth, that it will bear a very near View. At the Auctions, which are very numerous here, good Bargains of Books and Pictures may be picked up for furnishing an House or Library."

[10] Georg Wilhelm Friedrich Hegel, *Vorlesungen über die Aesthetik,* Berlin, 1838, III, 117-124; *idem, The Philosophy of Fine Art,* translated, with notes, by F. P. B. Osmaston, London, 1920, III, 330-337. Also see Meyer Schapiro, "Fromentin as Critic," *Partisan Review,* XVI (1949), 35.

[11] Evidence to support this thesis is found in Pieter Geyl, *Geschiedenis van de Nederlandsche Stam,* Amsterdam, 3 vols., 1930-1937. Geyl's *The Revolt of the Netherlands* (1555-1609), London, 1932, and *The Netherlands Divided* (1609-1648), London, 1936, are based on his *Geschiedenis van de Nederlandsche Stam;* also see his *From Ranke to Toynbee: Five Lectures on Historians and Historiographical Problems,* "The National State and the Writers of Netherlands History" (*Smith College Studies in History,* XXXIX, Northampton, Mass., 1952, pp. 36-51). Professor Geyl has examined the implications of his thesis to art history in two articles "De kunsthistorie onder de ban van de moderne staat" and "Heeft het zin van een Noord-Nederlandse school van primitieven te spreken?" which have been reprinted in his *Eenheid en Tweenheid in de Nederlanden,* Lochem, 1946, and in "De Historische Achtergrond van de Nederlandse Schilderkunst," *Nieuw Vlaamsch Tijdschrift,* I (1946), 540-556. For a sympathetic critique of some aspects of Geyl's reformulation of the origin of the Dutch state see G. J. Renier, *The Criterion of Dutch Nationhood,* London, 1946; also see *idem, The Dutch Nation,* London, 1944.

[12] P. T. A. Swillens, *Johannes Vermeer,* Utrecht and Brussels, 1950, pp. 20-21.

[13] *Ibid.,* pp. 96-99; A. J. Barnouw, "Vermeer's zoogenaamd 'Novum Testamentum,'" *Oud Holland,* XXXII (1914), 50-54.

[14] Barnouw cited the Dutch translation of Ripa's *Iconologia* made by D. P. Pers, published in 1644. The translation used here is from Swillens, *op. cit.,* p. 97.

[15] The *Crucifixion* is by Jordaens and is now in the Terninck Foundation, Antwerp. Benedict Nicolson, "Caravaggio and the Netherlands," *The Burlington Magazine,* XCIV (1952), 248, note 12, observed that Vermeer either copied another version or took liberties with the Terninck picture by cutting off a wide strip at the bottom. Mr. Nicolson accepts the importance which has recently been placed upon the pictures which Vermeer introduced into his interiors, and he correctly adds that Vermeer's use of a picture is not conclusive proof that he owned the picture. He suggests that it is more likely that Vermeer borrowed them for specific purposes—particularly in the case of a painting which is as bulky as Jordaens' *Crucifixion.* This is certainly a possibility. However, it is interesting to note that in the inventory made of Vermeer's effects in 1676 mention is made of "Een groote schildery, sijnde Christus aen't Cruys" in "de binnenkeuken"; the same inventory cites "Een Christus aent Cruys" in "de kelderkamer": see A. Bredius, "Iets over Johannes Vermeer ('De Delftische Vermeer')", *Oud Holland,* III (1885), 219.

[16] Barnouw, *op. cit.,* pp. 53-54; Swillens, *op. cit.,* pp. 97-98.

[17] An exception is J. G. van Gelder's short note on Van de Velde's *Christ on the Cross,* signed and dated 1660, collection H. A. J. Stenger, The Hague, published in *Kunsthistorische Mededeelingen van het Rijksbureau voor Kunsthistorische Documentatie,* I (1946), 10.

[18] C. Hofstede de Groot, *A Catalogue Raisonné . . . Based on the Work of John Smith,* translated and edited by Edward G. Hawke, London, 1912, IV, 453.

[19] W. Martin, *De Hollandsche Schilderkunst in de Zeventiende Eeuw,* 2nd ed., Amsterdam, 1942, I, 110-111: "Wie in het Rijksmuseum de geheel in Bologneeschen trant geschilderde Annonciatie van Adriaen van de Velde aanschouwt verbaast zich, dat deze aristocraat onder onze landschapsschilders ooit zóó iets heeft willen maken. Of zou ook dit een poging zijn om, door de regelen van het academisme te hulp te roepen, een gebrek aan smijdigheid te overwinnen, dat hij vreesde voor geval hij zich al te veel hield aan zijn landelijke modellen?"

[20] See Denis Mahon, *Studies in Seicento Art and Theory,* London, 1947, and his "Eclecticism and the Carracci: Further Reflections on the Validity of a Label," *Journal of the Warburg and Courtauld Institutes,* XVI (1953), 303-341.

(35)

21 G. J. Hoogewerff, "Nederlandsche Schilders en Italiaansche scholing in de 17e eeuw," *Mededeelingen van het Nederlandsch Historisch Instituut te Rome*, IX (1929), 172-173, and L. J. Rogier, *Geschiedenis van het Katholicisme in Noord-Nederland in de 16e en de 17e Eeuw*, Amsterdam, 1946, II, 674-691, discuss Catholic seventeenth century Dutch artists, but a fully documented, comprehensive study of them has never been made. It is sometimes suggested that Frans and Dirck Hals, Adriaen and Isaac van Ostade, Paulus Potter and Carel and Barent Fabritius were Catholics because there is evidence that they had close contacts with Catholics; however, conclusions about the religion of these artists, which are only based upon their associations, are unsubstantial.

22 J. A. Worp, "Constantyn Huygens over de Schilders van zijn tijd," *Oud Holland*, IX (1891), 70-73; on Huygens as an art critic see A. H. Kan, *De Jeugd van Constantijn Huygens door hemzelf beschreven*, which contains an essay by G. Kamphuis, "Constantijn Huygens als kunstcriticus," pp. 141-147, and S. Slive, *Rembrandt and His Critics: 1630-1720*, The Hague, 1953, pp. 9-26. Wolfgang Stechow's article "Esaias van de Velde and the Beginnings of Dutch Landscape Painting," *Nederlandsch Kunsthistorisch Jaarboek*, 1947, pp. 83-94, establishes the importance of Van de Velde's landscapes, dated around 1615, in the Mansi Collection in Lucca.

23 On the difficult question of whether or not it is possible to speak of a "Dutch" fifteenth century school of painting see Geyl, "De kunsthistorie onder de ban van de moderne staat" and "Heeft het zin van een Noord-Nederlandse school van primitieven te spreken?" in *Eenheid en Tweenheid in de Nederlanden;* W. Vogelsang, "Over den stijl in de Noord-Nederlandsche Schilderkunst," *Oudheidkundig Jaarboek*, IV (1924), 75-87 and his monograph on *Geertgen tot Sint Jans*, Paletserie, Amsterdam, 1942, p. 2; Otto Pächt, "Gestaltungsprinzipien der Westlichen Malerei des 15.Jahrhunderts," *Kunstwissenschaftliche Forschungen*, II, (1933), 75 f. and Meyer Schapiro's review of this article in *The Art Bulletin*, XVIII (1936), 262-264; Hoogewerf, *De Noord-Nederlandsche Schilderkunst*, The Hague, 1936, p. 1 ff.; W. R. Valentiner, *Catalogue Early Dutch Paintings: 1460-1540*, The Detroit Institute of Arts, 1944, p. 3 f.; Erwin Panofsky, *Early Netherlandish Painting*, Cambridge, 1953, I, 322-324.

24 J. Huizinga, "Nederland's beschaving in de zeventiende eeuw," *Verzamelde Werken*, II, 451 and 459; this study is a revised and expanded version of Huizinga's *Holländische Kultur des siebzehnten Jahrhunderts, Ihre sozialen Grundlagen und nationale Eigenart*, Jena, 1933.

(36)

15

SEYMOUR SLIVE

# Realism and Symbolism

# in Seventeenth-Century Dutch Painting

As LONG AS man believed that painting worthy of serious consideration must depict noble subjects which instruct as well as delight, and that great artists are those who idealize man and nature, seventeenth-century Dutch painting was considered an inferior kind of art. Only when these notions were successfully challenged by nineteenth-century artists and critics was Dutch painting looked on as an important contribution to man's artistic heritage. It was then possible for a painting such as Paulus Potter's life-size painting of "The Young Bull" (Figure 1) to become one of the world's most famous and admired pictures.

Potter's "Young Bull" still has admirers. The director of the Mauritshuis, the museum at The Hague where the picture hangs, told me that an American cattleman offered to buy the painting from the gallery for one million dollars, and there is reason to believe that Premier Khrushchev, who is on record as favoring "the kind of art where you do not have to ask whether it is a cow or a horse," would also have high praise for it. More experienced gallery visitors are also struck by a certain power in Potter's picture. They are impressed by the original way the young bull, the farmer, and the trees have been silhouetted against the light sky, and by the wide expanse of landscape in the background. However, most of them are also familiar with the way artists of many different cultures and epochs depicted bulls. They know those from the prehistoric caves at Lascaux, the sacred bull on the wall of the Temple of Isis at Pompeii, and the impressive herd created by Picasso during his long career, from those that show the bull as a symbol of man's nature to the witty ones which belong to a series of eleven lithographs Picasso produced in 1945-1946 (Figure 2). Our familiarity with bulls, from paleolithic times to Picasso, make the meticu-

469

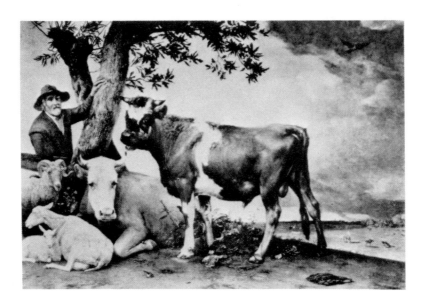

Figure 1. PAULUS POTTER, Young Bull, 1647.
Mauritshuis, The Hague.

lously painted one by Potter appear a bit boring. It is too realistic for our taste.

The charge of being "too realistic" is easier to lay than to demonstrate. The charge can also lead easily to a philosophic and semantic shambles. If we think of some of the different uses of the word realism—of realism as opposed to nominalism, or of realism as the antipode of idealism, of Courbet's realism, of social realism, magic realism, or of the real McCoy—it is easy to understand why Ortega y Gasset maintained that to say simply that an art is realistic is the most emphatic way of saying nothing. Nevertheless, it seems reasonable to call Potter and most seventeenth-century Dutch painters realists. If we must have a label, "realist" is a satisfactory one. Today, when it is no longer necessary to argue that the importance of a work of art qua work of art depends on the nobility or meanness of its subject, "realist" is no longer an opprobrious word.

We have accepted the idea that the formative energy of an artist can transform almost—not every, but almost every subject into a work of art. Everyone knows genre pictures, still-life paintings and landscapes which are superior to pictures of religious, allegorical, or historical subjects, and artists of our time have shown

470

Figure 2. PABLO PICASSO, Bull, 1946.

(39)

that there can be aesthetic significance in pictures that have no subject in the traditional sense of the word. It is platitudinous to say that all painting is an abstraction. The most realistic painting is a transformation of the three-dimensional world into paint on a two-dimensional surface. Even in the effective *trompe l'oeil* by the Amsterdam painter Wallerant Vaillant, dated 1658 (Figure 3), the deception, if not a very profound or imaginative one, is carefully calculated. To convince us that his painting is part of the real world, Vaillant, like *trompe l'oeil* artists from the Italian Renaissance painter Jacopo di Barberi to the American William Harnett (Figure 4) minimized the space represented in his picture. Vaillant painted objects life-size in a very shallow space. The ribbons, the folded sheets of paper, and the pens are all kept parallel to the picture plane. When the corners of the pieces of paper project, they appear to come out toward us into our world, not into that of the picture.

The most literal attempt at transcribing the world into paint can never be purely passive and mechanical. No eye is virgin. Appearances rendered without the aid of conventions and schemes are always ambiguous. Distortions and adjustments must be made. The intensities of natural light cannot be reflected from paint with a

471

Figure 3.
WALLERANT VAILLANT,
Trompe l'Oeil: Letters, 1658.
Staatlichen Kunstsammlungen,
Dresden.

(40)

Figure 4.
WILLIAM HARNETT,
Trompe l'Oeil: Letters, 1879.
Formerly Mr. and Mrs. Arthur
Hornblow, Jr., Coll., New York.

Figure 5. FRANS HALS, Governors of the Old Men's Almshouse, detail of a hand, 1664.
Frans Hals Museum, Haarlem.

(41)

comparable range. Vanishing point perspective, a system accepted since the Renaissance by Western artists and their patrons to create the illusion of space, assumes that we are a race of man-sized Cyclops with flat retinas. No matter. In art, as in love, men rarely object to being fooled.

Pleasure in the mimetic aspect of painting—*pace* Plato—is an ancient one. Pliny wrote about the grapes painted by Zeuxis which deceived birds, and of the curtain painted by Parrhasius which even fooled Zeuxis. Philostratus tells of a picture in which it was impossible to decide whether an actual bee had been deceived by a painting, or a painted bee deceived the onlooker. But delight in this kind of deception has been limited for modern audiences. We take our art seriously and do not want it to be confused with life.

We have been prejudiced against *trompe l'oeil* pictures by the efficiency of the camera and because some surrealists have exploited this mode of representation for cheap effects. There is another difficulty. If illusionistic painters want to be successful, they must make their brush strokes invisible. They must paint themselves out of their pictures. This presents an obstacle for many

473

because of the contemporary bias against a high finish in painting. To be sure, not all pictures with a polished surface are found offensive. Van Eyck, Holbein, and Vermeer enjoy unchallenged reputations, and at least one hard-edge abstract painter is considered in many quarters as a likely candidate for election to our pantheon of artists. However, it is also true that our age, which has learned to see the merits of expressionistic painting, takes special delight in the wizardry of passages such as those in a late Frans Hals (Figure 5), in which no attempt has been made to hide the rapid touch of the brush, and the trained observer receives private pleasure trying to determine how a few slashes of yellow ocher, black, white, and venetian red have been used to suggest a glove, a cuff, and a sleeve. He also recognizes the artist's handwriting and likes to believe that he has begun to probe into the artist's personality—even into his soul.

Men of other ages found it easier to enjoy—or perhaps they were not as reluctant to confess that they enjoyed—being fooled by artists. Samuel Pepys recorded in his *Diary* in 1669 that a still-life painting of flowers by the Dutch artist Simon Verelst was "the finest thing, I think, I saw in my life." What fascinated Pepys in Verelst's still-life were "the drops of dew hanging on the leaves, so I was forced, again and again, to put my finger to it, to feel whether my eyes were deceived or no." Pepys noted that Verelst asked seventy pounds for his painting, and characteristically confessed that he "had the vanity to bid him £20; but a better picture I never saw in my whole life; and it is worth going twenty miles to see it."

Roger de Piles, the important French theorist of art and sensitive connoisseur of paintings and drawings, who has a much greater claim to distinction as a judge of pictures than Pepys, records that he too enjoyed *trompe l'oeil* pictures. In his *Cours de Peinture*, published in 1708, he wrote that Rembrandt painted the "Girl at a Window" (Figure 6) so that he could exhibit it at his own window and deceive the pedestrians. Rembrandt succeeded, de Piles adds, for "the deception was only noticed a few days later. It was not beautiful drawing, nor a noble expression which produced this effect. One does not look for these qualities in his work." Aside from the question whether Rembrandt's painting—or even the one by Rembrandt's pupil, Samuel van Hoogstraten, "Man at a Window" (Figure 7)—ever really deceived pedestrians, de Piles praised highly what he considered a *trompe l'oeil* by Rembrandt. And what is more important, he bought the picture.

474

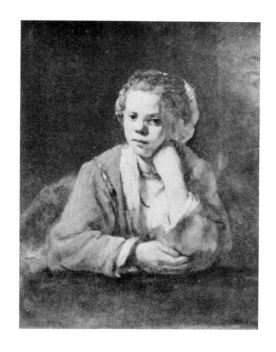

Figure 6.
REMBRANDT,
Girl at a Window, 1651.
National Museum, Stockholm.

Figure 7.
SAMUEL VAN HOOGSTRATEN,
Man at a Window, 1653.
Kunsthistorisches Museum, Vienna.

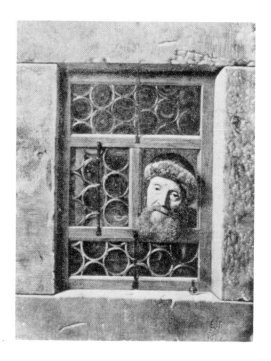

One of the things de Piles must have liked about it was its bold execution, for he too had a bias against a *léchée* surface. In the *Cours de Peinture* he distinguished between two styles of painting (*le stile ferme et le stile poli*), and he stated that he preferred the bold style to the polished one. "Le stile ferme," he wrote, "donne de la vie à l'ouvrage et fait excuser les mauvais choix." He was critical of the masters of *Feinmalerei* who were so popular throughout Europe during his life time. The polished style, de Piles shrewdly observes, finishes everything and leaves nothing to the imagination of the beholder, who enjoys finding and finishing things which he attributes to the painter, whether or not they are really in the picture. Moreover, he said, unless the polished style is buttressed by a beautiful subject, it is flat and insipid.

De Piles exhibited Rembrandt's "Girl at a Window" in what he called "une place considerable" in his cabinet, not because it was a curiosity but because he thought it was painted well and with great strength. We also know that de Piles did not confuse Rembrandt's achievement with the illusionism of Hoogstraten or of other Dutch painters. Rembrandt, after all, was the only seventeenth-

(44)

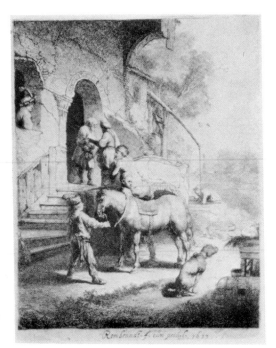

Figure 8. REMBRANDT, The Good Samaritan, 1633.

476

century Dutch painter honored with a place in de Piles's famous *Balance de la Peinture*. But, in the final analysis, according to de Piles, Rembrandt could not rank with the very greatest.

De Piles and other seventeenth- and eighteenth-century theorists who maintained that painting should idealize man and generalize nature objected to the works by Rembrandt and other Dutch painters because they did not show knowledge of the ancients and did not know how to select the most beautiful from nature. They objected to Dutch painting because it was specific and familiar. The charge cannot be denied. Even the seventeenth-century Italianate Dutch painters who painted idealized landscapes paid more attention to the contemporary scene than did other foreigners who worked in Italy and found inspiration for their pictures in the Roman countryside.

Poussin and Claude peopled their classical landcapes with Biblical and historic personages and mythological heroes. Their younger Dutch contemporaries working in Rome, such as Jan Both, Jan Asselyn, and Karel Dujardin, used the Campagna as a setting for modern idylls. Dutch painters were called servile copyists of nature and accused of ignoring established canons of beauty and reason. Critics who believed that great art must handle noble and heroic subjects objected to Dutch pictures, which sometimes fail in decorum and even contain scatalogical passages. Rembrandt's early etching of the "Good Samaritan" (Figure 8) and a few others of his works quickly achieved the kind of notoriety which a later age bestowed on Molly's soliloquy in *Ulysses* and on parts of Henry Miller's *Tropic of Cancer*. This criticism is part of the perennial and complicated argument between the ideal and the actual which can be traced back to the philosophers of antiquity, who insisted that in literature man and nature should be depicted as they ought to be, not as they are. Social psychologists may one day help explain why some schools of critics have chastised artists, and even whole cultures, because they were more concerned with what they observed than with the norm, or with an abstract idea of beauty.

(45)

During the nineteenth century a group of critics took the opposite view about Dutch painting and insisted that it was worthy of special applause precisely because it paid little attention to idealized gods and heroes. The radical socialist Thoré-Bürger lauded the *égalité* of Dutch painting in the brilliant article he published in 1866, which resuscitated Vermeer. Thoré-Bürger wrote that in other schools there is a hierarchy. The Dutch school, he claimed,

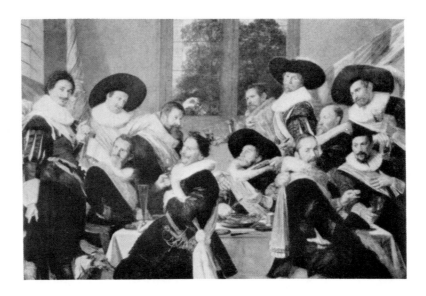

Figure 9. FRANS HALS, Banquet of the Officers of the St. Hadrian Militia Company of Haarlem, 1627.
Frans Hals Museum, Haarlem.

(46)

is a panarchy. In Holland each painter is a master, no matter what genre he chooses as his specialty: Brouwer and the Ostades, Both, Berchen and Dujardin, Paulus Potter, Dou, Cuyp and van der Neer, van Goyen and Wynants, de Heem and Hondecoeter, van der Heyden, Wouwerman, the van de Veldes, Ruisdael and Hobbema, Terborch and Metsu, Pieter de Hooch and Jan Steen and how many others, he said, are absolute masters, each according to his nature, even as Rembrandt and Frans Hals. The lion, the eagle, the butterfly, the dog, the violet, the ruby, and the emerald—all have equal rights in the universe, wrote Thoré-Bürger. From the seventeenth century up to Thoré-Bürger's time the majority of theorists and critics would have neither conceived nor accepted such democratic notions about painting. They implicitly or explicitly accepted a hierarchy of the kinds of painting when they endorsed the dogma that painting must instruct as well as please. The corollary of this proposition is that the finest subjects artists can represent are religious and historical themes. Next in the hierarchy came portraits, then landscapes, and still-life pictures ranked lowest.

In our day this hierarchy has been reversed. Indeed, an impressive number of contemporary artists and critics argue that

478

Figure 10. YALE UNIVERSITY BASKETBALL TEAM, "Best in 51 Years," 1947.

pictures without recognizable subjects are the only important ones which can be painted today, and most artists who have not accepted this position are more at home with still-life themes and landscapes than with the subjects earlier critics called elevated. And so are the rest of us. How many can recognize more than a handful of religious and mythological motifs without consulting reference books? Only our trained theologians and iconographers are as familiar with the Bible as Renaissance and Baroque men were, and it seems that, with the notable exceptions of Aphrodite and Bacchus, the ancient gods and heroes were retired to an Olympian limbo about a century ago.

Vague knowledge of the subjects used by a Piero della Francesca or a Poussin seldom interfere with our appreciation of their artistic form. It is as easy as it is unhistorical for us to approach Piero as a quattrocento Seurat, or Poussin as a seventeenth-century Cézanne. With seventeenth-century Dutch painting it is different. Everyone recognizes the subjects depicted by seventeenth-century Dutch artists—or at any rate, most of us have been led to believe that we do—but more of that presently. We are put off guard by their straightforward or anecdotal aspects. Unfamiliar episodes from the

479

*Apocrypha* or Ovid can be looked on with the same kind of detached wonderment most of us bring to the subjects portrayed by ancient Egyptian artists. The realistic subject matter used by seventeenth-century Dutch painters is different. It all looks so familiar. This familiarity has become as much of a stumbling block for critics today as the alleged mean and ignoble character of Dutch painting was for classicist critics of earlier epochs.

Nineteenth-century enthusiasts of Dutch painting praised it precisely because it reproduced the visual world so faithfully. Eugène Fromentin wrote in his *Les Maîtres d'autrefois,* which was first published in 1876 and quickly translated into most European languages and which is still frequently reprinted, that the only thing the Dutch succeeded in doing during their golden age of painting was to paint their own portrait. The word "portrait," Fromentin wrote, says everything. "Dutch painting, as one very soon perceives, was not and could not be anything but the portrait of Holland, its external image, faithful, exact, complete, life-like,

(48)

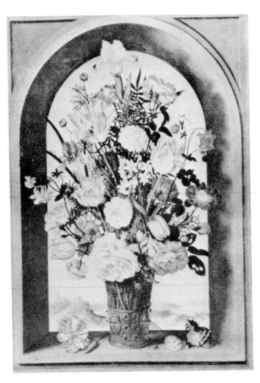

Figure 11.
AMBROSIUS BOSSCHAERT,
Bouquet.
Mauritshuis, The Hague.

480

Figure 12.
MICHIEL VAN MUSSCHER,
Painter in a Studio.
Lord Northbrook Coll.,
London.

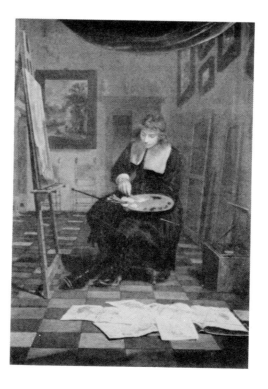

(49)

without any adornment. The portrait of men and places, of *bourgeois* customs, of squares, streets, and countryside, of sea and sky— such was bound to be, reduced to its primary elements, the programme adopted by the Dutch school; and such it was, from its first day until its decline."

There is no question that portraiture was the most popular branch of painting in seventeenth-century Holland. Thousands of Dutch faces were painted. According to an early biographer, one portraitist, the fashionable Delft painter Michiel van Miereveld, painted over five thousand during his lifetime. Portraits were made of substantial burghers, of children at play, of surgeons at work on cadavers, of the syndics of guilds around a ledger and ink-pot, of the regents of charitable institutions, and of members of municipal militia companies. These portraits are deceptively simple, and it is hard not to think that most Dutch portraitists were merely human kodaks, who made nothing but faithful, exact, complete, and life-like records of an uncle on the mother's side. However, if we compare a picture such as Frans Hals's group portrait of the "Banquet of the Officers of the St. Hadrian Militia Company of

**481**

Haarlem" (Figure 9) with the kind of results a modern cameraman usually achieves when he takes a picture of a group (Figure 10), we see how intricate and original a Dutch portrait can be.

Both pictures show twelve men. There the similarity ends. The photographer lined up Yale's "Best in 51 years" like birds on a fence, or, more accurately, like birds on two fences—the athletes in the back row are standing on a bench. He succeeded in doing only part of the job which faces every group portraitist; he made portraits of each member of the group, but he failed to give us any idea of the character of the group or to show the relation of the men to it. In the photograph the group is completely subordinated to the individuals represented. Hals, on the other hand, successfully co-ordinated the individuals and the group. Not only is each individual brilliantly portrayed, but, by the use of gestures and glances, Hals indicates the relationship of the men to one another, as well as something about the character of the officer corps by showing its mood when around a festive board. It is not surprising to learn that in 1621, only six years before Hals's group portrait was painted,

(50)

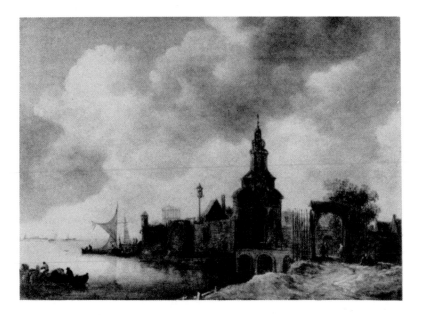

Figure 13. JAN VAN GOYEN, The Haarlem Gate at Amsterdam, 1653. Municipal Museum, Amsterdam.

482

Figure 14. GERBRAND VAN DEN EECKHOUT, The Haarlem Gate at Amsterdam.

Teyler Museum, Haarlem.

(51)

the Haarlem municipal authorities passed an ordinance limiting the banquets of the guardsmen to "three, or at most four days." The municipality paid for the banquets, and town officials objected when some of them lasted a week. The importance given to drinkers as well as to drinking glasses in the group portrait is not accidental. The same ordinance of 1621 gives some idea of the quantities of liquor consumed. It states that at the banquets the militia men could receive only three barrels of beer free of tax.

Now, of course, Hals did not paint his portraits of Dutch civic guards during the course of a banquet. He only deceives us into believing that he did. The powerful diagonal and vertical accents in his group portrait, the pattern in depth and on the surface of the canvas, the vivid color harmonies of black, orange, white, blue, and red, and the effect of bright sunlight in the life-size picture are all as carefully ordered as the elements in compositions made by other great Baroque masters. They were surely worked out after the event. It is also probably wrong to maintain that Hals made the officers pose for him while he painted them, with their heads tossed back or with a hand suspended over a plate of fresh oysters. There is no reason to assume that he was an ape of nature who could not depict arrested movement or instantaneous expressions unless he

483

had a model in front of him. The same claim can be made for his contemporaries.

Seventeenth-century Dutch still-life painters seldom made their compositions from nature. Close examination of the works by the flower painters shows that their colorful bouquets are based on carefully executed preliminary studies which served as patterns, and that they were not painted from freshly cut flowers. The same tulips, irises, and lilies of the valley appear in more than one picture by Bosschaert the Elder (Figure 11). Other still-life specialists followed the same practice. The great rarity and expense of some of the flowers—particularly the tulips—in the seventeenth century precluded working from fresh blooms for each new picture. It is also noteworthy that Dutch flower painters sometimes put in a vase blossoms which do not bloom in the same season. Their monumental compositions, which are always arranged to show each blossom fully, often make one wonder how the vases which hold the bouquets managed to remain upright.

As a rule, Dutch landscape painters did not make their pictures directly from nature, either. Only a few seventeenth-century artists seem to have painted in the open air. Joachim von Sandrart writes that he first met Claude while he was painting the famous waterfall at Tivoli, but, as is well known, it did not become common practice for artists to paint landscapes from nature until the last century. Most seventeenth-century Dutch landscapists must have worked the way the painter does in Michiel van Musscher's picture of an artist at work in his studio (Figure 12). Their landscapes were based on preliminary studies made out-of-doors. The studies were worked up into finished compositions in the studios and, as in the still-life pictures, the same motif was frequently used by the same artist in more than one painting. Seventeenth-century Dutch landscapes which appear to be topographical views can be deceptive. Jan van Goyen's painting of the "Haarlem Gate at Amsterdam" (Figure 13), looks like an accurate representation of part of the wall of Holland's leading city, but the large body of water on the left of van Goyen's painting was never visible at this place during the seventeenth century. Gerbrand van den Eeckhout's drawing of the same site shows what it looked like in Van Goyen's time (Figure 14). Van Goyen put elements from a river landscape into his view of the landmark. The picture is enhanced by the addition. The vista to the imaginary horizon on the left gave van Goyen the opportunity to show the endless expanse of a cloud-filled Dutch sky as well as

(52)

484

Figure 15.
CHARLES PHILLIPS, "The Assassin,"
an 18th-century mezzotint after
Rembrandt's St. Bartholomew.

( 5 3 )

Figure 16.
REMBRANDT, St. Bartholomew, 1661.
Major W. M. P. Kincaid Lennox Coll.,
Downton Castle, Ludlow.

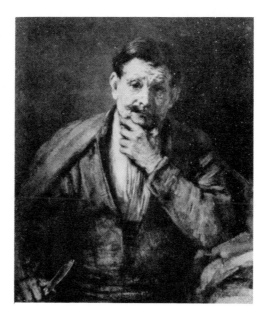

its towering height. His painting could be put in the category of landscapes Fritz Novotny aptly called *Mischlandschaften*, a category which should not be confused with what we in English would term mish-mash landscapes.

Although it is hardly necessary to labor the point that seventeenth-century Dutch artists did not merely paint what they saw before their eyes, it is still important to stress the fact that some Dutch paintings which appear to depict nothing more than a fragment of reality have symbolic or allegorical meaning. Our age is not the only one which needs this reminder. Around 1770, a mezzotint was published of Rembrandt's late painting of "St. Bartholomew" (Figure 15). The mezzotint, which was made in England by Charles Phillips, is a faithful copy of Rembrandt's half-length portrayal of the apostle, who is seen holding a knife in his right hand (Figure 16). The knife identifies the apostle as St. Bartholomew. It is a

(54)

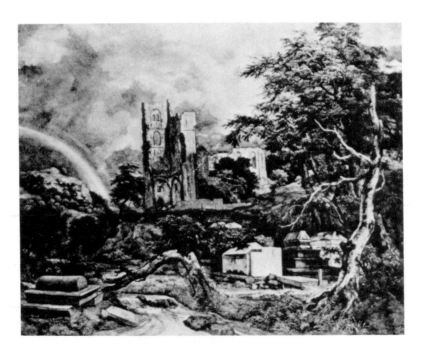

Figure 17. JACOB VAN RUISDAEL, Jewish Cemetery. The Detroit Institute of Arts.

486

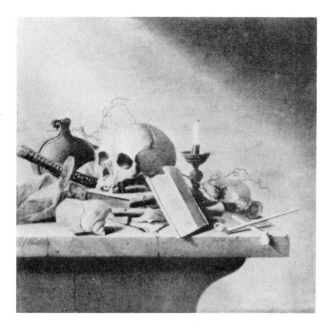

Figure 18. HARMEN STEENWIJCK, Vanitas: Still-life.
On loan from *Stichting Nederlandsch Kunstbezit,* Municipal Museum, Leiden.

reference to the tradition that he met his martyrdom by being flayed alive. Charles Phillips' mezzotint, however, is entitled "The Assassin," not "St. Bartholomew." Surely eighteenth-century artists knew that saints are represented with certain devices to insure recognition. But what seems to have been beyond the eighteenth-century engraver's ken was the idea that Rembrandt—or any seventeenth-century Dutchman—would make a picture of an apostle. Hence the man with a knife was dubbed "The Assassin." In the nineteenth century the knife led others to entitle the same picture "Rembrandt's Cook." The idea of Rembrandt's employing a chef in 1661—that is the date on the picture—would have surprised both Rembrandt and his creditors. The latter forced Holland's greatest artist into a kind of bankruptcy five years before the picture was painted. Yet another interpretation of Rembrandt's "St. Bartholomew" was made in 1893 when Emile Michel suggested in his monograph on the artist that the painting of the man with a knife was not Rembrandt's cook, but a portrait of a surgeon.

Seventeenth-century Dutch painters continued the well-established tradition of using man's actions, nature, and everyday objects to depict emblems and allegorical ideas, and to moralize. The

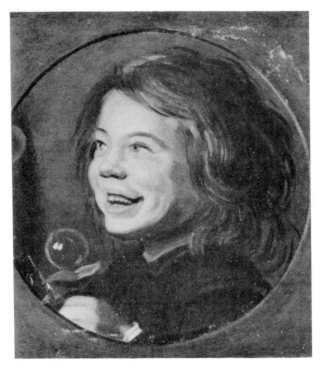

Figure 19. COPY AFTER A LOST FRANS HALS, Vanitas: Boy with Bubbles.
Virginia Museum of Fine Arts, Richmond.

late medieval tradition of using landscapes to show the months and
the seasons continued. Scenes from nature were also used to denote
the elements. Jacob van Ruisdael's "Jewish Cemetery" (Figure 17),
one of the greatest landscapes of the period, which is based on
studies Ruisdael made of the Jewish Cemetery still to be seen at
Oudekerk near Amsterdam, was painted to remind men how re-
lentless the natural and moral laws of the universe are. Man's edi-
fices crumble, even as his body returns to dust. Only one thing in
life is certain: death. Nothing is more uncertain than the hour
death will strike. The admonition *memento mori* was a constant one
during Renaissance and Baroque times.

A group of Dutch still-life painters (Figure 18) specialized in
making still-life pictures of skulls, time pieces, snuffed-out candles,
broken pipes, burned pieces of rope, books, musical instruments,
money and jewels, which were looked upon as emblems of mor-
tality to remind the viewer how transitory and fragile his pleasures
are and how easily beauty and life are broken. *Vanitas vanitatis.*

488

Figure 20. HENDRIK GOLTZIUS, "Qvis Evadet?," 1594.

The same theme is also found in some Dutch pictures which at first glance appear to be *genre pur*. The painting of a laughing boy with bubbles (Figure 19), which is probably an old copy of a lost work by Frans Hals, is most likely a *vanitas* picture. Was the original version of this picture, the unidentified "Vanitas" by Hals referred to in an inventory of Pieter Codde's effects at Amsterdam in 1636? An engraving, dated 1594, by Hendrik Goltzius, of a putto blowing bubbles while resting on a skull and with the inscription "Qvis Evadet?" and a poem which refers to the way man's life vanishes like a bubble or fleeting smoke, shows a more conventional way of treating the theme *Homo bulla* (Figure 20).

A seventeenth-century man did not need the skull, flowers, smoke, and Latin inscriptions to get the point. Not only is the comparison of man's life to a bubble found in the writings of the ancients, and

Figure 21. PIETER BRUEGEL, Children's Games, 1560.
Kunsthistorisches Museum, Vienna.

(58)

Figure 22.
PIETER BRUEGEL,
Boy Blowing a Bubble,
detail from
Children's Games.

Figure 23. ANONYMOUS, Illustration for Jacob Cats's poem on children's games viewed as moralized emblems, 1618.

(59)

frequently invoked again after the fifteenth century, but also artists before Hals often used the subject of a child blowing bubbles to convey the idea that the life of man resembles things of small account. As it was put in *An Herbal for the Bible* published in 1587, man's life can be compared "to a Dreame, to a smoke, to a vapour, to a puffe of winde, to a shadow, to a bubble of water, to hay, to grasse, to an herb, to a flower, to a leave, to a tale, to vanitie, to a weaver's shuttle, to a winde, to dried stubble, to a post, to nothing." Pieter Bruegel's famous painting of "Children's Games" (Figure 21) is probably more than an encyclopedia of the diversions of children. Most likely, Bruegel wanted to draw a parallel between the affairs of children and their elders. If this is correct, the little boy blowing bubbles in the lower left corner of Bruegel's painting (Figure 22) is a reference to the idea that a moral can be drawn from bubble blowing. There can be no doubt that this was the intention of the Dutch poet, Jacob Cats, who published a poem in 1618 on children's games seen as moralized emblems. ("Kinderspel Gheduyt tot Sinne-Beelden, ende Leere der Zeden"). The fine engraving used to illustrate Cats's poem (Figure 23) shows more than a dozen games. Cats, as was his custom, wrote homely aphor-

491

Figure 24.

(60)

Figure 24. FRANS HALS, Taste: Boy Drinking.
Figure 25. FRANS HALS, Hearing: Boy with Flute.
Both pictures in Museum, Schwerin.

Figure 26.
JAN MIENSE MOLENAER,
The Five Senses:
Sight, Touch, Taste, Hearing, Smell.
Mauritshuis, The Hague.

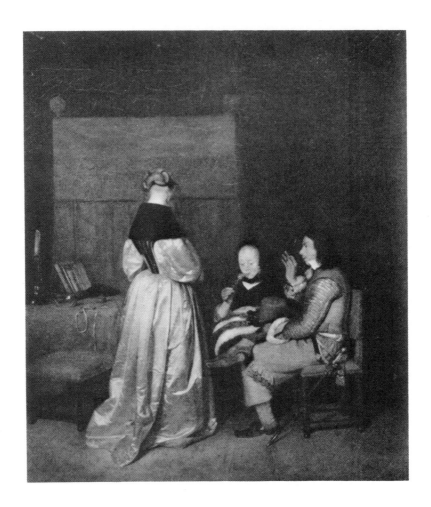

Figure 27. GERARD TERBORCH, so-called Parental Admonition.
Staatliche Museen, Berlin-Dahlem.

isms on all of them. Of the amazed boy blowing bubbles in the en-
graving, Cats noted that the broken bubble reminds us that he who
rises too quickly rides for a fall.

Frans Hals's genius was to take the bubble-blowing boy away
from his numerous companions in a town square and make him
the subject of an entire painting. Some of Hals's other pictures of
single children also have allegorical meaning. His tondos which,
in the literature, are called a "Boy Drinking" (Figure 24) and a
"Boy with a Flute" (Figure 25) are probably two panels used to
depict taste and hearing in a series of the Five Senses; the quality

494

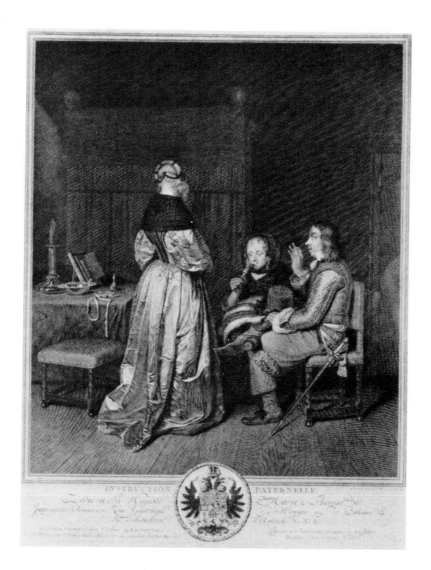

(63)

Figure 28. JOHANN GEORG WILLE, "Instruction Paternelle," 1765, engraving after Terborch's painting now in Berlin-Dahlem.

of these vivacious sketches animated by light and Hals's unmatched fluid touch make clear why the picture of the "Boy with Bubbles" (Figure 19) cannot be considered a work by the master himself. Other Dutch artists also used genre scenes to show the five senses. A series of five pictures by Jan Miense Molenaer of life amongst the lower classes depicts each of the senses (Figure 26). Additional

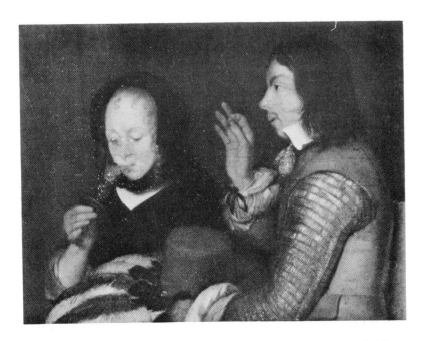

Figure 29. GERARD TERBORCH, detail from the so-called Parental Admonition.

examples can be cited from the works of Jan Steen, Adriaen Ostade, Pieter de Hooch, and a host of others to show how the age, sex, manners, and social status of the figures, as well as their activities, could vary in representations of the theme of the five senses.

Once we realize that there may be more significance to seventeenth-century Dutch pictures than earlier critics thought, we run the risk of reading the wrong meaning into them. It is also possible to read too much meaning into them. Terborch's famous "Parental Admonition" (Figure 27), now in Berlin, offers a good illustration of the difficulties which can be encountered. The first reference to the title is found on an engraving made by Johann Georg Wille in 1765, which is inscribed "L'Instruction Paternelle" (Figure 28). Goethe based a passage in his novel *Die Wahlverwandschaften* on this print. He made characters in his novel act out a *tableau vivant* upon the basis of it, and Goethe described the well-known engraving for his readers. "One foot thrown over the other," he wrote, "sits a noble knightly looking father; his daughter stands before him, to whose conscience he seems to be addressing himself. She, a fine striking figure, in a folding drapery of white satin, is only to be seen from behind, but her whole bearing appears to signify that she is

496

collecting herself. That the admonition is not too severe, that she is not being utterly put to shame, is to be gathered from the air and attitude of the father, while the mother seems as if she is looking into a glass of wine, which she is on the point of drinking."

Not all students of Dutch painting have accepted the eighteenth-century title given to Terborch's painting or Goethe's description of it. Dissenters state that it is not a minor episode in the life of a family, but that it is a tactful and unusually restrained depiction of a courtesan scene. They claim that the man Goethe described as a father admonishing his daughter is offering the standing woman a piece of money, and that the woman sipping wine is a procuress, not an embarrassed mother (Figure 29). It is particularly appropriate that Goethe's *Die Wahlverwandschaften* figures in this discussion of the possible interpretations of Terborch's picture. *Die*

(65)

Figure 30. DIRK VAN BABUREN, The Procuress. Museum of Fine Arts, Boston.

497

*Wahlverwandshaften* is a novel which deals with love, the nature of morality, and passion. It is a work which has been variously described as immoral, amoral, and moral, and, with the exception of *Faust,* no work of Goethe's has been interpreted in so many different ways and debated with such zeal.

The interpretation of Terborch's picture as a courtesan scene is not an impossible one. The theme is not unusual in seventeenth-century Dutch painting. It was frequently painted without much subtlety on a life-size scale by the Dutch followers of Caravaggio who worked in Utrecht during the 'twenties of the century. There is no need to debate the subject of Baburen's "Procuress," now at the Museum of Fine Arts in Boston (Figure 30). Vermeer handled the same subject in one of his earliest known pictures, and Terborch himself made pictures of men offering money to women, in which there can be little doubt about what is being purchased: one is in the Pushkin Museum at Moscow, another is the well-known "Gallant" at the Louvre.

Money is an indispensable prop in courtesan and procuress scenes. Without it, the character of the story changes. Where is the coin in Terborch's so-called "Parental Admonition"? It belongs between the thumb and forefinger of the seated man's right hand. The coin is not there. It has been suggested that it was painted out by a fastidious owner of the picture before it was engraved in the eighteenth century. However, a recent close examination of the picture has revealed no sign of a coin, and the specialist who conducted the search states that what has been taken for a coin in the father's hand is in fact the edge of the man's fingernail. This expert claims that the picture is neither a parental admonition, nor a courtesan scene, but a depiction of "The Tasting of Wine"—yet another theme not unknown in Holland during the seventeenth century. If this is the case, the seated man is neither admonishing his daughter nor offering the standing woman a coin, but is pressing the tip of his forefinger on the ball of his thumb to indicate that the wine is excellent.

Which of the three interpretations of Terborch's picture is correct? There is another autograph version of the painting in the Rijksmuseum at Amsterdam in which the characterizations of the man and drinking woman are superior to those in the Berlin picture. Unfortunately, the Amsterdam version does not answer the question. A crucial section of the Amsterdam painting—the area around the man's right hand—is abraded and it cannot be read properly.

(66)

498

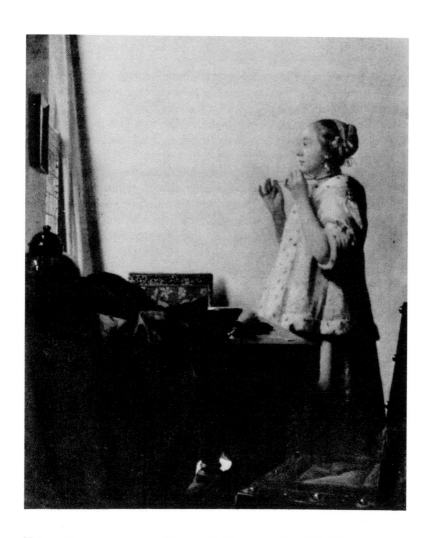

Figure 31. JAN VERMEER, Woman Putting on a Pearl Necklace.
Staatliche Museen, Berlin-Dahlem.

We have been offered three interpretations of Terborch's picture.
Which one is correct? Each man can be his own judge, but only
after intimate knowledge of the picture has been acquired. We have
seen how crucial it is to determine whether we are looking at the
edge of a coin or a fingernail. It is also clear that before we can
come to a sound conclusion about the theme of this little masterpiece
of seventeenth-century Dutch painting, we must do precisely what
is done when the signification of a work of any other epoch is dis-

499

cerned: we must become familiar with the artist's personal predilections and tendencies, and acquire knowledge of the range of possibilities available to the age in which he lived.

Once we are conscious of what has become for us a kind of covert meaning in seventeenth-century Dutch painting, it is difficult to ignore it—if only to point out that here and there is a picture without any. However, while deciphering the profundities and what are in most cases the contrived conceits of their pictorial symbolism, we must not forget that Dutch painters also broke with the old tradition of disguising symbols under the cloak of real things. They painted the world for its own sake more frequently than they used it for allegorical and moral significance. They took intense delight in their own countryside, their seas and great rivers, and in the ordinary things at their elbow. They scrutinized and dallied over the familiar, the insignificant, and the commonplace, without moralizing or depreciating it. Theirs was an unprecedented pleasure in perceiving and painting the harmony of colors, the sparkling play of light, the mystery of shadow, and intangible space.

In an attempt to qualify the oversimplified generalizations made by earlier critics who censured or praised Dutch painters for their realism, care must be taken not to exaggerate the significance of the symbolic or allegorical meaning in their work. Vermeer's "Woman with a Pearl Necklace" (Figure 31) may very well be a *vanitas* or a representative of the sense of sight. Yet an undue emphasis on these commonplace Renaissance and Baroque themes at the expense of the quivering intimacy of this momentary scene of a woman studying herself in the mirror on the wall, the exquisite balance between her figure and the silvery daylight that fills the interior, the strong tectonic design, and the fine cool color accord, would impoverish, not enrich, our response to the unique achievement of seventeenth-century Dutch painting.

(68)

500

# Two Aspects of the
# Dutch Baroque. Reason and Emotion

## JAN G. VAN GELDER

The Dutch historian Johan Huizinga once stated that no age was as difficult to understand as the seventeenth century. He referred to it as "the age of cold passion." The sound of trumpets and violins had died away; the obligato was organ music. The passionate feeling for beautiful form was lost. The ruling ideals had become order, regularity, and unity. In no other century, Huizinga claimed, did these ideals press so heavily on reality.

In endeavoring to assess the character, the origin, and the destiny of a given period, it is impossible to avoid generalizations. Here, as the title suggests, I shall try to reduce the great diversity of forms and themes that distinguishes the Dutch baroque to two ruling concepts, reason and emotion, which represent two opposite poles. Of course I do not suggest that we can sum up this age of immense vitality and creativity, in which small masters held their own beside the great, with such a crude oversimplification. I merely would like to suggest that we may use reason and emotion as two points of orientation. Huizinga, in struggling to find a formula which suited the Dutch seventeenth century, points at only one of its distinguishing features, that of reason, which expresses itself in the regularity of solid and fixed forms organized according to the dictates of certain laws. Yet the art historian and even the layman will immediately ask where Rembrandt's thought and Jan Steen's drama fit into Huizinga's scheme. As I hope to be able to show, Huizinga overstresses one aspect of the century.

(69)

Huizinga, moreover, seems to restrict the concept of reality, which he sees as endangered by the postulates of regularity, in a way that is incompatible with the ideas of the age. We should rather say that some of Rembrandt's contemporaries, and for a brief spell Rembrandt himself—no doubt inspired by Descartes' mode of thought—regarded mathematical laws as the fountainhead of reality. In taking this view they were humanists, although at the same time they inherited much from the Middle Ages. In the time of the Dutch baroque mathematics was seen as the means by which the laws underlying reality were made manifest. Yet there were also great artists who excelled in the refinements of representing reality in terms of naturalism—artists who ranged from virtuosi such as Vermeer (and in a sense also Episcopius, whose eye might be helped by or compared with the lens of the *camera obscura*) to the genius, such as Rembrandt, for whom the reality of things became primarily a means by which the emotions of the human soul could be adequately expressed.

It is my aim to show in the following pages how in a few decades, from shortly after the beginning of the century to the end of its third quarter, the Dutch baroque ran its course, and how this astonishingly short-lived development represented above all a discussion between reason and emotion. The final triumph of reason at the expense of emotion must have been

445

the cause of the withering of Dutch art, which failed to recover its prominent position even in
the eighteenth century when in sister countries such as France and England a new efflores-
cence began. From the outset the Dutch protagonists of the dictates of reason were a com-
pletely different group, socially and intellectually, from those whom we may call the cham-
pions of emotion. The first were the humanists who turned to the arts as dilettanti, while
the latter were professional artists who, even where they might claim to be Bohemians (if
such a word may be applied to the seventeenth century), were organized in guilds and con-
fraternities which differed little from those of the late Middle Ages. Carel van Mander, painter
and theoretician of art, might propagate the humanist theory of painting in his great didactic
poem (the so-called *Leergedicht*) of 1604. Yet his fellow painters, whom he addressed, and
likewise their pupils were unwilling to follow his teaching and for the most part refused to
adopt an Italianate outlook. The spirit of Coornhert (d. 1590), the great Dutch moralist who
was at the same time a graphic artist, remained dominant. This tenacious adherence to the
sixteenth century can be seen in Dutch emblem books, whose authors, though they were
deeply indebted to Andrea Alciati and his followers, nevertheless based their emblems on
the real things of daily life. As long as Dutch artists embraced reality with an almost religious
fervor and at the same time exploited it as a means to moralize and allegorize, Dutch art
retained its vitality.

(70)     When, to illustrate this point with a relatively late example, we look at Vermeer's *History
Inspiring Painting* in the Kunsthistorisches Museum, Vienna (Fig. 1), we see what seems at
first sight to be an elegant artist at work. Yet a second glance shows that the gentleman at the
easel, seen from behind, with his wonderfully rendered clothes and barret, is depicted in a
"Burgundian" stage costume, suggesting, in the midst of tangible Dutch reality, an approxi-
mation to the classical past. By virtue of his disguise he becomes the personification of
painting, and his model, the lady with book and laurel wreath, far from being an artist's
model in fancy costume, is in fact the muse of history, Clio, one of whose tasks is that of in-
spiring painting. Since the time of Leon Battista Alberti the artist's task had been to invent
his own *istorie*, and this is undoubtedly why Vermeer of Delft put the book of the historian
*par excellence*, Thucydides, in the hand of his muse, following a suggestion that might easily
have reached him through the Dutch translation, published in 1644, of the *Iconologia* of
Cesare Ripa.

     At this point we might well ask ourselves how it came about that reason asserted itself
with increasing power in the shaping of Dutch baroque art until, in the last quarter of the
century, it stifled the expression of reality charged with meaning, by reducing art either to a
statement of cold humanist theories or to superficial and playful renderings of fashionable con-
cepts which were far removed from the real Holland of the time.

     The answer lies, it seems to me, in the historical developments that led to the birth of
Holland as a political entity. In the Eighty Years' War, from 1568, against the Spanish crown,
the struggle to protect the rights of the cities of the Low Countries had gradually become a
battle for religious freedom. The Protestant creed was the cement that kept the North together.
Tolerance made Holland attractive even to those who were bound in religion to the Catholic
faith. The invasion of refugees from the South and the tensions that resulted (caused by the

clash of different shades of opinion, which grew fierce in the relatively small compass of Holland) created an enormous amount of what may best be called cultural energy. An increase of commerce and of military and maritime power such as had never before been experienced was closely connected with the blossoming of the arts and the sciences.

It is characteristic of these new impulses that in the darkest year, 1575, of the seemingly hopeless struggle against a mighty foe, William the Silent founded the first Dutch university at Leiden, only one year after the city's liberation from Spain. Until that time all those who wished to study in the Low Countries had to go to the ancient University of Louvain, near Brussels—the university which Erasmus and Vesalius had attended. Yet the North had never been short of scholars. After 1575, it might be said, learning settled in the United Provinces in its academic form, and this is not without significance for the developments we are concerned with. When the Peace of Munster was signed in the year 1648 there were already six universities in addition to Leiden on Dutch soil. From these centers came the intellectual élite that was to rule the United Provinces and found New Amsterdam, and that, increasingly, would guide and determine the destinies of the fine arts in Holland. It will be useful to illustrate the way in which their scholarly and rationalist attitude helped to shape Dutch art at a decisive point in its development.

The Dutch humanists (following a pattern set by the humanists of nearly every European country during the Renaissance) evolved an ethnogenetic theory by which they, the modern Dutch, came to see themselves as the direct descendants of the Batavians, a people mentioned in the *Commentaries* of Julius Caesar and by later writers. This theory could be used to draw meaningful parallels. Just as the Dutch, in the year 1609, had made a treaty with Spain, so the Batavians had concluded a *foedus aequum* with the Romans. The Batavians, in contrast to the barbarian Germans, had been allies—*amici et fratres*—of the Roman Empire. It followed that the Batavians had been the equals of the Romans, and indeed their superiors, just as the Dutch were the equals of the Spaniards when they concluded treaties with them, and in piety, honesty, and good government were clearly superior to them. This remarkable historical fiction was first propounded in 1610, in the *Liber de antiquitatibus rei publicae Bataviae* of the young Hugo Grotius.    (71)

Seventeenth-century artists who were commissioned to depict the glory of the Batavians at first dressed them like Teutonic heroes. Otto Vaenius, Rubens' teacher, and Antonio Tempesta represented them in the year 1612 in medieval costume. But official theory asserted itself in 1648, when the Batavians appeared dressed as heroes of antiquity in *tableaux vivants*, devised by Geerard Brandt, which formed part of the *fêtes* held in Amsterdam to celebrate the Peace of Munster. Amsterdam demanded such a representation of the Batavian story in a permanent form soon afterward, to decorate the walls of the city's new Town Hall. Clearly the poet Joost van den Vondel's proud reference to the Town Hall as Amsterdam's Capitol, erected on her Forum, is no mere accident.

In 1659 Govert Flinck, one of Rembrandt's former pupils, was commissioned to paint these scenes. He died prematurely, leaving only unfinished fragments and sketches for his work. The commission was divided among a number of artists, among them Rembrandt, who was to paint the *Oath of Claudius Civilis*. Rembrandt's completed painting, hung only

temporarily in the Town Hall, was removed to allow the painter to make certain changes requested by the burgomasters. While it was absent Maximilian, Elector of Bavaria, visited Amsterdam, and to fill the empty space Jurriaen Ovens, one of Flinck's pupils, finished the painting which his master had begun for it, adding twelve figures and completing it in four days (Fig. 3). His *tour de force* is still in the building. A fragment of Rembrandt's painting (Fig. 2) was sold to Stockholm in the eighteenth century and hangs there in the National Museum, while the whole composition is known from a sketch which Rembrandt himself made before finishing the composition.

A comparison between the composition by Flinck and Ovens and that of Rembrandt is rewarding. Rembrandt deviated from the accepted standards of his day by depicting the Batavians as rough barbarians, while in Flinck's design and Ovens' painting they appear as the Romans' equals. Rembrandt even went so far as to represent Claudius Civilis as one-eyed, following the account of Tacitus quite literally. Moreover, *barbaro ritu*, Rembrandt's Batavians took the oath of allegiance on the sword, while the Batavians of Flinck and Ovens were content with a martial handshake. We sense the reason for the failure of Rembrandt's composition in his lack of compliance with the official demands although, and indeed just because, his own concept came nearer to the truth of history.

While Rembrandt, by virtue of his intuitive adherence to historical truth, alienated himself from the official art that was current in Amsterdam, other artists succeeded in fulfilling its demands with the greatest refinement. One of the spokesmen of the new theories, an amateur of the arts who had been English ambassador in The Hague, Sir Henry Wotton, demanded that the arts should give delight to the art lover. Although as a theoretician of architecture he applied this demand to sculpture adorning buildings, he held that it was applicable to painting as well. In making a comparison between these two arts, he was in favor of painting. He praised it for its ability "to make diverse distinct Eminences appear upon a Flat, by force of Shadowes, and yet the Shadowes themselves not to appeare: which I conceive to be the uttermost value and vertue of a Painter, and to which very few have arrived in all Ages." He also remarked: "An excellent Piece of Painting, is to my judgement the more admirable Object, because it comes neere an Artificiall Miracle."

This ideal, no doubt, was aimed at by the Dutch Caravaggists who, having worked in Italy at the beginning of the century, returned to Holland about 1620. Hendrik Terbrugghen was foremost among them, and with his superb ability to create shadows by the use of color came closest to producing the "Artificiall Miracle" that was Sir Henry's ideal (Fig. 4).

Others as well as Sir Henry Wotton suggested that works of art should delight—and so, incidentally, came curiously close to the later doctrine of "art for art's sake"—and the dilettanti who laid stress on the mathematical foundation of all true art were just those for whom delight was essential.

Descartes agreed with his friend Mersenne, the distinguished French theoretician of music who was also a friend of Huygens, when he said that "les airs ne se font pas pour exciter la colere et plusieurs autres passions, mais pour resjouir l'esprit des auditeurs" and added that it was music's task "de charmer l'Esprit et l'oreille et nous faire passer la vie avec un peu de douceur" (November, 1640).

(72)

The close association between delight and mathematics can be seen most clearly in the palaces and great houses of the mid-century. Some of the most distinguished cycles of wall paintings and pictorial decorations of the age were planned by the dilettanti—scholarly amateurs who had designed the buildings these paintings embellished. I will mention only the Huis ten Bosch near The Hague and the seventeenth-century Town Hall of Amsterdam, both of which are now royal palaces. Huygens, Jacob van Campen, and Princess Amalia van Solms, all amateurs of the arts, were concerned with the Huis ten Bosch. Jacob van Campen and the burgomaster Andries de Graeff were responsible for the Town Hall's decoration. The paintings in both (see Figs. 3, 6 and 7), whether or not they are successful aesthetically, tended to emphasize that the visible world is not illusion but reality, and that "reality is truth, as mathematical properties are true."

Delight and reason at this point were thus closely allied. As postulated by Sir Henry Wotton and rendered by Hendrik Terbrugghen, delight had become, in the seventeenth century, a near equivalent to pleasing virtuosity. In tracing the early developments of this concept we find that in the fifteenth century the Flemish-Italian composer Tinctorius claimed, in his *Tractatum de musica*, that the main function of music was to delight God: *delectare Deum*. To delight man was a function that, even for Tinctorius, took second place. A hundred years later, at the end of the century that had seen the triumphant entry of the madrigal into music, Thomas Morley could write (1597): "The more variety you shew, the better shal you please." To put it differently, delight and virtuosity had become one. Not all those who subscribed to this postulate of delight were content to be bound within its limits, and I shall return to this in discussing the range and function of emotion as a ruling principle in the arts.

(73)

A few words must be said first about the role of the dilettanti in the development of the arts in the age of the baroque in Holland. The very concept of the nonprofessional practitioner of the arts may be described as a humanist phenomenon, typical of the post-medieval era. Leonardo, in a sense, came into this category; he had consciously fashioned himself as the incarnation of the all-round scholar-artist. Pliny, in advocating a many-sided education, had pointed the way. Baldassare Castiglione, among others, had recommended this course as an ideal in the formation of the *Corteggiano*. Many of the princes of the Renaissance, the Emperor Maximilian I and Francis I of France themselves, had practiced the arts and so had contributed unconsciously to the ennoblement of the mechanical *artes* which, in the Middle Ages, had been practiced only by ignoble craftsmen.

In seventeenth-century Holland Constantijn Huygens may be singled out as the ideal representative of this group, which was large and powerful. When he was five years old he started music lessons, when he was eight the study of Latin. At the age of eleven he spoke Latin and French fluently and a few years later English, Greek, and Italian. He composed music and played five different musical instruments. He finished his study of law when he was eighteen, and devoted the later years of his life to the study of medicine and physics. But, we learn from his memoirs, he learned also to draw and etch, to paint, and to engrave with the burin. He made wax *bozzetti* and, later, medals. Although in this age the concept of creative genius with all its modern implications had not come into being, the word *ingenium* could be applied to a female amateur of the arts rather than to a professional artist of the rank of

Rembrandt. When J. Houbraken, in 1718, published his *Groote schouburgh der Nederlantsche konstschilders en schilderessen*, he placed next to the portrait of Rembrandt that of Anna Maria Schurman, an accomplished scholar who drew, painted, and etched as an amateur.

Johannes Episcopius (Jan de Bisschop), a lawyer who was also an artist, unfortunately died without finishing the treatise he had projected, which would have been the true codification of the theoretical aims of the dilettanti of the Dutch baroque. We have to content ourselves with Samuel van Hoogstraeten's *Inleyding tot de hooge schoole der schilderkonst*. In one of the chapters of this book we see Euterpe, the muse of reason, giving advice to artists under the motto: "He that wishes to know reason must always measure." What the adherents of reason advocated was in essence what Leonardo da Vinci and Albrecht Dürer had preached in the sixteenth century: that art, being a science, must have mathematics as its foundation. The concomitant emphasis on measurable—that is, visible—reality found encouragement in Calvin's teaching. It was he who gave the warning that only what possessed visible form could be made visible in the arts. God, being invisible, was not to be represented in visible form or honored in an image. Between these two elements, the religious and the rationalist, seventeenth-century art was finally caught and suffocated. Ratio—atque Religio—artis perditrices.

As long as the humanists were more than mere virtuosi of mathematics their creations and those which they inspired had meaning and tended to emphasize the link between a reborn Holland and the classical past. The first great neoclassical buildings were erected in Holland in accordance with the severe and meaningful principles of Vitruvius, de l'Orme, Palladio, and Wotton. A working drawing showing the façade of one such palace, now the Historical Museum in Rotterdam (Fig. 10), may serve as an example of this living spirit of geometry which governs their structure. Here, *mutatis mutandis*, the spirit reigns supreme that governed some of the interiors created by Vermeer's brush and the subtle, emblematic *Vanitas* of Jan Steen, with its room seen through a classical doorway, that graces the Royal Collection at Buckingham Palace (Fig. 8). The same convention-bound spirit gave meaning to the arch which Episcopius designed for the entrance to the road from The Hague to the seaport Scheveningen (Fig. 9). Huygens wished to see this arch designed in emulation of the Arch of Constantine, on the road from Rome to the port of Ostia. The group of humanists saw all that was Dutch in Roman terms, with the result that the art which its members propagated was intentionally reduced to what they considered to be the foundation of art as a whole. The entire world was subsumed under this view. Huygens gave the place of honor above his mantelpiece to a painting by Saenredam which showed the mathematics of a Romanesque church interior, while Caspar Barlaeus acted as a self-appointed Tacitus when he wrote the history of a Roman-style expedition to Brazil made by the governor, Prince Johan Maurits. A pictorial counterpart of this written record is included in the decoration of the Huis ten Bosch, where the allegories and symbols, realistically portrayed, provide a triumphant reminiscence of the Brazilian expedition (Fig. 6). A similar realism accounts for the faithful representation there of seventeenth-century Dutch models as the muses who had inspired Prince Frederik Hendrik, and of Pegasus as a charger with wings attached who remained strictly earthbound (Fig. 7). Under the sway of reason even the clear, bright colors which

(74)

distinguish these paintings in their lack of "melancholy shades" stress the desire for controllable reality, as opposed to the mysteries of "Rembrandtian gloom."

In the official circles of The Hague and Amsterdam, to say it once more, art based on reason existed to promote delight. In turning to the postulate of emotion, the opposite pole to reason mentioned at the beginning of this essay, it becomes clear that the two were originally in no way felt to be mutually exclusive. In wishing to move (*permovere*), the painter, who had himself to be stirred, was originally no more than a faithful adherent of the tenets of the rhetoricians, in which delight and emotion stood side by side. We need only turn to Cicero's *De optimo genere oratorum* to learn that it was the orator's duty to teach, his honor to delight, his obligation to move: "Docere debitum est, delectare honorarium, permovere necessarium." What in classical times applied to the orator and his art was in the Renaissance equally applicable to the painter and the musician. Horace's *Ut pictura poesis* had pointed the way.

Nevertheless the triad of postulates could undoubtedly be seen as a hierarchy. Surely to "move," to instill deep emotions felt by the artist into the willing beholder's soul, would be seen by many Dutch artists in the seventeenth century as the highest aim of their art. It is in this sense that we must understand Rembrandt's own words, in a precious letter written in his own hand in 1637 to Constantijn Huygens, which accompanied a picture ordered by Prince Frederik Hendrik: "When the light comes from the right angle this picture possesses a most natural inward emotion"—"die meeste ende die naetuereelste beweechgelickheyt."

It is important to note that in the same year Bannius (Johan Albert Ban), a composer and theoretician of music and secretly a Roman Catholic priest, could write: "Finis musicae est docere, delectare et permovere." I do not think that we would go too far if we were to suspect that such an idea forms the background to one of Rembrandt's earliest compositions, his *Family Making Music*, of 1626 (Fig. 5). Rembrandt never consciously tried to set himself apart from the currents of his time. On the contrary, he did his best to assimilate the conventions of his contemporaries, especially in his formative years. As we have already seen in the case of the *Claudius Civilis*, however, he cannot help thinking of the *istorie* commissioned from him as a means of conveying a message at the deeper level of emotion, and he cannot help using light and shadow to this end, even where he may seem to concentrate on surfaces and textures. This drive, from which he cannot escape, is revealed in the tribute which Rembrandt paid to the Caravaggists, for example in his *Money Changer* in Berlin, though it is self-evident that even there he was not trying to create the "Artificiall Miracle" of a Terbrugghen and that to him the contrast between light and dark was a means of evoking an emotional response in the beholder.

(75)

Even when we are confronted by a simple drawing by Rembrandt such as the *View at Amersfoort* (Fig. 12) we sense how the artist's emotion has formed and given accent to the lines. The structure of what is seen is hinted at with the greatest economy, and by this means the beholder is drawn into a world which is merely suggested. He is, as it were, obliged to complete the scene in his own mind, and this he can only do by means of empathy into the artist's innermost emotions.

We might compare this with a similar drawing by Huygens' friend Episcopius, who died in

1671 at the age of forty-two. In this drawing we see a cobbled street leading up to the Rotter-
dam Gate at Delft (Fig. 11). The scene is bathed in sunlight and is alive with the step of
casual passers-by, whose very movements are registered as though with the lens of a camera,
quickly exposed. It is significant that this work should represent a scene in the town where
the virtuoso of optical refinement, Jan Vermeer, was active, and where Leeuwenhoeck ob-
served the finest details of the visible world through his microscopes. Episcopius indeed re-
created a sample of his vibrant vision of a world in which everything seemed to move fleet-
ingly, which might at any moment evaporate in the sun or crystallize again in the shadow—a
world beyond the emotions of the artist, who observed it objectively.

It is not the historian's task to rejoice or lament over the events that he has set himself to
consider. Holland as a nation prospered economically until the dawn of the French Revo-
lution. Yet from 1675, the year of Vermeer's death, the arts declined. This was the Age of
Reason and Enlightenment, whose inner impulses—the artistic will to delight and the religious
will to refuse the representation of anything but the visible world—acted as a blight on those
striving to express the inner images and messages of emotion. It is strange to see how,
nevertheless, both these currents and impulses remained characteristic of the Dutch nation,
and how at the end of the nineteenth century and the beginning of the twentieth emotion and
reason triumphed once more, in the passionate work of Vincent van Gogh and the immacu-
late geometrical abstractions of Piet Mondriaan.

UTRECHT UNIVERSITY

(76)

The above text is based on a lecture written in Princeton in 1953–54 and delivered in New York and
elsewhere during my stay there. It originated more or less spontaneously in making an attempt
to characterize the wide variety of Dutch seventeenth-century art in relation to the historical
facts which account for it—for the current view, in writing the history of that art, is not the cor-
rect one. I am still convinced that the moralizing, rational, and religious (or emotional) elements
of Dutch seventeenth-century art must be seen as versions of the antique trio *docere*, *delectare*, and
*permovere*. This trio, in all its variations, lies at the root of the allegory, realism, and contrasts of
Dutch art.

Through Professor Panofsky, who introduced my lecture in New York, I first made the acquaint-
ance of Professor W. S. Heckscher, now my colleague at Utrecht. To his help and friendly counsel
I owe the present arrangement of my text.

I append a list of literature concerning the subject.

J. Huizinga, *Verzamelde werken*, II, 1948, pp. 390ff. Lecture (1925) on Hugo de Groot.
*Idem, Nederland's beschaving in de zeventiende eeuw*, 2nd ed., Haarlem, 1956.
H. A. Enno van Gelder, "Ratio artis perditrix," *Jaarboek Maatschappij der Nederlandsche Letter-
kunde*, 1935–36, pp. 54–78.
W. J. A. Jonckbloet and J. P. N. Land, *Correspondance et œuvre musicales de Constantin Huygens*, Lei-
den, 1882.
B. Willey, *The Seventeenth-century Background (The Thought of the Age in Relation to Religion and
Poetry)*, London, 1934. Reprinted in New York, 1953.

E. J. Dijksterhuis, *De mechanisering van het wereldbeeld*, Amsterdam, 1950.

H. van de Waal, *Drie eeuwen vaderlandsche geschied-uitbeelding, 1500–1800*, The Hague, 1952, 2 vols.

H. V. S. Ogden, "Variety and Contrast in Seventeenth-century Aesthetics and Milton's Poetry," *Journal of the History of Ideas*, 1949, pp. 159–182.

S. Slive, "Notes on the Relationship of Protestantism to Seventeenth-century Dutch Painting," *The Art Quarterly*, 1956, pp. 3–15.

J. J. Timmers, *Gérard Lairesse*, Amsterdam, 1942.

J. G. van Gelder, "Rembrandt en de zeventiende eeuw," *De Gids*, 1956, pp. 397–413.

*Idem* (with commentary by J. A. Emmens), *"De Schilderkunst" van Jan Vermeer*, Utrecht, 1958.

*Sources*

Sir Henry Wotton, *The Elements of Architecture*, London, 1624.

Samuel van Hoogstraeten, *Inleyding tot de hooge schoole der schilderkonst*, Rotterdam, 1678.

(77)

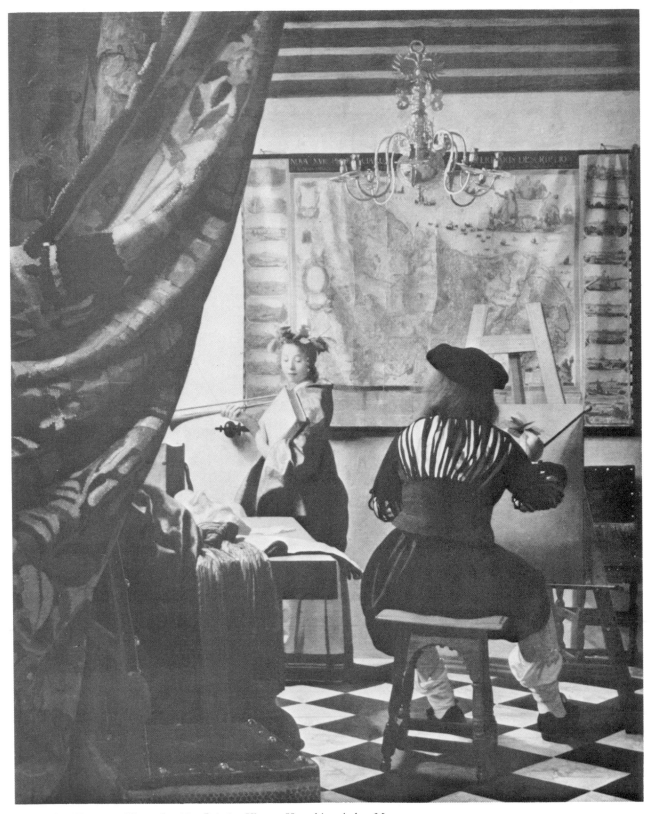

Fig. 1   Jan Vermeer, *History Inspiring Painting*. Vienna, Kunsthistorisches Museum

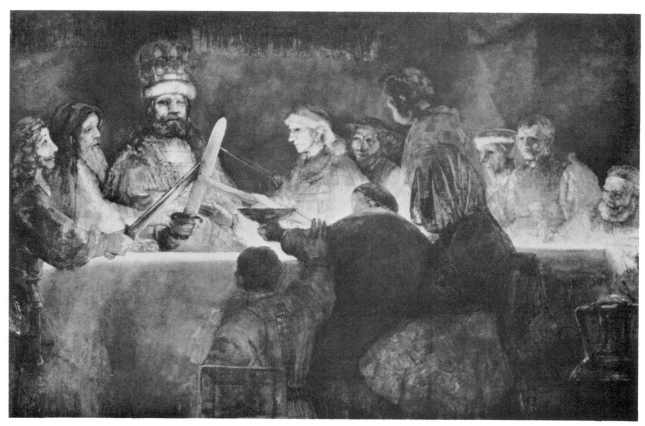

Fig. 2  Rembrandt, *The Oath of Claudius Civilis* (fragment). Stockholm, Nationalmuseum

Fig. 3  Jurriaen Ovens, *The Oath of Claudius Civilis*. Amsterdam, Royal Palace

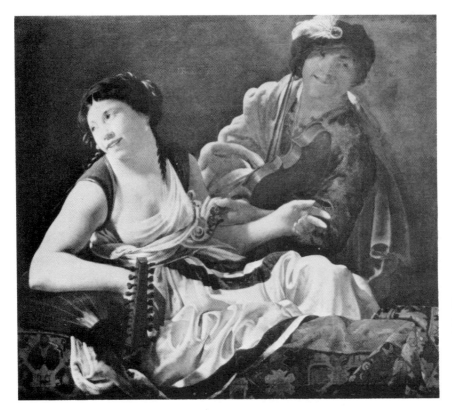

Fig. 4 Hendrik Terbrugghen, *Two Musicians*. Rome, Galleria Nazionale, Palazzo Barberini

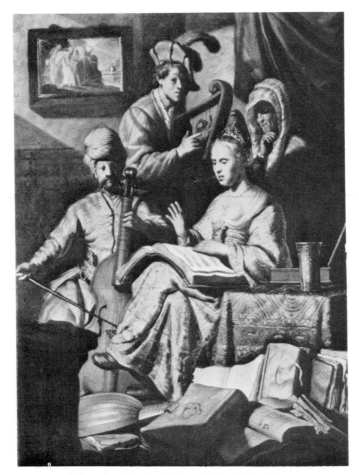

Fig. 5 Rembrandt, *Family Making Music*. Paris, Private Collection

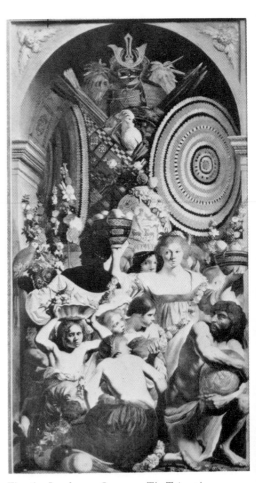

Fig. 6 Jacob van Campen, *The Triumph of Brazil*. The Hague, Huis ten Bosch

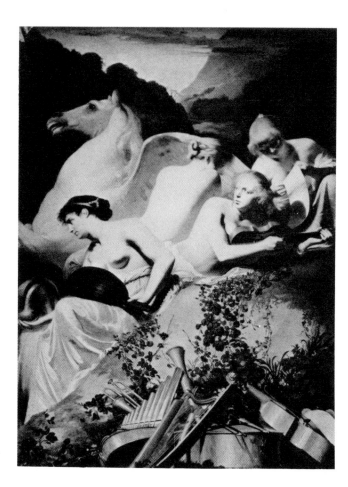

Fig. 7 Cesar van Everdingen, *Four Muses with Pegasus*. The Hague, Huis ten Bosch

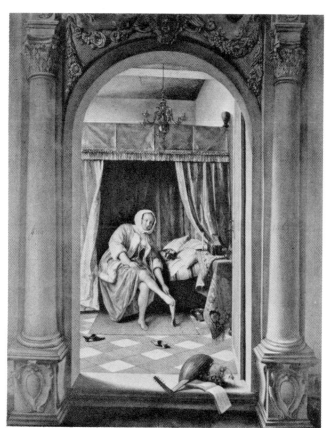

Fig. 8 Jan Steen, *Vanitas*. London, Buckingham Palace

Fig. 9 Johannes Episcopius, Arch for the road to Scheveningen, etching by Romein de Hooghe

Fig. 10 Jacob Lois, Schielandshuis, Rotterdam. Rotterdam, Municipal Archives.

Fig. 11   Johannes Episcopius, *The Rotterdam Gate at Delft*. Amsterdam, Fodor Museum

Fig. 12   Rembrandt, *View at Amersfoort*. Paris, Louvre

# THE LIFE OF A DUTCH ARTIST IN THE SEVENTEENTH CENTURY
## ❧ BY DR. W. MARTIN[1] ❧
## I—INSTRUCTION IN DRAWING

THERE is a type of person who can look at a Dutch picture like Rembrandt's Night Watch, Vermeer's View of Delft, or Hobbema's Avenue at Middelharnis, and surrender himself completely to aesthetic enjoyment without puzzling his head over the conditions under which these and similar gems of Dutch painting of the seventeeth century were produced. For such a one enjoyment suffices, enjoyment varying in proportion to the subject of the picture, and the taste and artistic appreciation of the beholder, from profound reverence to ecstatic admiration, as he wanders through a picture gallery or contemplates single pictures in the peaceful seclusion of a collector's home.

Anyone who has made himself familiar in this way with the works of the great period of Dutch painting, does not need to know the names or lives of the artists, still less does he require a book to instruct him on the subject, and he may very well leave this article unread.

But the case is different with the amateur who, besides enjoyment, feels the need of exploring the forces from whose operation his enjoyment is derived, and ascertaining the circumstances which led to the production of these masterpieces. 'Who painted the picture?' is then the first question that rises to his lips. It is followed by several others; he must learn to estimate the personality of the artist by endeavouring to trace clearly the development of his talent; he must know how far the man's work was original and progressive, how far his art was the reflection of his mind, his environment, his nationality, his period.

The satisfaction of this need, supplementing purely aesthetic enjoyment by pleasure of another kind, lies at the bottom of all methodical art criticism. It has led many students to examine the state of civilization with which the development of Dutch painting in the seventeenth century was closely connected. What was the origin of the hundreds, nay thousands, of pictures which were produced in Holland in the short period from about 1620 to 1700? What motives, what circumstances, occasioned their production? How were the pictures painted, and for what purpose? How did their authors live, and how did they earn their livelihood?

We do not intend to answer all these questions in the following pages. The principal aim of our article is to answer the two last.

For years the notions people formed of the life of the old Dutch masters were derived exclusively from the amusing anecdotes of Houbraken, Weyerman, Van Gool, and other early writers on art. It is only in the last few decades that earnest and systematic study of archives and pictures has laid a firmer foundation for our knowledge of the conditions under which they lived. Thus we find it possible to-day to form some notions on the subject, fairly clear even if incomplete. A few years ago I endeavoured in my monograph on Gerard Dou[2] to put together the scattered material on the subject, and since then Dr. Hans Floerke has done a piece of work that may be called in many respects exhaustive in his excellent 'Studien zur Niederländischen Kunst und Kulturgeschichte.'[3] Hitherto, however, the rich material in the way of pictures, drawings, and prints, often affording the most

(85)

[1] Translated by Campbell Dodgson.
[2] Leyden, 1901. A condensed edition was published by G. Bell & Sons, London, 1902.
[3] Munich and Leipzig, Georg Müller, 1905.

L

125

Garland Publishing, Inc./545 Madison Avenue/New York, N.Y./10022

striking illustrations, has been very scantily published in this connexion, so that I was glad when the Editors of THE BURLINGTON MAGAZINE gave me another opportunity of summarizing the chief points in a series of articles illustrated by select reproductions of a characteristic kind.

On the surface it may seem as if the situation of a painter at that time was not so very different from what it is at the present day. The would-be artist goes to a teacher, goes through a course of training, and then sets up as an independent master, tries to sell his pictures as well as he can, and lives, according to his means, in ease or poverty. So it is to-day, so it was three hundred years ago in Holland. On the whole, that is true ; but if one compares the state of things more exactly, differences of many kinds become evident : the relation of pupil to teacher, the status of the two in the eyes of the law, the right of ownership in pictures, and the power to sell them—all these things differed as much from modern usage as modern colouring and technique differ from those of the seventeenth century.

In order to view these differences more closely, we will try to reconstruct the life of a painter of that time from the sources accessible to us. We will first deal with the question, how a youth of that time received a painter's education, how he set up as a master, and what his studio was like. Then we will see how he sold his pictures, and lastly, in connexion with the trade in works of art, consider their ultimate destination.

The Dutch boy—we can hardly call him a youth—who meant to devote himself to painting practised drawing in the first instance. He was generally sent— often at the age of ten or twelve—to a drawing master or painter, who properly grounded him in the art of drawing. Carel van Mander, the well-known painter nd author, and the earliest historian of

art in the Netherlands, emphasizes the desirability of such preliminary instruction in verses, of little poetical merit, but interesting for their contents, printed at the beginning of his book on painters, published in 1604. In this poem on 'the foundations of the noble and liberal art of painting,' Van Mander declares that the beginner must first seek 'a good master,' in order that he may learn properly to compose, sketch, shade, and work up neatly, 'first with charcoal, then with chalk or pen.' The pupil has also to learn neatness in 'doezelen' (stump drawing).

With this object the master first made his pupil copy all sorts of prints and drawings. Then came—just as it does at the present time—drawing from the plaster cast, a method which was usual in the Netherlands, even in the sixteenth century. How they drew from the cast we learn, for instance, from the celebrated Dutch poet and statesman Constantyn Huyghens, who learnt drawing from 1629 to 1631 from the painter Hendrick Hondius, and describes his instruction in the following words :

Hondius corporis humani membra . . . suis dimensionibus singula et maiusculo volumine efformanda dabat.

'Human limbs in plaster were to be drawn the size of life and also on a larger scale.' Samuel van Hoogstraten, again, at a later date, 1678, speaks in his 'Inleyding tot de Hooge Schoole der Schilderkonst' of 'eyes, noses, mouths, ears, and various faces,' as well as engravings, as instruments for the instruction of youth in drawing.

The inventories of the effects left by Dutch painters at their decease also give us the clearest information on this point. Rembrandt, for instance, possessed a great quantity of plaster casts for this purpose. In the inventory of his possessions taken in July 1656 we find a considerable number mentioned, such as naked children, a sleeping child, casts from antique Greek sculptures, and many casts from life, including

one of a negro. Then there was a whole basketful of plaster heads, and finally, in two of the little rooms in which he made his pupils work apart from one another, '17 hands and arms, moulded from life' and 'a great quantity of hands and faces, moulded from life.' Evidently Rembrandt used all these things in teaching. He proves it himself in one of his etchings, here reproduced,[4] which shows a young pupil engaged in drawing by candlelight from a plaster bust.

Our two following illustrations[4] are also instructive in this connexion. The first is from an engraving by Brichet from a picture by Gabriel Metzu in the Poullain cabinet. The picture, whose present whereabouts I do not know, represents a female artist drawing from a cast. No further explanation is required. The second illustration reproduces a well-known print by Wallerant Vaillant, a young pupil in the corner of a studio, in which among other things a plaster figure of a boy and some plaster heads are to be seen.

The paintings of the Dutch school afford several other instances of the use of plaster casts for instruction in drawing. We will not here enumerate all the etchings and pictures of Ostade, Schalcken; Dou, Frans van Mieris, etc., which prove this fact, but will only refer to two very characteristic examples. Both are pictures by the painter-etcher Michiel Sweerts, who lived about 1650. The first belonged a few years ago to a London dealer. It represents a painter's studio in which plaster casts are present in great numbers. Unfortunately we cannot publish the picture here. The second painting by Sweerts is still more interesting. It was bought a few years ago for the Rijksmuseum at Amsterdam, and is published here for the first time.[5] A spacious studio is represented, in which several very youthful artists are employed. In the foreground on the left

one of them is engaged in drawing from a large anatomical plaster model, which is set up in the middle of the studio. Two youths watch him at his work. Farther back another is painting from the nude living model, whilst a third, more in the middle at the back, is drawing from a plaster cast of the well-known head of the Ludovisi Juno. A whole heap of other casts, mostly from the antique, occupies the right half of the foreground.

This picture shows us most clearly the various stages of instruction: simple drawing from the cast, drawing from anatomical figures in plaster, and drawing from life. Anatomical plaster figures — or 'flayed plaster casts,' as an artist of the period calls them—were indispensable for the study of anatomy, to which the young pupil had to devote himself seriously after the primary instruction in drawing. Anatomical study was no easy matter in those days. It was unlawful till 1555 to dissect corpses in the Netherlands, and then permission was only granted in respect of malefactors of the male sex.[6] How difficult it was to obtain permission to draw from a corpse, we see from the story told by Carel van Mander in 1604 of the painter Aert Mytens, who went himself to cut down a body from the gallows for the purpose of study, and took it home with him in a sack. Even at a later date it was difficult to draw from a dead body. In 1641 the painter Philips Angel complains that there is no opportunity of doing so in the town of Leyden. They had recourse, therefore, to anatomical plaster casts (as in the picture by Sweerts described above) or to illustrations in the handbooks which soon began to appear in Holland in considerable numbers.

Along with this anatomical knowledge students were also grounded in the theory of perspective, especially according to the principles of Dürer's well-known book, which was much used in Dutch translations, as

(87)

---

[4] Plate I, page 129.
[5] Plate II, page 131. I am indebted for the photograph to Jhr. van Riemsdjik, Director of the Rijksmuseum at Amsterdam.

[6] The date of the first dissection of a woman is 1720.

we learn by the inventories of painters' effects. The books on perspective by Abraham Bosse and Hendrick Hondius were also popular with students.

At a later date more and more handbooks on perspective and anatomy were written for the Dutch painters, which soon degenerated into a sort of recipe books for painting, in which it is exactly described how this or that theme is to be represented, how colours are to be ground and how used, and so forth. It is worth noticing that the number of these books grows with the increasing decadence of Dutch painting. The best known books, by Goeree, de Pas, Hoogstraten, and Lairesse, did not appear till after 1660.

In the first half of the seventeenth century books were of second-rate importance to the student of painting. The time was still remote in which the effort of painting was to beautify nature by aesthetic rules, a time which thought the worse of Rembrandt for choosing a Dutch washerwoman as model for a Venus, and putting her in a picture straight from nature, without beautifying her in the least.[7] Dutch pupils were not vexed with such academic observations in the first half of the seventeenth century, unless they were in the studio of some academic painter of the school of Goltzius or Bloemaert. The Dutch realists were of quite a different way of thinking. They did not go in for philosophy, still less did they point to Raphael and Michelangelo as the only painters worth imitating ; but they were for ever impressing on their pupils a deep love of nature as she is. The precept, ' Look at nature and imitate her,' takes precedence of all others throughout the flourishing period of Dutch painting. The pupil, accordingly, as soon as he acquired a certain sureness of hand, was confronted with nature herself. Whether he was given fruit or still-life to draw, no picture or other source of information tells us.

So far, therefore, we know little about drawing from nature. So much, however, is clear, that even then the young artist was confronted as early as possible with the chief representative of nature, the living man. He had first and foremost to draw from the living model.

It is Michiel Sweerts again who has left us a vivid description of a drawing lesson of that date from the living model in a picture at the townhall of Haarlem, reproduced here.[8] In a large room the male model stands on a raised platform round which numerous lads, aged from ten to fifteen, sit in a circle. On the right one is hard at work, on the left another passes a sheet of drawing-paper to a comrade, and another fair-haired boy in the middle stops for a moment. The master, talking to a gentleman, stands at the back of the room, seen from the back pointing to his pupils.

It is a picture full of life and freshness, which has no equal in bringing before our eyes a drawing lesson from the nude model in the seventeenth century. We are struck with the youthfulness of these incipient artists, whose names, unfortunately, are not known, for the old hypothesis which took them for pupils of Frans Hals is untenable. How glad we should be to learn their names ! Then the picture would be a still better illustration of those past times in which many a one resolved, even in boyhood, to dedicate his life to art. Most of our greatest painters went to a master for instruction at the age of ten to fifteen, as we can see from the dates of their lives. They often needed five to ten years of energetic work and preparation before they got so far as to be allowed to set up as independent masters and members of a painters' guild, and were permitted to sell their pictures. We shall deal with this further period of the development of a Dutch painter in a subsequent article.

[8] Plate II, page 131.

(*To be continued.*)

[7] Poem by Andries Pels, quoted by Houbraken, i. 268

PUPIL DRAWING FROM PLASTER BY CANDLELIGHT;
ETCHING BY REMBRANDT

WOMAN DRAWING FROM PLASTER; ENGRAVING BY BRICHET
AFTER GABRIEL METZU

THE PUPIL IN THE STUDIO; ENGRAVING
BY WALLERANT VAILLANT

PLATE I

PUPILS DRAWING AND PAINTING; RIJKSMUSEUM, AMSTERDAM

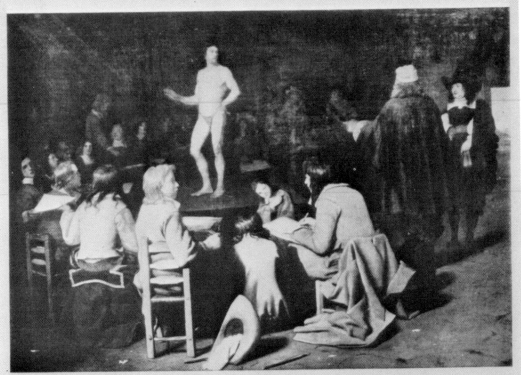

THE DRAWING SCHOOL; MUNICIPAL MUSEUM, HAARLEM

PLATE II. PAINTINGS BY MICHAEL SWEERTS

# THE LIFE OF A DUTCH ARTIST IN THE SEVENTEENTH CENTURY
## ❧ BY DR. W. MARTIN ❧
## PART II—INSTRUCTION IN PAINTING[1]

BEFORE I proceed to examine the method employed in teaching painting, which, after the instruction in drawing had been mastered, was the first step in the career of the young artist, I wish to call attention to one other interesting example of teaching in drawing as it was understood by the old Dutch masters. I am indebted for this example to Jonkheer van Riemsdijk, chief director of the Amsterdam Rijksmuseum, who drew my attention to the picture (ascribed by him to Ludolf de Jongh), which is in his possession. This interesting work is published here for the first time.[2] It represents two young men, one of whom is drawing from plaster. These plaster casts are another convincing proof to us of the importance attached at that period to the study of the antique. It was looked upon as absolutely indispensable to the artistic education of the pupil, a fact which is the more surprising as this taste in no way prejudiced the realistic vein of the great Dutch masters.

When the young painter was sufficiently practised in drawing to be able to begin to paint, he was allowed to handle the palette and brush. He either remained with the same master, or, as was usually the case, he went to study under some artist of renown, recognized as a good teacher. Various points, such as the course of instruction to be pursued and the terms of apprenticeship, then had to be settled between the father or guardian of the pupil and the new master. The points were the outcome of certain mediaeval regulations existing in the painters' workshops, and everyone intending to become a 'free master' was obliged to conform to them. The master or teacher himself was liable to penalties for the infringement of the said laws. In many towns only a settled maximum of pupils was allowed to a single master, and any master receiving more pupils was obliged to pay an extra sum. The duration of time for the instruction of the pupil was also prescribed in some towns; it was frequently, however, left to the parties themselves to decide.

As a general rule, a pupil remained for at least two years under one master, at the expiration of which time, if he proved himself sufficiently able, he was admitted to the guild of painters as a free master. It is not my intention to enter into detail here regarding the Dutch painters' guilds and their development in the seventeenth century, but only to indicate a few of their most important characteristics. The condition of these guilds in Holland in the seventeenth century, we must remember, was the effect of causes operating in the two preceding centuries. The St. Luke guilds, while losing on the one hand their ecclesiastical character, firmly maintained their chief scope, which lay in the upholding of the arts they protected and in the exclusion of all rivalry. Whoever intended to become a painter was obliged to enter the guild, and, if he wished to enter it, had to give proofs of understanding his calling, otherwise he was debarred from becoming a free master and from the sale of his works. This state of things had existed in previous centuries and continued to exist in the seventeenth century. The main relations of pupils to their masters in the art, as a natural consequence, had altered as little as these general ordinances of the guild. As an instance of this,

(91)

[1] Translated by the Baroness Augusta von Schneider. For Part I see page 125, *ante* (May 1905).
[2] Plate III, p. 425.

416

I cite Karel van Mander in his biography of the painter Jan van Scorel (1495-1562).

Van Mander relates that the youthful Scorel, who was an orphan, was first taken by some friends to the painter Willem Cornelisz at Haarlem,

'who would not receive him as a pupil, unless he bound himself to remain for three years. Scorel's friends agreed to this, and further pledged themselves to pay a fixed sum if Scorel should leave before the entire period of instruction was completed. The master always carried this contract in his pocket.'

Later on Scorel became pupil to Jacob Cornelisz van Oostsanen, and Van Mander continues to relate that

'the master had a high opinion of Scorel, whom he treated as if he had been his own son. And, because of his clever and thorough work, he gave him a certain sum yearly into the bargain, and even allowed him in his spare time to paint a few pieces for himself. Thus Scorel earned a pretty sum yearly for his advancement.'

Soon, however, we find Scorel leaving this master and learning from Jan Gossaert, called Mabuse.

(92)

'And'—so continues Van Mander—'as Mabuse had great fame, Scorel went to live in his house at Utrecht as a pupil, to learn of him. But this did not last long; for, as the master led an irregular life, and drank and fought much in low hostels, Scorel often had to pay for him and to risk his own life in his behalf. Therefore he judged it useless to remain longer.'

The above three anecdotes clearly bring before us the customs existing in the sixteenth century; even if they are invented stories, it cannot be denied that they must be based on the habits and the mode of life of the day.

We see in them, firstly, that the pupil worked in the service of his master by a formal contract. He was hired like a labourer, and a fine was paid if he did not complete the number of years specified in the contract. The pupil's work was not his own property, but the master's. Usually the pupil was not even permitted in his free time to paint for himself, for this is specially mentioned in indentures as a favour granted by the master, for which he paid his pupil. Last, but not least, we find that the pupil boarded with his master, and was obliged to accompany him and be helpful to him out of work-time. All this Van Mander considers as quite natural, and it was so at the time.

With some slight deviation, perhaps, in one or other particular, things had remained the same in the seventeenth century, as far as we are able to ascertain, being only in possession of facts relating to single cases. These few cases, however, are extremely striking, and their likeness to the above-mentioned customs of the sixteenth century is very remarkable. For example, in an indenture which is still preserved, the painter, Isaac Isaacsz, of Amsterdam, agrees on December 15, 1635, to take Adriaen Carmen, aged 17, as a pupil. The latter is to live in the master's house, to prepare the colours for his master and himself, to stretch the canvas, and to behave himself altogether as an industrious, obedient servant should do. In return, the master undertakes to give his pupil food, drink, and lessons in painting. The pupil's father is to bring the master a yearly gift of a barrel of herrings or cod. Further, the pupil is to be allowed to paint one picture yearly for himself, on a two-and-a-half-florin panel or on canvas. It is also stipulated that the pupil shall bring his own bed and bedding.

In another agreement of the year 1662, Ferdinand van Apshoven takes a pupil for £3 15s. yearly upon the understanding that everything painted by the pupil during his apprenticeship should remain the master's property. The following is another instance: the Antwerp painter, Lucas van Uden, agrees to teach a pupil, to take him into his studio, and to board him at his own table for the price of 800 florins, to be paid beforehand. The indenture seems to have been an exceptional one, as it is specially stipulated that the pupil is to buy his own painting utensils; in exchange, the work

done by him during this time is to be his own property.

For a scholar to leave the painter's workshop before the expiration of the contract was regarded as a most serious loss to the latter. We are reminded of this in Ferdinand Bol's petition for 60 florins, to which he was entitled as compensation for two pictures, begun by one of his pupils (who had left him before his time had expired) as well as for one picture that the pupil in question was bound to paint but had not begun.

From these instances, to which might be added many more, mostly quoted by Dr. Floerke in his work,[3] we see plainly that in the seventeenth century, too, the rule was for pupils to live with their masters and to paint without profit—*i.e.*, without appropriating their work.

In these circumstances it is hardly surprising to find it a recognized custom for the pupil's work to be sold as the master's, and even for the master to sign his pupil's work with his own name. This seems to have occurred especially often in the case of portrait painters. They were often required to furnish several copies of a portrait, and it was necessary for them sometimes to keep the likeness of a celebrity in stock in order to satisfy the demand of purchasers. In such a case one or more pupils would be set to work at turning out copies of the original portrait painted by the master himself from nature ; these copies the master then corrected, if necessary, with his own hand, and signed with his own name. The best example of this procedure in Holland is afforded by the studio of Michiel Mierevelt at Delft. Only a relatively small proportion of the numerous portraits painted in that studio was the work of Mierevelt's own hand. The remainder, copies or imitations of his originals, with some slight difference, were produced by his assistants ; and we know, from Miere-

velt's note book and from the inventory of the effects left at his death, that assistants often painted the drapery of his original portraits, just as they did in the studio of Van Dyck. Mierevelt signed such works with his own name, and thus all sorts of pictures were long taken for authentic works of Mierevelt, in which there is nothing of his own except the original composition and the signature, while the actual execution is far less accomplished than that of his genuine paintings. In some cases the original can be compared with the contemporary studio repetitions made from it, and so the part taken by pupils can be determined exactly. The pupil often remained with the same master even after he had become a master himself (this was evidently the case with some of the pupils of Mierevelt) without doing much independent work on his own account.

As these instances show, the painter looked upon his pupil as an apprentice or labourer, whose work he turned to account and profited by. When once this fact is made clear, many points in the tales of the old Dutch painters are easy to understand. The complaints of David Bailly against his two pupils, Pieter and Harmen van Steenwyck, whom he accuses of eating their fill in his house while their idleness brought him no profit, appear in a new light. We can also understand the description which Houbraken gives of the relations existing between Adriaen Brouwer and Frans Hals. Houbraken tells us that Hals, perceiving the talents of the youthful Brouwer, engaged him as a pupil with the consent of the boy's mother, who made the sole condition that Hals was to feed him. Upon this, Hals set the boy to work in the loft alone ; and we hear, further, that he sold Brouwer's paintings for a good sum, pocketing the profits. If the tale is untrue, it is, at all events, not improbable, as occurrences of this kind were quite common and allowable in the seventeenth century.

(93)

[3] 'Studien zur Niederländischen Kunst-und-Kulturgeschichte.' (Munich and Leipzig: Georg Müller.)

418

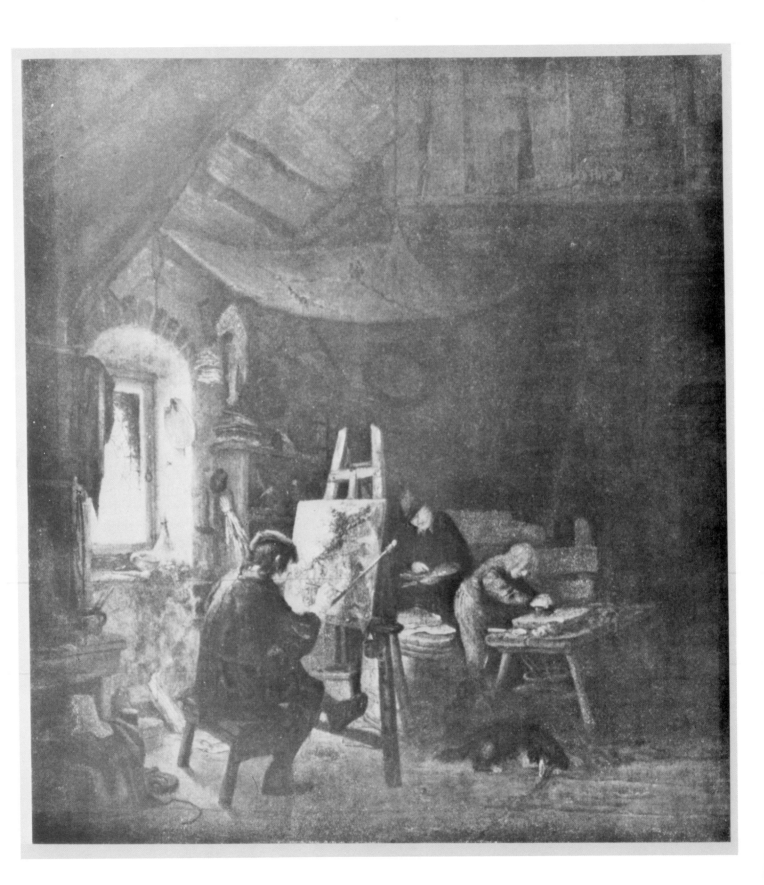

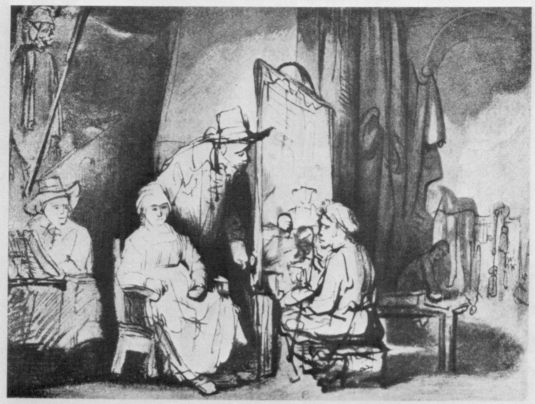

REMBRANDT'S STUDIO: WASH DRAWING BY REMBRANDT, IN THE LOUVRE

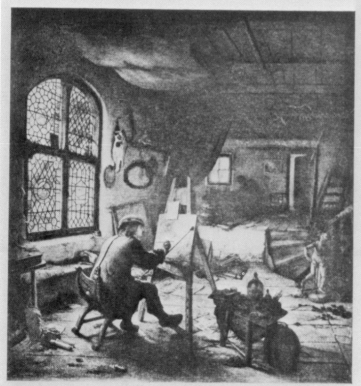

A PAINTER IN HIS STUDIO: PAINTING BY ADRIAN VAN OSTADE IN THE
DRESDEN GALLERY

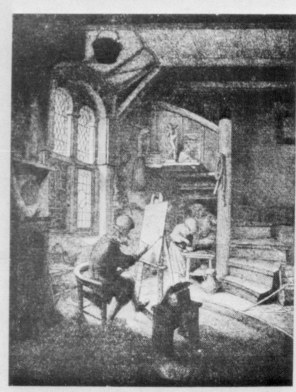

A PAINTER IN HIS STUDIO: ETCHING BY ADRIAN VAN OSTADE

THE LIFE OF A DUTCH ARTIST
IN THE SEVENTEENTH CEN-
TURY. PLATE II

The above-mentioned instances go to prove that the prices paid for teaching varied considerably. We may mention here that Rembrandt demanded 100 florins yearly for each pupil, and that Honthorst and also Gerard Dou, from whom three receipts are still extant, made the same charges, while some painters were satisfied with a much smaller sum.

After the pupil had become apprenticed to the master by virtue of an indenture or by some other form of agreement, the instruction began by teaching the art or groundwork of painting. This teaching is one of the great secrets of the old Dutch school of painting. Its meaning has never been better given than by Eugène Fromentin, in his splendid work 'Les Maîtres d'Autrefois,' in which he says:

(96)

'. . . il y a dans la peinture un métier qui s'apprend et par conséquent peut et doit être enseigné, une méthode élémentaire qui egalement peut et doit être transmise . . . ce métier et cette méthode sont aussi nécessaires en peinture que l'art de bien dire et de bien écrire pour ceux qui se servent de la parole ou de la plume.'

This 'métier' gives all painters some characteristic in common, an 'air de famille.'

'Eh bien'—says Fromentin—'cet air de famille leur venait d'une éducation simple, uniforme, bien entendue, et, comme on le voit, grandement salutaire. Or, cette éducation, dont nous n'avons pas conservé une seule trace, quelle etait-elle ?'

We are in a position now to know more than Fromentin knew on the subject of this education, and it is precisely what we know of it that is a convincing proof of the justice of Fromentin's views when he imagined 'une éducation simple, uniforme, bien entendue.' It was simple, but severe. It began with grinding colours, cleaning palettes, placing the fresh colours on the palette, stretching canvas and such-like work. In various pictures, particularly in those of Adriaen van Ostade, we may remark pupils occupied in work of this kind. A plain instance may be seen in Ostade's pic-

ture in the Rijksmuseum at Amsterdam.[4] This work represents a boy on the right, grinding colours on the stone; behind him to the left, another boy is occupied in putting the colours in order on the palette, to be handed to the master when the latter's palette has run out. In Ostade's painting at Dresden[5] we also have an example of a pupil grinding colours in the background. The same master's etching, which we give here,[5] shows us two very young pupils engaged on the same task. In the pictures of several other painters, amongst others, in David Ryckaert's works, we observe pupils or servants employed; in my previous article the illustration of the picture from Sweerts in the Rijksmuseum at Amsterdam[6] gives another good instance of a colour-grinder, though the impression conveyed in this picture is less that of a pupil than of a wholly un-artistic workman. It is probable that assistants of this description were employed in the painter's workshops, though we have no certain information on the subject.

The pupils certainly learnt to prepare the colours, as a first step, thoroughly. This was a matter of primary importance, as the technical working of the picture, the whole 'métier' of the art, depended upon it. Great attention was given to the utmost cleanliness in the grounding as well as to a careful preparation of the colours, though of course certain painters ignorant of the art always existed, who were held up to the derision of others because their canvas cracked.[7] Besides the colours, the painter had to prepare his canvas and palette himself, and this also the pupil was obliged to learn. Even the brushes appear to have been made in the painters' workshops. Rough panels, cut to certain sizes, were alone for sale, the prices for such being much the same everywhere, as in the indications given by painters to each other, in

[4] Plate I, p. 419.   [5] Plate II, p. 422.   [6] Page 131 *ante* (May 1905).
[7] Adriaen van de Venne, Belacchende Werelt.

describing the size of a picture, we find the price of the panel named. Several contracts, for instance, make mention of a ten-stuiver panel, or of a $2\frac{1}{2}$ florin panel, or of a one crown panel, and we even hear of 'a portrait in sixteen-stuivers' size.' The custom of buying colours and other painting utensils ready-made as in our day does not seem to have spread much in Holland till towards the middle of the seventeenth century. There is no instance of it before the year 1643, when the painter and fine-arts dealer, Volmarijn, established a shop at Leyden [8] for 'prepared and unprepared colours, panels, canvas, brushes and painting utensils of every kind.' The dealer makes known that up till then no shop of the kind had existed in Leyden, which seems to prove that painters were obliged to prepare their own colours and canvas in the workshop, a custom that apparently lasted in Holland till the beginning of the nineteenth century.

When the pupil had learnt the preparation of colours, the actual instruction in painting began. For this purpose the pupil usually copied some picture either from the master's own hand or out of his collection. This appears to have been the common practice as early as the sixteenth century. Van Mander states that his master, Lucas de Heere, had several pictures by Frans Floris in his studio, and that his pupils were daily occupied in making studies from them.

Several inventories of deceased painters' effects prove this. For instance, in the catalogue of pictures from Cornelis van der Voort's workshop in Amsterdam, sold in the year 1624 after his death, the following pictures are enumerated as having been used by pupils to copy from :—*A Crucifixion*, by Cornelis van Haarlem; *Whitsunday*, by Pieter Aertsen ; *Venus and Cupid*, by Honthorst ; besides paintings by Lastman and Jordaens.

In the seventeenth century it is evident that the same custom continued ; among other cases we have the apprenticeship of Matheus Terwesten. This master had been a pupil of Willem Doudijns, at the Hague. Doudijns, as he relates, had as a pupil copied peasants from Ostade's pictures, and he subsequently gave these copies to his pupils to paint from.

I can, so far, only recall one single instance among paintings of the seventeenth century in which copying from a picture is represented. This is in a picture ascribed to Pieter de Hooch, but more probably from the hand of Michiel Sweerts, in Sir Frederick Cook's collection at Richmond,[9] and the subject is a young pupil copying a painting. Even this can hardly rightly be called an instance, as the pupil is drawing and not painting. Nevertheless the picture is too curious and interesting to be left unpublished. The reproduction, for which I am indebted to Mr. Herbert Cook, who most kindly allowed me to have the picture photographed, shows a young boy drawing from a picture that represents a battle of horsemen on a bridge. He has begun a copy of this battle scene (probably by Van de Stoffe or Hendrick de Meyer) on a piece of paper which he has on his knees. The tree on the left of the picture and some of the horsemen are to be seen clearly on the paper. In the backgound on the right of the picture we see a lay figure, which occurs in the studios of that time as often as in studios of to-day, as we shall see in our next article.

The exclusive object of copying was to teach the pupil the technicalities of the brush and colours. In this way he learnt the time which certain colours or oils require to dry, what colours will not mix, and so forth. When these difficulties were overcome he began to study from life. The *métier* had been learnt, the A B C of painting mastered, the young painter had henceforth to give his own expression to the art, and to paint from the nude or clothed model.

(97)

---

[8] *Vide* my article in the magazine, *Oud Holland*, 1901.

[9] Plate III, p. 425.

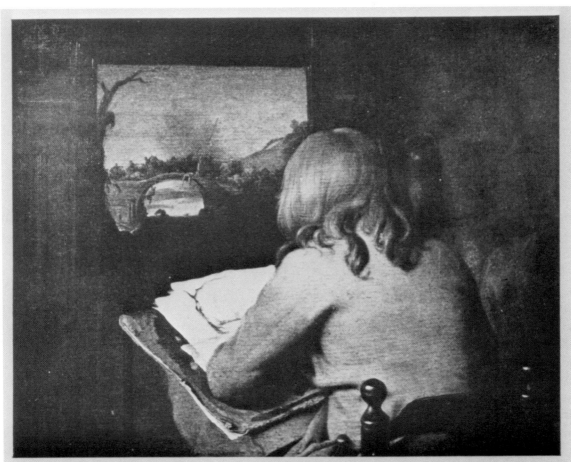

YOUTH DRAWING AFTER A PICTURE; PROBABLY BY MICHIEL SWEERTS; IN THE COLLECTION OF SIR FREDERICK COOK, BART., M.P.

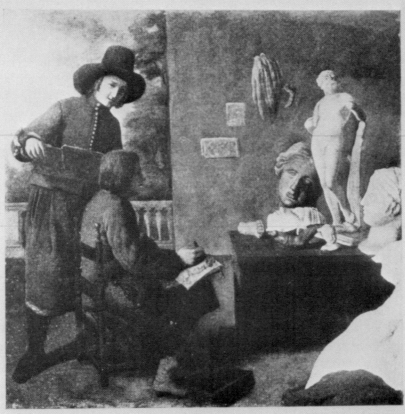

STUDENT DRAWING AFTER PLASTER; ATTRIBUTED TO LUDOLF DE JONGH;
IN THE COLLECTION OF JONKHEER B. W. F. VAN RIEMSDIJK, AMSTERDAM

THE LIFE OF A DUTCH ARTIST,
PLATE III

Rembrandt has given us an interesting example of the latter in one of his drawings in the Louvre Collection, of which an illustration is given here.[10] It is a very graphic instance of painting under the master's eye. In this picture Rembrandt is seen seated to the left in a spacious studio before a drawing or etching board ; he is watching one of his pupils occupied in painting a large picture from life. A man and woman are the principal figures in it ; the pupil is intent on studying the woman, who sits motionless and patient ; the man is evidently taking a look at the picture to see how it is progressing. In the background a model is seen in the act of pulling on his stockings ; this figure is unfortunately not clear in the reproduction.

The last stage of instruction was reached when the pupil began to paint the same subject that the master was engaged on. This appears very strange to our modern conceptions, so adverse to imitation, aiming solely at originality. It is only possible to come to a right conclusion regarding these imitations painted by finished artists, in calling to mind, for instance, that Rembrandt gave his pupils *Jacob's Blessing* to paint, and in the contemplation of the various representations of *Jacob's Dream*, painted by many of Rembrandt's pupils in such striking uniformity of character. The lack of originality in the subject and composition even after the pupil's training was completed, may seem a proof of helplessness in the rising artist, and yet the same artist, when minded not to paint 'in Rembrandt's style,' will shine forth as a great and original master. The reason for this lies in the fact that the imitation of the master's subject, composition and manner was not only permissible in those days, but was thought highly desirable.

We can only explain this idea by the old conception of painting as a higher kind of craft. The pupil's aim generally con-

[10] Plate II, p. 422.

sisted in the first place in closely following the master in all technical and artistic peculiarities ; if possible, he would try to surpass him in some way. After Gerard Dou had left Rembrandt's workshop, he worked exclusively in the master's style, at that period still minutely technical, and did his best to excel him. For this reason he kept to the same subjects as his old master, working in an elaborately minute manner ; later, however, we find that the smaller mind and inferior taste of the former pupil led him into widely diverging paths from his great master. Dou's own pupils, Mieris among them, also worked solely in their master's style and endeavoured to surpass him. Dou freely admits that Mieris succeeded in this. So the usual course of things was for the pupil to adhere strictly to the master's style in all technical points as well as in the composition and colouring of his work, the pupil's youth naturally giving the master the more influence over him. If he had an independent mind his work soon showed some more individual traits ; in certain cases he experimented, using some new method in mixing his colours, or acquiring some trick in the art which he had lighted upon by chance. Usually, however, during his apprenticeship, the pupil remained within the traditional limits of his master's workshop, and in composition and rendering betokened his training.

When at length the pupil had given sufficient proofs of understanding his calling and the days of training were past, he was allowed to enter himself as a free master in the guild of his native city, with the privilege of signing his pictures with his name and of selling his work. He could now take pupils and deal in works of art, in fact set up his own workshop, which it is our intention in a forthcoming paper to describe.

*(To be continued.)*

(99)

# THE LIFE OF A DUTCH ARTIST IN THE SEVENTEENTH CENTURY
## ❧ BY DR. W. MARTIN ❧
### PART III—THE PAINTER'S STUDIO[1]

THE description of a Dutch painter's studio in the seventeenth century is no easy task, for then as now the studios of different painters varied greatly in character. The rich artist naturally built a studio according to his taste, and the poor had to content themselves with such accommodation as they could find. The requirements of a portrait-painter, again, were not of course the same as those of a landscape-painter, and so forth. In spite of these diversities, however, we find a certain resemblance in the Dutch studios—a common type which their origin seems to explain.

The old Dutch studio (called in old Dutch *Schilder-camer* = painting-room) was originally nothing more than a sitting-room, a chamber with one or two windows, generally on the north side so that the sun could not penetrate into the room. The floor was of wood or paved with stones, according to whether the room was situated on the ground-floor or above it; the walls were whitewashed, and the ceiling of woodwork was supported by wooden beams.

A good instance of a studio of the very simplest description is to be found in a drawing by Gerard Terborch, which is reproduced in the journal *Oud Holland*. Nothing but the studies and palettes hanging on the walls remind us here of the fact that we have a studio before us. The workshop of Jan Miense Molenaer in one of his pictures in the museum at Berlin[2] is a similar example of a room of the most simple kind. Many pictures, too, by

Frans van Mieris and Adriaen van Ostade show us painting-rooms equally simple in style. Even cellars and garrets were often adapted to this purpose. A studio of the same severe simplicity is shown in a clumsy work painted by Gerard Dou in his youth, which is now in the collection of Sir Frederick Cook at Richmond. It represents most probably a view of Rembrandt's workshop at Leyden, and it would be difficult to imagine anything more simple than the rough walls and floor of this chamber.[3] No trace of luxury is to be found, and nothing but the most necessary utensils and articles are visible.

As to the light—the principal condition for every studio—it is clear that a northern aspect was chosen by preference in rooms of this kind, and so we read without surprise in Joachim von Sandrart's biography of Gerard Dou that the latter had a studio facing north. This was the case with many other artists, as we may gather from the fact that they almost always inhabited streets running from east to west, the houses in which consequently had a northern aspect either to the front or the back. As it is a serious hindrance if the sunlight falls on the painter's work, an expedient was used such as we might resort to in the present day. This consisted of oiled paper or canvas stretched on a frame, and placed in the window as a screen or sun-blind. We give here a reproduction of a noteworthy instance of this kind, the only one which has come to our knowledge, in a picture by Jacob van Spreeuwen contained in a private collection in Sweden.[4] The screen is clearly visible in the window, and can by no possibility be mistaken for a pane of glass, as no panes of the size existed at that period. It is very evi-

(100)

---

[1] Translated by the Baroness Augusta von Schneider. For Parts I and II see Vol. VII, pp. 125 and 416 (May and September).
[2] To be reproduced in the next article.

[3] Plate II, p. 19.　　　　[4] Plate III, p. 22.

dent, moreover, that the frame is placed within the window opening. The light falling sideways into the room could be easily regulated by means of the construction of the windows; curtains were a great help, and allowed the light to be shut out wherever this was desirable. The most advantageous light was to be obtained in studios with large windows divided into four squares, with two openings in each square which could be closed or opened at will. The most varied effects of light were obtainable in this way; it was possible, for instance, to let the full light fall on the canvas and to leave the model in a more subdued light. Again the lower half of the window could be entirely closed, while the model remained in a high light without disturbing reflections from the outside.

Every lover of old Dutch paintings knows how the picturesque indoor effects gained by means of window-lights were cherished by the artists of the day, and how often they painted them. A careful examination of the paintings in which artists' workshops are depicted will prove the truth of the above assertion. An example is furnished by the well-known painting of a studio by Frans van Mieris the elder in Dresden, reproduced in our illustration.[5] The subject is a portrait-painter allowing his model to rest; and if we observe the lights in the studio with care, we shall see that the vacant chair for the model behind the easel stands in a subdued light slanting in from above, since the small lower pane to the right is closed while the easel stands in full light. A similar division of light is to be seen in a picture by Jan Vermeer of Delft in the Royal Picture Gallery at the Hague. It represents an allegory from the New Testament, and contains in the background and in various accessories many objects belonging to the painter's own workshop,

[5] Plate I, p. 15.

14

as proved by the inventory of his studio. It seems probable, therefore, that this painting depicts the artist's studio. A glass globe hanging from the ceiling indicates the lights with the greatest accuracy. The reflections of two large windows, and of a smaller one, possibly situated over the door, are distinctly seen in the globe. The first of the large windows is open, as we perceive by the reflection of a brick-tiled roof; the second is entirely closed from below. Thus the practical and picturesque principle adopted by van Mieris, of throwing the full light on the canvas and a side-light from above on the model, is carried out here also, with the difference that van Mieris was obliged to content himself with one window, whereas Vermeer has two at his disposal. The reflections of the various lights on the floor are clearly shown. This feature is noticeable also in other works of Vermeer—*e.g.*, in his *Interior of a Studio* in Count Czernin's collection in Vienna.

The reproductions given in our last article of works representing painters' workshops, by Adriaen van Ostade, show at a glance that a side-light from above was not always given the preference. We must notice, however, that the painter in the workshop referred to is not working at a model or still-life at the moment, but seems rather to be painting an imaginative subject, or copying a study fixed high on the easel. Nevertheless, we do not affirm that a high side-light was exclusively used in painting from life, though we can give several examples proving that it was often the case. In these pictures the model or models are seen in a light coming, not from a window half darkened below, but from a window built *high up in the wall*. The first instance of the kind, to which we intend calling attention later, is the workshop of Joost van Craesbeeck, in the collection of the duke of Arenberg at Brussels. The light here falls on the models from a bow-window

(101)

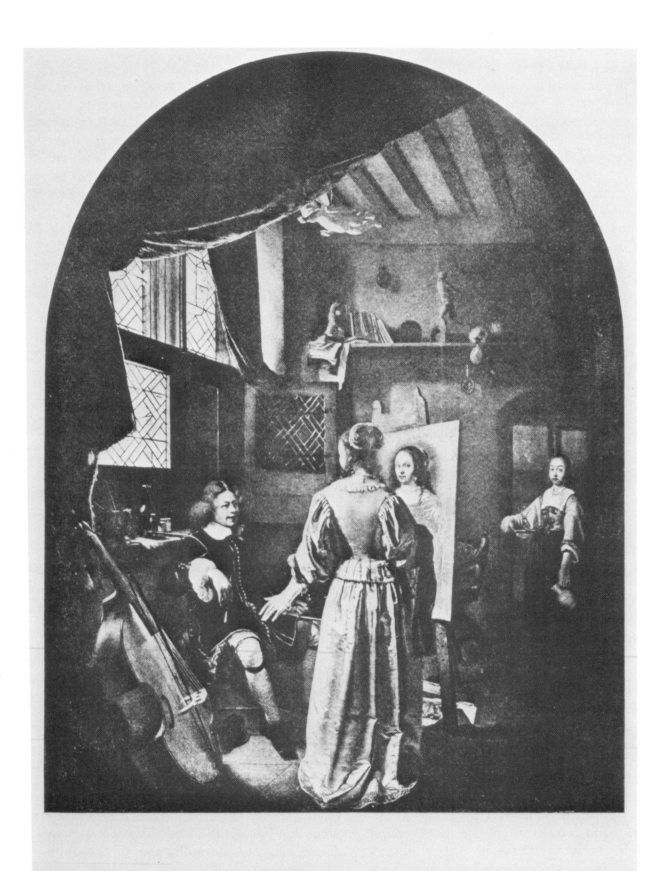

built high in the wall; another window, not visible in the painting, throws a high light on the painter's easel. The workshop of Jan Miense Molenaer, of which we also intend to give an illustration, shows plainly another high window of this kind. We might also mention the picture of a studio by Michiel Sweerts, in the Rijksmuseum at Amsterdam, reproduced in Plate II, p. 131, in our first article. In this work also the light streaming in on the model falls from a high window. We must bear in mind, however, that this is an Italian studio, as we perceive by the street scene visible through the door.

To sum up, we may affirm that, on the whole, painting in the Dutch studios of the seventeenth century was done by side-light mostly falling high from the north. Not a single convincing proof of a top-light being used in Holland has come to our knowledge. Only the Flemish painter Rubens seems to have painted with a top-light, and this fact is mentioned in a manner rather conveying the impression of an unusual circumstance, as the narrator, the Dane Sperling, alludes to 'a large room without any windows, lighted by *a large opening* in the middle of the ceiling.'

As to the Dutch painters, we are only able to quote one single notice of Houbraken, who remarks that Govert Flinck had built a painting-room 'with high lights.' This might mean a top-light, but on the other hand a side-light high up might also be intended. The natural conclusion from this habit of painting with a high side-light, so dear to the old Dutch painters, is that paintings of this description should be hung only in a side-light. Fortunately this conviction has been steadily gaining ground during the last few years. The new rooms in the Louvre and the recently opened Kaiser Friedrich's museum at Berlin afford proof that these efforts are progressing, and that the works painted in a side-light for old

Dutch dwelling-rooms and state chambers are now being hung in a similar light in the museums. The anticipated placing of Rembrandt's so-called *Nightwatch* in a side-light next year is another pleasing step in this direction, for the picture will then be visible in the light for which it was intended.

The question as to the inner arrangement of the old Dutch studio has now to be considered. Of course, we find there the usual indispensable painting utensils, without which no painter can work. We find numerous allusions to them in the inventories of effects of deceased painters, often even as their sole property, excepting, perhaps, a debtor's bill. Moreover, we find these accessories painted so often that it is easy to form an idea of the requirements of an artist at that time. The various reproductions accompanying this and the previous article, together with those illustrating future pages, will be found a sufficient guide in this respect. In a painter's workshop we observe, besides the place occupied by the painter's easel, a corner where colours were ground, and where other work, such as preparing the palettes, stretching the canvas, and so forth, was done. All this can be plainly seen in Ostade's paintings reproduced in the last article. The pupils often worked in the same room with the master (as, for instance, is the case in Rembrandt's drawing illustrating our second article); often, however, an easel stood in an adjoining room. Rembrandt, as we know from the inventory of his lodging, usually gave a separate room to each of his pupils.

As to the contents of the painter's workshop, they comprised first all the requisites for making paints, beginning with the raw unmixed colours which were prepared by grinding in a mill.[6] The colours were then pounded and mixed with oil (or water, if water-colours were wanted) on a stone.

[6] We know that, among others, the artist Gilles van Coninxloo possessed a colour mill.

(103)

As we have already seen, this stone is never missing in any studio. Not only do pictures show us this indispensable article, but written statements also mention it, for example, the inventory of Jan Vermeer of Delft, in which mention is made of 'a stone table for grinding colours, and the stone near it.' When the colours were ready for use the oil paints were put into bladders [7] and the water-colours on shells. Oil-colours were mixed while in use with oil prepared in different ways.

Wood was used to paint upon, but after the first quarter of the seventeenth century canvas came into more frequent use. In the case of paintings on wood it remains an open question whether the panel was prepared beforehand, or whether the artist painted on the smoothly planed surface without any kind of ground. We often incline to the latter view, as a surprising number of fairly well preserved pictures exist in which the grain is visible through the paint. This is a technical question which deserves closer investigation, since it is certain that a great many pictures were also painted on a ground composed of chalk and white colour.

Canvas was of course prepared beforehand by saturation. As linen was not woven so wide as in the present day, it was necessary to sew several widths together for a large picture. Canvas was either stretched on a frame for painting or gathered into a frame, a most original proceeding, rarely met with elsewhere, resembling the manner of framing embroidery. We give an illustration of a fine picture by Gonzales Coques in the gallery at Schwerin, plainly showing the latter method of stretching canvas.[8] A young painter is here seen sitting in an elegantly furnished studio playing the guitar to while away the time, as we often find Dutch painters doing

in the works of Dou, Mieris, and others; a large landscape stands on an easel behind the painter, the canvas stretched as described.[9]

What is curious to us in Coques' picture is not only the lute and the violoncello, propped up against the clavichord, indicating the musical tastes of the artist, or the connoisseur, to whom a woman in the background is showing a picture, but above all the painting-box on the floor near the easel. This ponderous piece of furniture, containing many drawers and partitions, is of a shape familiar to us till the second half of the nineteenth century. The painter's colours, brushes, oil flasks, and palettes were kept in it. It seems hardly likely that the artist would have taken such a heavy box with him for painting from nature; nevertheless it contains here, fastened to the inside of the lid, a study for the large oil-painting, which might lead to that supposition. The remaining painting utensils do not require any special mention. The palette was no longer the mediaeval board with a handle, nor the ornate sixteenth-century palette, it was of the exact pattern of the oval board now in use, with a hole for inserting the thumb. Rectangular palettes, like those we sometimes use, were unknown, and palettes in general were made much smaller than ours. Large size palettes, covering the arm to beyond the elbow, were unheard of in the seventeenth century. Instead, it seems that several palettes were used, one after the other. When the colours on one palette were almost exhausted, the painter called for a fresh palette, which was brought to him by his servant or palette-boy. In cases when the painter had no assistant he performed this office himself.

A clean palette and brushes were considered of the utmost importance, and one of the secrets of the fine work of that

[7] See a very interesting illustration in Floerke's 'Studien zur Niederländischen Kunst- und Kulturgeschichte,' p. 124.

[8] Plate II, p. 19.

[9] Another instance of the canvas being gathered into the frame is seen in the painting by van Spreeuwen, reproduced on Plate II, p. 19, and another very good example may be found in the picture by Aert de Gelder, in the Städel Institute at Frankfort.

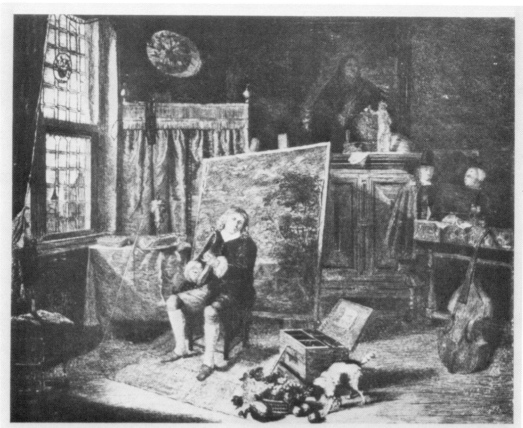

THE PAINTER'S STUDIO, BY GONZALES COQUES; IN THE SCHWERIN GALLERY

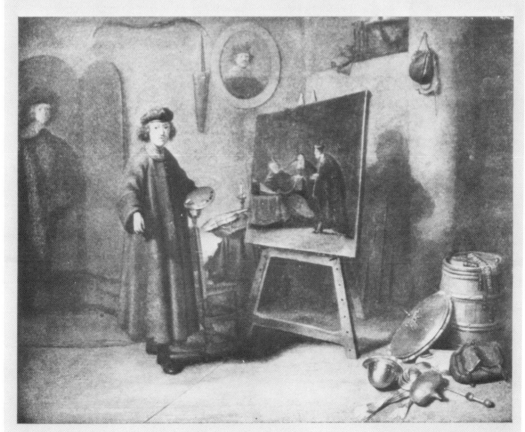

REMBRANDT IN HIS STUDIO, BY GERARD DOU; IN THE COLLECTION OF SIR FREDERICK COOK, BART., M.P.

PLATE II.  THE LIFE OF A
DUTCH ARTIST IN THE SEVEN-
TEENTH CENTURY

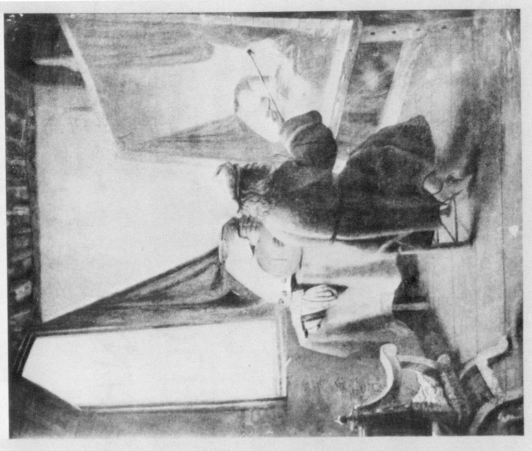

A PAINTER IN HIS STUDIO, BY J. VAN SPREEUWEN

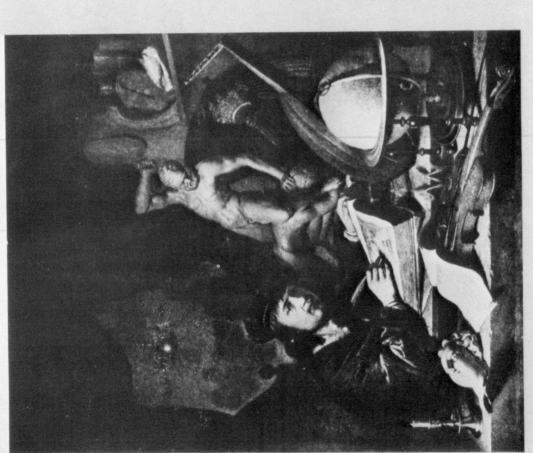

THE ARTIST IN HIS STUDIO, BY GERARD DOU, IN THE DRESDEN GALLERY

PLATE III. THE LIFE OF A DUTCH ARTIST IN THE SEVEN-TEENTH CENTURY

period lies in the scrupulous cleanliness that was always observed. The neatness and clearness of pictures such as Hals' *Riflemen*, in the town-hall at Haarlem, characterized by a strong 'impressionist' style, painted in single strokes of the brush, would be inconceivable without the utmost cleanliness of palette and brushes. Or, to cite minute painting as a contrast to Hals' impressionism, we may be equally certain that the detailed nicety of Potter's or Terborch's work would never have been attained without the same precaution. It was not in vain than van Mander, in his 'Painting Song,' thus apostrophized the pupils:—

' Have a care of the master's palette and brushes and of mixing and preparing (the colours), have a care of canvas and panels, grind the colours right fine and see to it that they are kept clean,' etc.

We notice further how carefully painters preserved their pictures from dust ; for instance, in a painting by Ostade (reproduced in the second article), a piece of linen is suspended under the roof to keep the dust from coming through. Some of Gerard Dou's pictures in Amsterdam and Dresden show a Japanese umbrella, which the painter used to fasten to the top of the easel for the same purpose. If we see those things on the pictures it seems not at all improbable that some painters, whom a hair on the canvas could drive to distraction, should have resorted to some of the drastic methods of sweeping away dust and dirt described by Sandrart in his 'Accademia Tedesca.'

The brushes of that age resembled those used now ; the mahlstick and palette-knife were also the same. Some small details had not yet been invented : the oilpan was not hooked to the palette, nor could colour and oilpans be put on the easel ; they were placed on a table or stool beside it (see Ostade's pictures in the second article). Nothing but the picture in hand was on the easel, except perhaps a study pinned upon it, or a

palette hung there during a pause. The picture was placed leaning backwards, in the position of the easel itself, and not in the forward inclination now in favour. Easels in a vertical position did not exist ; the common easel (as the illustrations plainly show) was a three-legged apparatus, like those used for our black-boards in the schools, so that it was not easy to let up and down the picture to change its position.

No further painting utensils were needed to furnish the studio; but, as we know, every studio contained a great number of various accessories necessary to the painter's handiwork. In the portrait-painter's studio there will be seats for the models, a table to lean against, and curtains for draping. We can easily see, by comparing the portraits of one painter, how the same articles were used over and over again. How often does Gerard Terborch give the ladies and cavaliers he is painting the same old chair to lean on, and the same red velvet cloth over the same table upon which to put their hats !

In addition to these few articles, a lay-figure was, of course, indispensable to the portrait-painter for arranging drapery to paint from nature. Historical and subject-painters required the lay-figure for identical purposes. We often find it in pictures— for instance, in the painting by Ostade of a studio represented in the second article, where the lay-figure is in the foreground to the right, and on the picture by Sweerts in the same article.

Painters of historical and other subjects, of course, required many more accessories than portrait-painters. Costumes of different descriptions, arms and implements, had to be provided according to the subject of the picture ; casts of different parts of the body were also necessary. The best and most complete studio was, without doubt, that of Rembrandt. The inventory of his furniture and stuffs in 1656 shows at a glance what a large stock

(107)

of requisites the painter kept for his biblical and historical compositions. He had begun to collect these as quite a young artist—about 1630, when still at Leyden. Then we see that he had already a coloured scarf, a shield, helmet, and curved sword in his possession. We meet with these articles in several works doubtless painted in his studio at that period, among others in the painting of the studio by Gerard Dou in the first illustration to this article. Again and again, in Rembrandt's own later works, we come across costumes and implements recognizable as his property. He wore his costly furs himself, and these we find on his models also; the well-known gold chain appears frequently in his pictures: in a word, we gain a fairly complete idea of his property from acquaintance with his work.

(108)

Several other Dutch *genre*-painters give us as true an index of the objects in their workshops, lovingly dwelt on and depicted by them in every variety of position and light. Jan Steen, for instance, delights in an old arm chair, with a rickety and broken back, mended with a cross-piece of wood. It would seem that the painter had an affection for that old piece of furniture with its quaint carving and red cover, for he painted it innumerable times. A careful observation of the chairs in the pictures of Metzu, Vermeer of Delft, Brekelenkam, and other masters, leads to the conviction that the above-mentioned artists also repeatedly painted the chairs in their own workshops. It is not rare to see the whole workshop depicted, or a corner from it, full of accessories and utensils. An instance of this may be found in Gerard Dou's picture in the Dresden Gallery,[10] representing the artist in his studio drawing in a book, and surrounded by most of the objects which his pictures usually contain. The globe in the corner, unmistakable from the shape of the feet, is the same one we see in so many of Dou's pictures; also the umbrella for protecting the

[10] Plate III, p. 22.

24

paintings from dust, the hot-water bottle used in his doctor's scenes, the shell, candlestick, and various other objects, recurring, for example, in the *Dropsical Woman*, of the Louvre, and in the *Young Mother* at the Hague Gallery.

A few more instances from old inventories may be enumerated, such as the inventory of Netscher's studio. This artist, we are aware, was renowned for his manner of painting satin; thus it is not surprising that the inventory contains ' a few pieces of silk and satin.' The catalogue of the contents of Jan Vermeer's workshop in Delft is also very remarkable. We are told that among other things there were seven ells of gold leather hanging, a landscape, a sea-piece, a large picture of the Crucifixion, and so on. We can trace all these in Vermeer's pictures. The landscape and sea-piece are both to be found in a small picture in the Rijksmuseum at Amsterdam, while the gold leather hanging and the great *Crucifixion* are in a picture in the gallery at the Hague, belonging to Dr. Bredius. It follows as a matter of course that still-life artists no less than *genre* painters possessed the originals of many of the objects they painted, and it is easy to verify this by a comparison of the works of the same artist.

Landscape, cattle, and sea painters, and painters of architecture and animals, however, had not the same conveniences at their disposal. We have seen that in Holland, at that period, painting directly from nature was a matter of the first importance, and as painters of the last-named category did not paint out-of-doors, as we shall subsequently find, their drawings from nature were all they had to rely upon, unless, indeed, they could keep their models behind the house, as did the reptile and insect painter Otto Marseus, and perhaps also painters like Hondecoeter, who may have kept their poultry in the same way.

*(To be continued.)*

# HOW A DUTCH PICTURE WAS PAINTED [1]
## ❧ BY DR. W. MARTIN ❧

IN the last article on the life of a Dutch painter in the seventeenth century we spoke broadly of the arrangement of a studio of that period with its painting apparatus and principal requisites. We omitted, however, all mention of several important matters ; the models of the genre painter, the sketches of landscape, architecture, marine and animal painters, were not discussed. Nor did we mention the literary aids of the painters who borrowed their subjects from the Bible, history, mythology and allegory, and, lastly, the actual painting was left on one side. We will now address ourselves to the latter subject in the first instance, and it will lead us by degrees to the answers of the remaining questions.

Painting in itself is always a very individual thing ; one artist does it in this way, another in that, and if you ask an artist how he paints, he will tell you that he does not know himself. So it was with the Dutch painters of two and a half centuries ago. But there existed then, just as there exists to-day, a method with which everyone began, a foundation just as indispensable as finger exercises to the pianist. They learnt this ABC as pupils, and it was not till they had become masters that they gave it a new form, each according to the greater or less degree of individuality that he possessed. Thus, although every master, even in those days, created a style of his own, it may be broadly asserted that there was a universal technique of painting in the Dutch school of the period. We know it principally from unfinished pictures, which make the close observer acquainted with the most surprising details about the technique of the time.

Translated by Campbell Dodgson.

144

As an example of such pictures we may name, for instance, a landscape by Aert van der Neer, in the collection of Professor Götz Martius, at Kiel. This picture, a winter landscape, is for the most part finished in the left and right corners, and also in the tall trees and the houses. But the background is only begun, and the bold sketchy pencil lines by which it is indicated are drawn upon the thin layer of paint of this first commencement. A little church, some houses and trees, and a town quite in the distance, are sketched in this way with pencil. Beneath a tree half painted, where a sledge full of people is just on the point of starting, the outline sketch of a boat is still plainly visible. The sledge has been painted in later over the boat, which was originally to have come in this place. Other portions of this picture are also unfinished, and one can study exactly Van der Neer's way of painting in the year 1642, the date of the picture. By so doing one arrives at the conclusion that he first drew in the composition with pencil, then began the underpainting and by degrees finished the whole, working probably, like most artists, on several pictures at once, while he added and altered all kinds of details during the progress of the painting.[2]

(109)

A sea piece by this master in the collection of Herr H. Thulesius at Bremen, also not quite finished, displays exactly the same manner of painting. Here, too, are a number of bold pencil strokes with which the preliminary drawing of the whole was carried out.

A further example of a picture which has remained unfinished is a Gerard Dou

[2] It can not be said that this picture is an unfinished one from an aesthetic point of view. It is, on the contrary, very probable that van der Neer left it technically unfinished as it is, just because he saw that it was as beautiful in *this* state.

in the Schwerin Gallery representing a woman in her shop. There it can plainly be seen that in many parts only the under-painting has been done, and the whole was left still waiting to be finished, and in parts re-painted.

A third example, a portrait of a lady by Abraham van den Tempel, in the Rijks-museum at Amsterdam, is reproduced here (p. 147). This picture is partly finished, but in other parts only the under-painting is done, for instance on the face, the collar and the hands. The latter shows plainly how the colours were originally laid on ; while the painting of the roses on the right, for example, is completely finished.

Representations of the preliminary drawing are to be found, moreover, in many pictures of artists' studios. For instance, in the picture of the *Studio of Joos van Craesbeeck*, here reproduced (p. 151), the painter is engaged in drawing the group on the panel with white chalk. So, too, in the celebrated *Studio* of Jan Vermeer of Delft, in the Czernin gallery at Vienna, the picture on the easel shows the preliminary drawing in white, and if the reader will turn to the eighth volume of this magazine he will find on p. 15, in the illustration of the studio of Frans van Mieris, a lady's portrait standing on the easel, similarly sketched in white. The back of the armchair, even, on which she is sitting, is plainly suggested.

(110)

Besides this preliminary drawing, the method of under-painting and re-painting for finish can be studied precisely in many pictures. And if the occurrence of *pentimenti* and other alterations and re-paintings by the artist's own hand be taken into account, much that was puzzling in the technique of that period becomes intelligible. Among *pentimenti* we have mentioned already the boat, afterwards painted over, in the picture by Aert van der Neer in the collection of Professor Martius at Kiel. We will mention, further, certain especially clear examples, the *pentimenti* on a picture by Brekelenkam and on one by Jan Vermeer of Delft. The former, in the collection of Dr. Bredius in the Royal Picture Gallery at The Hague, shows the operation of letting blood in a simple room in which a basket of cucumbers stands on a table. The whole composition is remarkably successful and the basket, especially, is extremely effective both in colour and as an element in the composition at the place where it stands. That makes it all the more interesting to see that the painter in his original sketch has proposed to place the basket with its contents in a different part of the picture, on the floor in front. The effect of this was not good, and he made the alteration while the painting was in progress. In looking closely at the picture the whole basket is plainly to be seen through the paint subsequently laid on over it.

The *pentimento* of Vermeer, to which we alluded, is to be seen on his celebrated picture, *The Procuress*, in the Dresden Gallery, one of the most splendid arrangements of colour in the whole of Dutch painting. One of the finest things in this picture is the harmony of the white cap of the young girl with the yellow jacket and the red costume of the young man who stands behind her. Change in the costume of the girl in yellow shows that Vermeer evidently made experiments with a view to harmonizing these three colours as tastefully as possible. She first wore, in addition to the white headdress with lace, a large white lace collar. That evidently gave too much of a white surface and consequently Vermeer reduced the collar by more than half and also omitted the lace. In this way he evidently arrived at a better harmony of colours. If the picture at

Dresden be closely observed, the larger lace collar will plainly be perceived through the yellow of the jacket. In a reproduction it is, unfortunately, imperceptible.

There are still many more examples of *pentimenti* in the Dutch school; for instance, in Vermeer's *View of Delft* in the Royal Gallery at the Hague, where a gentleman walking has been painted out by the artist himself, who had originally painted him in the foreground. But it would take too much space to enumerate all the examples we know, and therefore we mention only these two.

There is much more that might be said about the technique of Dutch painting in general. The said technique cannot, however, be described in detail: one must study the pictures themselves and even the best reproductions are, as a rule, no help. This general conclusion may be drawn, that in the Dutch technique of the seventeenth century the preliminary drawing is followed by a first and second painting. With this tendency, however, there are endless variations, which may be divided into certain principal groups, each having its own recipes, as they might almost be termed; but in these groups again, every artist has dodges of his own. For instance, the delicate painters of the Leyden school have a glazing technique peculiarly their own, of which the tradition lasted into the nineteenth century. Rembrandt's various styles of painting also have their imitators; his trick, for instance, of drawing the hairs of the beard or curls on the wet paint with the wooden end of the brush is imitated as early as 1628 by De Heem (still-life in the Royal Picture Gallery at The Hague), while the strongly impressionist technique of his late period, which seems to defy any precise descrip-

tion, is closely copied by Aert de Gelder. Yet he, even, paints quite differently from Rembrandt. In fact, no two artists ever paint in the same way, and even in technique everyone has his peculiarities, even if his brushwork seem on the surface to be almost indistinguishable from another's.

The preliminary drawing, just as in modern times, was made on the panel or canvas either straight off or from sketches and other materials; it might also be transferred by tracing, as is proved by various drawings of the old masters still extant in which the outlines are pricked with a needle. How a painter used his sketches when at work is shown, for instance, by the picture of Ostade's studio, reproduced in vol. vii, p. 422, where the painter has fastened one of his sketches at the top of the easel.

How far was a picture painted entirely from nature, how far with the help of sketches or other aids? This question, again, is not easy to answer; it depends entirely on the talents of the individual master. The portrait painters acted then, much as they do to-day; first, sketches were made for pose and composition, as we have them by Rembrandt, for instance, and numerous other painters of the time; then the whole portrait was designed, the head and generally the hands were painted from nature, and lastly, the costume was draped over the lay-figure and painted so. If only a slighter kind of portrait was attempted, the procedure, of course, was different and less careful.

In the picture by Frans van Mieris, reproduced in October, 1905 (vol. viii, p. 15), we see clearly how a portrait was produced at that date. There are numerous other examples; for instance, an engraving by Adriaen van de Venne illus-

(111)

PORTRAIT OF A LADY, BY ABRAHAM VAN DEN
TEMPEL. IN THE RIJKSMUSEUM, AMSTERDAM

trating the 'Houwelyck' of Jacob Cats, in which a painter is likewise engaged in taking the portrait of a lady seated before him.

The procedure of a genre or historical painter was more complicated. He worked, according to his ability, in various ways. The numerous sketches of masters like Jan Steen, David Teniers, Adriaen van Ostade and Adriaen Brouwer show us that these masters made short notes from nature of single figures and groups, as they saw them in the street or in the alehouse. We need only remember Brouwer's magnificent studies of the movement of dancing peasants. Many of these splendid groups however may also have been produced from memory, being drawn immediately on returning home. Such drawings served these painters as materials for composing their genre pictures. Then they would often draw or paint single figures in the studio as preliminary studies for their pictures. Thus we see Teniers in one of his pictures engaged in painting a peasant with a flail in the studio.

There is no lack of single figures drawn in preparation for genre paintings. In fact they are so numerous that it is impossible to reckon them up. Moreover everyone knows a certain number, at least, of such studies from draped or nude models of every kind. The model was almost a more important person in the studio in those days than now. One has only to turn over Rembrandt's etchings and drawings to gain a clear impression of the behaviour of these numerous men and women in his studio and those of his pupils, how they rest, put on their clothes, or warm themselves by the stove (as in Rembrandt's etching, B 197). We see Rembrandt himself painting from the nude model in the splendid picture belonging to the Glasgow Corporation Art Gallery. Aert de Gelder gives us a representation of a painter (? himself) engaged in painting a study of a draped model, an old woman. The picture is now in the Städel institute at Frankfurt, and is, further, very instructive as regards the painting apparatus and the manner in which the canvas is stretched.

Not merely single figures were painted in this way in the studio, but also whole groups. This is a remarkable phenomenon at that date, of which we encounter several examples. The first is a picture by the Flemish painter Joos van Craesbeeck, belonging to the duke of Arenberg at Brussels, to whose kindness we are indebted for permission to publish the engraving (p. 151). It represents a painter's studio with a high side-light. On the left sits the painter, who turns his back to us. We see a jug of beer and his pipe beside him on a bench, a cloth and some crayons lie on a stool to his right, while his painting tools lie on the table quite to the right in the foreground. For the present he does not need them, as he is only engaged on the preliminary drawing. The remarkable thing here is that the drawing in question shows the whole of the group placed to the right of the studio, so that here the painter has posed no less than six models at once in a definite position and begun to paint them directly from nature. Many a 'party carousing' may have been painted in this way.

A second extant example of this kind is in the Kaiser Friedrich museum, at Berlin, and is painted by a pupil of Frans Hals, Jan Miense Molenaer (p. 151). In the studio there stands to the right, on an easel, a picture on canvas representing a ridiculous scene in a studio, a pupil, a serving maid, a dwarf, and a dog dancing merrily round to the music of a hurdy-gurdy played by an old man. The painter

(113)

**149**

has just left off working at his picture; he has got up from his stool, laid his pipe upon it and his mahlstick against it, after hanging up his palette on the easel. In walking he has upset his jug of beer. It is the model's resting time. The young painter has set about preparing another palette, and has gone with this object to the table where his colours are kept. The models meanwhile are taking a little exercise: the dwarf dances with the dog, the organ-grinder plays a tune, and the maid and the pupil, the latter with mahlstick and palette, look on.

Here, then, is another example of an artist painting a whole group from the life.

There is a further point of interest about this picture. A second room is seen through the open door, with an easel at which the pupil is evidently working. Besides the painting apparatus by the window a stuffed bird may also be noticed standing on the floor in front of the table.

(114)

There is a third genre painting in which the artist clearly betrays that he painted it entirely from nature in the studio. We mean an early picture by Nicolaes Maes formerly in the château of Buitenrust at The Hague. It represents a mother sitting by a cradle with a child asleep. She threatens her other child with the rod because he is making a noise with a drum which might wake his little brother. A complete piece of genre. And what do we see, to our astonishment? That in the mirror which hangs on the wall over the mother the artist is clearly visible at his easel engaged in painting the scene.

Not only the genre painters but also painters of still life betray themselves in this manner by letting us see them reflected on the polished surface of vessels in their pictures. In the collection of the late M. Rudolph Kann at Paris, for example, is a magnificent piece of still life by Abraham van Beyeren, on which there is a beautiful silver ewer. On this ewer we find a reflection of the painter seated at his easel, the best proof that the whole was painted from nature. On another piece of still life by van Beyeren, in the Cook collection at Richmond, we find a similar instance of reflection on a silver ewer.

Such reflections often show plainly how the studio was lighted; the reflections of windows on the flower-vases of Jan Davidszoon de Heem, Rachel Ruysch and their imitators are especially remarkable in this respect. For instance, on a vase of flowers by the first named painter in the Dresden gallery (No. 1265) we see the reflection of a window with curtain drawn back which serves as evidence that this piece of still life was painted by a side light.

Of the still life painters, in fact, it may be said that they probably hardly painted at all except from nature in the studio, although one might be inclined to think that a good part of the productions of de Heem and his school, with their unusually complicated and finished still life, were worked up from sketches of detail.

Here, too, we see, it was most usual to work from nature. But there were other ways that led to the goal and were used especially by the less gifted of the fraternity. We mean the borrowing and copying of details and often even of entire compositions. In Holland, in the sixteenth and early seventeenth centuries this was not considered an improper proceeding. Above all the copying and imitation of the great Italian masters was highly commended in many circles. Even later than this Rembrandt did not disdain to make use of the compositions of other masters on

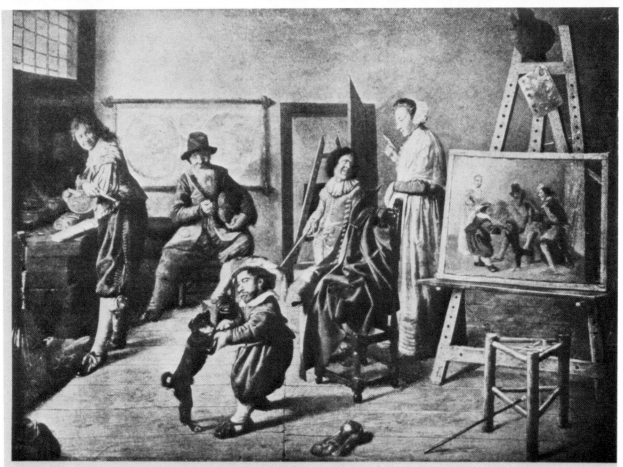

SCENE IN A STUDIO, BY JAN MIENSE MOLENAER,
IN THE KAISER FRIEDRICH MUSEUM, BERLIN

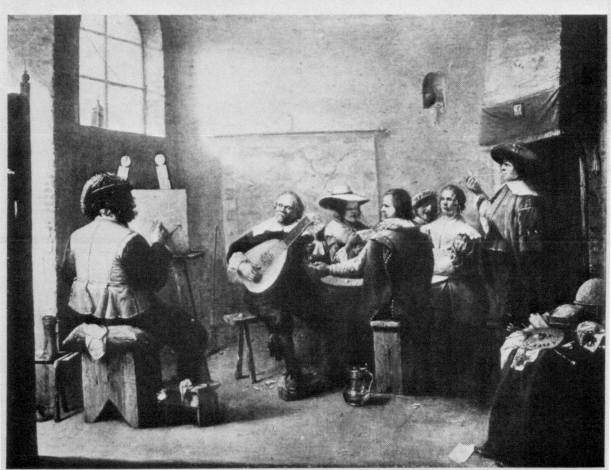

SCENE IN A STUDIO, BY JOOS VAN CRAESBEECK,
IN THE COLLECTION OF THE DUKE OF ARENBERG

HOW A DUTCH PICTURE WAS PAINTED
PLATE II

several occasions in his works. Rubens and Van Dyck did the same. This is too well known to be dwelt on here. Many did at this time like Rembrandt; the influence of engravings and original pictures on the work of great Dutch and foreign painters was much greater than one is apt to suppose. In numerous inventories and biographies of painters mention is found of engravings. It is related, for instance, of Govert Flinck, that he 'possessed a fine collection of prints, which he not only understood very well, but knew how to make an ingenious use of them in designing his historical pictures and other works.' We often find in pictures attitudes, groups or details which are borrowed from prints, especially by Italian engravers, which were known at that date. It is especially among the painters of historical, allegorical and mythological subjects that such cases of borrowing occur, and of them it is chiefly the mediocre men, lacking in original invention, that make most use of engravings. The less important genre painters also often used engravings, and I remember, for instance, seeing at an Amsterdam dealer's an old Dutch picture of an assembly, in which entire groups were derived from the prints of the Frenchman Abraham Bosse. As a further instance, to repeat what I have already printed[3], the well known print by Cornelis Visscher of a woman baking cakes has been imitated times untold in pictures of the seventeenth century. From a series of other examples enumerated by Dr. Floerke in the book already mentioned, a few may be named here. The painter Arnold Verbuys copied details from prints of Gerard de Lairesse, Van Dyck and Annibale Carracci; the battle-painter Arnold Rubbens copied in oils engravings by C. P. Rugendas,

(116)

while Ary van der Kabel used to make similar use of the prints of Tempesta. But this excessive use of engravings, and especially the borrowing of whole compositions was considered unseemly, at least, towards the middle of the century. This is best proved by the story of the series of pictures of the fable of Psyche painted by Gonzales Coques for the Prince Frederick Henry, stadtholder of Holland.[4]

Gonzales Coques had painted several portraits for the prince to his great satisfaction. Later he received a commission to paint the fable of Psyche in ten large pictures. Although Coques was an able portrait painter but by no means an historical painter, he accepted a commission which did him so much honour. But in doing so he overestimated his talent, and when he returned to Antwerp and set about painting he soon saw that these pictures were beyond him, so he secretly had recourse to the well known artist, Abraham van Diepenbeeck, who promised to furnish a sketch for the composition of the first of the ten pictures on payment of twenty florins. This was done; Coques travelled to The Hague with Diepenbeeck's sketch, and the prince pronounced it excellent. Now Coques set to work at carrying out the picture on the full scale, while Diepenbeeck in the meantime furnished the remainder of the designs at eighteen florins a piece. Coques finished painting these as well in full size and then exhibited the complete series to the stadtholder. Hereupon the well known poet, connoisseur and statesman, Constantyn Huyghens, secretary to the prince of Orange, produced a quantity of engravings after Raphael which showed the same compositions. Diepenbeeck had copied these prints without telling Coques.

---

[3] In my biography of Gerard Dou. London: Bell & Sons, 1902.

[4] Van den Branden, 'Geschiedenis der Antwerpsche Schilder school,' Antwerp, 1883, p. 968.

Then there was a scene in which Coques was so ridiculed that he afterwards declared he would have wished 'to be far away.' This affair seriously injured Coques' reputation as an historical painter.

Later on, in the eighteenth century, people were much less strict in this respect. The decadence of taste and technical capacity in Dutch painting showed itself here too. The writer on art, Jacob Campo Weyerman, writing in the year 1729, says expressly that he has nothing to urge against the use of foreign prints and drawings, provided they are discreetly employed. Gerard de Lairesse (1740) will have it that the artist must first make his own design, but then, in carrying out the whole, he may borrow details of buildings and the like from engravings by other artists with an easy conscience. By degrees, in fact, the employment of prints became so extensive that a painter who did not avail himself of them was praised for it. In 1751, Jan van Gool writes as follows: 'Heroman van der Mijn had a peculiarity which you shall find in few painters. He possessed neither prints nor drawings by any master; everything that he painted was done from life or out of his head as the result of long experience.' Roger de Piles, in his well known book of 1725, even devotes two chapters to this abuse, the first with the heading 'that it is a good thing to employ the studies of others without scruple,' and the second under the title 'of the benefit of copper engravings and their employment.'

So we see how this habit gradually degenerated into an abuse. In the flourishing period of Dutch painting the abuse was much slighter than afterwards; the systematic copying of complete compositions was censured, while details, on the other hand, are borrowed without reserve, even by the greatest masters. And why not? When Rembrandt borrows a detail from Mantegna, he does not copy it, but translates it into the terms of his own art, and that was fully permitted in those days, and rightly so.

Thus we have now discussed in their broad outlines the principal resources of the painters of portraits, genre, history and still life. It remains for us to approach the studies of the landscape, marine and architectural painters, and lastly to discuss the literary material of which the various Dutch painters of the seventeenth century availed themselves. My next article will deal with these two subjects.

(117)

NOTE—For previous articles on *The Life of a Dutch Painter in the Seventeenth Century* see THE BURLINGTON MAGAZINE, Vol. VII, pp. 125 and 416 (May and September, 1905); Vol. VIII, p. 13 (October, 1905).

# VII

## REMBRANDT AT THE LATIN SCHOOL

IN the biographies of Rembrandt only a few words, for the most part inconclusive, are given to his years at school and at the university. In truth, it may not seem essential to know upon what school benches the bored young artist sat, for, possessed by a single idea, he soon managed to devote himself to art. He can have been little more than a year at the university when he entered a painter's studio. But it was not only this brief period at college in Leyden that brought him into contact with the humanistic culture of the day.

As he was only fourteen at the time of his matriculation, the entry regarding it has been thought to indicate his admission to the Latin school. For instance, we read of a brief attendance at "the Latin school of the university," although there was in fact no connection between the school and the college; or we are told that "the parents took the boy out of the Latin school," although it is certain that he passed through it from beginning to end. This means that he enjoyed seven years or, if we add about a twelve-month at the university, eight years of such instruction

[ 130 ]

(119)

Reprinted from Wilhelm R. Valentiner, THE ART
OF THE LOW COUNTRIES, trans. Mrs. S. van
Rensselaer (New York, 1914).

as was suited to an embryo man of letters, for only those boys were sent to the Latin school whose abilities, in their parents' opinion, gave promise of scholarship. This explains why boys entered the Latin school earlier than they do to-day, at the age of seven. To the humanists the number seven still seemed significant. For seven years, according to Erasmus, the future humanist should play, for seven he should attend school, and for seven the university. So it squares with the schedule if Rembrandt graduated from the Latin school at fourteen. If, as seems evident, his parents meant to bring him up to be a scholar he must have shown in early youth distinct intellectual ability, whether or no the father yet recognized the direction in which it pointed; and certainly it was not to Rembrandt's detriment that at first he was led along plainly prescribed paths.

Artists of genius who instinctively develop into exponents of a phase of civilization need a certain amount of knowledge as a basis upon which, in manifold ways, their powerful imaginations may build. This does not mean that they must be, like Rubens or Velasquez, aristocrats with the means of culture always close at hand. They may be, by birth and breeding, simple folk like Dürer or Michelangelo, provided that the new intellectual life of their time is brought conspicuously to their notice, even if only, perhaps, by a small circle of its representatives. Then, dowered with broad powers of comprehension, they will assimilate the proffered material and will embody its essentials in that conception of life which, without formulating it in words, they express in their art.

[ 131 ]

According to the general verdict, Rembrandt was the least cultivated of all great artists. It is true that he must always have retained a certain slow simplicity of nature, but the course of his life tended to make of the miller's son, in mind and in manners, an accomplished man. The twenty years that he spent, rich and famous, in Amsterdam cannot have failed to affect him, but the training he received in his youth must also have contributed to his intellectual development.

In a history of the Leyden Latin school there is mention of a school ordinance which took effect soon after Rembrandt graduated; and as it was evidently meant not to alter but merely to formulate existing conditions it shows what books the boy must have studied or read. It also informs us in regard to something more important — the spirit that guided the teaching.

(121)

In the year 1600 the Latin school was rebuilt by the municipality for the furtherance of "piety, the languages, and the liberal arts," as is inscribed above the entrance of the building which still stands to-day. In the year when Rembrandt entered a wing was added for the rector and the boarders (among whom Rembrandt was certainly not counted), and the graceful portal of this wing, now in the Rijks Museum at Amsterdam, was adorned by a figure of Pallas Athene, with the legend, not quite so graceful, *Pallas is veilig door haar schild* (Pallas is safe because of her buckler) and by two lions bearing armorial shields. The school contained six rooms for the six classes from *Sexta* to *Prima*, only the last of which was divided into two — Lower and Upper *Prima*.

[ 132 ]

The name of the school shows that the main goal of education was a knowledge of Latin, then the universal language of the learned. As far as possible it was to be used by the boys in conversation. In addition to a grammar the members of the sixth class were given at once a book containing conversations by Cordier and an introduction with examples for use in daily life prepared by Erasmus of Rotterdam. From the fifth class onward two hours a week were devoted to disputations about scholastic sophistries *pro victoria loci* — that is, "for a higher place" in the class. In the upper classes the pupils learned to extemporize and to write Latin compositions upon themes chosen by themselves; and now they were obliged to speak Latin out of school as well as in school, and to keep watch upon one another lest they lapse into their mother tongue. The old humanistic idea of education still prevailed — the development of men of all-round ability. It must be confessed that the method was superficial. What were considered the liberal arts were a calligraphy rich in flourishes, the ready writing of formal Latin epistles, and the composition in complicated metres of Latin hymns and odes. To these things long school hours were devoted year after year, and thus the men were trained who, with an eye to immortal renown, wrote letters like lengthy treatises and prefaced their books with endless poems that quenched in the reader all sense of the purport of the work. As the school ordinance said, the pupils must be able, as cultivated men, to make a Latin verse in the turning of a hand. A comprehensive acquaintance with Latin authors seemed an essential preliminary. The fifth

[ 133 ]

class made a beginning with the letters of Cicero, whose wisdom, especially as it is contained in his orations, thenceforward accompanied the boys throughout their school life. Then followed in due order Terence, Ovid's Tristia and Metamorphoses, Virgil's Eclogues, the fables of Æsop, Cæsar's Commentaries, certain cantos of the Æneid, Sallust, Livy, Curtius, Horace, and others. As is the case to-day, instruction in Greek was somewhat subordinated to instruction in Latin, although the ordinance pointed out that the Grecian tongue was the foundation of all wisdom and that without it Latin itself could not be rightly understood. In the fifth class the boys began the Greek alphabet, in the fourth class grammar and the texts. Rembrandt read Euripides, although neither of the two great elder tragedians, Sophocles and Æschylus. Hesiod and Homer are likewise named.

It was also thought that learning should influence the man as such. Good manners were inculcated, albeit, according to our ideas, in a wonderful way: the pupils were to wean themselves from roughness and rude behaviour by reciprocal displays of these traits. On the other hand, they were taught how they ought to behave by specimens of courtly Latin phrases which were free, indeed, from prudery but flat and insipid and seldom fit for the mouths of children. For example, sixth-class boys were to greet a young married woman with the words, "God grant that you may make your husband the father of a fine child," and to a person who sneezed they were to exclaim, "Good luck," or "May God direct it for the best." A good influence upon manners was expected from the distiches of Cato

(123)

[ 134 ]

and the maxims of Solon, and from the Ethics of Waläus, a Christianized version of Aristotle's lessons in behaviour.

This gives an idea of the value set upon Christianity in the education of youth. It stood upon an equal footing with classic antiquity. Everything else was subordinated; for example, Rembrandt learned no modern language. All else that was thought to pertain to general culture was hastily disposed of in the first class. Then something of philosophy was taught (logic was combined with the instruction in Latin), and also the higher mathematics, geography, and a little history which, from what we know of the time, must have related only to the development of states and above all to the constitution of the Roman state.

(124)

The importance of religion was announced by the inscription over the entrance to the Latin school, of which the school ordinance gave, in this sense, a further explanation. An appeal to the pupils of the sixth class in the preface of the first Latin grammar ends with the words: "In the name of Christ, the guide in all studies, farewell!" In Greek the boys learned to repeat the Lord's Prayer in the original and to read the evangelists. School began and ended with prayer in common, followed, in the morning, by the reading of a chapter of the Bible. In the upper classes the Psalms of David were sung "so that the boys might be accustomed to the pious tunes." They were charged to attend church twice on Sunday, in the morning and the afternoon, and had to repeat in school what they remembered of the sermon. The Heidelberg catechism and in connection with it the teaching of dogma

[ 135 ]

were taken up astonishingly early, in the second class. Religious instruction ended in the first class with discussions of heretical opinions.

There is little to be said about Rembrandt's university life, which followed upon his course at the Latin school, for we do not know how long it lasted. He was enrolled as *studiosus litterarum* and therefore attended the lectures of the professors of a preliminary faculty, introductory to those of the three main faculties. As is indicated by the age of very many of the students, from fourteen to sixteen, the course did not differ much from school instruction. Rembrandt must have enlarged his knowledge of Latin grammar and Latin authors and have followed courses in the history of dogma and of the Christian Church; and perhaps it was at this time that he learned Hebrew which, as inscriptions on his pictures show, he understood to some extent.

This training at school and university left lasting traces in the artist's attitude of mind. In his time humanistic and Christian scholarship were more closely related to life than they are in our own. At Leyden even the ordinary man listened with pleasure to the disputes of the learned upon points of criticism, and the "small burgher" strove, as he still does in Holland, to form an opinion of his own upon dogmatic questions. In so far as it is possible to divine Rembrandt's intellectual attitude from his pictures and from the records, it may be said that Roman antiquity meant more to him than Grecian, as at school Latin took rank above Greek. His knowledge of Latin is revealed by occasional inscriptions on his pictures and portrait etchings; and that it pleased him in later life to look into the books

(125)

[ 136 ]

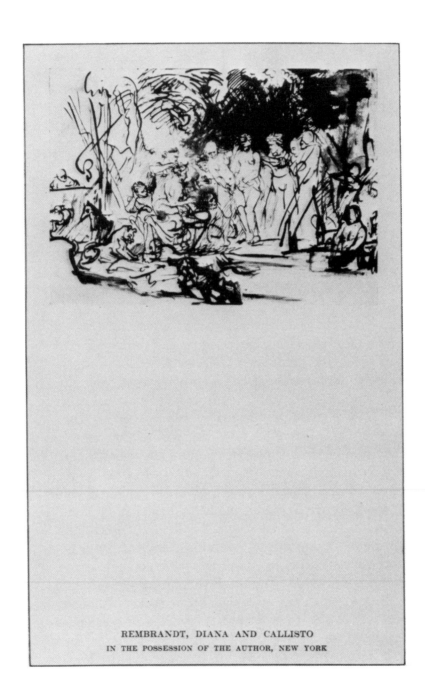

REMBRANDT, DIANA AND CALLISTO
IN THE POSSESSION OF THE AUTHOR, NEW YORK

he had known in his youth seems probable in view of certain representations of themes taken in especial from Ovid, Livy, and Cicero which, like his Biblical illustrations, adhere so faithfully to the text that we can hardly think that he created them wholly from memory or utilized the work of other artists.

Baldinucci relates that on the walls of the house of a merchant who belonged to the magistracy Rembrandt painted in oils a number of pictures from Ovid. It is uncertain whether this statement is correct or not. We can hardly connect it with the drawings and paintings of scenes from Ovid that still exist, as these date from various periods of Rembrandt's career. I may briefly indicate what they are, following approximately the order in which the poems themselves are arranged:

(127)

1. Io. Rembrandt has presented three moments in this familiar myth. In a drawing at Berlin and in one in the Victoria and Albert Museum at London,* Juno leads the metamorphosed Io to Argus. Two drawings, owned by Léon Bonnat and Walter Gay in Paris, show Mercury lulling the warder to sleep with his flute. A fifth, in the collection of J. C. Robinson at London, and a sixth, in the Albertina at Vienna, represent the beheading of Argus.

2. Callisto. In a picture at Anholt Rembrandt strives to render in a drastic way the words in which the poet describes Diana's discovery of the nymph's misstep. The scene between Diana and Actæon is also introduced into this picture. A drawing of the Callisto episode, of about 1635, is in my possession.

* These drawings and the others that will be named are described by C. Hofstede de Groot in his *Katalog der Handzeichnungen Rembrandt's*. Haarlem, 1906.

3. Europa. A picture of the Rape of Europa, owned by Herr Kappel of Berlin, shows the moment when the god changed into a bull slipped gently from the shore:

> Left the dry meadow and approach'd the seas
> Where now he dips his hoofs and wets his thighs,
> Now plunges in and carries off the prize. . . .

**and when Europa**

> . . . . looks backward on the shore
> And hears the tumbling billows round her roar;
> But still she holds him fast; one hand is borne
> Upon his back, the other grasps a horn;
> Her train of ruffling garments flies behind,
> Swells in the air and hovers in the wind.

As far as my knowledge goes, no other artist has so faithfully adhered to the text in the placing of Europa's hands.

4. Diana and Actæon. In 1630 or thereabouts Rembrandt both painted and etched the single figure of Diana as she puts her feet in the water and, startled, looks around for Actæon who is no longer visible. In the picture at Anholt already named (2), which was painted five years later, the artist borrows directly from the poet: Diana, accompanied by a number of nymphs, dashes the water on the bewildered huntsman, the metamorphosis of whose head is already accomplished. Rembrandt's contemporaries must have recognized his faithful following of the text, for in 1677 a print from the main group of this picture was used as an illustra-

(128)

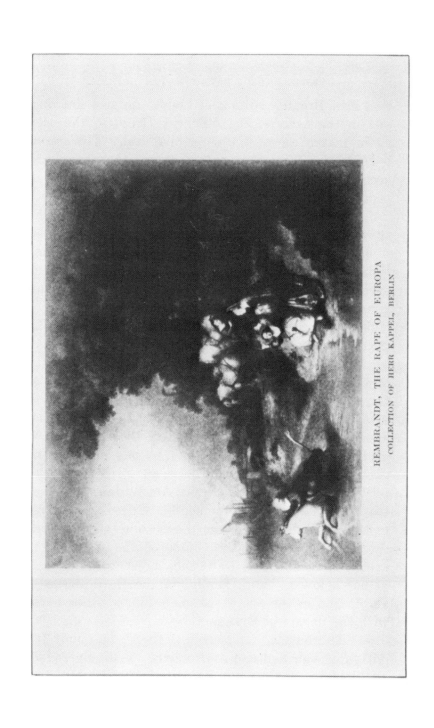

REMBRANDT, THE RAPE OF EUROPA
COLLECTION OF HERR KAPPEL, BERLIN

tion in a Brussels edition of Ovid. In two drawings, one in the Louvre, the other at Dresden, the artist again makes use of the same material. The second, which dates from the 'sixties, shows the nymphs, in accordance with the text, pressing closely around the goddess to conceal her from prying glances.

5. Narcissus. In a drawing at Lille Rembrandt has shown Narcissus mirroring himself in the water. A mythological representation at Amsterdam which for a time was called Narcissus, but incorrectly, as the figure gazing at its own reflection is that of a young woman, is no longer considered genuine.

6. Pyramus and Thisbe. This story, retold in poetry a few decades earlier by Rembrandt's great kinsman in the spirit, Shakespeare, inspired the artist of brush and pencil also. In Berlin alone there are three drawings of the final scene of this tragedy of love, and to these must be added one at Amsterdam, another at Munich, and a third in the Friedrich August II Collection at Dresden. In one of the Berlin sketches Thisbe gazes at the dead Pyramus with a pitying glance. In the one at Amsterdam she clasps her hands in sorrow at the sight. Grieving, she holds her head in her hands in the second of the Berlin drawings. Following the course of the story, in the sketch at Dresden she draws the dagger from the breast of her beloved. And, finally, in the third Berlin example and in the one at Munich Thisbe stabs herself with the dagger of Pyramus.

7. Andromeda. A picture dating from about 1632 with the single figure of Andromeda was discovered and acquired by Bredius not long ago. It seems to have

(130)

been cut away at one side, although it is hard to imagine how a Perseus could have been introduced.

8. Ceres. From the story of Ceres Rembrandt chose two episodes. In a picture of the Rape of Proserpine, now in the Berlin Museum, he tells with the impetuosity of youth, yet with a discreet respect for the text, of Pluto's furious chariot-ride, showing how the flowers which Proserpine had gathered in a basket and in her uplifted garment "fall from the flying skirt," and how her friends convulsively cling to its long folds while the frightened maiden calls in despair to her mother as the dark steeds drag the chariot into the deep-flowing lake called Pergus near the walls of Enna. The second episode appears in a drawing that dates from the 'fifties where three figures are standing quietly together: the goddess, a torch in her hand, is quenching her thirst, while a woman looks wonderingly at a boy who is mocking at Ceres.

9. Marsyas. A drawing at Berlin, a naked man bound to a tree and gazing upward with a despairing glance, is more probably a Marsyas than, as has been assumed, a Prometheus.

10. It has not yet been decided what scene from the underworld is shown in a drawing at Munich where a number of shades are pleading with Pluto and Proserpine, Cerberus is on guard in the foreground, and a woman leads a warrior to another masculine figure. Ovid tells similar tales in connection with Orpheus and Eurydice and with Ino and Athamas.

11. Philemon and Baucis. Rembrandt made several drawings of the visit of Jupiter and Mercury to Philemon and Baucis. Those at Berlin and at Am-

(131)

[ 140 ]

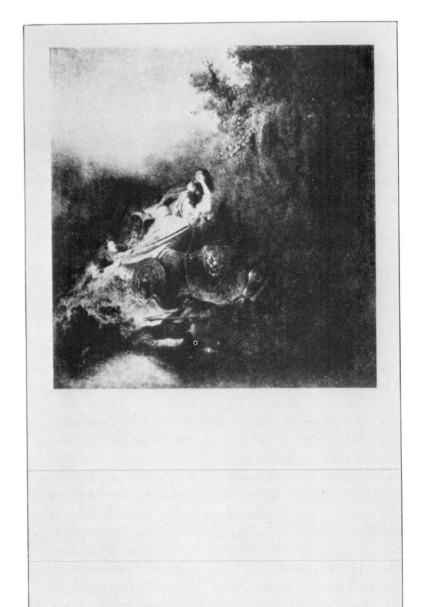

REMBRANDT, THE RAPE OF PROSERPINE
KAISER FRIEDRICH MUSEUM, BERLIN

sterdam are studies for the picture, painted shortly
before 1660, which is owned by Mr. Otto H. Kahn of
New York, and show the artist still searching for the
moment best suited to representation. First he de-
picts Philemon and Baucis preparing the repast —
Philemon, trying to grasp the goose, falls to the ground;
then he decides to render the moment when the gods
reveal themselves — the two old people kneel in prayer
before them. In these compositions the artist proves
his familiarity with the antique world by showing
Jupiter and Mercury in half-recumbent attitudes, by
introducing the sacred birds, and by utilizing for the
head of Jupiter, as is very evident, some work of sculp-
ture like the Zeus of Otricoli.

12. Vertumnus and Pomona. This story, which in
his day was very often interpreted by the Flemings and
the painters of Utrecht, attracted Rembrandt also.
His version of it is preserved in a drawing now at
Stockholm.

In addition to the Metamorphoses of Ovid Rem-
brandt made use of various passages from Livy's his-
tory. In several drawings he has told of the fortitude
of Mucius Scævola, in others of the passion of Tarquin,
who, as Lucretia repulses him, threatens her with a
dagger; and in one drawing and several paintings he
has portrayed the death of Lucretia. At Madrid
there is a picture of the dying Sophonisba, the spouse
of Syphax and daughter of Hasdrubal, to whom Mas-
inissa sent the poisoned bowl. Even a passage from
the eighth Philippic of Cicero must have dwelt in the
artist's memory, for a drawing at Rennes shows the
scene between Antiochus and the Roman consul, other-

(133)

[ 141 ]

wise quite unknown to the art of Holland. To an external impulse, a commission from the city of Amsterdam, was due the great composition of the year 1662, the Conspiracy of Claudius Civilis, a theme supplied by the Annals of Tacitus. Probably the same may be said of a large picture in the possession of Sedelmeyer, the Parisian dealer, which, following Livy or Valerius Maximus, represents Suessa ordering his father, Quintus Fabius Maximus, to dismount from his horse.

In another group of illustrations of the stories of ancient Rome the subjects are clear enough but I cannot feel sure of the source from which Rembrandt derived his knowledge of them. They include a mythological scene, Jupiter and Antiope; one from the history of the Roman republic, Scipio and the Spanish Bride; and one from the period of the decline of the empire, the blind Belisarius sitting as a beggar by the wayside. It cannot be said whether the etching of Cleopatra mentioned in the inventory of Clement de Jonghes soon after Rembrandt's death has been lost or should be recognized in one of those that we possess.

Finally, there are still a few works representing single figures of Roman deities, Minerva peacefully occupied in her study, Bellona panoplied for war, Mars with the fiery eyes of youth watching for an adversary. During his last years Rembrandt was at work on a Juno that has not been preserved.

In comparison with the many works for which Rembrandt drew inspiration from Latin authors those inspired by the writers of Greece make a scanty showing. An etching, not a very successful one, of Jupiter and Danae and a well-known large painting, the Ganymede

(134)

[ 142 ]

of the Dresden Gallery, were produced at the time when he took the most interest in the antique world, between 1630 and 1635. From this period we have also a Greek inscription on a picture, the beginning of the Second Epistle to the Thessalonians, which Rembrandt doubtless took from the Greek Testament that he had preserved from his schooldays. When in his later years he occupied himself with Homer, he was probably attracted more by the imaginative presentation of great men and poets than by that charm of strange tales which had appealed to him at an earlier time. He owned a copy of the familiar portrait bust of Homer and pictured to himself how the blind poet sang — either alone, or like the venerable Goethe with only a scribe beside him to whom he was dictating, or, surrounded by a circle of wise men, reciting his poems under the open sky. Passages from the Iliad and the Odyssey must have remained in the painter's memory, for from the one he took the beautiful scene between Achilles and Briseis which Rubens also painted, from the other the story of the vengeance wreaked by Vulcan when he caught Mars and Venus in a net and exhibited them to the gods. Perhaps it was Jan Six who brought Rembrandt, at more than fifty years of age, into touch again with the Greek world, for the drawing of Homer on Parnassus of the year 1652 is dedicated to Six and is bound into the guest-book, called the Pandora Album, of the Six family, and only a few years earlier Rembrandt had etched an illustration for Six's tragedy, Medea, a copy of which he had in his little library.

As upon Shakespeare, so also upon Rembrandt his

(135)

[ 143 ]

contemporaries made two diverse demands: he was expected to exert a moral influence and to represent the figures of antiquity. Seldom could either great artist successfully solve the problem so inartistically presented. In Shakespeare's case we feel it superfluous when the moral of a drama is set forth at its conclusion, and we cannot fully enjoy scenes of poetic import when they are filled with pictures from the antique world. Neither the poet's portrayals of antiquity nor Rembrandt's allegories show his art at its best. As didacticism disturbs us in the poet's case so in the painter's does the Baroque setting of his scenes, hardly suited to a world which, according to modern ideas, must have been symmetrically and harmoniously fashioned, but which revealed itself to the fancy of a young self-confident northern painter in the likeness of his own time. Moreover, the tales of ancient Greece and Rome are less familiar now than they were to a cultivated Hollander of the seventeenth century, and therefore the fundamental human significance that underlies them in Rembrandt's work is not immediately apparent. It is not as quickly grasped as when an incident is drawn from a Biblical narrative. Something better, perhaps, has taken the place of this kind of learning in the modern mind — a conception of the artistic spirit of antiquity; and it no longer coincides with the ideas of the painters of the Baroque period.

None the less Rembrandt, who was born to express the essence of all the intellectual and artistic aspirations of his race, has given us the best interpretation of the classic world that was produced in his fatherland. How unbearable are the antique or allegorical essays

(136)

of the other important Dutchmen of his time — Jan
Vermeer's commonplace New Testament allegories, Jan
Steen's grotesque picture of the Rape of the Sabines
or of the Temperance of Scipio, Metsu's unmeaning
blacksmith Vulcan or his clumsy allegories of Justice
or Faith, Paul Potter's almost comical Dutch Orpheus
surrounded by tame beasts, the incredible Argus of
Adriaen van der Velde — not to speak of lesser masters
and their unintentional drolleries! It is true that in
the earlier works of Rembrandt himself the gods make
merely the effect of costumed Dutchmen in an environ-
ment of customary studio properties. But in the course
of time his constant familiarity with the works of art
of other nations developed the ability to give his scenes
a more truthfully historical setting, and as his types
came more into keeping with the prescribed conditions
the disparity grew less between the two worlds, the
classic and the Dutch, that he wanted to combine.
How truly Roman seems to a naïve beholder the Tri-
umph of Suessa where lictors march beside the military
commander while the insignia of Rome — eagles, ban-
ners, and escutcheons — are carried behind him. And
looking at Rembrandt's hoary Homer, who can think
first of the fact that he was created by a Hollander of
the Baroque period? Who can fail to recognize at
once a great artist telling of a poet of the older time
in a language that every age must understand? If
the greatest artists of northern countries concerned
themselves at times with the study of the antique,
despite the feeling they must have had that to accept
the ideals of an unfamiliar world would at the outset
do them more harm than good, it was because they were

(137)

[ 145 ]

rightly convinced that in the end a knowledge of a purer language of form could not fail to exert an inspiring and enlightening influence upon their own style. It was by reason of Rembrandt's acquaintance with the art of other peoples, and especially those of the south, that his personages developed from inhabitants of a small Dutch city into figures which to the eye of every observer seem to express the best in his own nature.

Not only Rembrandt's portrayals of antiquity, but also certain fragments of humanistic ways of thinking that are preserved in his biographies, remind us of the training that he received at school. Calligraphy, verse-making, and "disputations" are occasionally mentioned. For many years the painter was on friendly terms with Coppenol, one of the foremost calligraphists of Amsterdam, twice he painted his portrait, and in the inventory of his art collections there is mention of a portfolio of admirable specimens of writing which were probably from Coppenol's pen. Rembrandt himself wrote a hand that shows training. Very crabbed and unskilful by comparison is the writing of his father or his mother. He does indeed form his firm letters according to his own sovereign will, but he likes to adorn the long ones with flourishes, loves scrolling initials, and has a personal and singularly beautiful way of arranging his page.

What seem to us in his letters stilted or involved expressions may well have been thought in his day the elements of beauty of style. The current liking for "occasional" poems speaks emphatically from numerous verses in praise of his work that were composed even during his lifetime. Some are of the most naïve

(138)

and simple kind, like the lines that his pupil Philip Koninck wrote on one of the master's landscapes:

*Dees tekeningh vertoont de buiten amstelkant*
*Soo braaf getekent door heer Rembrandt's eygen hant.*

(This picture shows the Amstel's outer strand,
So bravely painted by Heer Rembrandt's hand.)

And from distiches of this sort the tributes range to the most Baroque rhymed compositions where sophisticated phrases about the relations of nature and art are woven into complicated rhythms. At least one little rhyme, a witness to the uprightness of his character, has been preserved as Rembrandt himself wrote it in 1634 in the album of a German traveller from Weimar:

(139)

*Een vroom gemoet*
*Acht eer voor goed.*

(An upright spirit
Holds honour above wealth.)

Verse-making of this kind reveals that striving for clever turns of phrase which, in all times of high artistic development, characterizes the conversational and literary intercourse of cultivated men, as we realize if we remember the sonnet-writing of the Italian Renaissance and the dialogues in Shakespeare's plays. And this striving must have been more pleasingly expressed in verbal contests — in "disputations," to use the term that was current in Rembrandt's scholarly time — than in the "occasional" poem which put trifling thoughts into complicated forms in the effort to preserve them to all eternity. Hoogstraaten, one

[ 147 ]

of Rembrandt's pupils, tells how he and his studio associates often disputed with the master upon theoretical questions, and such conversations were probably couched in the lively sparkling turns of phrase then in vogue. There was more concern for art in the utterance, for piquant brilliant retorts, than for the expression of significant ideas. For instance, one member of the circle, Carel Fabritius, asks: "How may one know whether a young painter gives promise of ability?" Hoogstraaten answers: "By the fact that, as befits his age, he not only seems to love art but actually is in love with the portrayal of nature." Or Hoogstraaten asks: "How can one tell whether a story is well interpreted?" And the answer runs: "From a knowledge of the story." There is more meaning in the advice Rembrandt himself gives his pupil when he bothers him with needless questions about the secrets of the artist's craft, but Hoogstraaten cites it chiefly on account of its admirable form — partially lost, of course, in a translation: "Take pains to use well the knowledge you already have; thus you will soon enough discover what is now concealed." Nothing testifies more clearly to the influence that humanistic culture exerted upon Rembrandt, who stood at the centre of this little circle of painters, than these deliberately artistic locutions in which at a later period he still indulged.

It is not necessary to speak farther of the importance to Rembrandt of the religious views so assiduously inculcated at the Latin school. In this connection no stress should be laid upon his school training, for the main thing was the religious feeling that was a funda-

(140)

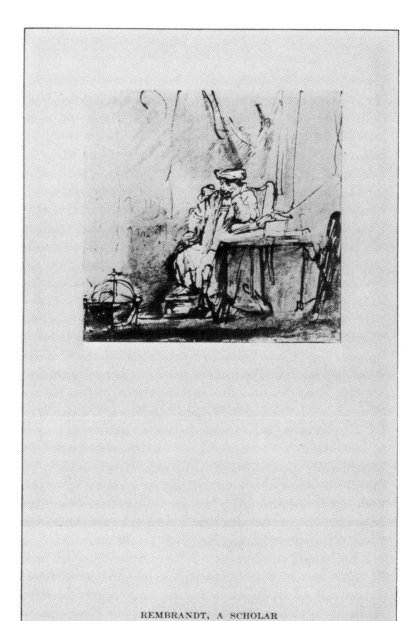

REMBRANDT, A SCHOLAR

PRINT ROOM, DRESDEN

mental part of his nature before he went to school. Yet when we remember that the boy must have had a daily familiarity with the Bible — even at home where his mother loved to absorb herself in its perusal, and perhaps read it aloud to him while he was painting her portrait — then it seems worthy of note that outside influences should have strengthened early tendencies in so marked a degree. Nor may we forget that in later days Rembrandt loved to portray the Psalmist whose songs he had sung in school, that he owned a harp, and that he was able to depict in an impressive fashion the effect of the harpstrings and the voice of song upon the wrathful spirit of Saul.

It is certain that Rembrandt did not turn his back in disgust upon scholarship when he determined to become a painter. His life's work shows that as time went on he seemed to behold, as though encircled by a nimbus, that humanistic career upon which he had entered as a child, partly, perhaps, by his own desire. In after years, so a contemporary declares, he was always one of those who liked to learn from books how to give their pictures a truly historical aspect. In fact, something like the scholar's spirit must have been part of his endowment. His art collections are another proof of this. They included, as we know, important products of almost every land and period; and while he acknowledged their value by the frequent use he made of them in his own compositions, he showed in regard to the art of other men a just discrimination, based upon historical knowledge, which in his time the historians of art did not possess — not even Vasari or van Mander. Only the modern science of criticism

(142)

[ 149 ]

judges in so well-balanced a way. Rembrandt stands almost by himself among great artists as regards this many-sided view of art; Rubens alone had the same cosmopolitan outlook. But while, as the elder artist, Rubens seems to have thought little of the Dutch master, Rembrandt admired the great Fleming and his circle in spite of the fact that their art is so alien to his own that many lovers of the one find it difficult to do reverence to the other.

Rembrandt's understanding of the scholar's spirit is manifested also in external ways. No other Dutch painter portrays with so much pleasure and sympathy the sage who is striving for knowledge. Rembrandt idealized him in pictures that, as the logical successors of the studious St. Jeromes of Primitive painters, give these a broader significance, and he interpreted the characteristics of men of learning in portraits that are more veracious than those by other artists of the time. The scholars of Jan Vermeer or Gabriel Metsu coquet with learning; they are dandies who consider how they may sit most comfortably at their desks, and who love to listen to the scratching of their own pens. Those of Gerard Dou or Thomas Wyck are pedants or slovenly dirty bookworms who shut their eyes to the beauty of the world and think that they have compassed all knowledge because they live in a cage full of folios. But the earnest eyes of Rembrandt's sages tell that an inner impulse drives them to effort, that they make use of learning to express the best in their own natures, that they have seen much of life and can give much by giving of themselves.

(143)

# The Young Rembrandt

Dürer is reputed to have said that Geertgen, the most lovable of all fifteenth-century Dutch masters, was a painter even while he was in his mother's womb. The statement is a recognition of the idea that artistic creativity is a miraculous gift. Training and hard work are of course essential, but perspiration without inspiration will only produce workmanlike results.

Dürer had good reason to believe that some men are given the ability to create from the very beginning. The famous Albertina *Self-Portrait,* drawn by Dürer with a silverpoint at the age of thirteen, shows that he was one of the most precocious artists who ever lived. It is extraordinary that the child chose himself as a subject at a time when few artists thought their own faces made worthwhile motifs. His choice of media is also noteworthy. The boy did his self-portrait in a technique which demands the greatest surety. Silverpoint lines are indelible. They cannot be erased. Confident young Dürer came off brilliantly. Only a few *pentimenti* around his hat, sleeve and pointing finger are visible in the drawing.

If we accept Van Mander's assertion that Lucas van Leyden was born in 1494, Lucas was even a greater prodigy than his contemporary Dürer. Lucas' masterly engraving of *Mohammed and the Murdered Monk* is dated 1508. If Van Mander's vital statistic is correct, Lucas made the print when he was fourteen years old. Upon the basis of stylistic evidence more than a score of Lucas' engravings can be dated before the Mohammed print. Van Mander prepares us for this astonishing conclusion. He writes that Lucas began to make beautiful engravings when he was a child of nine, that is in 1503. Is such precocity possible? How could a boy handle an engraver's burin with such virtuosity? And what is even harder to understand, how could a child show the psychological insight found in the prints assigned to Lucas' early phase? These queries have led some students to doubt Van Mander's facts, but a review of the evidence strengthens rather than weakens belief in his account.[1] Scepticism, however, is understandable. Child prodigies are rare in the history of the visual arts. No artist can match

(145)

---

[1] Good reasons for accepting the reliability of Van Mander's biographical data are found in Max J. Friedländer, *Lucas van Leyden,* ed. F. Winkler, Berlin, 1963, pp. 7 ff.

120

Mozart who composed little pieces at the age of four. The youthful works by Dürer, Lucas van Leyden, and a few others — Picasso's name belongs on the list — are notable exceptions.

When Rembrandt's earliest known pieces are compared with the first efforts by his illustrious townsman Lucas van Leyden, the man who became Holland's greatest painter looks like a slow starter. Rembrandt was born in Leiden July 15, 1606. The earliest dated work which can be attributed to him is inscribed 1625 — thus it was made when he was about eighteen or nineteen years old. A few other works ascribed to him may have been made around the same time. Nothing much earlier is known.

Rembrandt's earliest works burst with energy, but they can hardly be called youthful masterpieces. On the contrary, they suggest that Rembrandt struggled and worked incessantly to gain the facility which came earlier and with greater ease to others. However, it should be noted that Rembrandt did not make his appearance as late as the other two leading seventeenth-century Dutch masters. Frans Hals was at least twenty-six, and he may have been as old as thirty, before he appeared on the scene. Vermeer was about twenty-two or twenty-three years old before he produced a work that is now recognized as his.

As far as we know Rembrandt gave no unmistakable signs of artistic genius during his early boyhood. If he did they were not recognized or taken seriously by his father, for at the age of seven, Rembrandt was enrolled at the Latin school of Leiden. Matriculation at the school designed to prepare students for entrance to the University of Leiden, the center of higher learning of the new Republic, was not the normal procedure for a boy who was going to become an artist. No seventeenth-century Dutch father thought of giving his son a liberal education as preparation for life as a painter. A Dutch boy destined to be an artist was apprenticed to a painter straightaway. Rembrandt's close friend Jan Lievens was sent to work with a Leiden artist at the age of eight. The reliable historian Orlers, our primary source for the early life of Rembrandt, tells us in his history of Leiden published in 1641 that Rembrandt's parents had different plans for their son. They wanted to send him through the University of Leiden to equip him for a career as a public servant. Rembrandt's father, who was a miller, probably wanted to see his son improve his station in life.

Rembrandt spent seven years at the Latin School, the time prescribed by Erasmus who wrote that the future humanist should play for seven years, attend school for seven years and study for seven years at the

university. The main purpose of the school was of course the mastery of Latin. The curriculum included study of Caesar, Cicero, Horace, Terence, Ovid and Aesop, and whenever possible the boys were supposed to converse in Latin. Work at the school did not make a humanist of Rembrandt, but as his historical and mythological works show, studies there stood him in good stead for more than half a century. There is no foundation for the statement, made by some critics of later centuries as an accusation, and put forth by others as a proud boast, that Rembrandt was an inspired ignoramus.

It was not an affectation for Rembrandt to sign his early works with the monogram of RHL, which stands for the Latin form of his name, Rembrantus Harmensis Leydensis (Rembrandt the son of Harmen of Leiden). He heard his name Latinized from the moment he entered the Latin school, and it was put in a Latin form when he enrolled as a student at the University of Leiden. He was matriculated at the famous University on May 20, 1620, almost two months before his fourteenth birthday.

Young Rembrandt's stay at the University was brief — perhaps he did little more than register. Orlers states in his biography that Rembrandt had no desire for academic studies. His only interest was in drawing and painting. For this reason, Orlers adds, he was withdrawn from school. Orlers does not mention that Rembrandt was actually enrolled at the University. He only notes that the boy's parents wanted to prepare him for work there.

The conflict young Rembrandt and his parents faced is a familiar one. Should the boy be trained for life as an artist, or educated for a life which art would enrich? In Rembrandt's day a choice had to be made between one or the other. The compromise solution offered in our time by most American institutions of higher learning, where it is possible to study the practice of art as well as the traditional academic disciplines, had not yet been invented.

Rembrandt, we are told, was sent to a painter to learn the fundamentals of art. The name of the man who had the honor to give the boy his first formal instruction is not known. He was then sent to work with the obscure Leiden artist Jacob van Swanenburgh who specialized in painting architectural scenes (fig. 1) and views of Hell. Van Swanenburgh worked in Italy for a time, but remained impervious to Italian influence. Rembrandt was with Van Swanenburgh for three years, that is from the time he was about fourteen or fifteen until he was seventeen or eighteen years old. It is not known how teacher and pupil got on, but

122

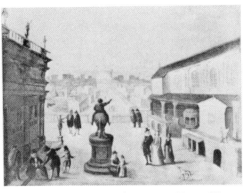

1   Jacob van Swanenburgh, *Fantastic View of Piazza del Campidoglio and Castel S. Angelo,* 1604
        formerly Semenov Collection, St. Petersburg

2   Jan Lievens (copy after), *Boy in a Studio*          London, National Gallery

it is significant that as far as we know, Rembrandt, who depicted almost every subject during the course of his long and productive career never painted an architectural scene or a view of Hell.

His early training was probably the usual one of making drawings after other works of art, and then drawing from plaster casts. A painting by Lievens[2] (fig. 2) of a youth in a studio shows some of the paraphernalia with which a Dutch apprentice worked. The prominent plaster cast in the picture is one of the Christ Child from Michelangelo's *Madonna and Child,* which has been in the church of Notre Dame at Bruges at least since 1521, when Dürer reported having seen it there. Rembrandt soon began to accumulate his own collection of casts of classical and modern sculpture — including one of Michelangelo's Christ Child — which he used for instructional purposes as well as his own work. Publicity recently given to *Aristotle Contemplating the Bust of Homer* has made everyone familiar with at least one cast in his large collection; all

[2] H. Schneider, *Jan Lievens,* Haarlem, 1932, no. 129, p. 123, identified the Louvre version of this picture as a characteristic early work by Lievens. A replica of it, now at the National Gallery, London, is reproduced here. Neil Maclaren, *The Dutch School, National Gallery Catalogues,* London, 1960, no. 3591, p. 411, suggests that the Louvre version is probably a youthful work by Wallerant Vaillant made with some early work by Lievens in mind, but he adds, the attribution to Vaillant "cannot be confirmed in the absence of a comparable work."

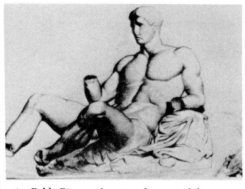

4 Pablo Picasso, drawing after cast of the
Parthenon 'Dionysus'  location unknown

3 J. A. D. Ingres, drawing after cast of a classical head, 1789
             formerly Henry Lapauze Collection

(149)

of them are itemized in the well-known 1656 inventory of his effects
made in preparation for the sale held to satisfy his creditors. A handful of
Rembrandt's mature drawings after casts have been identified, but none
of his youthful ones have been discovered. If early ones turn up one day,
they probably will not differ much from the study made by Ingres after
a classical head (fig. 3) at age nine, or the drawing Picasso made at twelve
of a cast of a figure from the Parthenon (fig. 4). They will be precise
studies of the effect of light and shadows on form. With the benefit of
historical hindsight we can discern premonitions of mature modes and
moods in the *juvenilia* of Ingres and Picasso. One wonders if drawings
done by young Rembrandt at the same early stage would provide similar
indications.

Van Swanenburgh, the specialist in architectural views, probably
helped Rembrandt master the rudiments of perspective. The most pop-
ular handbooks on this important subject during Rembrandt's day were
those published by Vredeman de Vries. It is reasonable to assume that
Van Swanenburgh had some of Vredeman de Vries' volumes in his
studio, for the plates in them were useful for the young pupil trying
to resolve complicated perspective problems such as the one posed by a
spiral staircase (fig. 5). Rembrandt's masterful drawing of an interior
(fig. 7) made in the early 1630's which represents a spiral staircase with
a few swift strokes of the pen and some bold washes shows how brilliant-
ly Rembrandt learned his lesson. Perspective handbooks of the period
must also be counted among the sources for the fantastic architectural

124

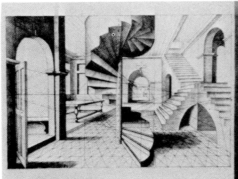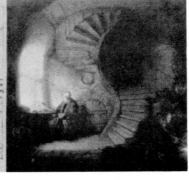

5  *Perspective Study,* designed by Jan Vredeman de Vries, engraved by Hendrik Hondius, published in *Perspective, id est celeberrima ars . . . Lvgdvni Batavorvm 1604, pl. 36*

6  Rembrandt, *Two Figures in an Interior with a Winding Staircase,* 1633, detail

Paris, Louvre

(150)

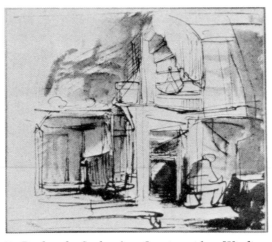

7  Rembrandt, *Study of an Interior with a Winding Staircase,* pen and wash drawing
Copenhagen, Kobberstiksamling

interiors (fig. 6) Rembrandt invented to help set the mood for his early subject and genre pictures.

According to Orlers, Rembrandt showed such great promise during his three years with Van Swanenburgh that his father, in order to place

125

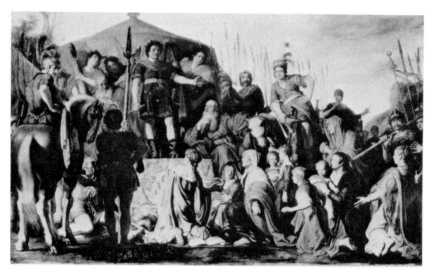

8    Pieter Lastman, *Coriolanus Receiving an Embassy of Roman Matrons*
Dublin, Provost's House, Trinity College

(151)

him to his best advantage, sent him to work with the leading history painter, Pieter Lastman, in Amsterdam. Lastman had been in Rome during the first decade of the century, where he studied the paintings of Caravaggio, and where he was even more impressed by the works of Adam Elsheimer, a German painter who settled in Italy. Elsheimer, like Caravaggio, was aware of the expressive effects which could be achieved by manipulating light and shadow. The mysterious mood and dramatic power of his small, meticulously finished pictures were carried to Holland by Lastman and other Dutchmen who fell under the German artist's spell. Elsheimer also influenced the brothers Jacob and Jan Pynas who had been to Rome and were working in Amsterdam when Rembrandt arrived. There is probably some truth to the old tradition that Rembrandt studied with Jacob Pynas and was stimulated by his brother Jan.[3]

[3]  Arnold Houbraken, *De Groote Schouburgh ...* Amsterdam, 1718, I, is the source for the suggestion that Rembrandt had contact with the Pynas brothers. He writes that after Rembrandt spent six months with Lastman he spent "nog eenige maanden by Jak. Pinas tot hy besluit nam van voortaan by zig zelven de konst te oeffenen . . . Anderen willen dat Pinas zyn eerste onderwyzer in de konst zou geweest zyn" (*ibid.*, pp. 254-255). Houbraken notes in his biography of Jan Pynas: "Zyn penceelwerk helde naar den bruinen kant, waarom vele

126

Rembrandt stayed with Lastman for about six months. This must have been around 1624. Lastman's *Coriolanus Receiving an Embassy of Roman Matrons,* (fig. 8) painted in 1622, is characteristic of the work this artist was doing when Rembrandt went to study with him. As usual, Lastman's subject is a dramatic one requiring a great number of figures. Lastman shows the Roman matrons led by Coriolanus's own mother and wife imploring the renegade Roman not to invade his native city. It is the exciting moment before Coriolanus yields to their supplication and shouts: "Mother you have saved Rome, but destroyed your son!" Lastman does not want us to miss a thing. The figures have been crowded into the foreground, where all the details and the expressions of the solidly modeled members of the crowd, who react in various ways to the tense situation, can be studied. The contrast between light and shadow is harsh, the paint is glossy and the bright colours are intense.

Comparison of Lastman's *Coriolanus* with Rembrandt's recently discovered *Stoning of St. Stephen*[4] of 1625 (figs. 9, 11, 18), now in the Museum at Lyon, as well as with other works painted during his first phase, shows how decisive the young artist's short encounter with his third teacher was. Rembrandt's early style is primarily derived from Lastman, and it was probably the Amsterdam artist who inspired the Leiden youth to become a history painter and not a specialist in one of the other genres which attracted most seventeenth-century Dutch artists. Rembrandt was in dead earnest about his calling. From the beginning until the end of his career he worked as a history painter. He dedicated himself to the branch of painting Renaissance and Baroque artists and theorists implicitly or explicitly accepted as most noble and worthwhile. As far as we know Rembrandt did not make a commissioned portrait from the time he began his independent activity in Leiden around 1624-

(152)

gelooven dat Rembrandt hem daar in na geaapt heeft" (*ibid.,* 214-215). Houbraken also knew that as early as 1675 it was claimed that the Leiden painter Joris van Schooten was one of Rembrandt's teachers. For a discussion of the trustworthiness of this assertion see Seymour Slive, *Rembrandt and His Critics: 1630-1730,* The Hague, 1953, note 4, pp. 195 f.

4   The author is grateful to Horst Gerson for generously lending him photographs of the work and a copy of the typescript of his note on the picture which will appear in *Bulletin des Musées et Monuments Lyonnais,* III (1962-66), no. 4, p. 57 (trans. Ilse Gerson). His note is the source for the material on the painting presented here. It has been at the Museum of Lyon since it was bought at a public sale in 1844. It is cited as a "oeuvre de l'école de Rembrandt" in a catalogue of the Lyon Museum published in 1854. The painting is on panel and measures 89.5 x 123.6 cm. It has virtually the same dimensions as Rembrandt's painting of an unidentified historical subject, inscribed with a faint date usually read 1626, now at the Lakenhal in Leiden. The latter is on panel and measures 91 x 121 cm (reproduced, A. Bredius, *Rembrandt, Gemälde,* Vienna, 1935, no. 460). The circumstances of the discovery of the Lyon painting are discussed below.

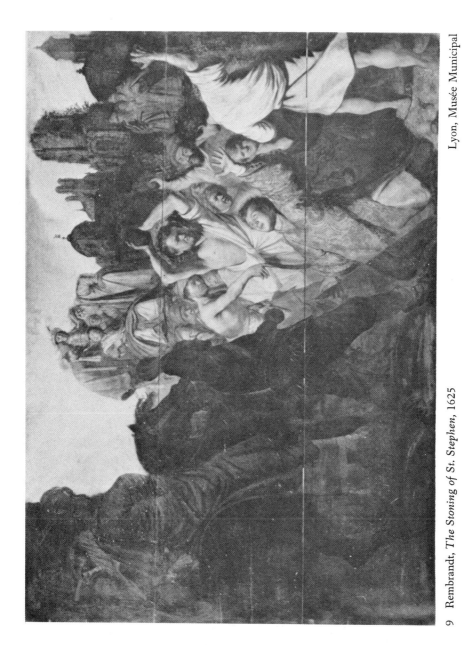

9  Rembrandt, *The Stoning of St. Stephen*, 1625

Lyon, Musée Municipal

(153)

25 until late in 1631 when he moved to Amsterdam. And even during his first decade in the great metropolis, when he was the most fashionable portraitist of the city, and it was said that patrons had to beg as well as pay him for a portrait, he never devoted himself exclusively to painting faces. Landscape painting did not attract him until about a decade after he left Lastman. History pictures — especially Biblical subjects — were always his principal preoccupation.

After his brief stay in Amsterdam Rembrandt returned to Leiden, where, now eighteen or nineteen years old, he started his activity as an independent artist. Unlike his teachers he did not travel to Italy to continue his education. The breathtaking progress he made during the next three or four years proves that he did not offer Constantin Huygens merely a polite excuse when he told him he had no time for travel. Huygens confirms the impression that Rembrandt worked day and night. He notes in his diary that the young artist worked so diligently there was reason to fear for his health.

Before Rembrandt's *Stoning of St. Stephen* of 1625 was recognized, the earliest signed works were dated 1626.[5] Thus, the St. Stephen picture adds a firm year to our scanty knowledge of Rembrandt's formative years. This important addition was a result of the systematic research conducted is recent years by The Netherlands Institute for Art History at The Hague. A photograph of the panel was among those sent to the Institute in 1961 of works exiled to the storeroom of the Museum at Lyon. At Lyon the picture was vaguely attributed to "l'école de Rembrandt." The picture intrigued Horst Gerson and Sturla Gudlaugsson of the Institute at The Hague. Upon the basis of the photograph these expert connoisseurs ascribed the work to Rembrandt himself and dated it around 1625 since the painting fits perfectly with what is known about Rembrandt's beginnings. Their conclusions were confirmed in October 1962 when they viewed the painting in Lyon. A swipe with a damp swab revealed a large Rembrandt monogram in the upper left corner and the date 1625.[6]

It must be obvious to everyone that the painting now at Lyon insisted upon remaining anonymous until it learned about the events organized at Oberlin College to honor Professor Wolfgang Stechow. Well aware of Professor Stechow's numerous contributions to the enjoyment

[5] See note 15 below for a discussion of the date inscribed on Rembrandt's *David Presenting the Head of Goliath to Saul*, Bredius, *ibid.*, no. 488, Kunstmuseum, Basel, which has been read as 1625 and 1627.

[6] Horst Gerson states that he is not certain if the monogram should be read as the usual Leiden interconnected monogram: RHL, or as R.f.

(154)

129

and understanding of Rembrandt's works, and knowing that a signed and dated Rembrandt of 1625 would be of some interest to him, and confident that it qualified to take part in a symposium on youthful works by great artists, it decided to reveal its existence a few months ago. It is difficult to cite better proof for the belief that pictures lead a life of their own.

The St. Stephen picture shows how much young Rembrandt learned in Amsterdam. He is still full of admiration for his well-known teacher and tries hard to emulate him. In a few short years he will surpass Lastman, but he will not forget him, for even when Rembrandt was an internationally known figure, with his own unmistakable style, he found it worthwhile to make close copies after his old master's pictures. Most of Rembrandt's own pupils adopted quite a different attitude when they left their master's studio.

In the St. Stephen picture the emphatic gestures and intense expressions, as well as the close attention to detail, the strong outlines and pasty paint, recall Lastman. The fantastic bits of architecture, and pieces such as turbans, slashed berets and plumes were props commonly used by Lastman and other Amsterdam followers of Elsheimer. All the bits and pieces have not yet been fitted together into a satisfactory whole. Rembrandt's immaturity is evident in the overcrowding and the confused spatial relationships. Quite original, however, is the way the horsemen and figures on the left have been massed into a group by a dark shadow which suppresses detail in almost half the picture. This arrangement focuses attention on the main action and intensifies the mood. There is nothing comparable to it in Lastman's *oeuvre*. Jan Pynas, who has been cited as one of Rembrandt's models, sometimes placed a shadowed figure in the foreground of his paintings. However, he used such forms primarily as a *repoussoir,* the way the late mannerists did, to establish the front plane of the picture. The effectiveness of young Rembrandt's use of light and shadow becomes patent when his St. Stephen picture is compared with one painted in 1617 by Jacob Pynas[7] of the same subject (fig. 10). It will be remembered that Jacob Pynas, brother of Jan, has been called one of Rembrandt's teachers. He was active in Amsterdam when Rembrandt was there and it is quite possible that the student from Leiden saw his version of the martyrdom of St. Stephen. Comparison of the two works shows what sets the youthful painter apart from the very beginning. Pynas captures little of the drama of the Saint's death

(155)

[7] The picture was published by Gabriel v. Térey, "Unbekannte Werke seltener niederländischer Maler des 17. Jahrhunderts," *Der Cicerone* XVIII (1926) p. 798f., where it is listed as in a private collection in Budapest.

(156)

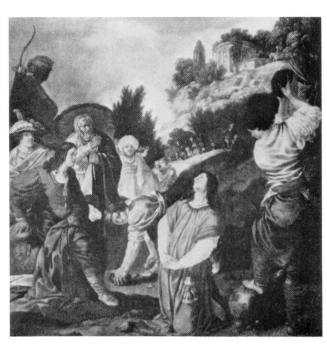

10   Jacob Pynas, *The Stoning of St. Stephen,* 1617
formerly private collection, Budapest

(Acts 7). Rembrandt did what he could to heighten it. He painted a
scene of mob violence. Rembrandt's crowd is one which reacted to
Stephen's charge that his accusers were "stiffnecked and uncircumcised
in heart and ears." They are the impassioned ones who "were cut to the
heart" and who "gnashed their teeth." Ten years later, at the height of
his High Baroque phase, when Rembrandt deliberately chose the most
violent themes for his works, he depicted the lynching of St. Stephen
again, this time in an etching (Bartsch 97). It is not unusual to find
Rembrandt returning to a motif he worked on in his youth. As is often
the case, the germ for a later solution is found in his first effort. The
etching corrects the awkward qualities of the earlier representation.
Greater concentration on the main theme heightens the gruesome
aspects of the martyrdom. The moment shown is also more horrifying.
The deacon has been reduced to insensibility, yet his savage persecutors
continue to stone him.

131

11  Rembrandt, self-portrait, detail, *Stoning of St. Stephen,* 1625

12  Rembrandt, *Self-portrait,* pen and wash drawing
London, British Museum

(157)

14  Rembrandt, self-portrait, detail, an unidentified historical scene, 1626
Leiden, Lakenhal

13  Rembrandt, self-portrait, detail,
*A Group of Musicians,* 1626
U. S. A., private collection

It is significant that in the 1625 painting Rembrandt put the important group witnessing the martyrdom in the background far behind the main action. Rembrandt's predilection for developing a composition in depth is apparent from the very beginning. The momentary gesture of the man seated on high who points to the brutal event while looking up at one of his companions indicates that the artist was already making penetrating observations of people and their relationship to each other. One of the heads in the picture — the one looking at the scene in pained horror just below the arm of the man holding a rock with both hands high above his head — reveals that Rembrandt was also making studies of his own physiognomy at this date. It is a self-portrait (fig. 11), the earliest known one by the artist who represented himself more frequently than any other master. During his Leiden years Rembrandt frequently used himself, as he used members of his family, for the study of facial expressions and chiaroscuro effects (fig. 12). His early etched self-portraits offer a gallery of the emotions: laughter, intense concentration, pain, astonishment, and so on. These prints must have been eagerly collected by artists as models for their own work, as well as by seventeenth-century collectors of graphic art. Rembrandt included himself in Biblical scenes, as he did in the 1625 painting, more than once. He appears in two of his five extant paintings dated 1626: as a harpist (fig. 13) in a genre picture which may be an allegorical representation of the sense of hearing; and as a solemn witness (fig. 14) to an unidentified historical scene. Independent paintings of himself appear within a year or two and Rembrandt continued to make them until the year of his death in 1669. Today almost one hundred self-portraits of Rembrandt are known. They form an unique autobiography in the history of art and are an intimate record of the artist's conception of himself in every mood: as a gay gallant, as a respectable burgher, as a majestic master conscious of his unmatched power, and as an aged, humble man who has plumbed the innermost secrets of his soul.

A crude pen and wash drawing (fig. 15), not without some vigour, which is now in the British Museum, should be mentioned in connection with the Lyon painting. It was formerly ascribed to Joris van Vliet,[8] an early follower and copyist of Rembrandt. The attribution of the drawing to Van Vliet is understandable. He was responsible for some of the more miserable works produced by Rembrandt's first followers. In recent years the attribution to Van Vliet has been discarded. Students of seventeenth-century Dutch art now agree the shortcomings in the work

[8] Arthur M. Hind, *Catalogue of Drawings by Dutch and Flemish Artists . . . in the British Museum*, London, 1915, I, p. 95.

133

(158)

are those of a beginner, not of an uninspired imitator, and that the drawing was probably made in the early 1620's by either Rembrandt or his close friend Jan Lievens.[9] If it is by Rembrandt, it must be considered one of his earliest known efforts.

Since the subject of the drawing has been identified as the *Stoning of St. Stephen* by all the Rembrandt specialists who have discussed it, discovery of Rembrandt's painting of the martyrdom of St. Stephen of 1625 draws attention to the British Museum sheet again. But before attempts are made to relate the drawing to the Lyon painting it should be noted that it probably does not represent Stephen's martyrdom. Andrew Pigler pointed this out in 1939.[10] Pigler's remarks, which were published in his article appropriately titled "The Importance of Iconographical Exactitude," were overlooked by experts working on the attribution of the drawing. He observes that the British Museum sketch represents the martyrdom of an old and bearded man, which does not fit the traditional conception of Stephen. This is correct. Rembrandt followed a venerable tradition when he shows the deacon as a young man in his two representations of the saint. Stephen also appears youthful in a Dutch drawing, now at Berlin, which was made around the same time that young Rembrandt was at work on the Lyon painting. The attribution of the Berlin drawing has been disputed,[11] but there can be no question about the artist's idea of the period of life Stephen had reached when he was martyred. Pigler rightly notes that other saints were stoned at an advanced age. St. Paul was stoned at Lystra, "though

(159)

---

9 The attribution to Lievens was made by Kurt Bauch, "Rembrandt und Lievens," *Wallraf-Richartz-Jahrbuch*, XI (1939), pp. 241 ff. J. G. van Gelder, "Rembrandt's Vroegste Ontwikkeling," *Mededelingen der Koninklijke Nederlandse Akademie van Wetenschappen, Afd. Letterkunde, Nieuwe Reeks*, Deel 16, No. 5, Amsterdam, 1953, p. 8, argues for an attribution to young Rembrandt. Bauch discusses the drawing once again as a work by Lievens in *Der frühe Rembrandt und seine Zeit*, Berlin, 1960, p. 216.

10 Andrew Pigler, "The Importance of Iconographical Exactitude," *The Art Bulletin*, XXI (1939), pp. 230 ff.

11 Cornelis Müller, "Studien zu Lastman und Rembrandt," *Jahrbuch der Preussischen Kunstsammlungen*, L (1929), pp. 61 ff., reprod. p. 62, fig. 12, ascribes the sheet to Lastman and considers it a prototype for Rembrandt's 1635 etching of the same subject. It is hard to accept this attribution. Elfried Bock and Jakob Rosenberg, *Staatliche Museen zu Berlin, Die Zeichnungen alter Meister, Die niederländischen Meister*, Berlin, 1930, no. 10323, p. 172, rightly point out: "Das Blatt fällt aber durch einen bewegteren Zeichenstil aus der Gruppe der sonst bekannten Lastman-Zeichnungen heraus und dürfte eher, da es auch an Moeyaert erinnert, ein Frühwerk von Salomon Koninck sein (Bestimmung von H. Lütjens), dessen Frühwerke den doppelten Einfluss von Lastman und Moeyaert zeigen." The paucity of drawings which can be attributed without question to Salomon Koninck make it difficult to ascribe the work to him without reservation. The possibility that it is work by Moeyaert should not be excluded.

134

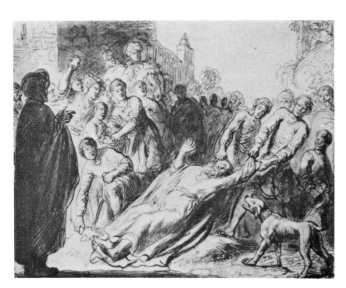

15 Jan Lievens, *The Stoning of St. Paul,* pen and wash drawing
London, British Museum

he escaped death, his companion, Barnabas, died in this manner on the island of Salamis. But as the martyrdom of the latter is only mentioned in the Apocrypha, the drawing represents in all probability the fate of St. Paul."[12]

Though both Rembrandt and Lievens knew the Apocrypha and could have represented the legend of the martyrdom of Barnabas, and although the possibility that a young artist made the British Museum drawing as a martyrdom of St. Stephen before he was familiar with the established tradition for its representation, the case for accepting Pigler's identification of this drawing as St. Paul is a strong one. The Bible says nothing about Stephen or Barnabas being dragged, but we are told that after the people stoned St. Paul, supposing him to be dead, they drew him out of the city (Acts 14, 19).

Who made the coarse British Museum drawing? Is it Rembrandt *avant* Rembrandt? What deficiencies will we permit young Rembrandt? Or is it by young Lievens? Ever mindful of Max Lieberman's observation that art historians exist to eliminate poor works from the *oeuvre* of a master, it still seems reasonable to assign the British Museum sheet to the

[12] Pigler, p. 233.

135

convincing group of drawings Kurt Bauch ascribed to Jan Lievens. A characteristic drawing of this group is the pen and wash drawing of *Christ Praying at Gethsemane* (fig. 16), now at Dresden, which is inscribed "Livens."[13] These drawings are characterized by exaggerated, almost grotesque gestures and expressions. The forms are large and tend to be bloated, outlines are thick, surfaces are modeled with a distinctive pattern of cross-hatching and dots, and the large areas of dark wash tend to obscure rather than order forms in space. It can be argued, however, that Rembrandt's early drawings may have had quite the same characteristics and might easily be mistaken for works by Lievens. After all it is known that Rembrandt and Lievens were in close contact during their Leiden years. Though Lievens was a year younger he was far more advanced at the beginning of their careers. We have already noted that Lievens began his training in Leiden at the age of eight. When he was around ten he was sent to Amsterdam to work with Lastman for two years. Twelve or thirteen years old, Lievens then returned to Leiden and began his independent activity as an artist. At this time Rembrandt was in the sixth form of the Leiden Latin School, and when Rembrandt was sent to learn the rudiments of art around 1620-1621 Lievens was already a competent technician making proficient copies and portraits. Before Rembrandt could match Lievens' performance five or six years had to pass — an aeon in a boy's calendar.

(161)

It is not difficult to imagine that there was a time when Rembrandt received help and criticism from the more advanced Lievens, and as one boy emulating another he probably adopted his mannerisms. After Rembrandt caught up with Lievens there is no indication that an unwholesome rivalry developed between the two friends. The young masters shared models and worked on similar themes during their Leiden years. They also collaborated. Lievens' *Portrait of a Boy,* now at the Rijks-

[13] Bauch's arguments for assigning this group to Lievens are set forth in the studies he published in 1939 and 1960 cited above in note 9. See Van Gelder's study of 1953, also cited in note 9, for the view that the group is by young Rembrandt, not Lievens. It should be noted that there is disagreement about the authenticity of the "Livens" signature on the Dresden drawing of *Christ Praying at Gethsemane* (fig. 16). In 1932 H. Schneider assigned the drawing without reservation to Lievens in his monograph on the artist (p. 187, Z8), but stated that it is "von anderer Hand bezeichnet: Livens." Bauch states that the drawing is "bezeichnet 'Livens'" in his 1939 article (p. 256, note 18) without comment about its authenticity, and in 1960 (p. 216) writes that the drawing can be safely assigned to Lievens because of its signature. Van Gelder (1953), p. 11, states flatly that the signature is false and for this reason the drawing has been wrongly ascribed to Lievens instead of Rembrandt. Though the Lievens group assembled by Bauch does not stand or fall upon the authenticity of this signature, the case for accepting the group as the work of Lievens would be considerably strengthened if the signature were autograph.

136

16  Jan Lievens, *Christ Praying
at Gethsemane,* pen and
wash drawing
Dresden, Kupferstichkabinet

(162)

museum, which is easily recognizable as his work by the characteristic
puffy cheeks of the model, is inscribed "Rembrandt geretucee... Lieve
..." (Lievens retouched by Rembrandt), and a *Portrait of an Old Man*
of 1632 at the Fogg Art Museum bearing an authentic Rembrandt sig-
nature shows unmistakable traces of the soft, silky touch Lievens de-
veloped around 1630. No wonder it is sometimes difficult to separate
their hands. A case in point is the energetic drawing of a *Mounted
Trumpeter* (fig. 17) accepted by some as a Lievens and by others as a
Rembrandt of around 1624-25.[14] The sharp contrasts of light and dark,
the heavy calligraphic lines, and the modeling with hatching and dots
make evident its connection with the group of drawings given to Lievens.

[14] First published as a work by Rembrandt of around 1624-25 by J. G. van
Gelder, *The Burlington Magazine,* XCI (1949), p. 207 and discussed again as a
youthful work by him in his article of 1953, p. 7 f. J. Q. van Regteren Altena,
"Tekeningen van Rembrandt," *Bulletin van het Rijksmuseum,* I (1953), p. 55,
published it as an early Rembrandt with the suggestion that the date 1636 in
the upper left corner of the drawing (which is not original) may be based upon
an erroneous reading of 1626. Otto Benesch, *The Drawings of Rembrandt,*
London, 1954, I, no. 21a, accepts the work as a Rembrandt and dates it 1627-28.
Bauch (1960), p. 217, ascribes it to Lievens.

18  Rembrandt, detail, *Stoning of St. Stephen*, 1625

(163)

17  Jan Lievens, *Mounted Trumpeter*, pen and wash drawing
Amsterdam, Rijksprentenkabinet

On the other hand, its similarity to the turbaned horseman in Rembrandt's 1625 Lyon painting (fig. 18) and its close relation to the prominent horseman in Rembrandt's *David Offering the Head of Goliath to Saul* (variously dated 1625 and 1627[15]) in the Kunstmuseum, Basel, is also striking. Is the *Mounted Trumpeter* an early drawing by Rembrandt done in Lievens' manner? Does the young artist's inexperience explain weaknesses, such as the lack of coördination between the pen work and the washes on the hind quarters of the horse which gives the animal an original, but improbable anatomy? Affirmative answers to these questions would not be unreasonable, but until additional material is brought to light showing that Rembrandt did, in fact, simulate Lievens' drawing style so closely, it seems prudent to ascribe the sheet to Lievens.

The large unsigned painting of *Esther's Feast* (fig. 19; p. 190), now in the museum at Raleigh, North Carolina, is another work that can be dated around 1625. It has been ascribed to Rembrandt by one group of specialists, and to Lievens by others.[16] King Ahasuerus and Haman are at the banquet prepared by Esther. She has just made her accusation: "The adversary and enemy is this wicked Haman. Then Haman was afraid before the king and queen" (Esther 7,6). Enraged Ahasuerus clenches his fists in wrath, while behind him stands his chamberlain

(164)

[15] There is no consensus about the date inscribed on this picture. Bredius, p. 21, no. 488, reads it as "1627(?)," and adds "Das Datum ist nicht mehr deutlich zu lesen." W. Martin, "Uit Rembrandt's Leidsche jaren," *Jaarboek van de Maatschappij der Nederlandsche Letterkunde te Leiden*, 1936-1937, p. 62, note 2, wrote that he saw the painting before it was cleaned, shortly after it was discovered in 1909, and at that time it was clearly inscribed 1625 ("Schrijver dezes zag in 1909 het paneeltje toen het pas was ontdekt en nog niet was schoongemaakt. Hij las toen zeer duidelijk 1625"). If Martin's memory served him well, the Lyon *Stoning of St. Stephen* is not the only extant work by Rembrandt dated 1625. Bauch (1960), p. 119, has no doubts about the date; he categorically asserts the date inscribed on the picture is 1627 ("das Datum ist völlig klar lesbar"). It is of course not possible to take a stand on this problem without making a first hand examination of the work. However, the clarity of the spatial order and the free treatment of the liquid paint in the small Basel sketch (26.5 x 38 cm) suggest it was painted later than the Lyon *Stoning of St. Stephen*.

[16] The picture was published as an early Rembrandt by J. G. van Gelder in *Elsevier's Maandschrift*, 1937, and again in "Rembrandt's Vroegste Ontwikkeling," p. 9 ff. W. R. Valentiner also vigorously defended the attribution to Rembrandt and called it "An early work, probably 1626" in his *Catalogue of Paintings, North Carolina Museum of Art*, 1956, no. 65, pp. 51-52. Horst Gerson, "Probleme der Rembrandtschule," *Kunstchronik*, X (1957), p. 122, ascribes it to Lievens: "Im Gegensatz zu van Gelders Meinung erscheint der 'Ahasver' in Raleigh durch seine bombastische Aufmachung eher als ein Werk des Lievens." Bauch (1939), p. 240, note 6, wrote that the picture is surely by Rembrandt, but may show traces of another hand; in 1960, pp. 112 ff., he repeats this view and suggests the second hand may be Lievens'.

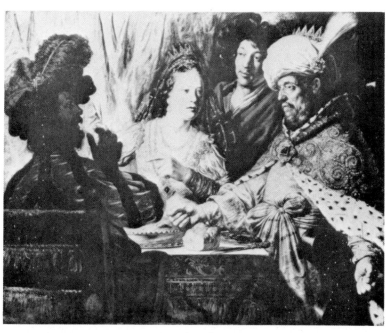

19   Rembrandt, *Esther's Feast*        Raleigh, North Carolina Museum of Art

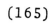

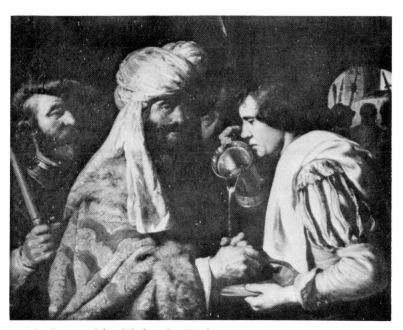

20   Jan Lievens, *Pilate Washing his Hands,*
                    Capetown, South Africa, Princess Labia Collection

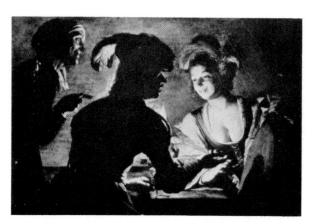

21   Gerrit van Honthorst, *The Procuress,* 1625
Utrecht, Centraal Museum

Harbonah, who already appears to have in mind his recommendation
that Haman should be hanged from a recently constructed gallows fifty
cubits in height. The life-size painting of half-length figures around a
table has little in common with Lastman's pictures done in the Elsheimer
tradition. It shows the unmistakable influence of the Utrecht Caravag-
gesque painters who returned to the Netherlands around 1620 with a
firm grasp of what the great innovator Caravaggio accomplished with
his realism and chiaroscuro effects. Thanks to the Utrecht *Caravaggisti,*
Dutch painting came into contact with this important current of Italian
Baroque art, which had a decisive influence on Frans Hals as well as
Rembrandt, and, in the following generation, stimulated Vermeer. Ger-
rit van Honthorst, the leading Caravaggesque painter of Utrecht, popu-
larized nocturnal scenes illuminated by a source of light hidden by a
figure dramatically silhouetted in the foreground (fig. 21). As the Raleigh
picture shows, the device quickly became part of the stock-in-trade of
Dutch artists. Highly illusionistic pictures of half-length life-size groups
and single figures soon became the *dernier cri.* Lievens, who worked on
a large scale from the beginning, was attracted by the new fashion. His
*Boy Blowing on a Dish of Coals* (fig. 22) is one of his early attempts to
follow Honthorst's tricks with artificial light. The modeling of the boy's
bumpy puffed cheek, bare shoulder, and knotty hand recall some of the
anatomical difficulties encountered by the artist who made the drawing
of the *Mounted Trumpeter* (fig. 17). Passages such as these lend support
to the attribution of that drawing to Lievens. Lievens' *Boy Blowing on*

141

a *Dish of Coals* also shows the impact of Terbrugghen, by far the most gifted of the Dutch *Caravaggisti,* but the beautiful classical rhythms Terbrugghen incorporated in his works were never understood by him.

The exceptional size of the Esther picture — it measures 53″ x 65″ — has led some to reject the attribution to Rembrandt in favour of Lievens, but surely young Rembrandt must have been willing to attempt a work on a grand scale at least once during his early years. Lievens' own preoccupation with life-size pictures could have inspired Rembrandt to try his hand at a work done on the same scale soon after he returned to his native city from Amsterdam.

Yet another argument that can be raised in favour of Lievens' authorship of the Raleigh picture is the close similarity of parts of the work to a drawing[17] which belongs to the same Lievens group as the *Stoning of St. Paul* and the *Mounted Trumpeter* sketches. This drawing represents King Porsenna watching Scaevola put his right hand in fire to show his indifference to the order that he was to be burned alive. Likenesses between the figure of Porsenna in the drawing (fig. 23) and King Ahasuerus in the painting are indeed remarkable. The figures not only assume the same attitudes but they wear the same clothing and jewelry. These correspondences, however, do not prove that drawing and painting are by the same hand, for it seems that at this juncture the young friends already copied and borrowed from each other's works, as well as used the same models and studio props. If the unsigned painting of *Pilate Washing his Hands* (fig. 20), which must have been made around the same time as Esther's banquet, was painted by Jan Lievens,[18] as there is reason to suppose, we have some evidence for this hypothesis. The man who posed for frightened Haman in the Raleigh picture appears again as the soldier wearing the ubiquitous slashed beret behind Pilate. Ahasuerus and Pilate may also have been based upon the same prototype. But the stiff, smooth faced boy in profile, whose eyes appear to be focused on Pilate's elbow while he pours water on his master's

(167)

---

[17] See the Exhibition Catalogue prepared by Miss L. C. J. Frerichs of *De Verzameling van Dr. A. Welcker,* Rijksprentenkabinet, Amsterdam, 1956, no. 96, pp. 43-44, for a complete bibliography of the drawing. Bauch (1960), p. 217, defends his original attribution of the work to Lievens.

[18] The painting was acquired by Sir Joseph Robinson; at his death in 1929 it passed to his daughter Princess Labia. When it was exhibited at the famous sale arranged at Christie's (July 6, 1923, no. 57) it was called Aert de Gelder. In 1958 it was shown at the Royal Academy (*The Robinson Collection,* no. 59); E. K. Waterhouse rightly stated in his catalogue of that exhibition that the work is unrelated to de Gelder and added "It seems to be by a painter related in style to some of Rembrandt's earliest work." Study of the picture led to the conclusions presented here. Bauch (1960), p. 257, note 85, who calls the work "offenbar von Lievens" is of the same opinion.

142

22  Jan Lievens, *Boy Blowing on a*    23  Jan Lievens, detail, *King Porsenna*
    *Dish of Coals*                         *and Scaevola,* pen and wash drawing
        Warsaw, Muzeum Narodowe            University of Leiden, Prentenkabinet

hands, is a special and unmistakable type. He is a close friend of the *Boy Blowing on a Dish of Coals* by Lievens. His presence suggests the picture is by Lievens, not Rembrandt. So do differences in the conceptions of the two pictures, which are as diverse as their subjects. Though the spatial order of the Esther picture has not been completely resolved, it has little in common with the one in the cramped Pilate painting. In the latter only the two foreground figures are fully modeled. This was not Rembrandt's approach. From the beginning — whether he depicted an indoor scene or a group in an interior — Rembrandt differentiated the position of every figure in space. He did not always succeed, but he immediately sensed the importance of giving his figures air to breathe and he instinctively knew the dramatic significance of intervals. The author of the Pilate picture is unaware of such things. If we consider the subsequent development of Rembrandt and Lievens it is difficult to avoid the conclusion that Rembrandt, not Lievens painted it. The lively baroque contours of the figures in the banquet picture, the barbaric splendour of its dazzling colours, the delight its painter had in juxtaposing broad strokes next to fine ones, and in laying heavy paste next to glazes all point to Rembrandt. To be sure, there are some heavy impasto passages in the Pilate painting — particularly on Pilate's bulbous turban

143

and on his robes. These, however, look like quotations from the Esther picture where not merely a few isolated passages, but every square inch of the large surface of the canvas has been animated by a rich painterly treatment.

If the large Raleigh picture is by Rembrandt its scale makes it unique among the paintings he made during his six or seven years of activity in Leiden. All the others done during this period are of a small format. As far as we know, he did not attempt another life-size figure composition until 1631 when he painted the *Rest on the Flight* now at Munich. Perhaps after his early experiment Rembrandt felt the *maniera grande* was not for him. Perhaps most of us would agree. But surely young Rembrandt had the courage to try it. The ambitious eighteen- or nineteen-year-old painter must have been anxious to discover his range. Young Rembrandt had the nerve to fail. He also had the good sense to recognize failure, and to realize that sometimes more can be achieved when a man deliberately holds his ambitions in check.

The possibility that young Rembrandt and Lievens collaborated on life-size pictures very early in their careers cannot be dismissed. After all, they worked together on pictures at the end of the Leiden period. Why not at the very beginning too? However, it seems to me that the Esther painting can be attributed to the immature Rembrandt himself and is an imporant early sign of his powerful temperament.

After 1625 Rembrandt made progress with giant strides. The main line of his development, especially as a painter, during his subsequent years in Leiden is clear. The Lastman influence remains a dominant one for a few more years, but he soon outstrips his teacher in depth of expression and in his ability to interweave light and shadow for mysterious effects in small, exquisitely finished cabinet pictures. Rembrandt's achievement during his Leiden period is mainly associated with his precious, jewel-like works. This is one reason why the Esther picture strikes such a discordant note. However, the well-known early pictures by the youthful master, which inspired generations of *Feinmalerei* specialists should not allow us to forget that young as well as mature Rembrandt was a man of daring originality, tremendous boldness and passion. Youthful Rembrandt quickly learned to control these aspects of his nature, but he never suppressed them. His inventive powers, and his unique response to the materials of his art and to the potential of the formal achievement of Early Baroque painting set him apart from the beginning. They account for the early breaks he made with artistic orthodoxy. His innovations, unlike those inaugurated by some later artists, were not made because he was contemptuous of his teachers

(169)

144

24  Rembrandt, *Rest on the Flight to Egypt,*
etching (Bartsch 59)

and peers, or because he was frantically searching for an individual style. This is apparent in one of his earliest extant etchings, the *Rest on the Flight to Egypt*[19] (fig. 24) which can be dated around 1625. There is

[19] The etching was catalogued as a Rembrandt by Gersaint, *Catalogue Raisonné ...de Rembrandt,* Paris, 1751, no. 59, pp. 48f. He wrote: "Il n'est pas exécuté avec autant de goût que Rembrandt mettoit ordinairement dans sa pointe, quoi-qu'elle passe néanmoins pour être indubitablement de lui. En effet on y reconnoît beaucoup de sa maniere, mais on ne la peut donner qu'à ses com-mencemens. Indépendamment des apparences qui la lui font attribuer, ce qui détermine encore à n'en point douter, est qu'elle faisoit partie de l'Oeuvre du fameux Bourguemestre Six, qui a été formé du tems même de Rembrandt, ou pour mieux dire, que Rembrandt, a formé lui-même, parce qu'étant son ami par-ticulier, comme il sera dit ci-après au Portrait de ce Bourguemestre, il avoit attention de lui donner ses ouvrages à mesure qu'il les faisoit. M. Houbraken fit l'acquisition de ce Morceau rare, ainsi que de plusieurs autres dont nous aurons occasion de parler, à la vente qui se fit après la mort de ce Bourguemestre, ce qui fait une preuve assez convaincante en faveur de ce Morceau." Jan Six, "Ger-saints Lijst van Rembrandts Prenten," *Oud Holland,* XXVII (1909), p. 68f., points out that Houbraken must have acquired the print from Willem Six, the nephew of Jan Six, and not from the well-known friend of Rembrandt himself,

145

25   Rembrandt, *Self-portrait*
     Cassel, Gemäldegalerie

26   Rembrandt, *Self-portrait,* 1629, etching
(Bartsch 338)

27   Rembrandt, *Portrait of Rembrandt's
Mother,* 1628, etching (Bartsch 354)

28   Rembrandt, *Self-portrait,* 1629
     Boston, Gardner Museum

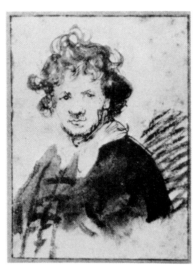

29  Rembrandt, *Self-portrait,* pen and
wash drawing
Amsterdam, Rijksprentenkabinet

no precedent for the youth's warm, human treatment of the subject. The
Virgin holds the Child on her lap and feeds Him with a spoon from a
dish held by Joseph. Excitement with his idea and with the possibilities
of the graphic technique, make him ignore the conventional ways of
drawing and hatching with an etcher's needle. He is content with spon-
taneous scribbles and scrawls. It may be argued that the print is the
fumbling effort of a beginner not yet familiar with the craft of etching.
A few years had to pass before he mastered the technique. In this
medium, as in painting and drawing, he made lightning progress. By
1628, the year of his first dated etchings, he was a master graphic artist.
In his *Portrait of His Mother* (fig. 27) dated 1628 he has gained such
control over the medium that we are hardly conscious of the rich net-
work of finely etched lines which suggest the play of vibrant air and
light around the head of the old woman whose character has been
grasped with such uncanny penetration by her twenty-one or twenty-

but he does not question the tradition of the provenance of this rare print. The
etching has been rejected by W. von Seidlitz, *Die Radierungen Rembrandts,*
Leipzig, 1922, no. 59, and Arthur M. Hind, *A Catalogue of Rembrandt's Etch-
ings,* London, 1923, no. 307, p. 121: "I cannot imagine Rembrandt even in his
youth displaying the meaningless calligraphic touch of this print." It has been
accepted by all other modern students of Rembrandt's etched work.

two year old son. However, while Rembrandt was making fine and delicate etchings he continued to experiment with the coarse and bold. The powerful lines of his audacious etched *Self-portrait* of 1629 (fig. 26), which look like strokes of a blunt quill pen, were made with a double pointed etcher's needle. It may have been an essay with a broken needle. He employed the rare tool in an unprecedented attempt to translate the directness of a drawing into a print. The etching is based on a pen and wash drawing (fig. 29) now at Amsterdam. He did not use his drawing as a preparatory study for a more finished print as earlier graphic artists did, but deliberately attempted to transfer the intimacy and freshness of the drawing to the etching. The etched self-portrait has the unrevised spontaneity of the powerful chalk drawings made around the same time. During the years Rembrandt was making these bold studies he was also capable of working with infinite perseverance on the tiny, minutely executed pictures which soon established the Leiden school of *Feinmalerei*. His early followers were attracted by the refinement of his finished paintings. They learned to imitate them, but they had no idea of the toughness and the blood and bones beneath their surfaces which give strength and vitality to these polished works.

Rembrandt's painted self-portraits also show how the conventional and the radical, the delicate and the rough, the finished and the broad run as parallel currents during the artist's Leiden period. His *Self-portrait* of 1629 (fig. 28) now at the Gardner Museum in Boston, has the character of a half-length commissioned portrait. The painter gave as much attention to his elegant clothing as he did to his face. Scrupulous care has been given to rendering textures and the touch of the brush has been minimized. What sets it apart from portraits made by his contemporaries is the subtle execution of the delicate halftones which enliven the diffused shadows. The artist's poignant look is a premonition of the depth of expression Rembrandt will soon bring to portraiture. A completely different spirit and touch animates the *Self-portrait* (fig. 25), made around the same time, which is now at Cassel. At the age of twenty-two or twenty-three unbuttoned Rembrandt does not look as withdrawn or vulnerable as he does in finery. The artist's powerful head and neck dominate the portrait. He appears to have just turned to look at us. Shadow is concentrated on his face, but his alert expression and rather coarse features are not hidden. It was unusual for the artist to dramatically silhouette himself in shadow against a light wall. Earlier portraitists placed their models in light against a dark background. The young painter also experimented with the effects he could achieve by varying his touch and the viscosity of paint. Heavy impasto is used for the

148

accents of light, the wall is thinly brushed, and vigorous scratches made with the butt end of the brush in wet paint suggest the hairs of his wild mane. The iron strength, intensity and volcanic energy which predominate in the Cassel picture[20] are as much a part of youthful Rembrandt as the sensitivity and refinement of the Gardner *Self-portrait*. These traits are found in Rembrandt's work from the very beginning. They are part of the extraordinary range Rembrandt possessed from the moment his hand became recognizable. They enable him to accomplish more during his short Leiden period than a minor master does in a lifetime, and they remain an integral part of the later achievement which places Rembrandt's art with the most profound and original accomplishments of the human spirit.

Seymour Slive
Harvard University

(174)

[20] Recent publications of a more finished and delicately handled version of the Cassel *Self-portrait* (D. Cevat coll., London, Bauch [1960], pp. 174 f., fig. 157 and "Ein Selbstbildnis des frühen Rembrandt," *Wallraf-Richartz-Jahrbuch*, XXIV [1962], pp. 321 ff.) raise the question whether Rembrandt himself made restrained, stroke for stroke copies of his fiery early works. Weaknesses in the modeling of the form, slack outlines, a tame touch, and the lack of integration of the scratches in the wet paint with the brushwork led the author to conclude, after examining the new version when it was on view at the Rijksmuseum in 1962, that it was the work of a copyist and not the youthful master repeating himself. However, a final decision on this question must be postponed until one has had the opportunity of confronting the new version with the formidable Cassel painting.

# REMBRANDT'S TECHNICAL MEANS AND
# THEIR STYLISTIC SIGNIFICANCE[1]

### By JAKOB ROSENBERG

During the last decade many valuable contributions have been made by technical research workers dealing with the problem of Rembrandt's method of painting. As far as I know, these contributions have not been sufficiently discussed by the art critics concerned with the work of Rembrandt. It seems to me that in art history, with a few exceptions, the two fields of technical research work and of stylistic criticism remain without sufficient contact. This is unlike the situation in many other branches of science today, in which co-operation is practiced between fields as closely connected and in a way complementing each other.

I am not able to give here a full account of all the contributions of technical research dealing with the problem of Rembrandt's method of painting. I may refer only to some of the most interesting ones and define my position toward them.[2] As long as the technical experts offer us exact data, resulting from an investigation by scientific method, their contribution is valid and most helpful. But when they proceed from the merely scientific investigation to art criticism they are on no safer ground than the art historian trained in the field of stylistic analysis and discrimination.

[1] This paper in its present form was delivered at the International Congress of History of Art in London, 1939. Its brief and rather sketchy character was conditioned by the time limitation. It seemed advisable to publish it here unchanged, leaving further and more detailed discussion to some future time. I am indebted to Miss Ruth Magurn for aid in correcting the manuscript.

[2] Max Doerner's chapter on Rembrandt's technique in his book, *The Materials of the Artist* (New York: Harcourt, Brace and Company, 1934); A. P. Laurie, *The Brushwork of Rembrandt and His School* (London: Humphrey Milford, Oxford University Press, 1932); and Alan Burroughs's chapter on Rembrandt problems in his book, *Art Criticism from a Laboratory* (Boston: Little, Brown and Company, 1938).

Among the experts referred to, Doerner is concerned chiefly with the problem of the materials of Rembrandt's painting and that of the structure of his technique. He combines technical hypotheses with stylistic judgments of a rather general nature. Of special value is his observation that Rembrandt used for his impasto quickly drying media because otherwise his full loaded impasto, put into a wet ground, would have lost its consistency. Doerner suggests that Rembrandt used, for this purpose, thick oils or resinous media, such as Venice turpentine or mastic. Doerner's analysis of the technical structure of Rembrandt's painting is not quite convincing. His theory that Rembrandt used rather systematically cold and warm glazes in successive layers can hardly be accepted as a general characteristic of Rembrandt's method of painting in his mature period. Finally, Doerner's interpretation of Rembrandt's chiaroscuro, which he finds almost identical with the chiaroscuro of Titian and Hans von Marées, seems too general.

(176)

Laurie also gives thought to the material and structure of Rembrandt's technique. His method is based on microscopic investigation. His main interest lies with the appearance of the actual surface of painting, the character of which he illustrates by photomicrographs. Laurie's text contains interesting statements about the technical structure of Rembrandt's paint. Particularly instructive is Laurie's method of presenting details from the actual surface of the painting in photomicrographs. It includes, however, the danger of an exaggeration of certain features of the surface such as the dark furrows in the depths of the brush work. This dark effect is often the result of the accumulation of dirt or the yellowing of the varnish and not a part of the original impression of the surface as created by Rembrandt.

Burroughs, who has contributed so much to the development of the x-ray method in the investigation of paintings, believes very strongly in the value of the shadowgraph as a means of art criticism.

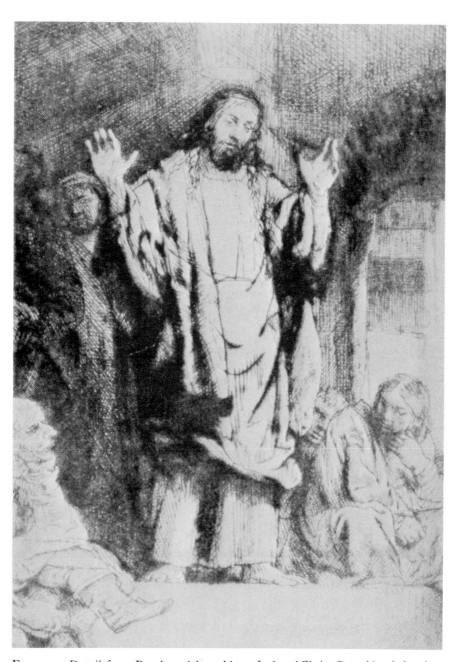

(177)

FIGURE I. Detail from Rembrandt's etching of 1652, 'Christ Preaching,' showing in the garment of Christ characteristic strokes of the dry point needle with its effect of burr.

The x-ray method is certainly of considerable value in discovering layers of original painting which have been made invisible by over-painting. And the state of preservation in general may be more fully ascertained by the findings of the shadowgraph, as well as certain characteristics of the underpainting. But as a means of stylistic criticism, the x-ray alone is of limited value or even misleading unless we consider first all evidence offered by the surface of the painting. As Burroughs himself explains, the x-ray fails to show essential parts of the surface.[3] Moreover, it also distorts, by its nature, the tonal relationships. For all these reasons, I think, its value for stylistic criticism is limited and the attributions which are based chiefly on the use of the shadowgraph are not fully convincing.

All these technical scholars may have felt in some way that a merely physical statement does not lead us very far in the interpretation of Rembrandt's method of painting unless the technical details are understood as resulting from a stylistic purpose on the part of the artist. The style of Rembrandt, however, is a most complex phenomenon, and I wonder whether a contribution from the field of art criticism may help to broaden the aspect of the whole problem and lead to a more comprehensive understanding of Rembrandt's method of painting.

My own contribution here will consist only in adding a new point of view to the discussion of the subject. I have tried to find the technical features which all three categories of Rembrandt's work have in common—his painting and his etching and drawing as well. The investigation of these common technical features may help us to broaden the basis of the discussion and to realize what is characteristic and important in his technical attitude and what is less significant. Since the technical procedure can be fully understood only as a result

(178)

[3] Burroughs, *op. cit.*, pp. 153 ff.

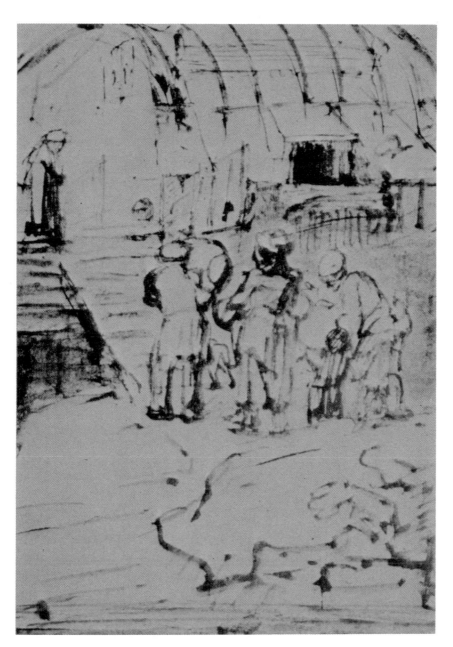

(179)

FIGURE 2. Detail from Rembrandt's drawing of about 1660, 'The Ark of Noah' (Strölin collection, Lausanne), showing characteristic strokes of the reed pen combined with brush work.

(180)

Figure 3. 'Lion Resting.' Drawing by Rembrandt of about 1650 in the Louvre, showing the peculiar effect of the half-dry brush.

of stylistic purposes, I may begin with a brief definition of Rembrandt's chief stylistic tendency as manifested in all three categories. It has often been said, and it is certainly evident, that the chiaroscuro effect forms the chief stylistic principle in Rembrandt's work. The notion, 'chiaroscuro,' however, is rather vague and we must try to define the specific character of the chiaroscuro with Rembrandt. Compared with the chiaroscuro of Caravaggio, that of Rembrandt has a much more complex tendency and function. In addition to the modelling of the form, it serves even more to connect the solid form with the surrounding space and atmosphere and also to accentuate the psychological effect. The chiaroscuro of Rembrandt suggests a space which is never sharply limited but seems to be part of the infinite space around and behind the forms. Therefore, one feels a fusion between the visible and the invisible. This miraculous effect of Rembrandt's chiaroscuro is a result of the very complex character of his style and technique. Even the smallest technical action participates, to some extent, in this comprehensive purpose and contributes to the rather fluctuating connection between all forms and colors, lines and tones. All three categories of Rembrandt's art, etchings, drawings, and paintings, show common technical features which are the result of the stylistic tendency characterized above. We observe these features especially in the mature stage of Rembrandt's art, which interests us chiefly here. I mean the period from the late 'forties to the end of his production.

(181)

In order to produce the effect of solid form surrounded by space and atmosphere, Rembrandt needed a stroke which had powerful accentuation but also had soft tonal qualities. In his etching he attained this complex aim by his masterly use of the dry point needle with its peculiar, rich effect of the burr (see figure 1). Rembrandt was the first to discover the full pictorial possibilities of that medium. In the drawings of his advanced style his ingenious application of the

(182)

FIGURE 4. 'Portrait of a Man' of 1665 (The Metropolitan Museum of Art, New York), probably unfinished. (Reproduced through the courtesy of the Museum.)

reed pen led to a similar result. We are indebted to Dr Hans Hell [4] for having pointed out the technical phenomenon of Rembrandt's use of the reed pen and its stylistic significance (see figure 2). In addition to the reed pen, Rembrandt's use of the brush is most remarkable in his drawings. For the same purpose of connecting by atmospheric effect the solid form with the surrounding space, Rembrandt uses most delicate touches of the brush and skillfully fuses them together with many kinds of pen strokes. Moreover, by means of a half-dry brush he produces in his drawings partially covered areas which, by their atmospheric effect, not only bind together the solid form with the surrounding space but give also a remarkable effect of 'texture' (see figure 3).

It may not be too difficult to discover the corresponding technical features in Rembrandt's paintings. There is, however, some difference because of the more vast possibilities of the medium of paint which allow a more complex work. In order to do justice to this more complex technical character of Rembrandt's paintings, we may divide the problem here into two parts. At first, we raise the question: What have Rembrandt's paintings in common with his etchings and drawings in the technical achievement of the chiaroscuro effect? The second question will be: What has Rembrandt's use of paint in common with the technical means in his graphic work in producing the peculiar effect of texture which is so important in his paintings?

With reference to the first question, one must observe at the beginning that the effect of Rembrandt's chiaroscuro in painting, on the one hand, and in the graphic arts, on the other, is built up in opposite ways. In the graphic arts the effect of light is already implied as a potential quality in the white paper to which the artist adds the effect of darkness. In painting, however, he puts the white on the dark

(183)

[4] 'Die Späten Handzeichnungen Rembrandts,' *Repertorium für Kunstwissenschaft*, LI (1930), pp. 4 ff. and 92 ff.

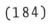

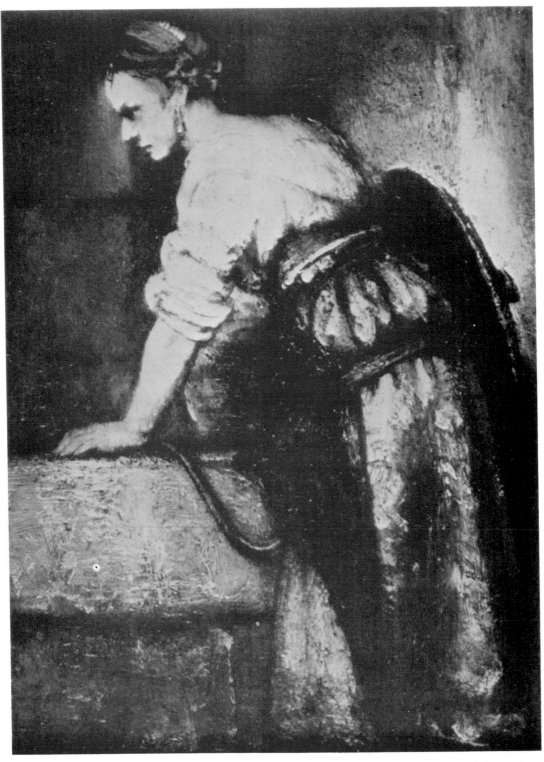

FIGURE 5. Detail from Rembrandt's painting of 1655, 'Christ and the Woman of Samaria' (William R. Timken collection, New York), showing the dragged impasto, the fusion of the tones, and the application of interrupted areas of color.

ground and proceeds, therefore, in the opposite manner in building up his chiaroscuro effect. In spite of that basic difference, there is with Rembrandt something essentially similar among his different methods of achieving the chiaroscuro effect. This common feature is the flexibility with which he builds up his darks and lights. Rembrandt never fixes the full effect of his chiaroscuro device at an early stage of his work but develops it in a rather elastic fashion. During the different stages of the execution the relation between light and shadow remains most flexible and grows only gradually with the accentuation of either one. Such flexibility in the execution may be natural, to a certain degree, but with Rembrandt it goes so far that even finished pictures, especially in his late period, produce the impression that the chiaroscuro effect could be developed further. Rembrandt's graphic art also gives an insight into this phenomenon by some early states of his etchings, and, in particular, by the unfinished plate, 'The Painter and his Model,' dating about 1650. Some unfinished paintings, too, reveal this flexible manner in the development of his chiaroscuro effect, as, for instance, the 'Portrait of a Man,' of 1665, in the Metropolitan Museum (see figure 4). The Rembrandt literature makes no reference to its incomplete state. It seems obvious, however, that Rembrandt left this painting unfinished, as the thick white of the collar is not yet counterbalanced by a deeper shadowing in the man's bust. This makes the body appear too flat, and the ponderation which we usually find in Rembrandt's chiaroscuro is not yet achieved. The fact that light and shadow have a fluctuating character in Rembrandt's compositions makes one easily forget that the finished effect is one of balanced relationship, but this balance is achieved, as I explained before, by most flexible methods. The technical structure, therefore, does not, as Doerner suggests, show a systematic piling up of cold and warm layers but, rather, an open interplay of strokes coming from various depths of the picture. By the peculiar flexibility

(185)

in his procedure, Rembrandt keeps alive the impulsive character of his art within the most complex organization.

As for the second problem defined above, I may describe briefly those technical features which all three categories of Rembrandt's work have in common in achieving the special effect of texture. It is Laurie who has drawn our attention to the importance of Rembrandt's modelling of the surface by means of the brush. The term, 'texture,' which I am using here refers to this as well as to other phenomena of the surface impression. There is first the unusual up and down movement in the relief of the paint. This, however, is a peculiarity of the material of paint alone and may be left undiscussed in this connection. Doerner and Laurie offer valuable observations on this most interesting technical phenomenon. Rembrandt's individual manner of modelling the surface with the brush is also peculiar to painting alone and is sufficiently discussed by Laurie's investigation. (In Rembrandt's handling of the tools we notice an equal versatility in painting and graphic work, and also the same ingenious and most economic exploitation of the media concerned.)

Another essential factor in producing the effect of texture is 'the breaking of the tones.' In achieving this, Rembrandt's technical means in all three fields have much in common. This breaking of the tones, which creates an atmospheric effect across the surface of the solid form, is technically produced by different means: the application of interrupted areas of color, only partially covering the surfaces; the dragging of the impasto; and the fusion of the tones towards their borders (see figures 5 and 6). All these features have their counterparts in the technical means of etching and drawing. We observed in his drawings the partially covering effect by means of the half-dry brush; in the etchings of his mature period a similar result is brought about by an open network of lines. The dragging of the impasto and its floating quality may be compared, in etching, to the effect of the burr

(186)

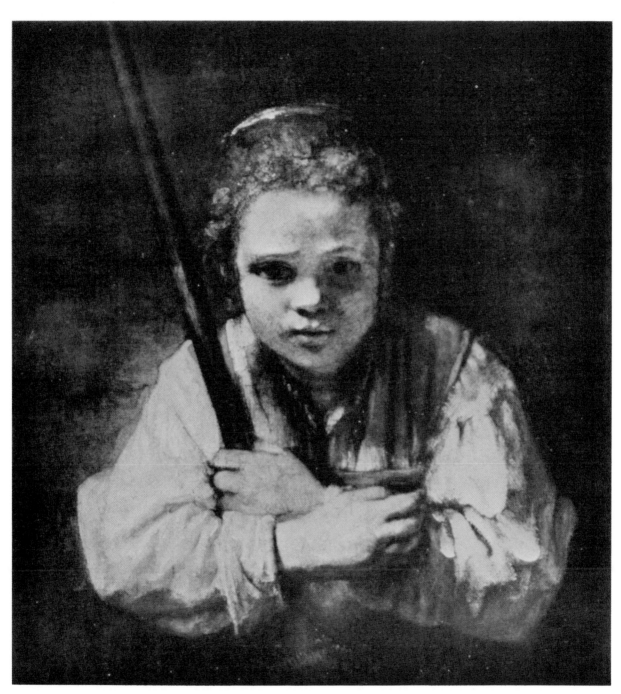

(187)

FIGURE 6. Detail from Rembrandt's painting of 1651, 'Young Girl with a Broom' (formerly Leningrad, Hermitage), showing the characteristic impasto of his mature style.

with its irregular border line, and the gradual vanishing of tone. In drawing we find its counterpart in the different strokes of the reed pen and their combination with the brush work. Finally, there is the fusion of the tones which is produced in painting by a subtle thinning of the impasto, by glazing over or by wiping with the thumb. In his drawings we noticed a similar effect in the delicate fusion of the brush work with the pen strokes; in etching it is again the burr but also a gradation and variation of lines as well as an occasional wiping of the plate which contributes to this effect.

The limited space prevents further consideration of common technical features in Rembrandt's painting, etching, and drawing, and their stylistic significance. I should be glad if these few remarks would arouse some future considerations of the technical problem of Rembrandt's painting on the part of the art critics. After the period of pioneer work, achieved by the technical experts, a closer co-operation between the technical scholar and the art critic may lead to new and more comprehensive results.

(188)

FOGG MUSEUM OF ART

# REMBRANDT AND CLASSICAL ANTIQUITY

In 1609, when Rembrandt was three years old, Joseph Scaliger bequeathed his library to Leiden University;[1] founded only after the city's successful defence against the Spaniards, it soon became one of the most important seats of classical learning in Europe. This fact should not be forgotten by anyone travelling to see the surroundings in which Rembrandt lived; but one is also likely to be struck by two other discoveries. One is the wide flat country beside the Rhine where Rembrandt was brought up; the other is his house on the edge of the Ghetto in Amsterdam, which we must imagine full of the Italian paintings, drawings and engravings, Roman Imperial portraits, casts and drawings after the antique which he collected. We know the contents of his collection from the inventory drawn up at the time of its sale in 1656[2].

What development in Rembrandt led to the making of such a collection, and what did it mean to him? I shall try to answer this question in the light of the classical subjects which he represented in certain of his works.

My first illustration shows one of his earliest paintings, a scene in military surroundings with arms, bodyguard, trophies, and soldiers held back by a sergeant in full uniform (Pl. 208a). Its size is 3 feet by 4 feet. The scene is laid in the south, as is shown by the architecture: two steps covered with drapery, columns on the left, and other foreign-looking buildings in the background. Its main figure is the kneeling man with sword and classical shield. His foil is the man with the sceptre, wearing classical garments, mantle and boots, and on his head something between a crown and a helmet. He is pronouncing sentence, while a secretary sitting at a desk covered with a carpet takes down his words. Behind the kneeling man stands a witness in modern military uniform, holding lance and hat and raising his right hand in the act of taking the oath; a second man kneels next to him, both hands raised in a gesture of protest; a third, with stick and bandolier, faces us—a rather pompous creature who does not seem to be deeply affected by the scene. Next to the king are a child carrying his robe, and a general vigorously grasping a staff and looking at the

[1] *Autobiography of Joseph Scaliger*, ed. G. W. Robinson, Cambridge, Mass., 1927, pp. 62, 68.

[2] *Die Urkunden über Rembrandt*, ed. C. Hofstede de Groot, The Hague, 1906, no. 169.

298

(189)

kneeling soldier—a great figure, dark and severe. His counterpart is the man in mufti behind the secretary who looks at us with a serious face, inclining his head as if to say: this is a pretty story—is it quite right? In the middle distance Rembrandt himself appears as one of the bodyguard. In the background there are a number of prisoners tied to a column and a half-naked figure, perhaps an executioner.

The subject of this picture can only be a court-martial—look at the secretary and at the way the king's sceptre is held; and, judging from the gesture of the second kneeling man, it can only be a grave sentence that is pronounced. This much is clear; but what is hardly explicable is the king's expression. The accused is frank and submissive; but the king's face is inscrutable: a great eye with heavy lid and a mouth with lips compressed and thin. There is no life in this figure whose wooden arm is holding the sceptre.

The composition is Italianate. Ultimately it goes back to Mantegna's fresco of St. James before the Judge; judge and accused are clearly separated and the majesty of the judge is enhanced by the heavy forms of the architecture. But within this outline the space is crowded with forms turned in a great variety of directions. The equilibrium between detail and main directions, between the principal actors and the minor figures, is not yet perfect.

(190)

Rembrandt painted this picture at the age of twenty. What do we know of his life up to that age? He was born on the Weddesteg in Leiden, the son of a well-to-do miller[3]. He went to school at the Groote School or Latynsche School and spent seven years in its new building, completed as recently as 1600, on whose porch we still read the old inscription dedicating it *Pietati linguis et artibus liberalibus*[4]. We know from the school regulations that the Latin works read by the pupils included Cicero's letters and orations, the plays of Terence, the poetry of Ovid, Virgil and Horace, the histories of Caesar, Sallust and Livy, as well as Aesop's fables probably in a Latin version.[5] They also read Hesiod, Homer, Euripides and the Gnomic poets.[6] All this was not merely for the sake of a 'liberal' education. The Gospels were read in Greek and there was some study of dogmatics. The *Disticha Catonis*

[3]Hofstede de Groot, *Urkunden*, nos. 5—8.

[4]*Oude Gebouwen te Leiden*, in opdracht van de vereeniging "Oud-Leiden", 1907, p. 43 f., picture on p. 73.

[5]One of the earliest printed editions of Phaedrus appeared at Leyden in 1598; *Phaedri Augusti Liberti Fabulae Aesopiae*, ed. J. G. S. Schwab, London, 1822, vol. 2, p. 709.

[6]L. Knappert, "Uit de geschiedenis der Latijnsche School te Leiden", II, in *Leidsch Jaarboekje*, Leiden, 1905, p. 30 ff.

were still regarded as a primer for the teaching of grammar, poetry and morals which had to be memorized and interpreted; and the pupils learned to converse, write letters and dispute after the method of Mathurin Cordier. Cordier's book was used in many European schools; it consists of models of dialogues on modern subjects. He himself had studied at Bologna, Padua and Milan, and one of his 'colloquia' discusses the advantages to be gained by travelling in Italy.[7]

This school had been established in order to prepare the future students of the University; for after the hell of the Spanish wars, described by Lipsius in his *De constantia*, the newly-won republic was modelled in the spirit of humanism. Good schools were founded to educate the children in wisdom, and Leiden was the heart of the education of the new state. Its burgomaster was also rector of the University; and only to mention the series of names of famous scholars who were its teachers, some of them also great characters like Lipsius and Heinsius, is enough to show the spirit reigning in the Academy. Justus Lipsius, the great classical historian, was one of those philologists whose writings and teachings brought about a renewal of Stoic philosophy. He tells us how civic war and Alba's military government drove him from Louvain and made him relinquish his post at the University. Friends received him at Liège on his way to Vienna, among them Charles Langius, Canon of St. Lambert's, who made him realize, in the Socratic manner, that the peace of mind and the quiet which Lipsius sought for his studies were not to be gained by escaping from the world but "by strengthening and forming that spirit which is our quietude in troubles and our peace in the midst of arms." The fruit of those conversations was Lipsius' book *De constantia*.[8] Joseph Scaliger was one of the first to combine a knowledge of both the classical languages with an interest in Oriental languages and studies, and he was a pioneer of critical chronology and epigraphy. He was followed by his friend Salmasius and his pupil Daniel Heinsius (1607—1655) was librarian to the University.

Now let us return to Rembrandt's picture: it represents a story of Roman civic virtue, the story of Manlius Torquatus who convicts his son for a breach of military discipline[9], a story told by both Livy and

(191)

---

[7]Mathurin Cordier, *Colloquiorum scholasticorum libri 5*, Basle, 1537 and many other editions. *Coll. XXX., Confabulatio de profectione in Italiam causa:* „Locorum fama et novarum rerum cupiditas nos inducit ad peregrinandum."

[8]J. Lipsius, *De constantia*, in *Opera Omnia*, Vesalia, 1675, Vol. 4, p. 526 ff.: Praefatio et introductio, querela item aliqua de Belgarum turbis; on Langius' death, *ibid.*, Vol. 1, p. 566 f.

[9]A. Bredius, *Rembrandts Gemälde*, Vienna, 1935, note by H. Gerson to no. 460, mentioning other proposed interpretations of the picture.

Valerius Maximus. This explains the expression on the consul's face. What you learned from Livy about the *res publica* was that private sentiments do not count when the commonwealth is in danger; then the father sacrifices even the son. That was the spirit in which the pupils who were destined to become the rulers of a free Holland were educated in Leiden. The picture might have been intended for the council room of a town hall: the Roman consul was to be the model for the Dutch magistrate. So far, therefore, if the picture did not result from Rembrandt's education at the Latin School and the Academy, it is at least in accordance with it. The heroic features in it are, in fact, clear; they are embodied in the grand figure of the father in his authoritative robes; the simple, wild son; the grave witness; the severe lay-out of the ground plan. But the scribe and the man behind him are anti-heroic; there is a mixture of accuracy and inaccuracy in the archaeological detail; and the filling of every empty space with a new figure facing in a new direction, the forced contrasts between lights and shadows in small units break up the monumentality of the composition.

We know how Rembrandt looked at that time; for the first of the long series of his self-portraits was painted, probably in 1628, when he had completed his training and not yet fully embarked on his career (Pl. 208b). Though he was born outside the walls of the town, near the Rhine, he was through his school in touch with the very centre of Leiden's intellectual quarter. When, at that time, a great light like Arend van Buchelius came to the University to see the rector's portrait by Frans Hals[10], Rembrandt would be introduced to him. But he returns to the Weddesteg. He would visit the humanists and study with them. They see something of his genius, and he takes in their classical teaching and the moral lesson with it had for his own time. But in this early period he is not yet concerned with the classical style of forms as a whole.

From Leiden Rembrandt turned to The Hague and to Amsterdam. At The Hague, where the Prince of Orange, head of the republic, resided, Constantin Huyghens was the artistic conscience of the court. Huyghens' ideal was Rubens, the diplomat, scholar and inexhaustible painter. Rubens did not care much for the small court, and when he left it Van Dyck, Poelenburg, and later Jordaens, became the favourites. But Huyghens was also one of Rembrandt's early patrons[11], and although Rembrandt's contacts with the court were not permanent he began to illustrate Ovid like the court painter Poelenburg and felt Rubens' influence. In 1637

[10] Arnoldus Buchelius, *Res Pictoriae*, ed. G. J. Hoogewerff and J. Q. van Regteren-Altena, The Hague, 1928, p. 66; Hofstede de Groot, *Urkunden*, no. 14.

[11] HdG., no. 18; correspondence nos. 47, 48.

he bought Rubens' picture of Hero and Leander[12]. He represented the amorous adventures of the classical gods, Diana and Callisto, Diana and Actaeon, the Rape of Europa, and when he painted the story of Ganymede he turned it into a comedy.

His picture of Pluto and Proserpine was painted for the Prince Frederik Hendrik from whose collection it comes (Pl. 210)[13]. Let us first see how Rubens treated the same subject (Pl. 209a). Pluto, a giant, maddened by Amor's arrows, runs towards his chariot drawn by four horses, carrying Proserpine in his arms. He looks towards Minerva and the two women; two cupids are near the chariot. Proserpine, crying and struggling, has lost her basket of flowers which lies overturned on the ground. A companion tries to hold her back by her garment. The chariot comes diagonically from out of the background, moving away from it. Rubens followed the design of a classical sarcophagus (Pl. 209b) (or more precisely two)[14]; but he altered the attitudes of the two figures in the main group. Rembrandt certainly knew Rubens' picture from an engraving[15]. But in his picture nothing is left of the original contrast of movement. Proserpine is scratching Pluto who averts his face in order to avoid her. Her basket is upset in the air; the terrified women are pulling with all their might to keep her back. The horses are half-way down in the earth; on the chariot there is a wild gilded lion's head; and of Minerva only the head is visible in the distance. Rembrandt does not paint a classical two-wheeled chariot; there is an enormous, dark back part to it on another pair of heavy wheels. There are no gigantic Rubens clouds, no shore, no cupids. The indistinct dark landscape has two very detailed accents which give us the impression that the scene is not set in an anonymous classical space. Instead of classical nudes we have elaborately dressed-up figures. An Oriental Pluto with a yellowish face wears a brown mantle with wonderful rich embroidery; Proserpine has a glossy dress and a blue mantle full of ornaments; in her hair, falling down, is a bunch of flowers. The diagonal of the woman's body is preserved from the classical sarcophagus, but it is opposed by the downward movement of the horses. Everything is based on light and colour. The strongest light and the highest concentration

(193)

12 HdG., no. 54.

13 S. W. A. Drossaers, "Inventaris van de meubelen van het Stadhouderlijk kwartier . . . te s'Gravenhage", in *Oud Holland*, Vol. 47, 1930, p. 203, no. 43.

14 C. Robert, *Die antiken Sarkophagreliefs*, Vol. 3, 3, Berlin, 1919, no. 359 (Paris, Louvre), pl. CXIX, p. 458 f., from which the group of the three women on the left is taken.

15 J. L. A. A. M. van Rijckevorsel, *Rembrandt en de Traditie*, Rotterdam, 1932, p. 97 f.

of colour make Proserpine's face and body stand out in all their details of beauty and defence; as in the landscape, vivid colours and clear details are concentrated only on some points. The terror of the scene is indicated by the downward diagonal, accentuated by the opposing diagonal of Proserpine's garment; by the course of the dark horses; the grave landscape, and the ugly expression of the lion. But the jewel-like colour in the centre conciliates. There is a tension between the realistic and the unreal which Rubens' picture lacks; the scene had a different degree of reality for Rembrandt from that which it had for Rubens.

The Rape of Proserpine is one of the greatest myths of classical religion. It is the cosmic myth of Eleusis; as plant-life dies and grows again, so does the human soul revive after death. From where did Rembrandt draw his knowledge of the pagan myth? There is no evidence that his rendering owes anything to Ovid. He may have known Jacob Struys' tragedy "Ontschakingh van Proserpina" which appeared in print only in 1634, but as we are told in the preface, it had already been performed on the stage at Amsterdam; the mask on Pluto's chariot in the title-page illustration which does not occur on any other representation reminds one of Rembrandt's gilded lion's head (Pl. 211a). But Rembrandt's picture means more than the violent rape of a woman. It is a grandiose and moving scene. Without using any of Rubens' classical paraphernalia he imparts a supernatural quality to the horses and the wild lion, the landscape and the yellow pirate. But the hero holds in his arms a young woman with a plain face, dressed like a princess, whom we cannot connect with our idea of a divinity. We are not meant to see in her the *Kore* of Eleusis. Rembrandt paints a cosmic fairy-tale; he had no more intention of giving it any pagan religious symbolism than Ovid had. It is a scene from a *danse macabre*, in which Pluto is the lover Death carrying away the virgin.

The picture was painted during Rembrandt's first years in Amsterdam. In 1634 he married; the following years are the years of great fame in which he established his connections with the *grand monde*. In 1639 he bought his house near the St. Anthony Bridge. He did some work for the court at the Hague, portrayed doctors, eminent preachers and theologians, Jewish scholars, diplomats, financiers, naval officers, as well as the wealthy bourgeois and his wife. His old interest in the scholar remains; I mention only the picture of a rabbi and the portrait of the preacher J. C. Sylvius[16].

In 1647 he portrayed Jan Six in an etching (Pl. 211b). Six was then a young man of 29, just returned from Italy. He was well educated, a good humanist, a poet, a friend of the best humanist poets of his day,

[16]Bredius, *Gemälde*, nos. 435 and 237.

(194)

303

and at the same time a friend of Rembrandt's. Like the flattering verses written for it by Jean Lescaille[17], Rembrandt's etching represents him as a scholar and poet; he has a clear forehead, somewhat romantic hair, a hard mouth; and above all he is very serious.

At that time Six had written his *Medea*, a tragedy after Seneca. Seneca's play is a tragedy of revenge, violence and wrath, written with an unlimited power of language but not intended for the stage. Medea murders her children to revenge herself on Jason for having deserted her, and at the end of the play she throws the bodies of their children down at his feet from the top of the house. After that she mounts the dragon car sent her by Apollo and is borne away while Jason calls after her: "Go through the lofty spaces of high heaven and bear witness that where thou ridest there are no gods. (Per alta vade spatia sublimi aethere testare nullos esse qua veheris deos.)" There was no similar intention in Jan Six, as we know from the preface to his play[18]. He has no use for either dragon car or miracles; his work is a clear-cut human tragedy of revenge, a non-thrilling poison murder case ending in suicide. Medea murders her child because she must do penance for having killed her brother for the sake of the unfaithful Jason. It is, of course, a humanist drama with some classical eloquence and contains great monologues, a classical messenger scene, miraculous dream visions, and the traditional dialogue between mistress and servant; a few pages are simply translations from Seneca, as the author acknowledges. Medea's dialogue with Creon, for instance, is a piece of pure classicism:

(195)

[17] Hofstede de Groot, *Urkunden*, no. 223.

[18] First edition, published by Abraham de Wees and Jacob Lescaille, Amsterdam, 1648; first performance in October, 1647.
"I selected this story, obscured by the patina of different treatment by various persons, because it left me free to choose what seemed most probable and most fitting; free as painters are, who may depict an object each in their own way and as it suits them. I needed this liberty 'because it seemed impossible that Medea should have been a sorceress who flew through the air in front of everybody and yet married Aegeus king of Athens. I had to reject this and suchlike things, in order not to appear capable of believing that an audience or readers will swallow pure nonsense. Also, in order not to treat my public to a rehash, I have deliberately avoided the thoughts of other people, except a few of Seneca's at the beginning of the second act; this seemed unavoidable as they tallied with my own work however much this differs from the work of the Latin poet. For he usually makes Medea repulsive, though in this one place he rouses our deepest pity for her; we on the other hand intend to show that faithlessness is hateful of all things and that Medea was a victim. Therefore she should be pitied rather when the wrong she suffered drives her to such despair and mad revenge that she kills herself and her child." Translations from the Dutch by Mrs. H. A. Frankfort-Groenewegen.

The banks which Phanis' flow bedews and those vast stretches
Where Amazones their widowed, warlike lives are leading,
The land Euxinus holds in its embrace, and where
Fresh streams in torrents rush from the high Caucasus:
All those sweet coasts obey my father's sovereign power . . .
But royal court and state cannot be alienated
Nor lost quite if at times the world inverted seems.
Imperishable boon, conferred on regal power!
Bereft of all, I praise but what is left to me.

Medea's curse has the style of tragedy but the mood is Christian and the
rather dry verses lack classical form:

How often, heavenly powers, who see my Jason's deeds
And his perfidiousness, to thee I raised my prayers!
And all in vain alas! . . .
Heaven no evil checks. I pray you fiends below
Come hither with your fire, your orgies celebrate,
Most welcome you will be. A tyrant needs you here,
Who steals a mother's child, her husband from her takes.
Make this usurper wear a crown of burning flame
A staff of red hot gold: he must join my lament . . .
Especially his bride, who joyless made my life
Treat her as she deserves . . .
Let Jason slight her but protect him for my sake
That I in turn may be equally false to him.

(196)

Six is at his best in the new parts, for instance in Creusa's speech as the
loving newly-wed bride:

Go freely golden sun and linger before dawn,
I mind not, but that he, that Jason thus should tarry,
Is more than I can bear. Where could my Jason be?
Where did my sun decline that was forever shining
So radiant and high as heaven in my thoughts?
For is he not the sun? and like a soft red glow
Soaring at early dawn on petaled wings of roses?
And am I not the moon? I fade away, I die
When the clear light of his beloved face is gone.

And in her dying words we hear something like an echo of Ophelia:

I know not what to do and know not what to think.
Yes, yes. there is something that's running in my mind . . .
Who plays the viol? look oh look, the floor is swaying,
I pray you listen—for who is that singing there?

And go now—oh I wish that I could speak to him.
Am I speaking to stone—or are these pillars human?
Now I myself must go . . .

Six's play appeared as a book in 1648, with Rembrandt's etching, bearing the same date, as its title-page. Perhaps the picture was not originally meant to appear there, but it can hardly be doubted that from the beginning there existed a close connection between the two works. Which scene would Rembrandt choose to illustrate? Medea's monologue of revenge, or the love scene between Jason and Creusa? Creusa's death, or Medea murdering her children?

What he chose was no scene of monologue, nor one of action; he represented a scene which actually does not exist in the poet's text. The second act of the play begins with a love dialogue between Jason and Creusa before their wedding which ends with the words:

Jason:  The magic of your gentle eyes
        Warrants my sunshine's vigilance
        For it is better that man dies
        Than lives without its radiance.
Creusa: Come Jason, for our road is long.
        My love, lord of my heart's recess,
        Many a prayer, hymn and song,
        These people will to you address.

The next scene opens with Medea saying:

        There goes the bridal procession . . .
        Now I shall wreck this joy, this wedding feast so gay;
        Maybe their agonies my suffering allay.

(197)

These words are the only reference in the text to the scene which Rembrandt represented; but it is not impossible that at this point there may have been an intermezzo, that is to say a dumb show on the stage.[19] The public would have seen the marriage ceremony, and Medea may have looked on from behind a stage requisite. Rembrandt represents, in one and the same moment, the height of Jason's and Creusa's ill-fated happiness and its psychological result, Medea's threat of revenge. He represents it as a contrast between light and shadow (Pl. 212b).

There is, deliberately, very little pagan detail. The setting is the interior of a church, illogical from the architect's point of view but festive in character. The heavy column and the strong horizontal bar of brightness beneath it are the main accents, set off by the effect of the big arch with

[19]P. Leendertz Jr., "Rembrandts Faust en Medea", II, "Medea", in *Oud Holland*, Vol. 41, 1923—24, p. 77.

the curtains and the dark columns on the right. The monumental foreground, almost empty, forms a base for the figures, small in scale compared with the architecture. The steps lead up to Creon, not to Creusa and Jason. The upward and downward movements meet in the heads of the bridal couple whose faces appear dimmed by the light from windows behind them. There is a column rising above Creusa, the only person turned full-face towards us. The light falling on Jason is broken up by the many folds of his dress. The statue of Juno and a burning altar instead of a Christian *mensa* is all that speaks of paganism. Through the open curtains we see the great festive scene, the crowned bride, the noble father holding his sceptre. Jason looks up devoutly and listens to the admonitions of the priest. A few courtiers, the musicians and what seem to be choir boys on the gallery are an attentive public.

The scene is built up on a contrast. There is, on the one hand, the beautiful couple shown at the moment of the *dextrarum iunctio*, a king's daughter and the man whom she will make king; the wise priest, before whom rises the smoke of sacrifice; the presiding naked divinity, and a dignified but rather simple and informal audience. On the other side there is the noble Medea, different from the rest in scale, Creon's counterpart. Her veiled face is in the shade, like the faces of the new couple. She wears a grand dress; a mysterious star sparkles on her breast; she carries the dagger and her heavy right arm is raised. An ugly old servant stands behind her. Jason's and the bride's happiness, the king's dignified satisfaction are in danger; Medea's splendour is darkened by the marriage scene.

Six had intended to create a realistic version of a subject of classical mythology. A woman who has made every sacrifice for her lover and is basely deserted takes a terrific revenge and, by the logic of events, commits suicide. In Rembrandt's drama some external details, such as the temple, the altar, the curtain rail, are realistic; but that term makes no sense if we try to apply it to the essence of the picture: the dark wishes of the deserted woman who faces the festival in the great open light.

Rembrandt chose a scene in which the essential word was not pronounced; he represents the wordless decision of revenge. Ovid describes in his *Heroides* how Medea hears the wedding procession pass; she feels her heart fill with ice but she prefers not to be certain of its being that of Jason and Creusa until her younger boy points it out to her. Then she behaves in the grand tragic manner, tearing her dress and threatening revenge: "ingentes parturit ira minas." Rembrandt's Medea is fully aware of what happens; she comes attired as for a wedding, accompanied by her attendant. Our anticipation of the impending tragedy is not due to any violent gestures; Medea's posture in Rembrandt's etching is as restrained as

(198)

307

that on a Roman sarcophagus—the only classical representation showing her in the company of the newly wedded couple[20] (Pl. 212a). Six's play was a compromise in contents and style; Rembrandt's picture is a new casting of the classical tale.

Four years later he designed, for the same Six, the title-page of a *liber amicorum* (Pl. 213). It represents a poet, or a prophet; the space is not specified except for some trees on the right. The bearded man in the middle is shown quietly speaking; only the gesture of his hands announces the moment of creation. A young man sitting at his feet attentively takes down his words; the rest are gathered round in admiration and quiet rapture. A poet who is also a sage, standing under trees and listened to by people of every age and description—that is Rembrandt's dedication to the poet Six. Now think again of Amsterdam—and you will realize how far afield Rembrandt has gone. The source of his composition is Raphael. In his Parnassus Raphael had represented poets of all kinds grouped around Apollo and the Muses; there is the blind inspired Homer, there is Dante; all are occupied with themselves except the scribe. It is the ideal land of poetry under the rule of Apollo. Rembrandt adopts from Raphael the figure of Homer, the scribe, the idea of the women among the audience, the people coming from below, the open air setting under trees. But now there is only one poet, Homer, and Dante is among his hearers. Rembrandt draws a Parnassus without Apollo and without classical gestures; the only feature that reminds us of classical antiquity is Homer's head, in which the blindness is hardly indicated. What is classical is the general idea of the poet-prophet amid the people; it is the conception of Orpheus *vates*.[21]

The blind man, his expression, his movements, his hands, were a problem that exercized Rembrandt all his life. Even before he made the drawing of the blind poet he had shown the blind Tobit eagerly advancing to meet his son. He showed him again waiting patiently in the darkening room. He painted the blind Jacob in the act of blessing and, finally, sketched the blind Belisarius, a beggar fallen from greatness (Pl. 214). About the same time he returns to the subject of Homer. This picture, as we now know it, is a fragment[22]. It shows the half-figure of the poet

(199)

[20]Robert, *loc. cit.*, vol. 2, Berlin, 1890, no. 190 (Turin, Museo di Antichità), pl. LXI, p. 203.

[21]W. K. C. Guthrie, *Orpheus and Greek Religion*, London, 1935, p. 39 ff. and Pl. 6.

[22]J. Kruse, "Eine neuentdeckte Homeruszeichnung von Rembrandt zu Stockholm, Studie zum Gemälde im Mauritshuis", in *Oud Holland*, Vol. 27, 1909, p. 221 ff.; F. Schmidt-Degener, "Rembrandt en Homerus", in *Feest-Bundel Abraham Bredius aangeboden*, Amsterdam, 1915, p. 15 ff.

and is a departure from everything that had gone before: Rembrandt used the authentic classical bust of Homer for his portrait (Pl. 215). The eyes are open, like those in the sculpture; but the thin ear of the blind poet, his organ of perception, which in the bust is hidden by the hair, is uncovered; and his mouth is half-open as if in speaking. He wears a cloak of many golden colours and a classical diadem on his head, but over the diadem there is the strange cap. The hands seem to scan the rhythm of verses. Here, at last, we find a clear trace of classical influence.

The external history of the picture is well known[23]. Ten years earlier, Count Ruffo, a Sicilian nobleman, had ordered pictures of famous philosophers for his library from a number of painters. Guercino, we know, had sent the portrait of a cosmographer, Rembrandt sent his Aristotle (Pl. 216). It seems a strange choice for Rembrandt to have made. True, Aristotle had always been acknowledged the greatest of philosophers, but with Homer's bust by his side he appears here as the law-giver of poetics. Wisdom and poetry belong together. This idea had been alive since the beginning of the sixteenth century when Aristotle's *Poetics* had been rediscovered; and while his reputation as moral and natural philosopher had tended to diminish, his fame as the author of the *Poetics* had grown. But this fame had rested on his rules of tragedy and had not been accompanied by an equal appreciation of Homer. On the contrary, there had been a wide difference of opinion about the greatness of the Greek poet ever since the days of J. C. Scaliger, and the question: Virgil or Homer? continued to be discussed throughout the seventeenth century, particularly in France in the *querelle des anciens et des modernes*.[24] It was in Holland, through the works of Rembrandt's learned contemporaries, Heinsius, Vossius and Scriverius, that Aristotle's mediation had led to a fresh and admiring understanding of the Greek epics.[25] Who advised Rembrandt to choose this up to date subject is not known. It might have been Six, whose portrait he painted in 1654.[26] But Rembrandt seems himself to have had a special admiration for Homer.

Several years after he had received the portrait of Aristotle Ruffo ordered two more pictures from Rembrandt, and this time the subjects chosen

[23]Documents published by Vincenzo Ruffo, "Galleria Ruffo nel secolo XVII in Messina", in *Bollettino d'Arte*, Vol. 10, 1916, pp. 127 ff., 166 f., 192, 283.

[24]G. Finsler, *Homer in der Neuzeit von Dante bis Goethe*, Leipzig, 1912, pp. 55 ff., 191 f.

[25]*ibid.*, p. 138 ff. In the introduction to his tragedy *Jeptha of Offerbelofte* (1659) Vondel names Heinsius and Vossius among his authorities on Aristotelian poetics.

[26]J. Six, "De Homerus van Rembrandt", in *Oud Holland*, Vol. 5, 1897, p. 6.

(200)

were Homer and Aristotle's pupil, Alexander the Great. The three portraits were to form a trilogy with Alexander in the centre[27]. The source of this idea was obviously Plutarch who talks of Alexander's admiration for Homer[28]. Thus the three men were to be seen together: the greatest poet; the wisest philosopher whom Homer had enabled to establish the eternal rules of poetry; and the mightiest king who drew the inspiration for his deeds from the poet whom the philosopher had taught him to understand.

In the picture of Aristotle the classical bust of the poet is seen as we would look at it today. It forms a striking contrast with Aristotle who is represented as a 'modern', typically Rembrandtesque, figure; yet Rembrandt must have known how Aristotle had looked, for a portrait bust of him was in the painter's collection. To our historical sense this seems unsatisfactory. The great solution is the picture which was to hang opposite and which shows the classical bust revived. Rembrandt's life-long experience of the face of the thinker; his sympathy with the blind; his admiration for the greatest poet of the Greeks: all these find expression through the revival of a hellenistic bust[29] (Pl. 217). In hellenistic sculpture the passion of the blind poet, the hollowness of his eyes, the wrinkles on his forehead, the burden of age were for the first time combined with the idea of the creative power of the poet who sang the Iliad and the Odyssey. This language of hellenism was accessible to the aging Rembrandt. We see him sitting in his house in 1653, admiring the bust and adding to it Aristotle, as it were a picture of himself; we see the later Rembrandt who has left his house and sold his collection, and is now finally able to identify himself with the poet of the Iliad.

We have followed Rembrandt's approach to antiquity through five stages. The first was didactic and in keeping with the neo-stoical ethics taught in the Holland of his youth. In the second, under the influence of Rubens, he illustrated the erotic tales of mythology. Then follows the non-archaeological new classical tragedy. The next step created the archaeological Aristotle; and in the last stage antiquity was brought to life in the picture of Homer.

*Courtauld Institute, January 1941.*

(201)

[27] Ruffo, *loc. cit.*, p. 128 note.
[28] Plutarch, *Vita Allexandri*, cap. VIII, XV, XXVI.
[29] F. Schmidt-Degener, *loc. cit.*, p. 17.

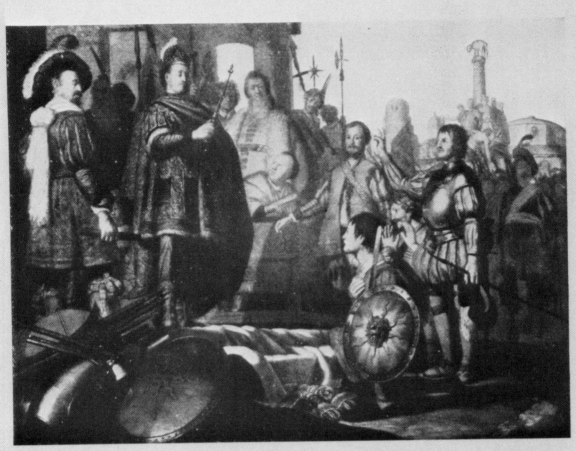

a   Rembrandt, Manlius Torquatus. 1626. Leiden, "De Lakenhal" Museum.

(202)

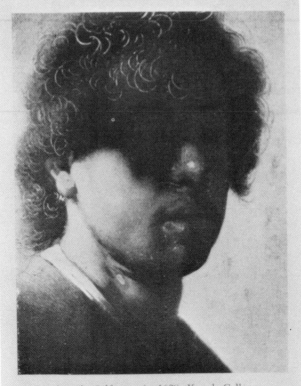

b   Rembrandt, Self-portrait. 1628. Kassel, Gallery.

PLATE 209        REMBRANDT AND ANTIQUITY

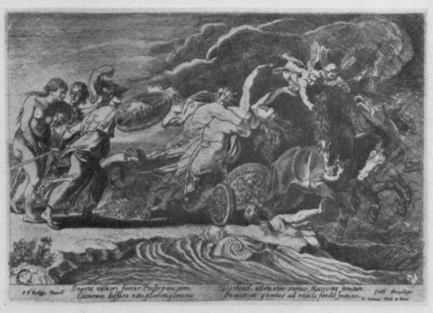

a   Pluto and Proserpina. Engraving by P. Soutman after a lost painting by Rubens.

(203)

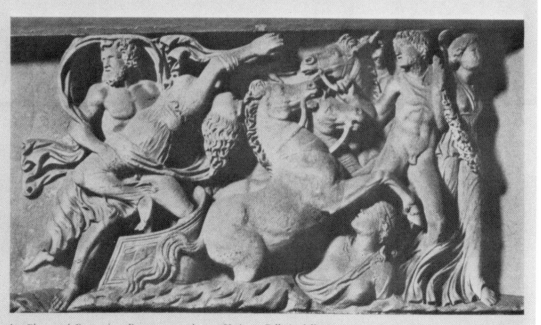

b   Pluto and Proserpina. Roman sarcophagus. Vatican, Galleria delle Statue.

(204)

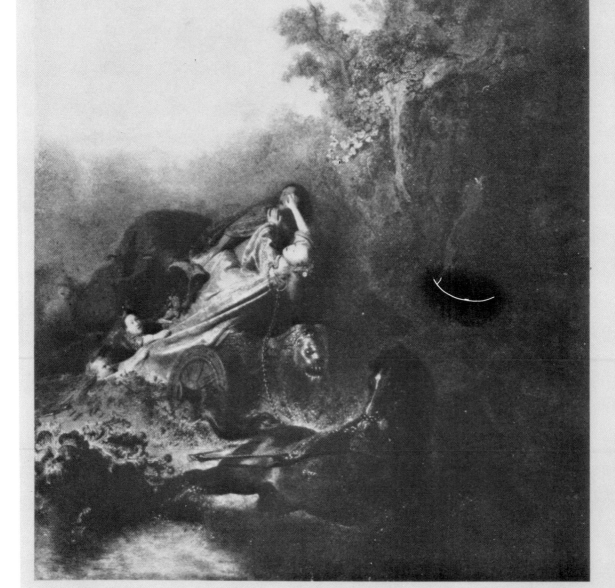

Rembrandt, Pluto and Proserpina. 1632. Berlin, Kaiser Friedrich Museum.

PLATE 211                    REMBRANDT AND ANTIQUITY

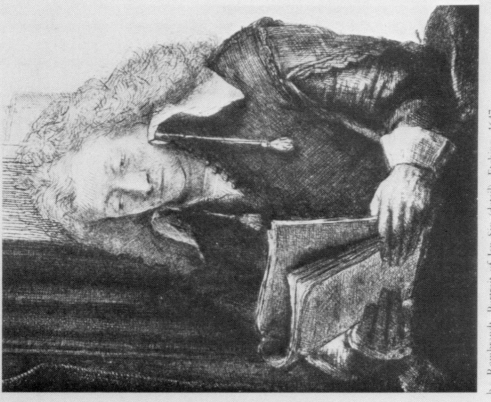

b Rembrandt, Portrait of Jan Six (detail). Etching. 1647.

JACOB STRUYS

Ontfchakingh van PROSERPINA,

Met de

BRVYLOFT van PLVTO.

*Ghefpeelt op de Amfterdamfche ACADEMIE.*

NED.
LETTERK.

t'AMSTELREDAM,

Ghedruckt voor CORNELIS DANCKERTSz. Papiere-Cunft
en Caert-vercooper inde Warmoeftraet, int Fufteyn-Vat, *Anno 1634.*

a  Pluto and Proserpina. Title-page.

(205)

a Medea sarcophagus (detail). Drawing. Ms. Coburgensis, fol. 32.

(206)

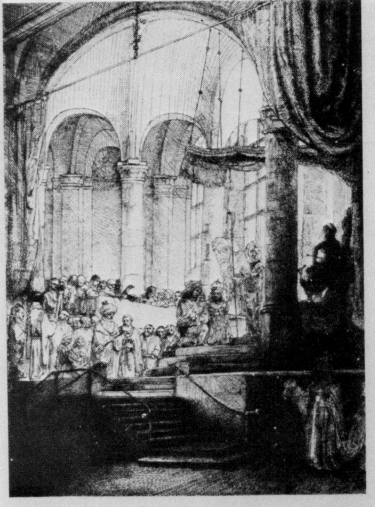

b Rembrandt, Medea. Etching. 1648.

PLATE 213                    REMBRANDT AND ANTIQUITY

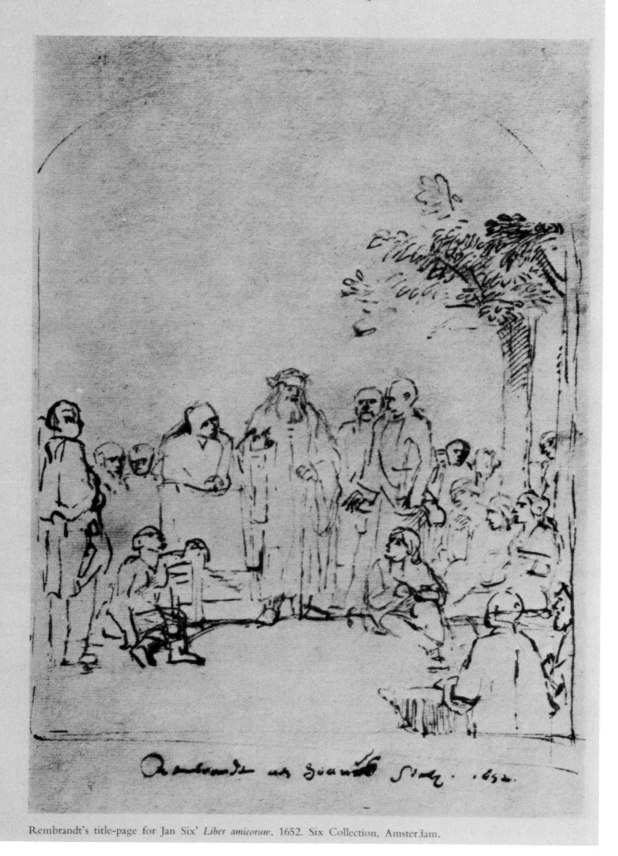

(207)

Rembrandt's title-page for Jan Six' *Liber amicorum*. 1652. Six Collection, Amsterdam.

a   Rembrandt, The blind Tobit (detail).          b   Rembrandt, The blind Tobit (detail).
    1659. Coll. W. van der Vorm, Rotterdam.           Etching. 1651.

(208)

c   Rembrandt, The blind Jacob (detail of Jacob       d   Rembrandt, The blind Belisarius. Drawing.
    blessing). 1656. Kassel, Gallery.                     1663. Berlin, Print Room.

PLATE 215                    REMBRANDT AND ANTIQUITY

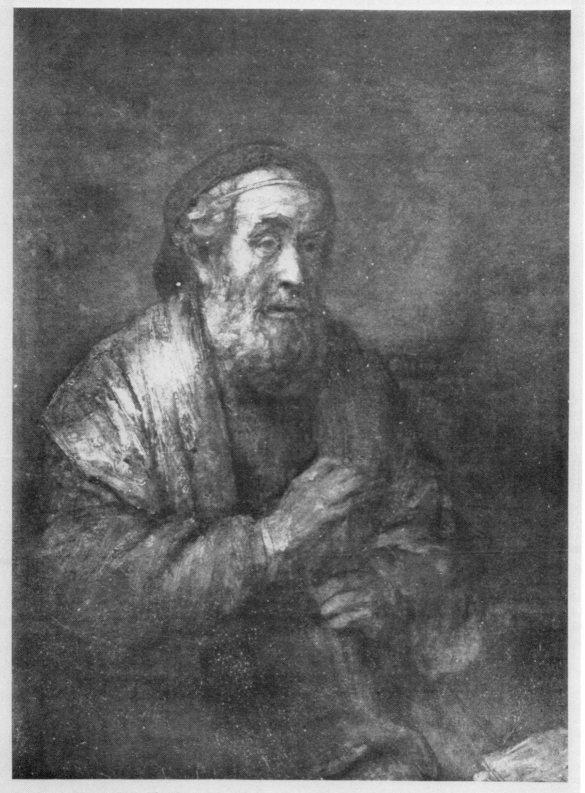

(209)

Rembrandt, Homer. 1663. The Hague, Mauritshuis.

PLATE 216

(210)

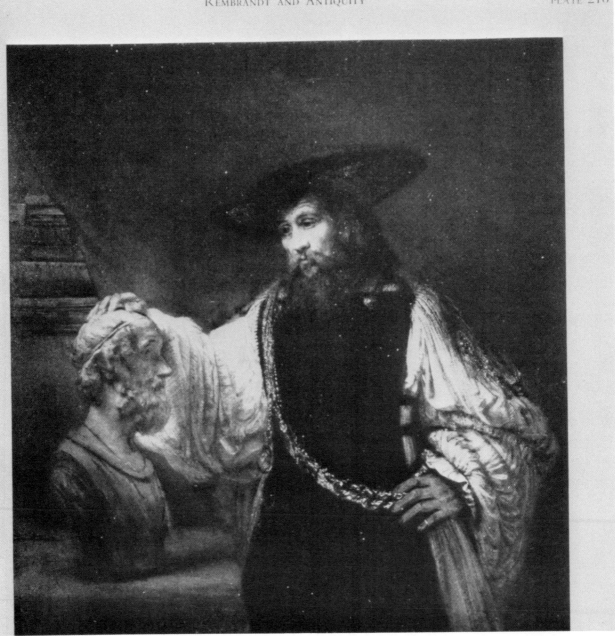

Rembrandt, Aristotle with the bust of Homer. 1653. Private Collection.

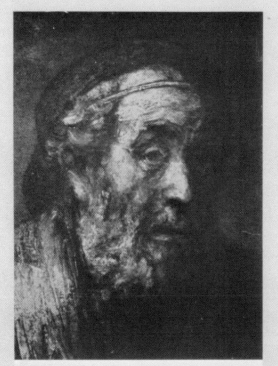

a   Detail of Pl. 215.

b   Classical bust of Homer (detail).

(211)

c   Detail of Pl. 216.

d   Classical bust of Homer (detail).

# THE MOTIF OF RADIANCE IN REMBRANDT'S BIBLICAL DRAWINGS

## By H.-M. Rotermund

In an essay published in 1922 H. Kauffmann made an attempt to establish a pictorial principle in Rembrandt's work, based on certain ornamental forms (star and rosette) which constantly recur in it; and on a study of detail ranging from peculiarities of costume to the rays which at times surround the figure of Christ.[1]

Whatever the value of this thesis to the history of art, by drawing attention to the motif of radiance in Rembrandt's Biblical works it has given the present author a starting-point for research with a different objective—namely, the inner, as distinct from the formal, significance of this radiance.

## I

### *The significant use of the radiance*

The rays whose significance we propose to study are not those of the "halo" properly so called, but a peculiar linear radiance by which the figure of Christ is surrounded in some of Rembrandt's works, notably in his drawings.

Writers on Rembrandt have often pointed out that although at first he made occasional use of the traditional halo (see B. 68 'The Tribute Money,' *c.* 1634; Val. 363 'Christ teaching his Disciples,' 1634), he soon discarded it in its stereotyped form. In the 'Expulsion of the Money-changers' he places the Glory, with audacious originality, not around the head of Christ but around the hand that wields the whip. (B. 69, 1635.) The radiant glow surrounding this hand shows that Christ is not swayed at this moment by violent personal emotion: he has seized the whip in order to carry out the will of God.

In other drawings the halo is replaced by some natural source of light—in the most unexpected fashion in the etching B. 63 of the 'Holy Family with the Cat,' 1654, where the tracery of the window forms a circle behind the head of Mary, coinciding with the disc of the setting sun and its rays in such a way that it is hard to say whether her head is surrounded by a halo or by the rays of the evening sun.

Where a stronger radiance is apparent, comparable with a halo, it usually serves to emphasize an important symbolic meaning, as in the etching B. 74—the "hundred guilder print"—where the rays emanating from the head of Christ are a confirmation, in face of the darkness in which such a flood of anguish and misery is bearing down on Him, of Jesus' claim: "I am the Light of the World." (Cf. 'Christ taken Prisoner,' Val. 455, 456).[2]

In many of Rembrandt's paintings, instead of a halo there appears a light of which the source is not indicated; a light that seems to be radiating from within: for instance, in pictures of the Supper at Emmaus. This light radiating from within also occurs in certain isolated etchings, most strikingly in the

(213)

---

[1] H. Kauffmann, *Rembrandts Bildgestaltung*, Stuttgart, 1922.

[2] Occasionally, instead of a halo, there is a little hovering circle above the head of Christ, as for instance in 'La Petite Tombe' B. 67, and in the drawing, Val. 407 'Christ and the Woman taken in Adultery.'

etching B. 50, showing the aged Simeon holding the Child in his arms (*c.* 1654).[1]

In the drawings, owing perhaps in part to the difference in technique, this light from an inner source is seldom seen, except where the drawing has assumed the character of a "picture," as in the 'Adoration of the Shepherds' (Heseltine Collection, London; Val. 294, before 1646). In his numerous drawings of subjects from the New Testament that we possess, Rembrandt as a rule depicts Christ without radiance of any sort. But is he actuated in this by technical considerations only? Dr. Visser 't Hooft shows us persuasively that the Christ without halo, without "form nor comeliness", expresses the true spirit of the Reformation, and thereby of the Bible itself. "He emptied himself, taking the form of a servant, being made in the likeness of men" (Phil. ii. 7 ; Isaiah liii).[2] In many of his drawings it is above all the Jewish Rabbi, the Teacher, preaching and healing throughout the land, that Rembrandt gives us in his portrayal of Christ.

Now it is a surprising fact that, contemporaneously with drawings of the above-mentioned character, there are others in his œuvre where he surrounds the figure of Christ with a definite ring of rays. And often a single ray issuing from this ring is shown falling upon the individual encountering Christ in this particular scene.

Attention has been drawn now and then to this strange phenomenon, but so far nobody has succeeded in adducing a plausible reason for it. It was taken for granted that Rembrandt's choice was an arbitrary one. I hope on the contrary to be able to show that Rembrandt is acting of set purpose in using or omitting the rays. Moreover I believe that to discover the law governing his choice is to learn much of Rembrandt's personal conception of Christ.

(214)

### (i)

To gain insight into Rembrandt's motive in the matter we may begin with the Resurrection scenes.

It is peculiar to all the Biblical accounts of Easter that Christ is not immediately recognized by His followers. Mary Magdalen, meeting Him by the sepulchre, takes Him at first for the gardener; the disciples at Emmaus take Him at first for a pilgrim who has not yet heard anything of "the things which are come to pass in these days." It is only in indirect ways that the risen Christ makes Himself known. He calls Mary Magdalen by name, and thus reminds her of their first meeting. He opens the Scriptures to the disciples ("Was not our heart burning within us, while He spake to us by the way, while He opened to us the Scriptures?"—Luke xxiv. 32). In Emmaus He breaks the bread for the disciples ("And their eyes were opened, and they knew Him"—Luke xxiv. 31). Rembrandt faithfully reproduces these details of the Bible story.

[1] Van Regteren Altena is certainly right when he says: "Rembrandt offers the solution of a problem unsolved by the greatest Italians: the problem of the halo" ("Rembrandt's 'Way to Emmaus'," *Kunstmuseets Årsskrift*, 1948/49, p. 10).

[2] Dr. Visser 't Hooft, *Rembrandt et la Bible*, Neuchâtel 1947, in the chapter "Le Christ dans l'oeuvre de Rembrandt," pp. 49 ff.

When Mary Magdalen mistakes Christ for the gardener ("Sir, if thou hast borne Him hence, tell me where thou hast laid Him, and I will take Him away"), we see Christ without the ring of rays; He wears a broad-brimmed gardener's hat and carries a spade in his hand.[1] (Pl. 19a, Val. 507). But when Mary Magdalen recognizes her Lord in the stranger, the figure of Christ is surrounded by the rays (Pl. 19b, Val. 511). Mary has fallen on her knees before the Lord. She is slightly raising her hands, as though to ward off an almost overwhelming recognition. But one of the rays issuing from Christ is drawn out to a great length and encloses her, the human being whose inward eyes are opened in that instant.

We meet with the same change in the illustrations of the Emmaus story. In a series of drawings Rembrandt shows the disciples journeying to Emmaus with the unknown pilgrim (Pl. 19c, Val. 521). In these drawings there is no radiance issuing from Christ.[2] He is the pilgrim the disciples have met with by the way. But when Rembrandt depicts the moment of recognition, a ring of rays flashes violently around Him. The disciples draw back, awestruck, from the suddenly recognized Lord (Pl. 19d, Val. 525).

This feature is found among some of the earliest of Rembrandt's drawings. It is obvious that in the Emmaus drawing known as the "recognition scene"[3] we have the germ from which the motif of the ring of rays developed in Rembrandt's work. In later representations of the 'Supper at Emmaus,' such as the etching B. 87 of 1654, the treatment is quieter. The sacramental character of the event is felt as well as the recognition. But even here we see the radiance issuing from Christ, and the recognition by the two disciples suggested in a different way for each of them.

A drawing of 1645 represents the final scene from the Emmaus story: "And He vanished out of their sight" (Pl. 19e, Val. 528).

Here the figure of Christ is as though de-materialized, devoured by a supernatural light. The ring of rays remains, glowing at the spot where Christ's head must have been at the moment of vanishing, or rather, a little higher (Christ vanishes upwards), and filling the dusky room with its jagged points of light.[4]

The same phenomenon of radiance is met with once again in the Resurrection scene of 'Doubting Thomas,' showing the moment when Thomas falls,

(215)

[1] In the corresponding painting of 1638 (London, Buckingham Palace) it is even plainer than in the drawing reproduced above, that Rembrandt had in view the moment *before* the recognition—emphasized in both works by the gardener emblems—even if one supposes that there is an unbroken passage from non-recognition through doubt to awareness. (Cf. also Val. 508-510, particularly Val. 509.)

[2] Val. 524 presents an apparent exception, in which the contrast between the help so near at hand and the still unconscious disciples is stressed. According to Valentiner this is "a copy of a lost original of *c.* 1655."

But this statement raises the question, whether another hand than Rembrandt's is not discernible in the figure of Christ, in the cloud of cherubs by which he is upheld, and in the peculiar shape of the radiance which here entirely surrounds him (see p. 118 below).

[3] Cf. W. Stechow, "Rembrandts Darstellungen des Emmausmahles," *Zeitschrift für Kunstgeschichte*, III, 1934, pp. 329 ff.

[4] Van Regteren Altena (*loc. cit.*, p. 11 ff.) discusses an interesting parallel, Rembrandt's 'Faust.' For according to his interpretation the disc of light radiating round the magic sign is the face of an angel which is completely dematerialized and transposed into light.

overwhelmed, upon his knees and cries: "My Lord and my God!" (John xx. 24-28) (Pl. 19f, Val. 513). The self-unveiling, self-revealing Christ is here again surrounded by the ring of rays. And as in the drawing with Mary Magdalen, there is a single ray, or path of light, issuing from Christ and falling upon the overwhelmed creature that has recognized Him.[1]

In the renderings of the Resurrection scenes, therefore, there is always a clear reason for Rembrandt's use or omission of the ring of rays. He surrounds Christ with the ring of rays when, and only when, the risen Lord is recognized in the stranger, the veiled one, the unknown. The ray issuing from Christ at these moments and striking the creature made suddenly aware, is the symbol of this recognition and awareness.

## (ii)

Having gained this insight into the problem, we must now enter a wider field. Setting aside the figure of Christ, we must consider the drawings by Rembrandt in which men are shown meeting with God, or in which we can discern how the voice of God reaches a man.

In a drawing representing Abraham's meeting with God, we come across the same phenomenon (Pl. 20a, Val. 7). God the Father is accompanied by two angels. His head is ringed round with a halo. It might be the sun itself shining in the face of God the Father, originating in the head of Divine Majesty. Abraham has cast himself on the ground. A ray, issuing from God's head, strikes him—the man fading away before God's Majesty. Here too, then, we see not only the ring of rays but the special feature that we noted in Rembrandt's Resurrection drawings: the single ray issuing from the ring and falling on the man meeting with God, becoming aware of God.[2]

Rembrandt does not often represent God's Majesty itself as in the drawing we have just described; in the Old Testament immediate encounters with God are mostly avoided. Instead we have a series of drawings in which Rembrandt shows how a man is reached by the voice of God, without God Himself appearing.[3]

We see Elijah at the brook Kerith (1 Kings xvii. 5) (Pl. 20b, Val. 182). On the right a ray of light falls obliquely from above and strikes the prophet awaiting the word of God. This ray does not originate in any earthly source of light; neither is it merely a sunbeam falling there by chance. To understand this ray aright, one must so to speak complete the picture: the Majesty of

---

[1] Cf. the same scene, Val. 514, where the ring of rays is so faint that it is only just discernible in the reproduction; likewise Val. 515, where the rays fan out over the whole sheet.

[2] The ring of rays in its usual star shape is found in the version of the same scene in the drawing Val. 8. What we have said is therefore applicable even if Val. 7 (Pl. 20a) is not by Rembrandt, or has been considerably worked over by another hand. (See p. 120 below.)

[3] There is a certain parallel in one of Rembrandt's mythological illustrations, Val. 605, where Jove's rain of gold is replaced by rays of light. In the case of Val. 570, on the other hand, the lines probably do not indicate rays, but ropes belonging to the rigging of a ship. Perhaps the interpretation of the subject of this drawing, which has not so far been successful, should start from the observation that the whole scene is set on board ship and that Valentiner's opinion that there is only a ship in the background is mistaken.

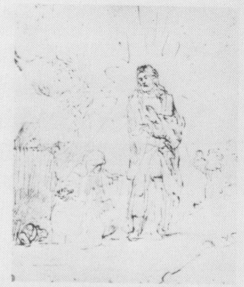

a—Rembrandt, 'Christ appears to Mary Magdalen,' Pen, *c.* 1638; Print Room, Amsterdam (*p.* 103)

b—Rembrandt, 'Christ appears to Mary Magdalen,' Pen, *c.* 1650; Formerly Coll. Th. Tuffier, Paris (*pp.* 103, 120)

(217)

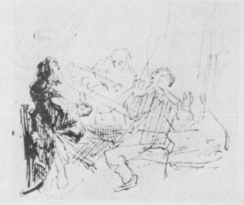

c—Rembrandt, 'The Disciples on the Way to Emmaus,' Pen, *c.* 1650; Louvre (*p.* 103)

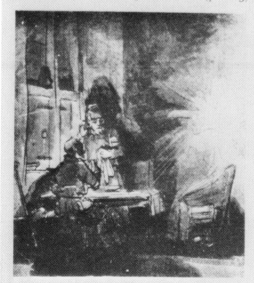

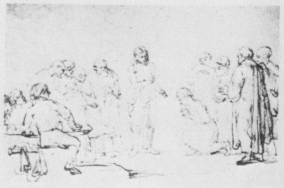

d—Rembrandt, 'The Supper at Emmaus,' Pen, *c.* 1629; formerly W. v. Bode coll., Berlin (*p.* 103)

e—Rembrandt, 'The Supper at Emmaus'; Pen, *c.* 1645; Ch. Ricketts and Ch. Shannon, London (*p.* 103)

f—Rembrandt, 'Doubting Thomas' (Copy ?), Pen, *c.* 1650; Print Room, Amsterdam (*pp.* 104, 111)

20

(218)

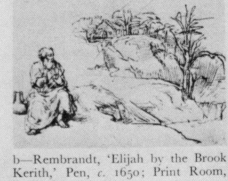

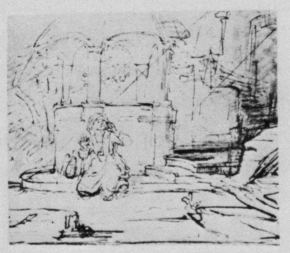

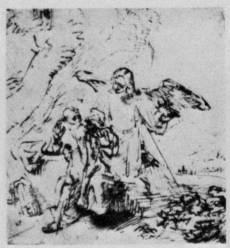

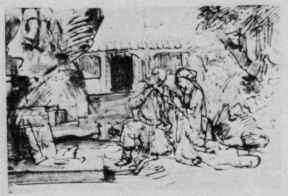

a—Rembrandt, 'God Appearing to Abraham,' Pen and Wash, *c.* 1647-50; Albertina, Vienna (*pp.* 104, 120)

b—Rembrandt, 'Elijah by the Brook Kerith,' Pen, *c.* 1650; Print Room, Berlin (*p.* 104)

c—Rembrandt, 'Hagar at the Well,' Pen and Wash, *c.* 1646-48; Louvre (*p.* 105)

*Copyright F. Lugt*

d—Rembrandt, 'Elijah and the Angel,' Pen, *c.* 1658?; Coll. F. Lugt, The Hague (*p.* 105)

e—Rembrandt, 'Sacrifice of Manoah,' Pen and Wash, Coll. Dr. Oskar Reinhart, Winterthur (*p.* 106)

f—Rembrandt, 'Christ Baptized in the Jordan,' Pen, *c.* 1660; Formerly Print Room, Dresden (*p.* 107)

God at an infinite distance, enveloped in the flames of the ring of rays, and issuing thence the ray that strikes the solitary prophet by the brook Kerith.

The same treatment occurs in a drawing showing 'Hagar at the fountain on the way to Shur' (Pl. 20c, Val. 16).

In this drawing there are several rays, as it were isolating a space in which the invasion of the divine light is accomplished; sheltered in this space, enclosed in it, is Hagar, hearkening to the voice of God.

That these are not sunbeams falling "by chance" into the picture is proved by the fact that in other scenes of the like nature Rembrandt may introduce an angel instead of the ray as the bearer of God's Word, in exactly the same manner.[1]

Occasionally they are seen side by side: the descending messenger of God and the penetrating ray from God's Majesty, as in another drawing of Elijah in the wilderness (Pl. 20d). Elijah does not see the angel. This is characteristic of many angelic apparitions in Rembrandt's interpretations. (Abraham sacrificing Isaac, Daniel in his vision by the waters of Ulai.) The angel is standing behind the man concerned, so that he is not seen. Even when Rembrandt actually depicts the angel of the Biblical narrative, it is in reality an inner voice which the prophet or the patriarch hears. To make this voice visible, ultimately therefore for the sake of the spectator, Rembrandt makes use of the angel or the ray of light falling from above.[2]

[1] On this point I am in complete agreement with H. Van der Waal, whose article "Hagar in de woestijn," *Nederlandsch Kunsthistorisch Jaarboek*, 1947, p. 145 ff., comes to the same conclusion. As neither this article nor the contributions of Van Regteren Altena and F. Saxl were known to me at the time when I first formulated my opinion expressed above, this may constitute a welcome confirmation.

[2] At this point I must insert a brief controversy. In his article "Hagar in the Wilderness" (*loc. cit.*, p. 163) Professor van de Waal takes account of the same phenomenon, but explains it differently. He asks why Rembrandt does not show the angel mentioned in the Bible story, in the drawing reproduced here (Pl. 20d), instead of replacing him by a ray of light. Van de Waal suggests a theological reason for this. He finds it in the text of Genesis xvi. 7, and in the comment which the State Bible of 1637 makes on this passage. Genesis xvi. 7 speaks of the "Angel of the L.o.r.d." The State Bible comments: "Here a divine act is assigned to the angel, from which it may be seen that he is not a creature but the Creator himself." May it have been the Commandment "Thou shalt not make to thyself any graven image, nor the likeness of anything. . ." that prevented Rembrandt from portraying the "Angel of the Lord" himself? If this were Rembrandt's motive, we should have dis-

covered a highly significant fact, namely that Rembrandt's Christianity had received the impress of the Reformed Church, perhaps not merely under *doopsgezinde* influences, and that he must have used the *Staaten-Vertaling*, the official Reformed translation of the Bible.

But in opposition to Van de Waal's theory I submit the following:
i. At other times—though not often—Rembrandt is not afraid of bringing God Himself on to the stage (we noted instances of this earlier); why then should the text of Genesis xvi. 7 have hindered him from depicting the "Angel of the Lord"?
ii. In other cases, in which the Bible likewise speaks of the "Angel of the Lord" or the "Angel of God," Rembrandt depicts the Angel himself. As in Val. 186, illustrating 1 Kings xix. 7: "And the Angel of the Lord . . . touched him, and said Arise and eat; because the journey is too great for thee" (cf. Pl. 20d). (Valentiner interprets this drawing wrongly. It has nothing to do with 1 Kings xix. 8 ff.—where we are told that Elijah went forty days and nights in the wilderness unto Horeb the mount of God—since no angel appeared to him at Horeb. It pictures the earlier scene, 1 Kings xix. 1-7, where Elijah lies down in despair under a juniper tree to die. The title beneath Val. 186 should therefore read "Arise and eat; because the journey is too great for thee," not "The

(219)

There is an interesting example of this type of symbolism, a drawing in the Reinhart Collection at Winterthur, representing the 'Sacrifice of Manoah' (Val. 137), for it seems to me that originally Rembrandt had represented a stream of light instead of the angel, and had only afterwards added the feet of the vanishing divine messenger[1] (Pl. 20e).

Both the angel and the ray of light have the same inner meaning in Rembrandt's work.[2] He uses both forms of expression entirely synonymously; he can replace one by the other at will.[3]

## (iii)

In our quest for Rembrandt's conception of Christ it is important to note

Angel appears to Elijah at Horeb.") And again in Val. 34, illustrating Gen. xxi. 17: "And the Angel of God called to Hagar out of heaven . . ."; and Val. 134, 135, Judges xiii. 20: "The Angel of the Lord ascended in the flame of the altar." Again Val. 437, illustrating Exodus xxii. 22.

iii. Where there are different drawings of the same subject, one may show the angel, another the ray of light. Cf. 'Hagar and Ismael in the Desert,' Val. 33 and Val. 34; and the Gethsemane scene: Val. 451 and 452.

[1] F. Saxl ("Rembrandt's 'Sacrifice of Manoah'," *Studies of the Warburg Institute*, IX, London, 1939) makes this drawing the starting-point of his theory according to which the Sacrifice of Manoah in Dresden (1641) is not preserved in its original state, but was repainted by Rembrandt towards the end of the 1640's. According to Saxl the arriving angel seen from behind belongs to this later state while the painting showed originally either an angel seen from in front or, instead of an angel, a strong stream of light.

Saxl seems undecided between the two alternatives. It seems to me that our analysis may help towards such a decision, at least as far as the drawing Val. 137 is concerned. Once one has trained one's eye for the way in which Rembrandt uses the stream of light instead of an angel in other Biblical scenes, one notices the same type of rays falling from the left side above on the drawing concerned, a fact not specifically mentioned by Saxl (they can be discerned above the door and on the lower corner of the window to the left of the door). May it not be that this drawing in its original state showed only the stream of light —apart from the flames rising from the sacrificial altar—and are not both the attempts to render the feet of the vanishing messenger of God later additions?

[2] In the case of another Biblical scene, F.

Saxl explicitly stresses the fact that to Rembrandt the ray of light and the angel mean the same. In fact, he comes to exactly the same conclusions on this point as are here advocated when he writes: "I think we are not over-rating these observations if we assume that they have some bearing on Rembrandt's religious attitude. At certain times he shrinks from representing the miracle in its traditional form—his belief in the miracle as such does not waver, but light is a more indefinite, and therefore sometimes a more adequate, expression of his religious feelings" (F. Saxl, *loc. cit.*, p. 11).

[3] There is one point where I have to contradict Saxl's views. At the end of his discussion of the 'Sacrifice of Manoah,' Saxl suggests that wherever in the rendering of this scene the angel is omitted, we are confronted with the final stage where the angel has disappeared, leaving only a stream of light behind him. Now there are certainly renderings by Rembrandt where this interpretation must apply, for instance, the etching B 43 of the 'Family of Tobit,' or the drawing of the 'Sacrifice of Manoah' in the Reinhart Collection (Val. 137) where we can see the feet of the divine messenger on the upper margin. In the case of Val. 182, one may also be in doubt whether Elijah is longingly expecting the ravens, the messengers of divine intervention, or whether his eyes follow them as they disappear. (I cannot agree with Van der Waal's interpretation of the drawing as representing 1 Kings xix. 6, and I think that the school drawings Val II, p. xvii, ill. 13 and 14, belong to Val. 186, but not to Val. 182.) There are, however, instances where the rays must certainly be interpreted as representing the presence of the divine messenger. Thus there can be no doubt that on Val. 16 the moment is represented when Hagar hears the voice of divine summons.

that in certain drawings Christ Himself is struck by one of the rays issuing from God's Majesty.

In the 'Baptism in Jordan' Christ is shown without radiance of any sort (Pl. 20f, Val. 350). He is the man come to "fulfil all righteousness" (Matt. iii. 15). Here it is not on Christ but on the hand of John the Baptist that the light falls from above. The Baptist is here accomplishing God's work in Christ.

In the 'Gethsemane' scene, special significance is assigned to the rays issuing from God's Majesty and breaking into the darkness of the world (Pl. 21a, Val. 450). We see Christ, strangely agitated and distressed, seeking help and support from the sleeping disciples. ("Could ye not watch with me one hour?"—Matt. xxvi. 40). Hardly any painter has ever dared to show Christ so weak, so distressed, unless it be in conceptions of the most modern origin, such as Barlach's. But even though at this moment Christ Himself is not aware of divine help, yet behind Him—unnoticed by Him—rays of light are breaking in, showing that this tempted and troubled man is after all not forsaken by God.[1] And when Rembrandt pictures the moment of which the Scripture says: "And there appeared unto Him an angel from heaven, strengthening Him" (Luke xxii. 43), we see the rays falling from above again, only now that the temptation is overcome, they are flowing towards Christ.[2]

The story of the Temptation presents a counterpart to this. "The devil taketh him unto an exceeding high mountain, and sheweth him all the kingdoms of the world, and the glory of them" (Matt. iv. 4-8 ff.) (Pl. 21b, Val. 356). Christ is kneeling close to the abyss, where the rocks fall steeply away. How masterly is the way the physical sensation of giddiness is used to convey the spiritual temptation of Christ! The threefold circle drawn in the picture is strangely affecting. It has been suggested that this triple circle indicates a design for a plate or a bowl.[3] But apart from the fact that "handicraft designs" are hardly frequent among Rembrandt's works, the 'Temptation,' as a subject, might be considered unsuited to a plate or a bowl. I find the Dutchman's interpretation more convincing, who comments on this drawing: "Rembrandt draws a double circle round the Devil and Jesus, and you feel at once that Jesus is under a spell: no light from above, no angel can reach Him."[4] The multiple circle cutting Christ off from the ray of divine light symbolizes the last degree of the Temptation.

But when Rembrandt shows the victory over the Tempter ("Get thee hence, Satan!"), we see once more the ray of light from God's Majesty descending like a flash of lightning (Pl. 21c, Val. 357).[5]

(221)

---

[1] Cf. the etching 'The Three Crosses' (B. 78) with rays of light falling from above.

[2] See Val. 451. Cf. also Val. 452, 453, 454, where the angel is depicted as well as the light.

[3] E.g. W. R. Valentiner, *Rembrandt. Des Meisters Handzeichnungen*, I, 1925, p. 486, on the subject of the above drawing.

[4] A. Kool, *Rembrandt en het Ongeziene*, Amsterdam, 1939, p. 57.

[5] Professor Van Gelder drew my attention to the fact that what we usually see on Rembrandt's drawings is not a single ray of light but rather a stream of light indicated by two rays (see, for instance, Val. 350). It would be tempting to make this observation a starting-point for a scrutiny of Rembrandt's paintings. Needless to say, however, such an investigation would have to be based on the originals, many of which have never been accessible to me.

## (iv)

These are instances of Christ Himself being struck by the ray issuing from God's Majesty. In these cases the same thing is happening to Christ as to an Elijah or a John the Baptist. But this is not Rembrandt's whole conception of Christ. In other drawings we find Christ Himself surrounded by the radiance which elsewhere belongs to God, and never emanates from any of Rembrandt's Prophets or Men of God. Not only the risen Christ, but Christ teaching and healing in Galilee is now and then surrounded by the ring of rays.

Here again it is usually possible to give the inner meaning of this radiance. There are two scenes especially in which Rembrandt surrounds Christ with rays: the 'Awakening of Jairus' Daughter' and the preceding encounter of Jesus with Jairus,[1] as well as the drawings of Christ walking on the sea. Thus, in both cases, they are scenes in which Rembrandt must have been deeply aware of the irruption of a supernatural element, and which from a theological point of view also are closely connected with the scenes of the Resurrection. Pl. 21d shows 'Christ and the Sinking Peter' (Val. 426). In an earlier version of this scene belonging to the 'thirties, Christ is surrounded by the ring of rays in the form we have met with hitherto (Val. 425 "c. 1638"). It has the same curiously fluttering character as in some of the earlier versions of the 'Awakening of Jairus' Daughter' where it is indicated so slightly and with such a hasty line that it would hardly be noticeable if one's attention had not been caught by the same phenomenon elsewhere (cf. Val. 418, 419).

(222)

In the later version of the subject, the radiance assumes a form which otherwise is only met with in the etchings. A ring of separate rays issues in every direction from the head of Christ. Two of these rays are drawn out to a great length and strike the water to left and right of the sinking Peter. Peter is thus gathered into the field of force circumscribed by the rays: outside this field of force he must sink.

There is an unequivocal example to show why and where Rembrandt used the ring of rays; it occurs in two drawings from the Passion series, in which one would least expect to meet with the phenomenon of radiance.[2] In the 'Trial of Christ before the High Priest,' apparently for no reason, Rembrandt depicts Christ once with, once without the ring of rays. But the Bible story itself provides conclusive grounds for this.

Christ's trial before the High Priest is the only scene in the Gospels— except for the declaration to the disciples at Caesarea Philippi—in which the Messianic secret is revealed, or at any rate directly declared. "I adjure thee by the living God, that thou tell us whether thou be the Christ, the Son of God." Thus the High Priest questions the Accused at the climax of the proceedings (Pl. 21e, Val. 467). The High Priest Caiaphas has risen from his seat. His hand is raised in adjuration. His gesture corresponds exactly to the

---

[1] Cf. Val. 414; Val. 418, 419, 420. But not in the Berlin drawing Val. 415, or Val. 824.

[2] Except in the drawing of 'Christ taken Prisoner,' where the text of St. John's Gospel:

"When therefore he said unto them, I am he, they went backward and fell to the ground" demands an exhibition of the divine character of Jesus. (See above, p. 101, on Val. 455, 456.)

a—Rembrandt, 'Christ Finds the Disciples Asleep,' Pen and Wash, *c.* 1655; Print Room, Berlin (*p.* 107)

b—Rembrandt, 'The Devil Showing Christ all the Kingdoms of the World,' Pen and Wash, *c.* 1645; Print Room, Berlin (*p.* 107)

c—Rembrandt, 'Temptation of Christ,' Pen, *c.* 1652; Formerly Print Room, Dresden (*p.* 107)

d—Rembrandt, 'Christ Walking on the Water,' Pen, *c.* 1655; British Museum (*p.* 108)

f—Rembrandt, 'Christ Before Caiaphas,' Pen and Wash, *c.* 1635; National Museum, Stockholm (*p.* 109)

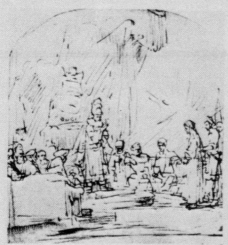

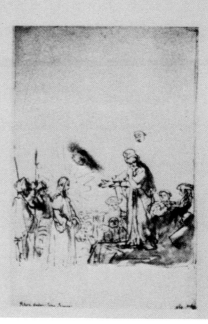

e—Rembrandt, 'Christ Before Caiaphas,' Pen, *c.* 1645; Coll. H. Oppenheimer, London (*pp.* 108, 121)

(223)

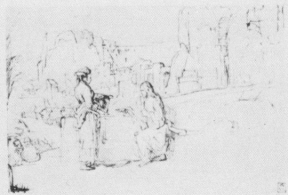

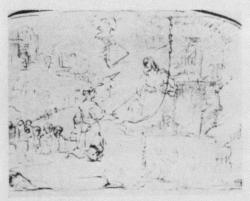

a—Rembrandt, 'Christ before Caiaphas,' Pen and Wash, *c.* 1652: Print Room, Berlin (*p.* 109)

b—Rembrandt, 'Christ and the Woman of Samaria,' Pen and Wash, *c.* 1655: National Museum, Budapest (*p.* 110)

c—Rembrandt, 'Christ and the Woman of Samaria,' Pen, *c.* 1658: Goethe Museum, Weimar (*p.* 110)

d—Rembrandt, 'The Samaritan Woman Bringing the People to see Jesus,' Pen and Wash, *c.* 1658: Coll. Tobias Christ, Basle (*p.* 110)

e—School of Rembrandt, 'St. Jerome at Prayer,' Pen: Kunsthalle, Hamburg (*p.* 113)

f—Rembrandt (?), 'St. Cecilia,' Pen: Museum of Fine Arts, Boston (*p.* 114)

Biblical text. Jesus replies: "Thou hast said," and meekly bows His head. At this moment we see the ring of rays flashing round Him. The secret is revealed. For an instant this man standing helpless and forsaken before His judge is visibly "the Christ."

In this drawing none of the rays is drawn out in length. Christ is surrounded only by adversaries; there is no one present to recognize Him through faith. The ring of rays is motivated here by the word of Christ alone.

The same reason applies to the radiance in a drawing in which—if Valentiner interprets it rightly—Christ is standing before Pilate (Pl. 21f, Val. 469). The Governor points to Christ with both hands and says: "Behold the man!" Here too, in the 'Ecce Homo!' Rembrandt must have seen a revelation of the Messianic mystery.

But does this drawing really represent the scene before Pontius Pilate, or is it another version of the trial before Caiaphas? The great crowd of people, whose heads fill the background of the picture in serried ranks, suggests the Pilate scene. But according to Valentiner these heads are adventitious, inserted later by another hand. "Only the figure of Christ is by Rembrandt, with the two soldiers behind him, Pilate, at whose feet two heads are seen on the left, and the two men's heads in profile leaning in on the right." (Valentiner, under Val. 469.) If we discount the additions, the emphatic, almost passionate gesture of the man pointing to Christ might equally well express the words of Caiaphas: "Behold, now ye have heard the blasphemy: What think ye?"[1]

It may be asked why, in a third drawing of the same scene—'Christ before Caiaphas'—Rembrandt omits the ring of rays (Pl. 22a, Val. 466). The reason is again to be found in the Bible story itself. The trial is over. One of the soldiers smites Christ on the cheek: "Prophesy unto us, thou Christ: who is it that struck Thee?" (Beside the head of Christ the hand raised for the blow is clearly visible, although only lightly indicated.) At this moment of deepest humiliation, following on the Messianic avowal, it is pertinent, and consonant with the Biblical account, that there should be no radiance.[2]

There is a theological work, of the school of liberal exegesis, which reveals better than any other the inner structure of the Synoptic Gospels: Wrede's *Messianic Mystery*.[3] It shows how the Messianic secret is strictly guarded, in Matthew particularly, up to the declaration to the disciples at Caesarea Philippi (Matt. xvi.) (the devils, who are at once aware of Christ, are forbidden to speak); and only after Caesarea Philippi is the secret disclosed at certain important junctures, as in Matthew xxvi. 24; whereas the Gospel of

(225)

[1] This interpretation of the drawing is also borne out by the fact that on all other occasions when he is standing before Pilate, even at the moment of *Ecce Homo*, Christ is depicted without any radiance. This interpretation of Val. 469 may be confirmed by another observation, if we compare our drawing with the drawing of 'Peter's Denial' (Val. 465). Here the background shows another rendering of Christ before Caiaphas with the same characteristic movement of the High Priest extending both hands as if in accusation and turning towards the beholder.

[2] If therefore we follow the inner course of the Biblical account with Valentiner, this drawing should come after Val. 467, or after 469. Valentiner seems to have overlooked the striking hand, and to be thinking of the moment when the soldiers bring Jesus before Caiaphas, whereas Rembrandt is depicting the movement after the trial, i.e. immediately before Christ is led away.

[3] W. Wrede, *Das Messias-Geheimnis in den Evangelien*, Göttingen, 1901.

John is concerned from the beginning to bear witness to his "glory." It is astonishing that Rembrandt should have grasped intuitively this design of the first three Gospels, which has only recently been expounded by a modern commentator, and expressed it by the presence or absence of the symbolic radiance.

One last instance of this radiance issuing from Christ must be mentioned: 'Jesus speaking to the Woman of Samaria at the Well'—most impressive and even more illuminating than any of the foregoing, since here, as in the Resurrection scenes, Rembrandt differentiates clearly between the situation of "not-yet-recognizing" and that of awareness. (John iv. 1-26.)

When Jesus is telling the Samaritan woman compromising facts about her past life there is no radiance. The woman is standing, half defiantly, half confounded by the deeply disturbing words of the stranger (Pl. 22b, Val. 404). In the moment of awareness all is changed. The woman questions the stranger about the promised Messiah (John iv. 25, 26), and the answer comes: "I that speak unto thee am He." This is the moment depicted in Pl. 22c (Val. 405). Christ—not the risen Christ but the historical Jesus—is surrounded by the ring of rays. The Woman of Samaria has fallen on her knees. A ray of the light issuing from Christ falls upon her at the moment of awareness.[1]

The ring of rays betokening the risen Lord in the Easter scenes is thus used in exactly the same connection whenever one meeting with Jesus the Jewish Rabbi realizes that He is "the Christ."

(226)

<p align="center">(v)</p>

In each of the foregoing examples only single persons (Mary Magdalen, Thomas, the disciples at Emmaus, the Woman of Samaria) are shown recognizing Christ in Jesus, and in consequence, a ray is falling upon them from His radiance. But in certain drawings of Rembrandt's later period the ring of rays surrounding Christ fans out over the entire scene. The spectator himself is as though confronted with the message: "This is indeed the Christ."

Pl. 22d (Val. 423) shows a drawing not previously identified.[2] It depicts the final scene of the meeting of Jesus with the Samaritan woman (cf. Pls. 22b, 22c). The long-drawn-out account in St. John's Gospel ends: "So the woman left her waterpot, and went away into the city, and saith to the men, Come, see a man which told me all things that ever I did: can this be the Christ? They went out of the city, and were coming to Him" (John iv. 28-30).

In the background the band of Samaritans is seen approaching, headed by the woman—recognizable by her figure and her broad-brimmed hat. She is pointing to Christ: "Come, see a man . . . can this be the Christ?"

Christ himself is standing by the brink of the well; seated on the steps at His feet are the disciples, eating. "In the meanwhile the disciples prayed Him,

---

[1] When Rembrandt surrounds Christ with the rays in drawings of 'Jesus visiting Mary and Martha,' the motive of awareness is still obviously the reason. One sister has recognized him as "the Christ" and is fulfilling the commandment of the hour, while the other is merely concerned with a guest. (Val. 395 and 399; but not Val. 396-98.)

[2] See the author's article, "Christus am Brunnen bei Sichar. Eine bisher nicht identifizierte Zeichnung Rembrandts zu dem Themenkreis: Jesus und die Samariterin," *Oud Holland*, 1951, I, pp. 9 ff.

saying, Rabbi, eat. But He said unto them . . . My meat is to do the will of Him that sent Me, and to accomplish His work" (John iv. 31-34).

The figure of Christ stands out, larger than life, from among the disciples. The ring of rays surrounding Him spreads out over the whole scene. The rays issuing from Him are not intended for any single person in the drawing, nor does Christ turn towards any one of them. In the left-hand corner of the foreground is a shepherd, leaning on his crook. He is not the chief character in the drawing—as one might almost suppose: this figure seen from behind in the foreground is often to be found in Rembrandt's work.[1] It serves a dual purpose; lending depth to the picture, and at the same time representing the spectator—the man looking at the drawing itself. Like the shepherd, the spectator is confronted with the testimony, and the question, of the Samaritan woman: "See a man . . . can this be the Christ?"

In two other works—both of them illustrating the revelation of the risen Christ to the doubting Thomas—instead of the single ray falling upon the disciple delivered from all doubt, as in Pl. 19f, we see the ring of rays spreading over the whole scene. (Cf. Val. 515 and the etching B. 89, both probably c. 1654.) It is as though the artist were asking the spectator himself to make the confession which Thomas expresses in the words: "My Lord and my God!"[2]

There is great danger in the religious interpretation of pictures; the piety of the interpreter may only too easily be substituted for that of the artist. The author believes, however, that this series of observations on the phenomenon of radiance provides objective evidence with regard to Rembrandt's conception of Christ, which has so far been our ultimate concern.

The sober, austere character of Rembrandt's depiction of Christ has often led to the conclusion that he saw in Him only the Jewish Rabbi, the teacher of divine truth, healing and preaching throughout Galilee; that his mind was closed to the claim of the Messianic mystery.

The most important examples we have been studying were connected with two themes in which the artist's conception of Christ is expressly involved: the Supper at Emmaus and the colloquy between Jesus and the Woman of Samaria at the well. Both of these are concerned with the same thing: awareness of Christ, the core of the Christian faith. By means of the ring of rays and the single ray issuing from it, Rembrandt succeeded in expressing something fundamentally undepictable. "And their eyes were opened, and they knew Him." These words are the key to Rembrandt's oft-renewed analysis of the theme of the Supper at Emmaus and to the drawings in which the ring of rays appears. It is characteristic of Rembrandt's profoundly Protestant approach to his subject that he thus makes use of a simple symbol as the means of expressing the central claim of the Gospel. Its reasoned use in his Biblical works proves that he saw in Jesus not merely the Jewish Rabbi: he recognized the Gospel claim that in this Rabbi dwells Christ, the Anointed of God.

(227)

---

[1] In the "Hundred-guilder print," among many others.

[2] Apart from the examples adduced, many of Rembrandt's works of the late '50s present this direct "preaching" character.

## (vi)

In connection with a lecture given by the author in the Kunsthistorische Institut in Utrecht, the question arose, how far the phenomenon of radiance derives from an original artistic or religious intuition on Rembrandt's part, and what parallels may be found in the mediaeval and Post-Tridentine art of the Netherlands. An important contribution to the answer is to be found in an essay by Millard Meiss, which discusses one tradition of Mediaeval art in which rays of light are used to represent the theological doctrine of a human being being reached by Divine summons—illustrations of the Immaculate Conception.[1]

Further instances are to be found in Father B. Knipping's study of Counter-Reformation iconography in the Netherlands.[2] These are mostly taken from title-pages, devotional pictures, and engravings, i.e. from the minor religious applied art of the seventeenth century. The most important are summarized below.

1. The Christ Child, in the guise of a little Cupid, is shooting an arrow at the lovesick soul, while from above rays of light fall on the kneeling, ecstatic figure. Thus a painting of St. Theresa by Anton Wierix (B. Knipping, Fig. 45; cf. Fig. 87, *ibid.*).

2. Another favourite subject is a saint kneeling before the altar; a pencil of rays issuing from the monstrance symbolizes the inward experience: the vision of the eucharistic Christ. Thus in paintings of St. Stanislas Kostka by Schelte a Bolswert and of St. John Berchman by Boetius a Bolswert (Knipping, Figs. 133, 135).

3. Stigmatizations also are often symbolized by rays. In a 'Stigmatization of St. Catherine of Siena,' a ray falls from each scar of the crucified Christ on the corresponding stigma of the saint (Knipping, Fig. 152).[3]

4. Finally there are examples, less Roman Catholic in character, in which, as in Rembrandt's work, rays issue from God Himself; e.g. on a title-page of Carel de Maléry's *God's Mercy towards the Fallen Man* (Knipping II, Fig. 192). Another title-page (Goltzius' *Return of the Penitent Sinner*) shows the *Majestas Dei* in the form of the Jahve-symbol, from which rays shoot down upon the penitent (Knipping II, Fig. 61).

In Dutch art of the Counter-Reformation in the seventeenth century, therefore, the use of rays to express religious experience lay ready, so to speak, to Rembrandt's hand.[4] But there is an essential difference. The Child Jesus

[1] *The Art Bulletin*, XXVII, 1945, pp. 175-181. The same problem of the ray in pictures of the Annunciation is also discussed in E. Panofsky, "The Friedsam Annunciation and the problem of the Ghent altarpiece," *Art Bulletin*, 1935, p. 433; particularly p. 450. One more instance of the widespread occurrence of light symbolism may be quoted for its technical affinity with the drawings discussed: the illustration in the Utrecht Psalter, f. 7ʳ, of Psalm xii (13), "In lumina oculos meos."

[2] *De Iconografie van de Contra-reformatie in de Nederlanden*, Hilversum, I, 1939, II, 1942.

[3] Rembrandt's etching of St. Francis (B. 107) proves that he must have been familiar with the rendering of rays in Roman Catholic imagery. For this etching has been shown by Schmidt-Degener (*Rembrandt und der holländische Barock, Stud. of Warb. Inst.*, Leipzig, 1928, p. 38) to have been inspired by a print by Federigo Barrocci, in which the traditional long lines indicate the moment of the stigmatization.

[4] Two examples from the Roman Catholic world of the 17th century may illustrate the

shooting an arrow is shown with a conventional halo, while the rays falling on the adoring soul come straight from above—the two symbols are not fused into one.

Herein, to my mind, lies Rembrandt's essential originality. He combines two traditional elements—the halo and the ray—into the peculiarly shaped ring of rays with which he surrounds the figure of Christ. The clearest instance of this fusion of two symbols are those drawings where one ray issues from a circle of radiance till it reaches the person who recognizes Christ. I have found no parallel to this in any of the iconographies or other material to which I have had access.

This is not merely a new means of expression, but a religious confession. The rays take Jesus out of the category of the Saints: in moments beyond our human reach the Glory of God Himself is in Him. I feel justified in claiming, therefore, that the ring of rays, and particularly the single ray issuing from it at moments when Christ is recognized, is a religious expression proper to Rembrandt, born of his personal conception of Christ.

## II

### *The Motif of Radiance in Drawings by Pupils, Anonymous drawings, and those doubtfully ascribed to Rembrandt*

There are a few drawings—whose attribution to Rembrandt or to one of his pupils lies in any case on the borderland of doubt—to which the considerations in Part I do not apply. But there is a larger number whose provenance has hitherto been queried, in which the ray symbol is so characteristically employed as to suggest conclusively that they are based on Rembrandt originals, and these we now propose to study.

In Part I the author was concerned with Rembrandt's personal attitude to the Christian faith. A further objective has led him to select, from the unique collection of photographs and reproductions in the Rijksbureau voor kunsthistorische Documentatie at The Hague, specimens of drawings by Rembrandt's pupils, and anonymous drawings, in which the ray symbols also appear. These fall of themselves into three groups: (1) Those in which the ray symbols are used in exactly the same way as by Rembrandt himself. (2) Those in which they are used in either a meaningless or a nonsensical way. (3) Those in which they express a religious content different from that assigned to them by Rembrandt. An examination of these pupils' drawings may afford us a criterion by which to judge the Rembrandt drawings whose authenticity is still in doubt.

(229)

similarities and differences between the treatment of light in the atmosphere of the Catholic mystics and the austere world of the Protestant master—one is a painting by Zurbarán representing the Vision of St. Alonso Rodriguez (cf. W. Weisbach, *Der Barock als Kunst der Gegenreformation*, Berlin, 1921, fig. 45). Here a ray issues from the hearts of the Virgin and of Christ towards the breast of the saint, where their image appears.

Another characteristic instance is Andrea Pozzo's ceiling fresco of S. Ignazio in Rome (for illustration cf. this *Journal*, XI, p. 186). According to Pascoli, the programme symbolizes the merits of the Saint in the spreading of the faith by showing rays issuing from the figure of Christ falling upon the Saint, where they divide into four to illuminate the four corners of the world.

(i)

The Hamburg drawing of St. Jerome at prayer (Pl. 22e) cannot be by Rembrandt, and Valentiner has not included it in his volumes of drawings by the Master. The treatment shows strong Catholic features, such as the ecstatic attitude of prayer—when Rembrandt shows his subjects praying their posture is far more composed—and the skull supporting the open devotional book. (A skull was used as an aid to meditation by the Spanish quietistic mystics of the period, as represented by Molinos, in a far deeper sense than the *memento mori* of the death's head in pictures by the mediaeval masters.) Apart from this, the rays of light descending on the left are drawn with a conspicuous hardness—much harder than is usual with Rembrandt.[1] Yet these rays have the same inner meaning as in authentic representations of similar subjects. They show that the Saint's prayer is answered by God.

The most enchanting of all the pupils' drawings is an almost unknown 'Saint Cecilia' in the Museum of Fine Arts in Boston (Pl. 22f). We are in an organ loft of baroque curves surmounted by a canopy. The Saint is sitting or kneeling at the keyboard, with her hands caressing the keys. In the background we discern the soaring wall of the organ pipes. Two rays of light fall from above upon the Saint's head. They figure the moment of inspiration, of inward hearing, and are used exactly as Rembrandt would do.

The drawing has an enchanting liveliness of line and form.[2] Might it not be by Rembrandt himself? It may be objected that the lines are all too swirling, too baroque in character to suggest Rembrandt's hand. But might not this swirling effect arise from the subject, and be motivated by it? The theme is inspiration, by heavenly music audible to the inward ear. And music—sound and rhythm—calls for movement.

Next we have two pupils' drawings showing the ring of rays with which Rembrandt surrounds the head of Christ. The first is the 'Raising of Lazarus,' by Philipp Koninck.[3] It is based on a drawing of the same subject by Rembrandt,[4] which Koninck has freely transmuted, as he often does, into a composition of his own. He has taken the rays surrounding the head of Christ from his model, and used them in the same sense.

The 'Angel's Annunciation to Mary,' another example of the use of the ring of rays by a pupil, is probably by F. Bol.[5] This is not based on a Rembrandt drawing; it is a free composition by a pupil. The head of the announcing angel is surrounded by a star-shaped radiance such as Rembrandt uses when Christ is revealed in the Rabbi. What is unusual is that the

[1] In Val. 186—where the angel appears to the Prophet Elijah on Mount Horeb—the rays are equally hard, besides being peculiarly broken, and for this reason I was uncertain whether it should be attributed to Rembrandt till I came across the original in Fr. Lugt's collection. Valentiner's reproduction is of a copy formerly in the Oppenheimer Collection in London. In the original the rays are drawn with the supple line Rembrandt always gives them.

[2] The Saint's face has a comparatively empty look.
[3] See H. Gerson, *Philipp Koninck*, Berlin, 1936, *Fig.* 175.
[4] See Val. 420. We possess only a copy of this drawing by Rembrandt.
[5] Cf. H. van de Waal, "Hagar en de Woestijn, door Rembrandt en zijn School," *Nederlandsch Kunsthistorisch Jaarboek*, 1947, I, p. 163.

separate, jagged rays do not issue direct from the divine messenger, as in Rembrandt's work, but from a ring surrounding the angel's head like a firmly outlined halo. All the same, it is a means of expression coined by Rembrandt which has here been adopted by a pupil.[1]

There is one thing, however—and this must be specially stressed in view of what is to follow—that is never found in a drawing proved incontestably to be the independent work of a pupil: namely, the combination of the ring of rays with the long-drawn-out single ray falling on the man or woman at the moment of awareness in faith. This fusion of two formal elements in one expressive symbol appears to have been, in a special sense, personal to the Master.

## (ii)

The layman studying Rembrandt's drawings may suppose at first that he has to do with a guaranteed body of work; especially if he has the two volumes of Valentiner's *Klassiker der Kunst* as his material. Only as he penetrates deeper into the subject does he realize how unsafe the ground is, how wide the borderland in which attributions are precarious. Our research into the significance of rays in Rembrandt's work may have led us to a possible criterion of authenticity.

It cannot be taken for granted that a pupil or imitator adopting the rays was aware of the religious significance which this means of expression possessed for Rembrandt himself. It should therefore be possible to detect the work of a pupil, where a superficial, or even nonsensical, use is made of the rays. The second group of drawings will serve to illustrate this.

The drawing shown in Pl. 23a, usually ascribed to S. Hoogstraaten, but of uncertain authorship, is particularly illuminating. The subject is the 'Woman of Samaria at the Well,' so often treated by Rembrandt, and so fruitful in elucidating the meaning of the rays.[2] Here, too, Christ is surrounded by rays. But this radiance is in strange disagreement with the attitude of the woman, who is pressing her hand to her mouth in confusion. This is obviously the moment when the Stranger, as yet unrecognized, reminds her of the five husbands she has had—not the moment when she recognizes Christ and is overwhelmed by that recognition. The radiance in this case has merely the character of a halo. It has unquestionably been taken from Rembrandt, but not understood in the inherent sense he gives to it. The subtle differentiation between not-yet-recognizing and recognition, so important in the use of the ray symbol, is left out of account. If there were no other evidence, this alone would prove that the drawing was not by Rembrandt.

A further example is to be found among the anonymous drawings. The subject is again one of Rembrandt's: 'Mary Magdalen before the risen Lord' (Pl. 23c). Here, too, the moment of recognition is presented. Here, too, the symbol of radiance is employed—not only the ring of rays around the head of Christ but the single ray directed towards the Magdalen. But how different from Rembrandt! Not only is the ring of rays different in shape, but the two symbols—ring and single ray—are separated, shown meaninglessly side by

(231)

---

[1] The same form of the ring of rays occurs in Hoogstraten's rendering of the 'Sacrifice of Manoah' (cf. F. Saxl, *loc. cit.*, fig. 40).

[2] See p. 110 *supra*, Val. 404, 405.

side.   Moreover the light from above does not actually fall on Mary, but without significance on the ground behind her.  This alone would characterize the drawing as that of a pupil.[1]

The same may be said of a drawing of 'Hagar at the Well' (anonymous School of Rembrandt, A. Strölin Collection, Lausanne).[2]  As in Rembrandt's drawings, the angel mentioned in the Biblical account is replaced by rays falling from above.  But the rays do not fall on Hagar, they fall behind her on the ground.  The connection between the path of light and the anxious hearkening of the woman, seen in Rembrandt's work, is missing.  Here again the expressive symbol is employed, but emptied of its inner meaning.

Further instances of this misuse of the ray symbols occur in a number of insignificant drawings not worth detailed discussion.

<div align="center">(iii)</div>

There is a third group among the anonymous drawings and pupils' work where the motif of the radiance is not used in a fortuitous or meaningless manner, but where its religious meaning differs from that of Rembrandt's.  The following are characteristic examples.  The 'Supper at Emmaus,' by S. van Hoogstraaten (Pl. 23b), shows the moment of recognition.  The disciples recognize the strange pilgrim by the Grace which Jesus used to say at the breaking of bread.  But whereas in Rembrandt's drawings the rays surrounding Christ at this moment serve to show the connection with the disciples—the act of surrender to belief—here the rays shoot straight upwards.  There is nothing even remotely suggestive of this in any of Rembrandt's drawings.  And the radiance differs not only in form; its inner meaning is entirely different.  Here Christ is glorified, transfigured.  It is a very significant drawing from the religious point of view,[3] but it speaks a different language from Rembrandt's in the same scene.

Our next example is a 'Saint Jerome' (Pl. 23d).  Here the ring of rays takes the same form as Rembrandt's, and is executed with great accuracy and emphasis.  But whereas Rembrandt only showed starry rays flashing round Christ at the rare moments of Messianic revelation, here the ring of rays is drawn round the head of a man, one of the Saints.  This is clearly contrary to Rembrandt's idea.  With him, Prophets and disciples are touched by the ray that issues from the *Majestas Dei* or from the Glory of Christ at the moment of His self-revelation; no man, not even a holy man, ever wears the ring of rays.  In this drawing, however, it is Jerome who is the starting-point, the source of the rays, so that these again express a different religious meaning from that assigned to them by Rembrandt.

(232)

[1] Unless my sense of style entirely misleads me, the drawing (Val. 192) of 'Elijah and the Shunammite on Mount Carmel' is by the same hand. Compare the kneeling Shunammite and the kneeling Mary Magdalen in Pl. 23c. If the stylistic connection between the two drawings is confirmed, Val. 192 must be attributed to the same pupil and not to Rembrandt himself. (Possibly to Maas or Renesse.)

[2] Reproduced by H. van de Waal, *loc. cit.*, p. 167, *Fig.* 14.

[3] S. van Hoogstraaten belonged to the *Doopsgezinden*, or Mennonites. He was one of the few among Rembrandt's pupils who had a personal attitude to Biblical subjects, and who remained true to those subjects even after having outgrown Rembrandt's School.

a—S. van Hoogstraten (?), 'Woman of Samaria at the Well,' Bibl. Reale, Turin (*p.* 115)

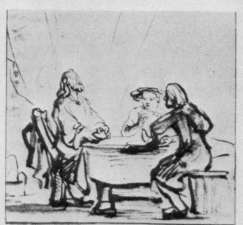

b—S. van Hoogstraten, 'Supper at Emmaus,' National Print Collection, Amsterdam (*p.* 116)

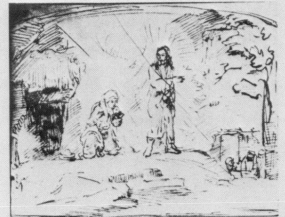

c—School of Rembrandt, 'Mary Magdalen before the Risen Lord,' J. Duveen's Art Gallery, N.Y. (*p.* 115)

(233)

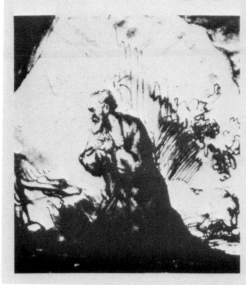

d—School of Rembrandt, 'St. Jerome,' Pierpont Morgan Library, New York (*p.* 116)

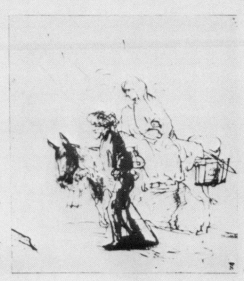

e—Rembrandt (?), 'Flight into Egypt,' *c.* 1640; Pen and Wash, E. Moreau-Nélaton, Paris (*p.* 117)

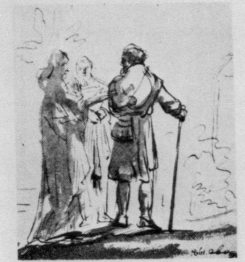

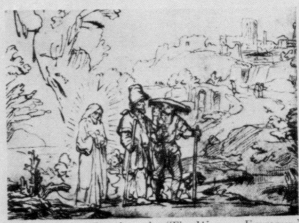

a—Copy after Rembrandt, 'The Way to Emmaus,' Pen and Wash, *c.* 1630, National Museum, Stockholm (*p.* 117)

b—Copy after Rembrandt, 'The Way to Emmaus,' *c.* 1655, Pen, Coll. Friedrich August II, Dresden (*p.* 117)

(234)

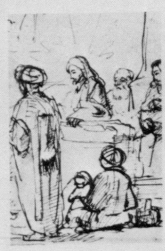

d—Copy after Rembrandt, 'Christ with the Disciples,' Pen, *c.* 1640; Print Collection, Amsterdam (*p.* 119)

c—Rembrandt (?), 'Jesus Appearing by the Lake of Genezareth,' Pen, *c.* 1655; Louvre (*p.* 118)

e—Rembrandt (?), 'Christ and Jairus (or the Centurion),' Pen, *c.* 1645, G. Blumenreich, Berlin (*p.* 120)

f—Rembrandt (?), 'Christ before Caiaphas,' P. de Boer's Art Gallery, Amsterdam (*p.* 121)

We can now turn back to the Rembrandt drawings mentioned at the beginning of this section.

First we may examine a number of drawings which do not conform to Rembrandt's habitual use of the ray symbols, so that we are faced with the alternative: either Rembrandt was not always quite true to his principle in this connection, or else these drawings are not by Rembrandt himself.

Pl. 23e shows a 'Flight into Egypt' (Val. No. 336). The head of Mary is surrounded by a ring of rays of exactly the same shape as that surrounding Christ's head in Rembrandt's drawings. The same objection would apply, therefore, as to the 'St. Jerome' above, were it not that during the childhood of Christ Mary might be crowned with rays in His stead, as in the instance mentioned earlier, where the rays of the setting sun form a halo round her head. (B. 63.) But the drawing under examination presents another difficulty. Besides the ring of rays round Mary, there are rays falling from the left. This destroys the significance assigned by Rembrandt to the ring of rays, since if the Majesty of God Himself is shining forth from Mary, she should be the source of the other rays as well.

A glance at the authorities may help us to a decision. Even Valentiner, who reproduces this drawing as one of Rembrandt's, adds: "timid in execution," and "if genuine, about 1640." The attribution has also been disputed by several critics. F. Lugt in his *Inventaire* (No. 1258) says: "not by Rembrandt"; so does O. Benesch in the *Mitteilungen der Gesellschaft für vervielfältigende Kunst*, 1922, p. 36. As the verdict of the critics agrees with our own doubts due to the use of the ray symbols, we may conclude that the drawing is in effect not by Rembrandt. It might be attributed to F. Bol.

We found the Resurrection drawings particularly helpful in determining the significance of the ray symbols; but in this very field there are certain drawings which contradict—or appear to contradict—our conclusions.

The drawing of the 'Disciples on the Way to Emmaus' (Pl. 24a, Val. 518) presents a flat contradiction to Rembrandt's versions of the subject, which were always clearly distinguished from those of the 'Supper at Emmaus.'

This is obviously the moment of the disciples' request to the unknown pilgrim: "Abide with us: for it is toward evening, and the day is now far spent," clearly to be distinguished therefore from the moment of miraculous recognition. And yet the head of Christ is surrounded by rays as in the drawings of the Supper.

Valentiner remarks: "Except for Hofstede de Groot, the critics have mostly attributed this drawing to the School of Rembrandt, but the originality of the composition, the light effects, and certain details such as the hands and the halo, suggest that despite its hesitant execution it is based on an early drawing by Rembrandt." In this light we may conclude that the rays were added by a pupil for whom the stereotyped halo was an essential attribute of the figure of Christ. Not finding it in his model, he added it in the form he had seen in other drawings by the Master.

A more positive verdict may be pronounced on another version of the 'Way to Emmaus,' although this drawing raises quite a number of questions (Pl. 24b, Val. 524). In the foreground of a spacious landscape, to which great depth is given by a winding road, we see the two disciples on their way to Emmaus.

(235)

Behind them—they are deep in conversation and oblivious of their surround-ings—Christ draws near. His figure is surrounded by a peculiar form of radiance. This might be thought to contradict all we have said before; but it must be remembered that the two disciples are not yet in the company of the pilgrim. It is an earlier scene.[1] The stranger is approaching from *behind*; the disciples have not yet seen him. Rembrandt could thus underline for the spectator the contrast between the "sad" disciples and the unsuspected help so close at hand, by surrounding Him with the radiance.[2] This would resolve the apparent contradiction.

But the shape of the radiance still gives rise to doubt, since it is not met with anywhere else in his work. It is not star-shaped, and it surrounds not only the head: the rays form an oval surrounding almost the entire figure, with the exception of the feet,[3] where a crowd of little cherubs peep out of a cloud, in which Christ appears to be floating rather than walking.

Valentiner says of this drawing: "As the preliminary drawing in black chalk shows, this is a copy. But no other than Rembrandt could have invented the extraordinary composition, with the visionary figure of Christ." We must agree with Valentiner's verdict, although from the standpoint of our own observations we might suspect that the copyist altered a good deal in the figure of Christ, and the radiance surrounding it, out of his own invention.[4]

Another drawing in the series of the Easter story may be thought to contradict our observations (Pl. 24c, Val. 512), called 'Jesus appearing by the Lake of Genezareth.' Here it is not the form of the radiance that gives rise to doubt, but the absence of radiance where one would have expected it—if Valentiner's interpretation of the drawing is correct.

According to John xxi, on which Valentiner believes the drawing to be based, Jesus, standing on the beach at daybreak, calls out to the disciples who are fishing, "Children, have ye aught to eat?" Whereupon John expresses the sudden recognition flashing through them all: "It is the Lord!" Peter casts himself into the water, swimming rapidly so as to be the first to land, while his companions draw slowly near with the overloaded net. If this was the scene intended, we should certainly expect to see the figure of Christ sur-rounded by the radiance.[5] For this is the moment of recognition—the moment in which the disciples become aware that the unknown figure standing on the shores is the risen Christ.

But the details do not agree with those in the text. There is no fire of coals, no meal prepared by the stranger on the beach. We do not see Peter coming ashore before the others, and there are not five but only two disciples in or

---

[1] J. Q. van Regteren-Altena points out in his essay, "Rembrandt's 'Way to Emmaus'," *Saertryk af Kunstmuseets Årsskrift 1948/49*, that Valentiner has dated this drawing wrongly in his catalogue; it should come before No. 520 ff.

[2] The contrast between a happening seen by the spectator and the ignorance of the person concerned in it is a true Rembrandt-esque motif.

[3] The oval form of radiance cannot be taken to mean that Christ has just come down from heaven to his disciples, since his Ascension has not yet taken place; Christ—how-ever transfigured—is still a wanderer upon earth.

[4] The cherubs, too, are suspect, here as in all similar cases.

[5] Fr. Lugt, who has examined this draw-ing afresh in the Louvre, assures me that there is no radiance to be seen in the original, nor even the slightest hint of it.

near the boat. Obviously we have here not the meeting with the risen Christ from John xxi, but the calling of the first disciples beside the sea. This conclusion, first suggested to the author by the absence of the radiance, is confirmed by Fr. Lugt's description of the drawing as 'Jesus calling Simon (Peter) and Andrew' (*Inventaire*, p. 43, No. 1261). The contradiction is thus resolved, and the drawing falls of itself into another group.

It would be most gratifying if we could reach a positive verdict on drawings hitherto considered doubtful, based on the form of the radiance. In the last group of drawings, consisting only of copies or mere fragments, the form of the radiance suggests that they may at any rate derive from Rembrandt originals.[1]

The subject of Pl. 24d (Val. 360) is quite uncertain. We see Christ in the midst of a group of people: a Pharisee standing; a woman seated on the ground with a child in her lap; a young man (almost too young for a disciple) and an older one who might be a disciple. All of them, including Jesus Himself, are looking towards the left, and one feels that there, where the drawing comes to an end—has perhaps been cut away—the real action is taking place.

This impression is confirmed by the form of the radiance with which Christ is surrounded. Besides the ring of rays there is a single ray issuing from Him, passing behind the Pharisee and ending at the edge of the picture. We have seen this ray in scenes of special encounters with Christ. But here there is no opposite party—the man encountering Christ is missing. The very fact that the ray here leads into a void is sufficient to prove that the drawing is a fragment and has been cut on the left side. In fact, the single ray should form the starting point of any interpretation of the subject. One thing is certain: on the missing part of the sheet Christ must have been confronted with a human being recognizing him in that very moment as the Christ.[2] There is another inference we can make.

The ray itself is very clumsily drawn. It appears to be issuing from the eye of Christ; and from this we may infer that although the union of ring and single ray proves the composition to be by Rembrandt, the drawing in question is only a copy.

Here again the authorities concur with our verdict, though on quite different grounds. Prof. Valentiner's note on this drawing reads: "Obviously a copy, misinterpreted in part, and probably a fragment at that."

Val. 414 is another drawing, the subject of which has not been unequivocally identified (Pl. 24e). We see the figure of Christ, the head surrounded

(237)

[1] There are two drawings whose interpretation remains difficult from the point of view which is here sketched out. One is the illustration of the Temptation (Val. 352); in this drawing, whose authorship is doubtful, there are faint indications of strangely incoherent rays over the head of Christ. The other is an illustration of Christ and the Woman taken in Adultery (Val. 822).

[2] May we venture a step further in the identification of the subject? It is not clear, and the copyist does not seem to have understood, what Christ is leaning on. An architectural fragment? The rim of a well? Might it be a boat in which he is standing, teaching the people? In the background the wideness of the sea? Might the oddly shaped pitcher beside the seated woman have been originally a post with the hawser coiled round it? If so, the missing figure might be Simon the fisherman, sinking to the ground as he recognizes Christ and calls out: "Depart from me, for I am a sinful man, O Lord." But these questions and suspicions cannot be solved unless some day the original composition by Rembrandt turns up.

by a ring of rays; before him is a kneeling man, wearing a sword at his left side. One of the rays from Christ's head is prolonged, and encloses the suppliant within His field of force.[1] Valentiner relates the drawing to the scene in which Jairus begs Jesus for help. It might also suggest the Centurion of Capernaum who, when Jesus said "I will come and heal thy servant," and he became aware in whose presence he found himself, cried, "Lord, I am not worthy that Thou shouldest come under my roof; but only speak the word, and my servant shall be healed."

In this drawing, "weak in execution" (Valentiner) and therefore doubtful, the ring of rays and the single ray issuing from it are of decisive importance to our verdict. We have noted instances of the star-shaped radiance being imitated and placed round the head of a Jerome or a Mary in a pupil's drawing, but never the ray issuing from it, and I feel justified in saying, therefore, that where the union of the two occurs, as in this case, if the work is not actually by Rembrandt's hand, it must be based on a composition of the Master's, which the pupil has adopted so to speak "literally."

The same conclusion may be reached regarding a drawing reproduced and examined earlier in this article (p. 104). In judging this drawing (of the doubting Thomas meeting with the risen Lord), instead of my own arguments I may quote Dr. H. E. van Gelder. Discussing the article in which I first drew attention to Rembrandt's ray symbolism,[2] van Gelder writes: "Lugt and Henkel attribute the drawing to Maes. Hind and Benesch adhere to the old attribution to Rembrandt. Valentiner thinks it is a copy, or at any rate an imitation of a Rembrandt drawing.[3] Perhaps the fact that the pencil of rays is drawn in such a peculiar fashion will tip the scale wholly in favour of Rembrandt again."[4]

The author had supported his claim on a further drawing which has been much in dispute: 'God appearing to Abraham by the Oaks of Mamre' (Val. 7, reproduced here on Pl. 20a). Here the radiance surrounding the head of God the Father is of a shape not found elsewhere in Rembrandt's work: not that of a star but that of the sun. But as God the Father himself is concerned, there is a reason for this special form, and it need not invalidate the attribution to Rembrandt. From this sun-shaped mandorla issues a single ray directed at the Patriarch, who has cast himself on the ground in terror before the Majesty of God. This single ray is so personal to Rembrandt, as signifying the moment of recognition of God, or of Christ, and is here so significantly employed, that it is difficult not to assume the drawing to be derived from an original conception of Rembrandt's, although its original character may have been greatly changed and confused by retouching, especially by the heavy shading.

[1] Cf. Rembrandt's drawing of 'Mary Magdalen before Christ,' Pl. 19b (Val. 511).

[2] H. M. Rotermund, "Begegnungen mit dem Auferstandenen," *Neue Schau*, 1951, pp. 59-62.

[3] With regard to Val. 515, which depicts the same event, and where the radiance spreads over the whole scene, Valentiner maintains (contrary to doubts which have been voiced) that the drawing is original, pointing out that the symmetrical character of this grandiose composition reveals the Italian influence which was particularly strong in Rembrandt's œuvre round about 1655.

[4] H. E. van Gelder, "Rembrandts Christusverschijningen," *Oud Holland*, 1951, p. 16, note 1.

A drawing long regarded as anonymous—although attempts have been made to attribute it to Rembrandt or to Hoogstraaten—may serve as a final example of the positive valuation of a drawing on the basis of the ray symbols (Pl. 24f).

The subject is the 'Trial of Christ before the High Priest Caiaphas.' It depicts the moment when Caiaphas raises his hand and says: "I adjure thee by the living God that thou tell us whether thou be the Christ, the Son of God!"

We saw earlier that the Biblical records are here concerned with the revelation of the Messianic secret; that in this scene, which he clearly and purposely separated from the other events of the Passion, Rembrandt surrounds Christ with the ring of rays. (Cf. Val. 467, reproduced here on Pl. 21e.) In this drawing (Pl. 24f) the ring of rays has precisely the same significance. We find exactly the same feature as in Val. 467: at the moment of assenting to the High Priest's question, Christ meekly bows His head. As in Val. 467, the contrast is expressed between the defencelessness of the Man standing bound before his judge, and the inner claim of the scene, by the juxtaposition of the ring of rays and the humble posture.

The inner meaning of the scene is so exactly the same as that of Val. 467 that I feel bound to connect it with a Rembrandt composition. It is for the art expert to determine whether on stylistic grounds the drawing must be reckoned a copy rather than by Rembrandt's own hand.[1]

A word in conclusion. The author had intended to subtitle Part II "The Phenomenon of Radiance as a Test of Genuineness." But he could not overlook the objection that a test of genuineness which pretends to absoluteness is subject to scruples of method, and he has therefore endeavoured to show that the drawings which appeared to contradict his observations could be rejected on other grounds as well, and were actually so rejected by individual art experts.

(239)

In the case of the last group of drawings, however, which hitherto had only been ranked as doubtful copies from Rembrandt's compositions, the author has attempted to make the radiance a criterion in itself.[2] The boundary between pupils' drawings, anonymous work, and genuine Rembrandt drawings is so widely fluctuating, the standards are often so uncertain, that any new aspect under which the doubtful drawings may be considered, offers a positive working basis. Rembrandt's reasoned and inwardly significant use of the ring of rays as a means of expression provides a new classifying principle of this kind. The fact that this criterion of content is concerned with only one viewpoint, besides which the art expert will have to take many others into account, self-evident though it is, must here be expressly admitted.

---

[1] The heads of members of the bench on the left in the background seem strangely feebly and awkwardly drawn. The care, on the other hand, with which the candlestick is rendered makes one think of Rembrandt's interest in Jewish ritual.

[2] As H. E. van Gelder does in the observation quoted above.

# THE POPULAR THEATRE OF THE REDERIJKERS IN THE WORK OF JAN STEEN AND HIS CONTEMPORARIES

## By Albert Heppner

*In Memoriam*
*Oscar Fischel*

### *1. Rederijkers and Painters*

When the mediæval mystery plays of the Church were succeeded in most European countries by the theatrical productions of the guilds, the new form of dramatic activity everywhere displayed important common characteristics. It was the small burghers and artisans who, through their guilds, now assumed the lead in the development of poetry and drama. It is only in the actual organisation of the poetical and dramatic activities of the guilds that certain differences occurred.

In contrast to the actors and artisans of a particular guild, such as that of the tanners or wool-weavers, each of which had its own players' company, the guild of the Rederijkers (rhetoricians) in the Netherlands was composed of artistically-minded members of a number of different craft-guilds, just as in Shakespeare's *Midsummer Night's Dream* a tailor, a joiner, a carpenter and other craftsmen perform a play together. The Rederijkers were organised throughout the Netherlands in "kamers" or chambers, which were in touch with one another and gave joint performances, such as dramatic competitions.

Historically speaking, the Dutch Rederijkers represented in a time of restless ferment the popular element in the arts of poetry and the drama, which at the end of the 17th century and in the course of the 18th was gradually superseded by baroque grand opera and drama. The prominent part played by the guilds in this popular dramatic art had the advantage that it ensured conscientious technical training, but also the disadvantage that owing to the conservatism of the guild the development of the drama was liable to be stifled by rigid and formalised conventions, as Richard Wagner so clearly brings out in the *Meistersinger*.[1]

But, as has been repeatedly acknowledged by recent writers, the Dutch Rederijkers did not produce plays which were merely of a stereotyped and conventional kind; during the two centuries of their activity (the 16th and 17th), there were many members of the guilds who were drawn to the poetical and dramatic arts by genuine talent.[2]

Though there is an abundance of excellent and illuminating material, the life of the Rederijkers and their conception of their work have not yet been adequately investigated. The paintings of the period give us much insight into their activities. Members of the guilds of painters were also members of the "kamers" of the Rederijkers, some as "beminaars" (sympathisers), others with a genuine talent as both painters and poets.[3]

(241)

---

[1] Max Herrmann makes a comparison between Rederijkers and mastersingers in *Forschungen zur des deutschen Theatergeschichte*, 1914, p. 374.

[2] Knuttel, "Rederijkers Eerherstel," *De Gids*, 1910–11, p. 433.

[3] A native of Antwerp who later lived and worked in Amsterdam, Guiliam van Nieuwe-

22

In Flanders, which continued to exercise an important influence on the artistic development of the northern Netherlands even after the separation of the two states, there was at least one significant fusion of the two arts: In Antwerp the painters' guild of St. Luke united with the Rederijker guild "De Violieren" to form a common "kamer," which was in existence from the year 1480 till the foundation of the Academy in 1663.

In the "kamers" of the Rederijkers in Holland, whether they were of old foundation or had been set up by Flemish refugees, there was always a high proportion of painters. This is shown by scattered references to painters,[1] and in particular by a fairly complete list of the membership of a Rederijker "kamer" which has come down to us.[2] It is that of Haarlem, where Van Mander, with his taste for poetry and painting, seems to have had a strong influence; among the members of this guild, whose motto is "Liefde boven al," we find the following painters :

| | |
|---|---|
| Nicolaes Kemp (1614–21) | "Arien" Brouwer (1626) |
| Frans Hals (1616–25) | Gerrit v. Bercheyde (1665–66) |
| Dirck Hals (1618–24) | Job v. Bercheyde (1665–72) |
| Salomon de Bray (1617) | Joh. Vermeer the Younger (1661–83) |
| Simon de Bray (1618–22) | Rich. Brakenburg (1687–95)[3] |
| Esaias van de Velde (1617–18) | Van Nickele (1691) |
| Jan Wijnants (1626) | |

From this it is clear that painters and Rederijkers needed to cooperate. The reasons, chiefly of a practical character, are easy to find. The painters could be of service to the Rederijkers in making the important "blazoenen" (coats-of-arms) and the scenery needed for dramatic performances.[4] The Rederijkers on their side could furnish the painters with ideas and suggest-ions; for though the Dutch painters of the 17th century were perfectly at home with domestic subjects, the naturalistic effects of the stage could often be a vital source of inspiration for them when faced with biblical or historical themes.[5] This is particularly true of Jan Steen.[6]

landt, wrote plays, painted and etched with equal industry. He was thus able to provide frontispieces by his own hand for the printed editions of his works. Cf., for instance, the frontispiece "Sophonisbe receiving the pois-oned Cup" for his tragedy *Sophonisba Aphri-cana.*

Other instances of double talent are the Dutchmen Hendrick Bloemaert, Richard Brakenburgh and Heiman Dullaert, the pupil of Rembrandt. The poet Bredero started as a painter.

[1] For the relations of the painters Ketel and Moeyaert with the Rederijkers see J. A. Worp, *Geschiedenis van den Amsterdamschen Schouwburg*, 1920, pp. 13 and 91; Van Mander in his biography; Valckert in Hudig, *Oud Holland*, LIV, 1937, p. 54.

[2] The "Lijst van broederen van de Rederijkerskamer Liefde boven al" is in the municipal archives of Haarlem (archives of "extinct guilds").

[3] We know that Richard Brakenburgh (1650–1702) was actually a member of two Rederijker guilds. G. J. Hoogewerff pointed out that a picture by F. Hals represents an actor as "Hamlet"; this would be the only indication of Hals's Rederijker interests.

[4] Else Ellerbroek-Fortuyn, *Amsterdamse Rederijkersspelen in de 16de eeuw*, Groningen, 1937, p. 116.

[5] It must not be forgotten, however, that influence sometimes went the other way. Thus Vondel's "Joseph in Dothan" was inspired by a picture by Jan Pynas. Cf. Vondel, ed. Sterk, Vol. IV, p. 74.

[6] Almost all the paintings of Jan Steen mentioned are catalogued in C. Hofstede de Groot's *Beschreibendes Verzeichnis* (vol. 1): here quoted HdG No. . . . An important

## 2. *Jan Steen's Connections with the Rederijkers*

We can find proof of two kinds that this artist was in touch with the Rederijkers. Many of his works portray scenes from the life of the Rederijkers and thus prove his intimacy with them. Further, if we look closely at his biblical and historical subjects, we discover numerous elements taken from the dramatic performances of the Rederijkers; a systematic examination of his whole work provides, in fact, unexpectedly abundant evidence of their influence.[1] There is, however, no documentary evidence of his membership, though chance has preserved a document according to which an uncle of his belonged to the Leyden guild "De Witte Accoleijen."[2] Apparently this uncle played the part of the Jester, and was probably related through his wife to the most famous Jester in Leyden, Pieter Cornelisz. van der Morsch.[3] Jan Steen shares with this great Jester of the Leyden Rederijkers his fondness for castigating abuses and his pleasure in contemplating the failings of humanity.[4] How reluctantly he dispensed with the power of the word, is shown by the frequent explanatory inscriptions, some of them short poems, introduced into his pictures.

Opinion has always been divided about Jan Steen's work. This, naturally, applies not to the more familiar part of his work depicting "disorderly ménages" and similar subjects, but to the considerable and artistically extremely important group of biblical and historical paintings. The reason why these works have met with such an uncertain response is because it is hard to decide whether Jan Steen intends this kind of representation seriously or whether he is making fun of the spectator and of the subject.[5]

Jan Steen's art may certainly be described as essentially didactic and

(243)

supplement to de Groot was made by Ed. Trautscholdt in his "Jan Steen" article in Thieme-Becker's *Künstlerlexicon;* the supplement carries on de Groot's numbering and is here quoted *Suppl.* As being by far the best work containing illustrations we frequently refer to A. Bredius, *Jan Steen,* 1927, by the abbreviation : Bred., Pl. .... For comparison of the various themes of painting with those of literature, the most useful work is the *Catalogus der Bibliotheek van de Maatschappij der Nederlandsche Letterkunde te Leiden* (part II, section 3), edited by Th. J. I. Arnold, Leyden, 1887, with supplement, here cited *Cat. Lett.* No. .... The most important publication on the Rederijkers (but without taking account of the sources in painting) is G. D. J. Schotel, *Geschiedenis der Rederijkers in Nederland,* 2 vols. (2nd ed. 1871) ; here cited as : Schotel, I or Schotel, II.

[1] O. Fischel, "Art and Theatre," *Burlington Magazine,* 1936, i, pp. 4 and 54, expressed his suspicion that the works of the "ardent friend of the Rederijkers," Jan Steen, must

have been connected with the theatre, and almost at the same time J. B. F. van Gils drew attention to the connection between published plays of the Rederijkers and pictures by Steen. ("Jan Steen en de Rederijkers," *Oud Holland,* LII, 1935, p. 130, and "Jan Steen in den Schouwburg" in *Op de Hoogte,* Haarlem, March, 1937, p. 92.)

[2] Bred. (text) p. 83. Jan Steen himself was a member only of a marksmen's guild. Cf. *ibid.,* p. 91.

[3] Portrait of Pieter Cornelisz. van der Morsch in Leyden, Lakenhal.

[4] In his portrait in the Leyden Museum appear his nickname Piero, his motto "A time for everything" and a poem in his honour which describes him as one "who mocked at vice." Cf. Schotel, II, p. 267, and Catalogue of the Lakenhal Museum, Leyden, No. 276.

[5] Thus August Fink, *Zeitschrift für Bildende Kunst,* LX, 1925, p. 230 discusses "how far Jan Steen intended his picture as a parody."

humorous, but his sturdy naturalism never allowed it to become caricature.
It is true that the dramatic performances of the Rederijkers, if only because
of the origin of the actors, were liable to produce an effect of parody;
incompetent acting may provoke laughter even when the performers are
in deadly earnest. And at the end of the 17th century, when the art of
the Rederijkers had finally been left behind by the development of the
theatre, a poet, Lucas Rotgans,[1] did actually take to parody. In the
description of a village festival he ridicules the performance by a company
of Rederijker actors of the drama by Jan Vos, *Aran en Titus*, and gives the
following description of the hero Aran, who in ordinary life is a knacker's
assistant :[2]

> He has smeared his face with soot from the chimney;
> He wears a veil to mark his rank of general;
> The chain that binds him as a captured slave
> Is that on which his old woman hangs the pot beside the hearth.
> A girl from the village gave him stuff from her apron,
> Red silk, that she long had ceased to wear and thrown away;
> Thereof is his turban made, and on every side
> You see it is decorated with pearls and ornaments.

There are certainly affinities between such a description and the decor
and poses in Jan Steen's historical compositions. But Jan Steen, though
he saw the same things as Rotgans, saw them with different eyes. He
is never mocking or condescending; he always reports accurately, without
parody. In his scenes from the Bible or antiquity, he drew living inspiration
from the performances of the Rederijkers which were for him a bridge
between nature and fantasy.

(244)

On the other hand his work provides pictorial evidence of the activities
of the Rederijkers. His connection with them has not received sufficient
attention, because the essential feature of the pictures in which he depicts
them has been overlooked. The "blazoen" (Pl. 2a), the coat-of-arms of
the various guilds, gives the clue to understanding such pictures. These
diamond shaped panels occur in almost every picture dealing with the guild
life of the Rederijkers. The guild brethren were as proud of their "blazoen"
as knights of their coats-of-arms. The only difference between coats-of-arms
and the "blazoenen" of the "kamers" is that the painting of the latter is
not heraldic but represents naturalistically either the patron saint of the guild
or the flower after which it is named. Many of these signs have been
preserved, and the names of important artists are included among those
who executed them.[3] A knowledge of the signs and mottoes of the guilds
of the time can sometimes help to determine localities in representations of
the Rederijkers.

A large and important picture by Jan Steen in the Brussels Museum,
"The Rederijkers" (Pl. 1a), shows us from close at hand the guild brethren

---

[1] *Boerekermis*, Amsterdam, 1708. In
connection with the date of publication it
must be observed that the poet frequently
remarks that he is describing the conditions
of somewhat earlier times. All his statements
are probably true of Jan Steen's time.

[2] *Ibid.*, p. 49.

[3] The largest and finest collection of
"blazoenen" is owned by the club "Trou
moet Blijcken" in Haarlem (15 specimens);
the Antwerp Museum has 9 specimens.

in their meeting-place.[1] The "blazoen" of the "kamer" hangs on the wall at the back, but the details of it can unfortunately no longer be made out.[2] The picture is nevertheless of fundamental importance, as it makes us familiar with all the typical characters of the "kamers," of whose existence we know from various "ordinances."[3] The drummer, in a magnificent doublet and with a scarf tied across his chest, is reading from the window to the people standing outside; he has placed his drum beside him on the floor and his hat on top of it. Behind him stands a man with the solemn features of a scholar, who may be the "factor" or the poet; he is the only person who preserves his dignity. The only other figure of suitably impressive demeanour is the standard-bearer who carried the banner of the guild at all its performances, and could win prizes for his guild by the grace and skill with which he waved the banner and flung it into the air.[4] The man smoking a pipe beside him may perhaps be identified, by reason of his embroidered cap, as the "emperor" or "prince" of the guild. There is no doubt of the identity of the bold young man in the foreground on the right; his is the important position of the jester, for he is wearing the fool's cap with the cock's feather.[5] In the background two members of the guild are deep in discussion, as if they were not concerned with the proceedings; a third is living up to the derogatory rhyme "Rederijker—Kannekijker" (in de kan kijken—look into the can). A pitcher and tankard of wine, generally acknowledged as the attributes of the Rederijkers, are hung on a branch outside the window as additional emblems.[6] The wreath of flowers which decorates the meetingroom of the guild in this picture, and also the motto "In liefde vrij" (loving and free), recall a competition instituted by the "kamer" of Naaldwijk in 1676, at which the thesis "Wherein consists real freedom?" had to be treated poetically.[7] The following answer was awarded the prize :

(245)

> That we are Dutch, the old Batavians,
> Crowned and decked with flowers to this day.[8]

At the window there hangs a splendid carpet, a property which was often employed at the dramatic performances of the Rederijkers. Outside the

---

[1] HdG No. 233.

[2] It seems, however, to represent a fish, and the motto appears to be "In liefde vrij," so that it cannot be identified exactly with the motto of any particular guild, though there are many which it very closely resembles. The Leyden "kamer" "De Oranie Lelie," for instance, had the motto "In Liefde vierig."

[3] A list of many "kamer" ordinances is given by Prudens van Duyse, De Rederijker-kamers in Nederland, Gent, 1900-1902, I, pp. 22-23.

[4] Schotel, I, pp. 94 and 297. The various offices in the Rederijker guilds are discussed by Van Duyse, op. cit., p. 41 : "Het Bestuur der Kamers."

[5] Van Duyse, op. cit., I, p. 57 : "De Zotten, Leden der Kamers."

[6] Originally this had probably been the custom of the innkeepers, but in the course of further development their interests came to coincide so closely with those of the Rederijkers that the competitions were arranged and the prizes offered no longer by the guilds but by the proprietors of the inns. Cf. Schotel, II, p. 109.

[7] Ibidem, p. 103.

[8] "Dat zijn wij Hollanders, den ouden
/Batavier
Tot huyden desen dagh bekranst
verciert met bloemen."

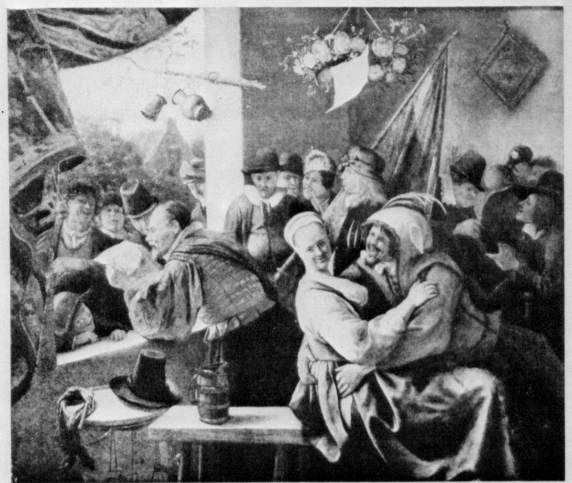

a—Jan Steen. Meeting of the Rederijkers. Brussels, Museum (*p. 26*)

b—Jan Steen. Rederijkers at the Window. Brussels, Stokvis Coll. (*p. 28*)

c—Adriaen van Ostade, Rederijkers. Drawing. Amsterdam, Paul Brandt Coll. (*p. 29*)

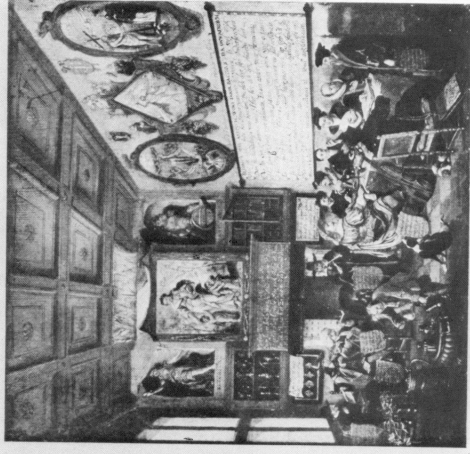

c—Hendrik Pot (?), Religious Disputes at a Meeting of Haarlem Rederijkers.
Haarlem, Frans Hals Museum (p. 27)

a—Coat-of-Arms of the Rederijkers of Rijswijk.  1566.
Leyden, Lakenhal (p. 25)

b—Job Berckheijde, Rehearsal of Haarlem Rederijkers.  Berlin,
Jagdschloss Grunewald (p. 35)

window is an audience of five adults and a boy. A man whose features are strongly reminiscent of Jan Steen himself seems the most amused by the drummer's recital. His gaiety is in keeping with the quatrain which is fastened to the wreath of flowers:

> Though Bacchus be their inspiration,
> The matter of their verse is dry;
> Flatness is beer's annihilation—
> Their bellies now for victuals cry.[1]

Though the Brussels picture is so eloquent of harmonious conviviality, contemporary reports show clearly that the Rederijkers did not always agree among themselves.[2] Religious disputes especially were a source of friction—but that is a subject which we cannot expect to find depicted by Jan Steen. The gap in our knowledge, however, is filled by an unknown master of the Haarlem School (Pl. 2c), who portrayed a religious dispute among the "poets of Bacchus" in a picture dated 1659.[3]

The painting represents a meeting of the Haarlem Rederijkers in their guild house. Although even here wine and tobacco play their part, the main topic of the debaters is religious doctrine in all its variety. The placard hanging like a map on the wall gives the painter's own critical view. The inscription states that the quarrels, which arose among the Rederijkers about religious questions—for everyone can interpret the writings of the founders of religion in the way he pleases—were due to an excessive homage to drink (Bacchus). Elsewhere it is written that although the virtue of Charity is represented above the mantelpiece and appears in the mottoes of the brothers, in reality she is unheeded. As is shown by the briefly worded creeds on the shields beside them or in their hands, the members of the meeting are representatives of the various sects which have fallen out among themselves, Calvinists, Arminians, Mennonists, Socinians, Libertines, Collegians, and Mohammedans, "even the very old Jewish Church is included."[4] The triumph of the Reformation which the Rederijkers had enthusiastically promoted, had been followed by a lamentable sectarianism; and this became particularly intense at a moment when the activities of well-established travelling theatrical companies[5] were doing the Rederijkers sufficient harm.

The room in which this theological debate takes place is no invention of the painter but a faithful reproduction of a richly-decorated guild room. It is highly probable that the Haarlem Kamer, "De Wijngaardtrancken," whose motto was "Liefde boven al" ("Love above all"), met here, for their "blazoen" with the Resurrection of Christ is placed in the centre of

(248)

---

[1] "Sy rymen van droge cost / Bachus poeten fijn / Drooch is al een vat bost / Maer ook moet er eten sijn."

[2] J. F. M. Sterck discusses this very fully, *Van Rederijkerskamer tot Muyderkring*, Amsterdam, 1928. Cf. especially p. 97 ff.

[3] Inventory of the Frans Hals Museum, Haarlem, No. 500. On wood, 46 : 43$^1/_2$ cm. All inscriptions on this picture, as far as

they are legible, are printed and discussed in Sterck, *op. cit.*

[4] "Ja, de Joodse Kerck seer out / wort hier mee noch opgebout."

[5] Chiefly French and English. For the former, cf. J. Fransen, *Les Comédiens français en Hollande au XVIIe et XVIIIe siècle*, Paris, 1925.

the long wall. To the left of it hangs the "blazoen" of the associated Rederijker guild "De Pelikaan" with the device "Trou moet blijcken" ("Loyalty will prevail") and to the right that of "De witte Angieren" kamer, which had been formed by Flemish emigrants under the motto "In Liefde getrouw" ("True in love"). The wall above the mantelpiece almost resembles the altar wall of a church, for here is concentrated everything that was, or should have been, sacred to the Rederijkers. Charity which appears in almost all their mottoes is placed above the chimney piece. To the right enthroned upon a wine barrel is the god Bacchus, who played an important part in the ceremonies of the Rederijkers—as also in those of the painters.[1] Under the figure of Rhetorica is seen a wall cupboard, containing the goblets, jugs and beakers in orderly array, no doubt the prizes won in various contests. Lower down appear "mouwschilden," medals which were hung upon the sleeve, which were only worn on especially important occasions.[2] Above hangs a piece of paper with a literary puzzle,[3] which is answered poetically by another on the right, hanging beneath a bookshelf, which must contain the literature of the Rederijkers. Rolled up, close to the roof of the room, is the guild flag, which we saw carried so demonstratively in Jan Steen's picture in Brussels.

Although in the Brussels picture Steen actually takes us inside the meeting-room he more frequently represents the Rederijkers as they were seen by the public from the street. In the early picture formerly in the collection of Capt. E. N. F. Loyd[4] (Pl. 1b), we see part of the meeting-house, apparently a timber construction filled in with brick and similar to the Rederijker building shown entire in another picture which will be discussed below.[5] The curtain, which in the Brussels picture was attached to the wall inside the room, is here fastened to the wall outside by a cord. The group of Rederijkers consists of four figures in the foreground and five figures, some of them hard to distinguish, in the interior of the room. The features of the man on the right, behind the man with the beard who is reciting from a paper, are those of Jan Steen; he is wearing a painter's beret, has a surly expression and does not appear to take part in the proceedings. The most striking figure is the man on the extreme right with the beer mug, whose pointed face with the prominent cheek-bones we shall recognise again when we examine Jan Steen's biblical and historical pictures. The fact that the "blazoen" receives such prominence in the picture is very important. The emblem and motto are clearly recognisable; they are those of the Amsterdam "kamer": flowering "egelantier" (eglantine—hence their name "De Egelantiers,") and the motto "in liefde bloeiende" (flourishing

(249)

[1] Compare the Bacchic festival of painters (or Rederijkers) in the painting by Ph. Koninck (Bredius Coll., The Hague). Reproduced in the Catalogue (1926), No. 48.

[2] Van Duyse, op. cit. I, p. 64. Armlets are occasionally seen in the portraits of marksmen; those of the Rederijkers are not known to us in pictures.

[3] Compositions for prizes on set subjects play a great part among the Rederijkers.

These competitions were held in connection with a "Landjuweel"; cf. Schotel, I, chapter IX, p. 193 ff.

[4] Suppl. Nos. 234/35. Later, in the possession of Katz, Dieren and Stokvis Coll., Brussels. Some (perhaps all) of the pictures given as copies in HdG are original works by Jan Steen; they also differ from one another in varying degrees.

[5] See p. 32.

in love). This guild tablet, of which specimens have been preserved,[1] is, for our purpose, one of the most important indications that Jan Steen had connections with Amsterdam, the town which had the most fully developed theatre in Holland.

The theme of "Rederijkers at the Window" recurs with striking frequency in Jan Steen's work.[2] In the picture in the Johnson Collection in Philadelphia[3] the treatment differs in some respects from the Loyd picture. More of the façade of the Rederijker house is visible, but the curtain is absent. This version gives an impression of greater artistic maturity; the psychological aspect is handled with greater ease. The types are different : the old man reading out to the audience is now jovial, short-sighted and rather stout; the author of the poem "Lof Lydt" (song of praise) prompts him out of the corner of his mouth. Jan Steen, making such a grimace as to be almost unrecognisable, calls for silence. He now sees himself as the fool—which was to be expected—and wears bells and a cock's feather on his hat; the painter's beret has become the fool's cap. The inscription on the "blazoen," which is difficult to read, is generally interpreted as "Ivcht nemt in"; if, as is very probable, the last word should be read as "aan," we should again have a well-known motto of the Rederijkers, namely that of the "kamer" of The Hague, "De groene Laurierspruit" ("The green laurel shoot"), and its meaning would be "Youth is attractive." Jan Steen might well have become acquainted with this guild while staying at The Hague (1649–1654); we know that it was in its most flourishing state about twenty years earlier.[4]

There are, however, indications that several variations of the composition we have just discussed were not painted till Jan Steen's later period at Haarlem (1661–1670). They are among those works where the resemblance in conception to his older colleague, the Haarlem painter Adriaen van Ostade, is most striking. The latter's picture of the Rederijkers in the possession of Sedelmeyer in Paris[5] shows a close affinity in the grouping of the figures, and it also contains the elements with which we are familiar —mullioned window, vine-leaves and "blazoen." Ostade made frequent use of the subject; in addition to this picture, we also find it in some of his drawings (Pl. 1c) and in an etching.[6] Unlike Jan Steen, Ostade shows the scene at night, with one of the guild brethren holding a candle instead of a beer mug as in Jan Steen's picture. But Jan Steen himself also once chose the same motive : in a small picture, which has all the freedom of a sketch, he shows a meeting of a group of Rederijkers at night.

(250)

[1] The communes of Beverwijk and Vlaardingen each possess one. Exhibited at the Amsterdam Historical Exhibition in 1925, Nos. 798/99.

[2] The same subject also occurs in pictures by followers of Jan Steen. In the Unger-Kannstadt Collection there is a characteristic adaptation of "Rederijkers leaning out of the window" by Egbert von Heemskerck (1645–1704?).

[3] W. R. Valentiner, *Catalogue of the Johnson Collection*, Philadelphia, 1913–1914, II, No. 512, Pl. 357. Bred., Pl. 92.

[4] Schotel, II, pp. 89, 90.

[5] *Sedelmeyer, Paris*: "*Hundred Paintings*," 1906, No. 28. Later, H. Heugel, Paris.

[6] Rough sketch in the Oppenheim Sale, London, 1929, No. 682; finished drawing, P. Brandt, Amsterdam, to whom I am indebted for the photograph. The Ostade etching which has often been reproduced is Bartsch, No. 19.

Candles and stable-lanterns provide the necessary light.[1]  Inside the house hangs the shield of the guild, with a fragment of an inscription "Vive L A".

In a number of other pictures of the Rederijkers the position of the on-looker is brought so close that hardly anything but the window-frame is visible.  Nothing else is shown except what is essential to the understanding of the subject : the top corner of the "blazoen," the pitcher of wine and the tobacco-pipes—the symbols of the Rederijkers.  The wooden division in the centre of the window is now absent, and the figures stand out more distinctly.

In the version in the Bredius Collection[2] the exceptional boldness and freedom of the brushwork is surprising.  This might well be the picture which Jan Steen painted in the competition with Frans van Mieris described by the biographer Weijerman in 1729.[3]  The subject of the picture, which he painted at great speed, was "three Rederijkers leaning out of the window to sing at a peasants' wake."  It is significant that Weijerman knew that the figures were Rederijkers; later the tradition was lost, and the picture became known as "Singers at the Window."[4]

The picture is particularly interesting because the inscription on the fragment of the shield[5] reads "In liefde verwarmt" (Warmed by love).  This is the motto of the "kamer" of Warmond, "De roode Maagdelieven," which puns on Warmond—warmd.[6]  As we now know that Jan Steen lived and worked in Warmond between 1656 and 1660, shortly before he went to Haarlem, this link with the Rederijkers of Warmond[7] is particularly important because it indicates that he made contact with the guild there, and it is probable that he painted it as a souvenir for his friends in the "Maagdelieven" of Warmond.  Thus in the picture in the Bredius Collection we see Jan Steen himself as the second most important person at the side of the good-humoured old man crowned with laurel who is reading out the verses.  The "factor," or poet, with the pen behind his ear, is no longer one of the chief personages.  Unfortunately, with the exception of the pictures in the Bredius and Johnson Collections, none of the numerous variations of this theme contain mottoes of Rederijkers which can be identified.

In the version which was formerly in the Peltzer Collection in Cologne, the "blazoen" is left empty.[8]  In the picture in the Alte Pinakothek in

(251)

[1] HdG No. 236.  M. Kann Sale, Paris, 9.6.1911, No. 75.  Later in the possession of Goudstikker; reproduced in the Goud-stikker catalogue of the exhibition in the "Pulchri Studio", The Hague, 1917.

[2] Catalogue of the Bredius Museum, 1926, No. 100.

[3] J. C. Weijerman, *De levensbeschrijvingen der Nederlandsche konst-schilders*, II, p. 346.

[4] It is possible that Weijerman was struck by the extraordinary freedom of this picture by Jan Steen, which gave him the idea that it was painted in a competition,

and he then confused Ostade with Van Mieris.

[5] The complete "blazoen" of the "kamer" of the Warmond Rederijkers is known to us from an engraving by H. van Berch, among other sources.

[6] These puns on the name of the place to which the guild belonged were usual.

[7] A. M. A. Machen, "Jan Steen te War-mond," *Oudheidkundig Jaarboek*, IV, 1924, p. 279.

[8] *Suppl*. No. 234.  Sale F. Muller, Amsterdam, 26.5.1914, No. 185; now in the A. F. Philips Coll., Eindhoven.

Munich[1] the following rhymed inscription occupies the place of the motto :

| | |
|---|---|
| Waerom draegt 'en sot syn teeken | Why does a fool wear his badge? |
| Om dat hy te voren geck geleken. | Because he has shown himself to be a fool. |

This, however, cannot be regarded as the motto of the "kamer." It seems rather to be the distinctive couplet of a particular jester of a Rederijker group; other examples have come down to us.

Since similar pictures of Rederijkers so frequently occur, it is justifiable to suppose that they often commissioned Jan Steen to paint the subject. Such representations of poetical entertainment would please a patron of "rhetorique" in Amsterdam, Warmond or Haarlem.

The picture in which Jan Steen depicted the life of the Rederijkers in greatest detail must have been intended for a member of the Haarlem guild. For in this lively picture (Pl. 3c), which was formerly in the Mandl Collection in Wiesbaden,[2] appears the motto : "Niet Sonder Dat" ("Not without this"—or perhaps "Not without fault"). This had been chosen as his device by J. van Mosscher,[3] who as painter was a pupil of Carel van Mander and as poet has left, in addition to a poem in praise of his master, a love poem in the true Rederijker style. Doubts, however, have sometimes been expressed whether Van Mander's pupil and the landscape-painter Mosscher were one and the same person (they might have been father and son), but it is in any case certain that a poet of this name used "Niet Sonder Dat" as his motto and that it was used by Jan Steen in one of his pictures, presumably commissioned by one of the Mosschers. There is also evidence that Jan Steen moved in Ostade's circle while at Haarlem,[4] and the landscape-painter Mosscher was certainly acquainted with Ostade; for he employed him to paint the figures in his landscapes. We can, therefore, be fairly sure that the poet Mosscher is identical with the landscape-painter.

But the subject of the picture in the Mandl collection is even more important than the question for whom it was painted. The scene is near one of the gates of the town. A doorway appears to lead to the rooms above the gate. Chronicles often mention that the magistrates readily placed the unused rooms in the town-gates at the disposal of the Rederijkers for their meetings.[5] Thus Van Mieris and Van Alphen mention in their "Description of the Town of Leyden" that the Leyden guild met in the "Blauwe Poort" till 1664 and after that "in the upper part of the Zijlpoort".[6] Similarly, a Haarlem document shows that until the year 1690 the "kamer" of "De Wijngaardtrancken" had a meeting-room "being and lying in a certain gate near the belfry," and an Amsterdam document states that the

[1] HdG No. 234, *Suppl.* No. 234; in 1919 it was moved from the Augsburg Museum to the Munich Museum.

[2] HdG No. 536; Sale F. Muller, Amsterdam, 13.7.1926, No. 656. My thanks are due to the auctioneers and the purchaser for allowing me to reproduce this picture.

[3] J. Q. van Regteren Altena, "J. van Mosscher," *Oud Holland,* XLIII, 1926, p. 18.

[4] After Ostade, not only the "Rederijkers" but also the paintings in Amsterdam, "Baker Oostwaard" and "The Charlatan." The ten years in Haarlem are the longest period Steen spent in the same place.

[5] Schotel, I, p. 113; II, p. 3.

[6] Van Mieris and Van Alphen, *Beschrijving der Stad Leijden,* I, 1762–1770, pp. 14 and 19, and II, p. 451. Document in the Haarlem municipal archives, No. 2342 c.

"Wit Lavendel" guild met in the "Regulierspoort" (the present mint) at Amsterdam.[1] Thus in Jan Steen's picture we see a town gate such as was often placed officially at the disposal of the guilds.

There appears, however, to be no contemporary evidence on the curious building behind the town-gate, which was clearly erected for the special use of the Rederijkers. It is a small building, less solid in construction than the gate; it rests on long wooden piles, which makes it somewhat resemble a prehistoric lake-dwelling. Constructed of wood and plaster, with windows on all sides,[2] it is approached by means of a ladder on the side nearest the town gate. The "blazoen" we have already mentioned hangs on the wall facing us, where we also see two guild brethren leaning out of the window and smoking their pipes. On the right a Rederijker fastens the banner of the guild outside the window. A characteristic inscription runs the length of one of the cross-beams of the building :

> When we have drunk and eaten right merrily
> We must not forget our good pipes.[3]

Beneath, the people are "drinking and eating" as in a peasant wedding by the master. It is probably one of the frequent feasts of the Rederijkers, to which members of "kamers" in other towns were also invited.[4] One of the brethren is being welcomed with a pipe and a flagon of wine, while others are employed in playing "kolf." A stout, bald man, in a rich doublet with a ruff, vividly reminds us of the reciter in the Rederijker pictures previously discussed. The man with the pointed face smoking a pipe on the right is also an old acquaintance.

Similar houses on piles occur in other paintings; it is most probable that the space beneath the house served as a stage. The level of the floor could easily be raised by means of a wooden dais, and if curtains were hung round we should have a stage like the improvised tents of the Rederijkers which we know from the representations of the 16th century (P. Balten after P. Breughel) (Pl. 3d).[5]

A painting of a wake by Jan Steen in the collection of Lord Desborough at Taplow[6] (Pl. 3a) shows a Rederijker house which is an exact counterpart to that in the picture in the Mandl Collection. Here the house rests on longer piles and has a sloping roof. A guild shield, with flagons and tankards hanging beside it, marks it as the meeting-place of the Rederijkers. From a corner waves the banner of the guild. The manner of lighting the interior is somewhat different, as the windows here are in a continuous row; the brethren can be seen in the room within. Above the windows great display is made with the trophies won in competitions. All the Rederijkers have retired within the building and the space where they hold

(253)

[1] Kossmann in *Tijdschrift voor Ned. Letterkunde*, XLI, pp. 34, 35.

[2] One of these windows seems to appear in the Loyd picture.

[3] Als men wel lostig heeft gesopen ont
　　　　　　　　/geweten (end gegeten?)
De vriendelijke pijpen vol toch niet
　　　　　　　　/vergeten.

[4] Schotel, I, p. 104 "Vergaderingen der Rederijkers."

[5] "Visions" could then appear from the windows above.

[6] HdG No. 643 ; Bred., Pl. 54, *Suppl.* No. 643.

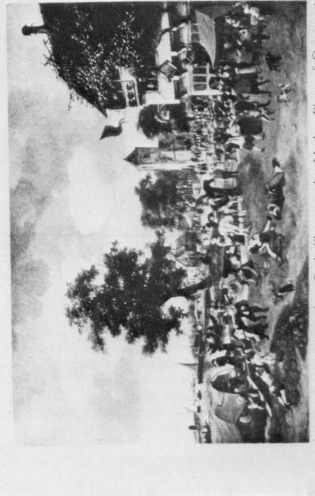

a—Jan Steen, Rederijkers and Quacks. Taplow, Lord Desborough Coll. (p. 32)

b—Jan Steen, Amsterdam Rederijkers on the Market Place of Oegstgeest. Dieren, Katz Coll. (p. 33)

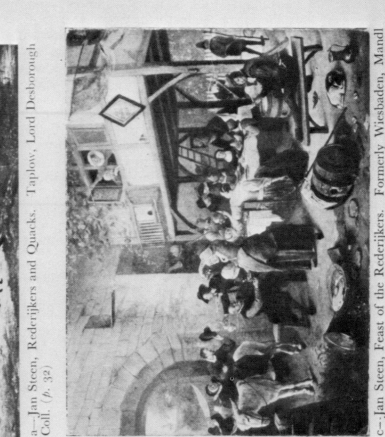

c—Jan Steen, Feast of the Rederijkers. Formerly Wiesbaden, Mandl Coll. (p. 31)

d—Pieter Balten (after P. Breughel the Elder), Detail : Rederijker Stage. Amsterdam, Rijksmuseum (p. 32)

their performances has been given over to a quack, who is also a man of very remarkable theatrical gifts and seems frequently to have used the dais of the Rederijkers for his own purposes (see Pl. 7d). A third picture by Jan Steen showing a house on piles similar to that in the present instance, though with only a corner of the building visible, was in the Van Alen Sale at Amsterdam.[1]

Up to the present it has been impossible to establish where such Rederijker houses actually stood; and we know them only from Jan Steen's paintings.[2]

Another work by Jan Steen depicting the Rederijkers (Pl. 3b)[3] shows a church-wake, with the indispensable meeting of the Rederijkers, on the market-place of the village of Oegstgeest.[4] The village-church, with the unusual structure, like a choir, built on to the west tower, made it possible to identify the scene with certainty. It is, however, not the local "kamer" which is holding its meeting on the market-place; for the guild of Oegstgeest, "De Oogentroostbloem" with the motto "Oegst geest vreugd" (founded 1615), does not appear in the picture. We see affixed to the inn "In de Eend" the "blazoen" of the Amsterdam Rederijkers with the motto "In Liefde bloeyende," which we have already noticed in the picture from the Loyd Collection. Although these Rederijkers have not assembled in a building on piles, their meeting-place is decorated as in the last picture: the guild brethren have hung out their banner, and three pewter plates are fastened to the front of the house as proof of their victories in competitions. The Rederijkers are leaning out of the windows on two storeys. One of them might almost be the reciter with the bald head whom we have seen in the previous pictures. Another member with a wide lace-collar stands on a ladder leaning against the wall and announces the programme to the audience. The figures elsewhere in the picture are in keeping with the usual representations of wakes. Jan Steen evidently regarded the visit of the Rederijkers of Amsterdam as an especially important event in the church-wake of Oegstgeest. Oegstgeest is close to Warmond and not far from Leyden, in a district where there was an extraordinary number of "kamers" of the Rederijkers. The map (cf. following page) shows how closely the "kamers" were situated in the region which came under Leyden, known as "Hoogheemraadschap Rijnland." In considering Jan Steen's pictures, therefore, we must not only think of Haarlem and its painters who belonged to the Rederijker guilds, but also of this district round Leyden.[5]

(255)

---

[1] Sale F. Muller, Amsterdam, 27.11.1910.

[2] It may, however, prove possible to determine the locality of the house in the picture in the possession of Lord Desborough, as certain indications are provided by the small church in the vicinity, the town-gate and the course of the *Grachten*.

[3] Katz Possession; it was shown at the Amsterdam Rijksmuseum in the exhibition "Oude Kunst," 1936, No. 152.

[4] In the background of the picture are the church towers of Leyden.

[5] Art historians hitherto have simplified matters by saying that Jan Steen invented the scenes of his pictures. The more thorough research of recent years has shown conclusively that Jan Steen liked to show views of actual towns and villages; he has painted Oud-Teylingen Castle near Warmond in "The Poultry-Yard," in the Mauritshuis, The Hague; the "Oude Delftgracht" in Delft in "The Burgomaster" (Lord Penrhyn); the "Fish-market at The Hague" in the Hague Gemeentemuseum (Cat. No. 33–26); the

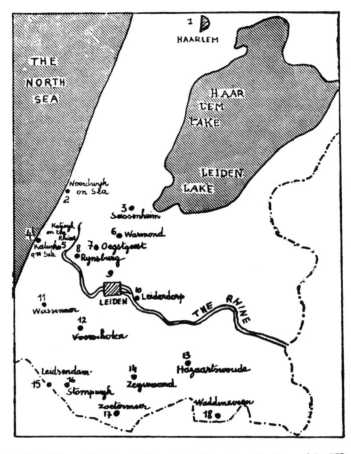

Plan of the Rederijker-"Kamers" in the neighbourhood of Leyden.     Territory of the "Hoogheemraadschap Rijnland" (Boundaries : ·—·—·—·—·—·—)

(256)

| | PLACE NAMES | FLOWERS OR NAME OF THE "KAMER" | MOTTO |
|---|---|---|---|
| 1 | HAARLEM | De Pelikaan (or : Speelkoornen) | Trou moet Blijcken |
| | - | De Wijngaartrancken | Liefd' boven al |
| | - | (Flemish "Kamer") De witte Angieren | In Liefd' getrouw |
| 2 | NOORDWIJK on Sea | De Lelie onder de Doorn | Wt Liefde bestaan |
| 3 | SASSENHEIM | De Boterbloem | ? |
| 4 | KATWIJK on Sea | De Kempenbloem | In Liefd' accoord |
| 5 | KATWIJK on the Rhine | De Koornairen | Liefd' moet blijcken |
| 6 | WARMOND | De roode Maagdelieven | In Liefd' verwarmd |
| 7 | OEGSTGEEST | De Oogentroostbloem | Oegst geest vreugd |
| 8 | RIJNSBURG | De roode Angieren | Het Woord is krachtig |
| 9 | LEIDEN | De witte Accoleijen | Liefd' is 't Fondament |
| | - | De Palmboom | In Liefde werckende |
| | - | De Orangienboom | In Liefde vierig |
| | - | (Flemish "Kamer") De Orangie Lelie | In Liefd' groeyende |
| 10 | LEIDERDORP | De Patientiebloem | Liefd' blijvt sonder end' |
| 11 | WASSENAER | De witte Roosen | In Liefde wast |
| 12 | VOORSCHOTEN | De witte Violen | Met liefd' eendrachtig |
| 13 | HAZERSWOUDE | De Haselieren | Aensiet Gods kracht |
| 14 | ZEGWAARD | De Seghbloem | Secht Waerheit |
| 15 | LEIDSENDAM | De Olijftak | Liefd' brengt vree |
| 16 | STOMPWIJK | De Afrikaan | ? |
| 17 | ZOETERMEER | De witte Meirbloem | Met soetheit meer |
| 18 | WADDINXVEEN | De Kandelaarsbloem | Altijd vree |

The rehearsals of the Rederijkers, which are not known from works by Jan Steen, are depicted by the Haarlem painter Job Berckheijde (Pl. 2b). It will be recalled that we have already found him mentioned as a member of a Rederijker guild. A picture by him[1] in the Jagdschloss Grunewald (near Berlin) shows a meeting-place of the Rederijkers which differs only in unimportant details from that represented in the painting in the Haarlem Museum. As the most important of the ten "blazoenen" hanging on the walls, we again find, in the middle of the longer wall, the shield of the guild whose motto is "Liefde boven al." There is also the long table for the guild brethren, one of whom is ringing the bell, presumably to obtain silence. A stout man holds a manuscript (the part for the actor). Another is seated in the centre of the room, and closely watches a man who is clearly wearing a stage costume. Classical heroes appear similarly dressed in pictures by Jan Steen and his contemporaries. In his hand he holds a sword; his attitude and expression are indicative of despair, almost as if in another moment he might fall upon his sword like Pyramus. This must be the preparation for a performance which appears to have been somewhat amateurish. There were weavers in Haarlem with as much or as little of the theatre in their blood as Bottom the weaver. Needless to say, there is again a great deal of drinking and smoking. The guild's banner shows up strikingly.[2]

### 3. The Influence of the Stage in Jan Steen's Historical Compositions

We have seen that Jan Steen's paintings form the best source of visual information about the Rederijkers but it is equally true that with a knowledge of Dutch stage-craft of his time we can understand many features in the work of the artist which often puzzle us to-day.

Jan Steen frequently painted classical and biblical scenes in several different versions. Like Pieter Quast, he was inspired by the stage either of the "kamers" of the Rederijkers or of the well-equipped professional theatre. In the first case, he used few figures and a simple setting; in the second case, his canvases are crowded with people and stage-properties— always a sure method of making an impression on the public.

Curtains were a very important stage-property both on the Rederijker stage and in the baroque theatre; and Jan Steen was fond of using them in his pictures.[3] Sometimes the scene depicted seems to require curtains,

(257)

Amsterdam "Damplain" (where the Rederijkers used to meet at the weighing house) in the Historical Section of the Rijksmuseum; the Fish Bridge at Leyden in the Städel Institute, Frankfort etc.. Among the Leyden views a representation of the "Vlietbrug" (in the possession of Mr. N. Beets, Amsterdam; exhibited at the Jan Steen Exhibition, Leyden, 1926), close to Jan Steen's house, is reminiscent to a certain extent of the familiar town-gate.

[1] Catalogue of the Collection in the Jagdschloss Grunewald, No. 9. I am grateful to Prof. Bauch for drawing my attention to this picture.

[2] The influence of the theatre can also be observed in other works by Job Berckheijde, for example, in a large composition "Joseph's Brothers in Egypt," dated 1669, in the Haarlem Museum (Catalogue 1929, No. 19; note the curtains), and "Odysseus among the Daughters of Lycomedes," which appeared in a sale in Amsterdam, Roos & Co., 20.10.1912, No. 14 (canvas, 110 × 160 cm.).

[3] For the function of the curtains, cf. G. Kalff, "Bijdrage tot de Geschiedenis

but they were frequently introduced without reason; at times they are completely or partly drawn up, and in other cases they hang down low. In some pictures they come between the scene and the spectator, in others they serve to drape the back wall of the stage with their sweeping folds.

Jan Steen's choice of biblical and historical themes is by no means determined simply by his own personal taste. They are taken rather from the group of didactic subjects which was familiar to his age. Steen not only drew on Plutarch's *Lives*, but was especially fond of subjects from the more imaginative *Metamorphoses* of Ovid, called by Karel van Mander "the painter's Bible" as being a treasure-house both for poets and painters.

The first theme adopted by Jan Steen in which the influence of contemporary stage productions can be seen is an episode in "Antony and Cleopatra," after Plutarch, which he painted no less than three times.[1]

This subject, which offers such scope for a display of luxury, had long fired the imagination of the poets of the theatre, as is shown in the "Egyptian Tragedy"[2] of Guiliam van Nieuwelandt, whom we have already mentioned. And Jan Steen employed it almost simultaneously with the performance of a drama translated from the French by the poetess Dieverina van Kouwenhoven,[3] in which Cleopatra was the heroine.

Simplest in conception is the picture in Göttingen, dated 1667 which simply represents a dialogue between the two chief characters. By comparison, the picture from the Mensing Collection is almost bombastic in spirit; indeed it is hardly possible for figures to be more theatrical than those in this picture (Pl. 4a). This is especially true of a remarkable secondary character, the soldier on the right, whose attitude and expression of grim loathing show his feeling only too clearly. The conception of this soldier is surprisingly similar to a "Study of a Head" by Pieter Quast;[4] it has always been difficult to see what this study represents, but it would seem best to regard it as the head of an actor. Further evidence of a connection between Pieter Quast and Jan Steen, both friends of the theatre, is to be found in the similarity between the third version of "Antony and Cleopatra" formerly in a Rothschild Collection in Frankfort (Pl. 4c) and Quast's drawing "Achilles and Polyxena," which appears as an illustration to a drama by P. C. Hooft.[5] It is unfortunate that we no longer have the large picture

(258)

van het Amsterdamsch Tooneel in de 17e eeuw," *Oud Holland*, XIII, 1895, p. 26 ff. The author discusses the use of curtains particularly in connection with *tableaux vivants*, but his remarks also apply to dramatic performances of all kinds.

[1] Göttingen : HdG No. 86; ill. in the Catalogue of the University Coll., 1926, No. 169.

Mensing : HdG No. 86b; *Suppl.* No. 86b; Bred., Pl. 14. Sale F. Muller, Amsterdam, 15.11.1938, No. 99. Loaned to the Leyden Museum, 1939.

Rothschild : Now in the possession of D. Katz Dieren.

[2] Written shortly before he settled in Amsterdam : *Aegyptica ofte Aegyptische tragoedie van M. Anthonius en Cleopatra.*

[3] Bred., text, p. 38.

[4] Formerly in the Geldner Coll., Basle. Ill. in Frimmel's *Blätter für Gemäldekunde*, II, 1906, p. 98.

[5] Vienna, Albertina. With great expression in gesture and action the artist shows in this drawing the dramatic climax when Achilles is wounded in the heel. The picture "Achilles and Polyxena," which is mentioned in the inventory of Quast's works (A. Bredius, *Künstlerinventare*, I, 1915, p. 274, No. 9) seems to have been lost.

There is also mention in documents of another scene from a play about Achilles

a—Jan Steen, Antony and Cleopatra. Formerly Amsterdam, Mensing Coll. (p. 36)

b—Jan Steen, Seleucus and Stratonice. Formerly Amsterdam, Douwes Coll. (p. 37)

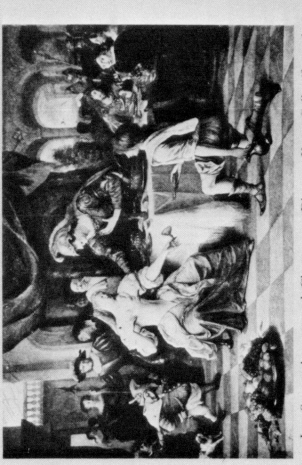

c—Jan Steen, Antony and Cleopatra. Dieren, Katz Coll. (formerly Frankfort, Rothschild Coll.) (p. 36)

d—Jan Steen, The Banquet of Esther. Amsterdam, Dreesmann Coll. (p. 42)

by Quast representing Antony and Cleopatra which is mentioned in the year 1646 as being in a collection at The Hague.[1] On the other hand, there is a number of paintings of the same subject by other masters, who could escape the influence of the theatre no more than Jan Steen.[2]

Thus there exists a painting of "Antony and Cleopatra" by Matthijs Naiveu (1647– about 1721), whose work throws more light on the stage than that of any other Dutch artist of the 17th century with the exception of Jan Steen. Throughout his whole career he painted pictures inspired by the stage, some with Leyden as a background, others with Amsterdam. His "Antony and Cleopatra" is overloaded with stage-properties and the scene is placed in a stage architecture in the classical style.[3] Gerard de Lairesse (1640-1711),[4] who worked for the Schouwburg in Amsterdam, also treated the same theme as if it were being played on a stage,[5] but, in contrast to the vigorous realism of Steen, he depicts the characters in the noble classic poses of the baroque theatre.

The same contrast may be observed with another classical theme which was treated both by Jan Steen and Lairesse under the influence of the stage (Pl. 4b).[6] It is the emotional story of Seleucus, who gives up Stratonice, his second wife, to his son Antiochus, who has fallen in love with his step-mother. In the pictures of both artists the very *décolletée* bride is seen on a large ornamental bed[7] behind the balustrade, and both artists also employ the motive of the stage curtain. Seleucus, bearded and turbaned, gives over to his son with a magnanimous gesture his beautiful step-mother, who is attended by her suite. This subject was also used for the stage by the French poet Philippe Quinault in 1660 who wrote the libretti for Lulli's operas.[8] The play was probably performed in Holland soon afterwards; in any case a Dutch translation of the play by Abraham Bogaert appeared in 1694. Once again, Jan Steen's treatment has more in common with the theatre of the Rederijkers than with opera; his figures

(260)

"Paris and Helen," which Quast painted "in een porspectijff," which expression was also used for theatrical scenery at that time. Cf. Worp, *op. cit.*, p. 88.

[1] A. Bredius, "P. J. Quast", *Oud Holland*, XX, 1902, p. 81.

[2] A picture by R. Brakenburgh in the Baron Steengracht Collection, Moyland, shows great similarity with the Mensing picture by Steen. Repr. in Rijksbureau voor Kunsthistorische Documentatie, The Hague.

[3] W. J. Abraham Coll., London. Sale Christie's, London, 24.7.1933, No. 30. Another historical picture, theatrical in conception, appeared at the Edgell Sale, Christie 20.11.1933, No. 75. The large number of Naiveus in England indicates perhaps that the artist lived in England at some time.

[4] Worp, *op. cit.*, p. 137, mentions, among others, a payment to de Lairesse on 12.8.1681

"for doing painting for the stage representing a room in a king's palace."

[5] Amsterdam Rijksmuseum, Catalogue, No. 1406.

[6] The picture by Steen was formerly in the Douwes Coll., Amsterdam; that by Lairesse in the Rijksmuseum, Amsterdam, Cat. No. 1407. The credit for the correct interpretation of the Jan Steen as "Stratonice" (not "The Prodigal Son," as in HdG) is due to Schneider, Cat. of the Jan Steen Exhibition, Leyden, 1926, No. 36. There are still more elaborate versions of Lairesse's "Stratonice" than that in Amsterdam in the Schwerin Museum and in Karlsruhe (probably a copy). They aroused the admiration of Winckelmann.

[7] Kalff, *op. cit.*, p. 12 mentions particularly the important place of the ornamental beds in the stage settings of that time.

[8] *Cat. Lett.*, No. 7091.

express genuine, natural feelings and know nothing of court etiquette. Lairesse, on the other hand, depicts a pompous scene which could only have belonged to the stage of a court theatre or even to an opera.

Nevertheless, Jan Steen and Lairesse seem sometimes to have used the same theatrical setting. The architectural details on the left in the Rothschild version of Jan Steen's "Antony and Cleopatra" (Pl. 4c) agree closely with those in the corresponding part of the picture in Lairesse's "Stratonice".[1] But the possibility of Lairesse copying from Jan Steen cannot be disregarded.

In one of the most important of Jan Steen's historical pictures, "The Sacrifice of Iphigenia" painted in the year 1671, Dr. Van Gils has rightly seen the influence of the contemporary theatre.[2] He clearly showed that numerous details in the picture derive from the play "Iphigenia" by Dr. Samuel Coster, the founder of the Schouwburg in Amsterdam. In Jan Steen's representation of the subject not only are the costumes and gestures theatrically striking, but among the characters there are various familiar actor types.[3]

Jan Steen was not the first artist in whose work the influence of the Amsterdam theatre can be shown. Pieter Lastman has obviously taken some of the details in his "Contest between Orestes and Pylades" (an incident which also forms part of the story of Iphigenia) from a dramatic production of which we have knowledge from an engraving by C. J. Visscher after Vinckeboons.[4] Further, the composition of two pictures by Pieter Quast representing Brutus playing the Fool before king Tarquin is designed after one of the "Tableaux Vivants" which the poet P. C. Hooft arranged for the Amsterdam "kamer" "In Liefde Bloeyende," and for which he wrote rhymes (Pl. 5a). Quast was familiar with the scene either through a contemporary engraving or through a later revival of the performance,[5] and he reproduced it in two different versions. In the one, he puts his figures in a simple setting, which may be the usual improvised stage of a Rederijker guild (Pl. 5b); in the other, almost the same group appears on a classical stage (Pl. 5c) which agrees even in the details with the "Schouwburg" of Amsterdam by Van Campen (Pl. 5d).[6]

(261)

[1] Cf. the high gallery with balustrade, the view beyond it, the curtain in the foreground and the corridor. The use of galleries is striking in the works of both masters (cf. Kalff, *op. cit.*, p. 4).

[2] HdG No. 74; *Suppl.* No. 74; Dr. van Gils in *Op de Hoogte* (Haarlem), March 1937, p. 92.
Dr. van Gils was the first to examine Jan Steen's work systematically with reference to its connections with dramatic literature, and it is a source of satisfaction to be able to state that the present study is confirmed and supplemented by his work.

[3] E.g., the warrior in the helmet on the right and the man beside him with the pointed profile.

[4] Ill. in *Jaarboek Amstelodamum*, XXXIII, 1936, p. 102.

[5] The engraving by J. C. Visscher contains all the *tableaux vivants* and poems by P. C. Hooft. For the whole of this question, cf. Heppner, "Pieter Quast en P. C. Hooft-schilderijen naar een vertooning en een tooneelscene," *Maandblad voor Beeldende Kunsten*, 1937, p. 370.

[6] The part with the throne in the centre is concealed by a curtain in Quast's picture. Quast's types are unmistakably taken from Callot, whose influence on the Dutch theatre has so far only been observed in this particular case.

a—J. C. Visscher, "Tableaux Vivants," 1609. Engraving. (The illustration combines two details) (*p.* 38)

b—Pieter Quast, Brutus playing the Fool before King Tarquin. Berlin, Sale Lepke 24.2.1914 (*p.* 38)

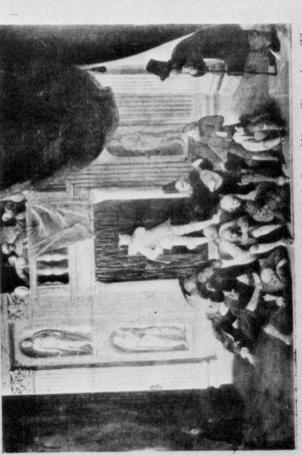

c—Pieter Quast, Brutus playing the Fool before King Tarquin. The Haag, Gemeentemuseum (*p.* 38)

d—Central part of the scenery of the Schouwburg in Amsterdam. Engraving (*p.* 38)

Since the time of the Renaissance some of the stories of classical antiquity were used to inspire civic virtues among the people; they were employed chiefly in the decoration of town halls and courts of justice, and also on the stage. The "Magnanimity of Scipio" and the "Unselfishness of Marcus Curius" were among the favourite subjects which served this purpose. Jan Steen painted the first theme in a free sketch[1] and also in a carefully executed composition. In both he uses a theatre-curtain; but it is now draped in front of an open landscape, and there is no architecture to which it could be attached. The whole structure is reminiscent of the setting in Jan Steen's "David and Michal," which we will discuss among his biblical pictures.

In a poem in praise of a picture by Govert Flinck above one of the mantle-pieces in the Amsterdam Town Hall, depicting the "Unselfishness of Marcus Curius Dentatus," Vondel described the virtue of the Roman as follows :

In the care of her burgomaster Rome may sleep secure,
For Marcus Curius, rejecting the offered gold
With scorn, contents himself with a meal of turnips.
Thus is a state built on moderation and virtue.[2]

The same scene provided Jan Steen with the opportunity of showing a procession of senators in rich and exotic dress meeting with simple peasants;[3] here he blends historical representation with comedy, also a favourite trick of the dramatic authors of the time. The motive of the standard-bearer behind Marcus Curius, and the inscription on the banner "Natura paucis contenta," are close to the spirit of the Rederijkers.

(263)

Such pictures as Naiveu's painting, now in Leyden,[4] of a scene from "Pyramus and Thisbe"—the play of Shakespeare's artisans—may also be looked upon as a burlesque of this kind. Near an Amsterdam church tower stands a large wooden stage where the misled Thisbe stabs herself while the personification of the Moon appears behind her; in front are the prompter and the lion. A Dutch "merry comedy" entitled: "Piramus and Thisbe or the cheated Duke of Pierlepon"[5] would seem here to supply the 'text'; the lion may well have asked :

How are things, Master Spillebeen? What else have I to say?

to which the prompter may have replied :

Nothing else; you go and lie down on the stage like a wild beast!

---

[1] HdG No. 83; *Suppl.* No. 83. There is confusion on this matter in the literature : there are two almost identical copies of this sketch, one with a monogram in the collection of Arthur Kay, Edinburgh, and another, unsigned, in Capetown Museum. The latter is reproduced in T. Martin Wood, *The Max Michael Gift*, London, 1913, pl. 32. The final picture is reproduced in Nöhring, *Kat. der Sammlung Weber*, 1892, pl. 245.

[2] Op Burgemeesters Wacht mag Romen
/veilig slapen
Als Marcus Curius, het aengeboden gout

Versmaende, zich vernoegt met een
/gerecht van Rapen.
Zoo wordt door Matigheid en Deugt
/een Staet gebouwd.

[3] HdG No. 84; *Suppl.* No. 84. Repr. in the Catalogue of the Exhibition *Oude Kunst* in the Rijksmuseum, Amsterdam, 1936, No. 154.

[4] Museum, No. 261 : "The Rederijkers".

[5] *Cat. Lett.*, No. 6231 : "Piramus en Thisbe of de bedrooge hartog van Pierlepon " by C. P. Biens, 1640. For a similar farce by A. Leeuw (1669), cf. *Cat. Lett.*, No. 6229.

This subject was popular in Holland for a long time. In the 16th century it was adapted by M. de Casteleyn, and also occurs among the plays performed by the Haarlem "kamer" "Trou moet Blijcken." In the foreground of Naiveu's picture is a large crowd of rich and poor, whose employments, as often in his work of this type, constitute the main attraction of the picture.

### 4.  *The Influence of the Stage in Jan Steen's Biblical Compositions*

Like most dramatists of his time, Jan Steen had a preference for the stories in the Bible which are full of emotion and incident. In the case of his picture in Copenhagen "David welcomed by Michal," Dr. Van Gils has again been able to show that Jan Steen's conception agrees with the content of a play performed by the Rederijkers which was written in the year 1619 by Job van de Wael for the "kamer" at Schiedam, "Het rood Roosjen."[1] In hardly any other picture by Jan Steen are the connections with literature so obvious, and in no other picture is the subject-matter described in writing at such length :

| SOLI DEO GLORIA | SOLI DEO GLORIA |
|---|---|
| 't heeft God behaeght | It pleased God |
| Dat David heeft gewaeght | That David dared |
| Als hij Goliat verslogh | To slay Goliath |
| En Saul in't Hart wrogh | And hurt Saul to the heart. |
| Victorieus hij treet vooruijt | Victorious he steps forth |
| Hier verwelkomt van sijn bruijt. | Here welcomed by his bride. |

(264)

These lines do not in fact appear in Van de Wael's play; they may perhaps be regarded as a free interpretation of the play by Jan Steen. They may be compared with the verses which are often added to explain frontispieces (cf. Pl. 6b) and illustrations of "Tableaux Vivants." If they were written by Jan Steen and not taken from an unknown work, they are further proof that he also tried his hand as a poet. Very reminiscent of the stage is the figure of the fool in this picture (he has a pair of spectacles on his posterior); numerous details in the setting, which correspond with the directions in Van de Wael's play, provide further proof that Jan Steen's model in this picture was the theatre.

The biblical story of Samson, with its scenes of action and violence, was exactly to the taste of Jan Steen. He has portrayed Samson's fate in four pictures : those in the possession of Matthiesen in London,[2] the Van den Bergh Collection in The Hague, and the Museums of Antwerp and Cologne. The Matthiesen picture shows the prelude to the tragedy. It is actually a combination of two scenes; in the background the Philistines appear with the cords (Judges XVI, 11), and in the foreground Delilah herself, contrary to the biblical text, cuts Samson's hair. "Delilah's Treachery" is excellently portrayed in the picture at The Hague. A. Welcker has published an extremely interesting drawing which represents a preliminary study for this picture. He comes to the conclusion that the surprising

---

[1] "Jan Steen en de Rederijkers," *Oud Holland*, LII, 1935, p. 130.
[2] Matthiesen : perhaps HdG No. 10; *Suppl.*

No. 10a. This picture has not been published.
V. d. Bergh : HdG No. 10; *Suppl.* No. 10;
Bred., Pl. 4.

changes in the picture as compared with the preliminary study are probably due to the influence of a theatrical performance of the same scene. And again Dr. Van Gils has been able clearly to show that a play by Abraham de Koning, "The Tragedy of Samson," published in 1618, might have had such an influence.[1] The pictures in the Museums in Antwerp and Cologne continue the story after Delilah's treachery : Samson who has fallen into the hands of his enemies has now to endure their cruel mockery. In the scene depicting Samson asleep, the figures had perforce to tread quietly. But now that the mêlée starts, the influence of the Rederijkers makes itself all the more clearly felt. In the Antwerp painting[2] the chief actor is a jester standing behind Samson, who is about to crown his enchained victim with a fool's cap. The action has all the appearance of taking place on a stage, since it takes place on a raised floor and is framed at the top with the large folds of a looped-up curtain. At the right is a standard-bearer with an expression of indifference on his face, as though he was there by chance; he may be regarded more justly as representing the guild of the Rederijkers rather than as symbolising the Philistine army. Behind the figure of Delilah is a large cartouche with an inscription which is no longer legible. It may also have been a poetical description of the scene written by Jan Steen. In the Cologne picture,[3] in which there is only a mere indication of the blinding of Samson, the standard-bearer, for whose presence there is no reason in the action, again appears in the midst of the crowd. It is significant that he resembles the standard-bearer in the picture in Brussels in which Jan Steen portrayed a meeting of the Rederijkers (Pl. 1a).

(265)

Jan Steen also made frequent use of the story of Esther. With its wealth of intrigues and surprises, it was a subject particularly attractive to dramatic poets and in various forms it was frequently acted both by the "kamers" of the Rederijkers and in the professional theatre. In 1638 a play appeared in Amsterdam by the doctor-poet, Nicolaes Fonteyn, entitled "Esther or the Picture of Obedience." Still more popular in Amsterdam appears to have been Joannes Serwouters'[4] play "Hester, or the Deliverance of the Jews"; it was often reprinted between 1659 and 1751.[5] An examination of Jan Steen's picture "Esther interceding with Ahasuerus" (Pl. 6a) in the Hermitage in Leningrad,[6] shows in the chief group a

---

[1] For the preliminary drawing and Van Gils' literature references, cf. A. Welcker "Jan Steen's Simson en Delila," *Oud Holland*, LIV, 1937, p. 254.

[2] HdG No. 11; Repr. in the Catalogue of the Antwerp Museum, 1924, Pl. 136.

[3] HdG No. 12; Bred., Pl. 5.

[4] The dramatist Joannes Serwouters is the son of the engraver Pieter Serwouters—a typical example of the literal 'relationship' of the arts. The Print Room in Amsterdam possesses an album giving the family history of the Serwouters which was begun by the artist and continued by the dramatist.

[5] It has been established that the Jews in Holland also had their theatre, and in this connection a comedy precisely on this theme, entitled "Of the Queen Hester," is mentioned. P. Scheltema, *Aemstels Oudheid*, VI, p. 198. The conditions he describes are those of about the year 1707; but it is stated that the Jewish theatre had then been in existence already for 100 years. There is also an interesting note that non-Jewish spectators visited the theatre, although this was prohibited.

[6] HdG No. 17.

striking similarity with the frontispiece of the printed edition of Serwouters' play (Pl. 6b). The divided folds of the raised theatre-curtain in the foreground of the picture and the presence once more of the standard-bearer point to a Rederijker performance. It is also remarkable that in pictures of this type by Jan Steen a limping dwarf with a halberd frequently appears; he may perhaps be regarded as a member of a particular company of players. In Dr. Fonteyn's play about Esther, in which serious and comic characters appear alternately, there is a figure with the comic name of "Captain Kokodrillo" who might well have been played by such a dwarf. The poet describes him as

> Een plomper, en een bok oft Panis mé gheselle.
> A plump fellow, and a he-goat or a boon companion of Pan.

The dramatic events of "Esther's Banquet" are portrayed by Jan Steen in two paintings, one rather simple and the other more pompous. In both pictures the theatrical gestures of Ahasuerus seem to illustrate some such speech as :

> Shame on thee, Haman, now curse the hour of thy birth;

and Haman, overwhelmed with embarrassment, would appear to cry in despair :

> Where shall I hide myself? I dare not look upon the face of the king.[1]

(266)

The version in the Dreesmann Collection[2] (Pl. 4d) contains numerous figures, among whom on the extreme right appears the fool, so frequently put on the stage at performances by the Rederijkers to enliven the audience. In the picture in the possession of Bachstitz[3] the large looped curtain again points to the influence of the theatre.

    The story of Tobias, which was very popular in the 17th century, was depicted by Jan Steen in three pictures forming a series. The popularity of the story on the stage is illustrated by Elizabeth Hartloop's "Tobias," which was published in 1688 with twelve engravings (considerably earlier in date). Jan Steen's picture "Tobias' Marriage Contract" in Brunswick[4] is so similar in composition to his picture of Esther in the Hermitage that its theatrical character need not be stressed here. Almost the same 'actors' again appear in the moving picture in the possession of Goudstikker, where Tobias and Sarah kneel down to pray.[5] Steen may here have followed the engraving of this subject in the edition of E. Hartloop's play. His third painting, "The Healing of the aged Tobias," was unfortunately lost when the Rotterdam Museum was destroyed by fire in 1864.[6]

[1] Joannes Serwouters, *Hester oft verlossing der Jooden*, 1659, p. 49.

[2] Dreesmann : *Suppl.* No. 19a; Bred., Pl. 7.

[3] Bachstitz : HdG No. 18; repr. in the Catalogue of the Exhibition *Oude Kunst* in the Rijksmuseum, Amsterdam, 1929, No. 139.

[4] HdG No. 457; the subject represented was formerly misinterpreted; the correct explanation was given by Fink, *Zeitschrift für Bildende Kunst*, LX, 1925, p. 230. A repetition with the figures in other costumes is in the Buchenau Coll. *Suppl.* No. 457.

[5] *Suppl.* Nos. 25a and 25b; reproduced in Goudstikker's 39th Catalogue, Pl. 70. Perhaps the "Angel" HdG No. 69 (Bredius Museum) is a fragment of this picture.

[6] HdG No. 24; reproductions of it are not known; it is supposed to have been very much in the style of Dou. Cf. J. G. van Gelder in *Oud Holland*, XLIII, 1926, p. 208.

a—Jan Steen, Esther interceding with Ahasverus. Leningrad, Hermitage (p. 42)

b—Pieter Quast (?), Esther before Ahasverus. Frontispiece of a play by Serwouters (p. 42)

c—Jan Steen, Wedding with Rederijkers. D'Oultremont Coll. (Lent to the Boymans Museum, Rotterdam) (p. 45)

d—Jan Steen, Seller of Poultry. Amsterdam, De Boer Coll. (p. 47)

In 1582 Coornhert's play "The Rich Man and Poor Lazarus" appeared, and in 1615 another play with the same title by Dr. S. Coster, the founder of the Schouwburg. The theatrical element in Jan Steen's picture of the story clearly appears in the picture in the Lugt Collection[1] : the scene takes place in a large hall, part of the floor of which is raised; the hall contains a musician's dais, and is shut off by a large curtain. Again we notice the fool and the cripple with the halberd. In two other pictures of the same theme (Possession of Katz and Strasbourg Museum) there is again the simplicity which suggests the influence of Rederijker performances.[2]

The picture in Cologne "Thamar and Amnon"[3] contains only three figures; they are gesticulating and declaiming in an excited manner. The tragic story of the brother who deceives his step-sister, seduces her and then drives her away, was first treated dramatically by the Hoorn Rederijker J. C. Mayvogel in 1642 under the title "The Seduction of Thamar, or Amnon's aberrant Love"; somewhat later, in 1659, the play appeared in Amsterdam.[4]

There is another biblical subject "The Marriage of Cana"[5] which was depicted by Jan Steen so often that the various versions give a very clear idea of the forms of theatrical art with which he was acquainted. The simplest version is the small picture in the former Mosse Collection;[6] that in the Dresden Museum also concentrates on the chief characters concerned, and the setting again recalls that of the Rederijker stage. But the picture in the possession of Sedelmeyer, painted in 1671, is pure baroque theatre. There are grandiose extensions to the stage in the form of colonnades, with a musician's gallery above; the whole scene is very similar to the permanent architectural stage settings with which we are familiar. But while the 'actors' here are on the same level, as it were, as the spectator, in the imposing picture in the Beit Collection they are elevated upon a dais surrounded by a balustrade, to which flights of steps at the

(268)

---

[1] HdG No. 59; a good photograph in the Witt Library, London; size, 69 × 82 cm.

[2] Like "Dives and Lazarus," the "Prodigal Son" is also one of the parables in the New Testament. But not every "Young Man in merry Company" can be regarded as a prodigal son. Only the "Return of the Prodigal Son" in the Wachtmeister Coll. can be regarded with certainty as a representation of this theme (HdG No. 55; Bred., Pl. 11).

[3] HdG No. 16; together with the Carstanjen Coll. it is now in the Wallraf-Richartz Mus., Cologne.

[4] In this connection mention should also be made of the following pictures by Steen : "Bathsheba with David's Letter" (Bute Coll.; note the curtain) HdG No. 16; "Christ in the House of Martha and Mary" (Maxwell Coll.; obvious theatre-curtain) HdG No. 51 ; Christ expelling the Money Changers" (Van Oss Coll., The Hague)

HdG No. 62. Ill. *Zeitschrift f. Bild. Kunst*, LXI, p. 337; "Jesus in the Temple" (Basle Museum) *Suppl.* No. 44. ; Bred., Pl. 10. There were eleven (!) biblical paintings by Steen at the "Bible in Art" Exhibition of the Rijksmuseum, Amsterdam, 1939.

[5] Fischel drew special attention to the "Marriage at Cana" (cf. p. 000, n. 11).

[6] Mosse : *Suppl.* No. 45 ; Sale Lepke, Berlin, 29.5.1934, No. 113 (with repr.).
Dresden : HdG No. 47; repr. in *Das Museum.*
Sedelmeyer : Now in the possession of Goudstikker, Amsterdam. Exhibited in the Municipal Museum, Amsterdam, *Gedenck-Clanck*, 1938, No. 102.
Beit : *Suppl.* No. 48; Bred., Pl. 12.
Hudig: Repr. and full discussion in *Oud Holland*, XLIII, 1926, p. 208.
Arenberg : HdG No. 46; good photograph in the Institute for the History of Art, Amsterdam University.

centre and the sides give access. The musicians' gallery has become an independent structure, with the same improvised appearance as the very similar arrangement in Lugt's "Lazarus."

In the "Marriage of Cana" in the Arenberg Collection where the artist overemphasized the curtain, he was perhaps striving to keep too close to the theatre.

But the representation of the "Marriage of Cana" in which the theatrical character of Steen's conception is most marked, is the picture in the Hudig Collection, which, it is supposed, is very early (Pl. 7a). There is great suggestive power in the manner in which the standpoint of the spectator is brought close up to one corner of the dais, so that he looks transversely across the stage, as he would if he were seated at the extreme end of the front row in a theatre. A central flight of steps leads up to the dais where Christ is performing the miracle. Through an arch the back wall of the stage is visible with a staircase leading to a gallery where musicians are playing. Except for this gallery, the arrangement of the stage has a close resemblance to Rembrandt's famous "Medea" etching,[1] which is connected with the play of the same name by Jan Six.

The frequent occurrence of this subject requires some explanation. It seems that at the time when prosperity and luxury had reached their height among the bourgeoisie of Holland, the Rederijkers or theatrical companies were called upon to give performances of the "Marriage of Cana" at the weddings of the wealthier families. These pictures by Jan Steen would then have served to commemorate wedding-celebrations; they show the biblical feast becoming a gluttonous wedding-banquet, in the same way as at theatrical performances there was no rigid separation between the actors playing on the stage and the audience enjoying itself in the hall.

(269)

### 5.   The Activity of the Rederijkers outside their Guilds

The remarks in the last section bring us to a new sphere of activity of the Rederijkers. They did not appear only at their own meetings and performances; they also had to take part in all kinds of festive occasions —weddings, patriotic celebrations and festivals connected with the seasons. They were in fact under a definite obligation to perform at the wedding of a guild brother.[2]

In the fine picture of a wedding in the Mannheimer Collection[3] it seems probable that the Rederijkers are participating in the festivities, for we see a group of musicians leaning out of a window who are very like the Rederijkers in other pictures by Jan Steen; there is also a similarity

---

[1] Leendertsz, "Rembrandt's Faust en Medea," *Oud Holland*, XLI, 1923–24, p. 68. Further discussion of Rembrandt and the stage in W. R. Valentiner, "Komödiantendarstellungen Rembrandt's," *Zeitschrift für Bildende Kunst*, LIX, 1925–26, p. 265, and Georg Witkowski, "Das Amsterdamer Theater und Rembrandt," *Jaarboek Amstelodamum*, XXXIII, 1936,

p. 97, where the connection is questioned.
[2] Cf. ordinance of the "kamer" of Veere : Willem Kops "Schets eener Geschiedenisse der Rederijkeren," *Werken van de Maatschappij der Nederlandsche Letterkunde te Leyden*, IIe deel, 1774, p. 346, paragraph XIX.
[3] *Suppl.* No. 455; Six Sale, F. Muller, Amsterdam, 29.6.1920, No. 111.

in the details, such as the pennant on the trumpet. In a similar picture in the d'Oultremont Collection[1] (Pl. 6c) Tuscan columns support a structure, built on to the main building, which recalls the house on piles of the Rederijkers.

One of the most important of the patriotic festivals was always "Prinsjes-dag," (Pl. 7b) which Jan Steen shows in a picture in Amsterdam.[2] The good-humoured man with the bald head who is kneeling in the centre of the picture in a slashed doublet is clearly a Rederijker. The fact that he is kneeling does not mean that he is doing homage to the prince; he is merely lifting his glass to his lips after having recited a poem which, in accordance with a Rederijker custom, he has composed "on his knees,"[3] as proof of his facility in improvisation. Some lines of the poem can still be deciphered on the paper which lies on the floor :

> Here's a health to Nassau's little lord,
> In one hand a glass in the other a sword.[4]

Further inscriptions in this interesting picture are a patriotic motto in Latin and the beginning of a patriotic song.

The anniversaries of the liberation of various Dutch towns from Spanish rule were also regularly celebrated with great merry-making.[5] In Leyden there was a free distribution of bread and herrings, and the hardships and victories of the struggle against Spain were regularly commemorated in dramatic performances. A contemporary[6] says that they were plays

> Which moved to laughter rather than to tears
> Although you saw the guild brethren weeping.[7]

A curious picture in Buckingham Palace[8] depicting an attack which is obviously only being acted may represent one of these popular performances; comic figures like the monk in the boat, the woman riding the broomstick and the night-watchman show the humorous side of this martial scene. As the same types are found in several representations of dramatic performances, they may be regarded as Rederijkers, who were renowned for their ability to supply comic figures at a moment's notice.

A picture by Jan Steen formerly in the Hensé Collection in London, seems to be connected with a festival in celebration of a change in the seasons (Pl. 7c). There are frequent mentions of May festivals,[9] and since

(270)

---

[1] Loaned to the Boymans Museum, Rotterdam.

[2] HdG No. 516; an excellent description in the *Algemeen Handelsblad*, Amsterdam, 12.5.1938.

[3] Kops, *op. cit.*, p. 290.

[4] Op de gesontheijt van het Nassaus baasie
In de eene hant 't rapier in d'andre het /glaasie.

[5] A festival play by R. Bontius, *Belegering ende ontsetting der Stadt Leyden, Treur-bley-eyndend-spel* was repeatedly published between 1647 and 1753. Jan Steen's wedding-day fell on the 75th anniversary of the liberation of Leyden.

[6] Coenraad Droste, *Overblijfsels van Ge-heugenis*, 1728, p. 10.

[7] Die meer belagchelyk als droevig heeft /gescheenen
Al sag men altemet de kameristen /weenen.

[8] HdG No. 628; Hanfstängl print No. 103. The description in HdG does not give a correct idea of the subject.

[9] In 1598 the jester Van der Morsch invited the guild brethren to one of these May festivals, which was at the same time his wedding-day.

the inn in this picture is decorated with fresh branches of birch it may be assumed that it represents such a festival.[1]  It is a scene of wild buffoonery : an old man wrapped up in sheets, with a wooden spoon as a sceptre, is being lifted up by a young couple on to a dais supported by beer-barrels.  Surrounding the old man and the young couple are figures kneeling, tobacco-pipes and drinking-vessels; Jan Steen is also present.  In the background is the familiar cripple and a wrinkled old woman, behind whom a figure is carrying the witch's broom.  The picture probably represents some form of celebration of the "Abdication of Winter," and it is justifiable to suppose that in such popular festivals the Rederijkers were called upon to assist.

It is certain that quacks habitually collaborated with the Rederijkers. The community of interests began as early as the Middle Ages, when in a mystery play,[2] at the "Anointing of the Dead Christ," a scene with a quack was introduced.  Both Rederijkers and quacks aimed at attracting a public who enjoyed a show.  The vendors of ointments and salves therefore borrowed the platforms of the Rederijkers and sometimes also the services of one of their comic figures (Pl. 7d).  In many pictures it is impossible to tell whether the scene represents a theatrical performance by the Rederijkers or the show of a quack.  Where there is a quack, a Rederijker is often not far distant, as in a picture by Jan Steen,[3] where behind the charlatan we see the diamond-shaped shield of the guild brethren.  The quacks were also anxious to be on good terms with the painters, since they needed them to paint the signs[4] which they erected beside their stage and used for giving medical instruction to their audiences.  Hence the painters also interested themselves in the quack adventurers as did Jan Steen and Ostade before him.  A follower of Steen, Egbert van Heemskerck, has not only left representations of Rederijkers but also a pleasant picture of this side of Dutch life : on a quack's platform soldiers with drums are apparently trying to attract customers.[5]  The views of towns by Gerrit Berkheijde sometimes show improvised open-air stages, surrounded by spectators, which seem intended for the use of quacks.[6]  It is recorded that the painter Romeyn de Hooghe[7] took a very active part in one such performance : "at a wake at Delft, standing in a quack's theatre, he broke out in a flood of such abominable language that not even the most notorious blasphemers could be accused of having allowed such expressions to pass their lips."

(271)

[1] HdG Nos. 496 and 496a, also No. 499; *Suppl*. Nos. 496 and 496a; the statement in HdG that this is a feast of the Three Kings may be regarded as an error.  Later in the Hensé Coll., London (?).

[2] Karl Holl, *Geschichte des Deutschen Lustspiels*, Leipzig, 1923; there is a whole chapter on "Das Quacksalberspiel," p. 10.  The quack also appeared frequently on the Dutch stage.  Kackadoris, who will be mentioned below, was a quack.  Bredero wrote a *Hoogduytschen Kwakzalver*.

[3] HdG No. 201 (identical with HdG No. 647), *Suppl*. No. 201; Chateau de R.

Sale, Paris, 22.12.1913, No. 126; later, Ween & Klepman, Amsterdam.  In this picture, as in "David and Michal," the fool has a pair of spectacles on his posterior.

[4] HdG No. 625; "Quack Theatre", loaned by Bredius to the Mauritshuis, The Hague.

[5] Burtlewoke Sale, Brussels (?) 22.10.1929, No. 210.  Repr. in Rijksbureau voor Kunsthistorische Documentatie, The Hague.  Cf. also p. 29, note 2.

[6] Sale M. P., Paris, G. Petit, 22.11.192,3 No. 13.

[7] *Beschrijving der Stad Haarlem*, 1765, p. 493.

a—Jan Steen, "Marriage of Cana." Rotterdam, Hudig Coll. (p. 44)

c—Jan Steen, "Abdication of Winter." London, Hensé Coll. (?) (p. 46)

b—Jan Steen, "Prinsjesdag." Amsterdam, Rijksmuseum (p. 45)

d—Jan Steen, Quacks on a Stage. Dieren, Katz Coll. (p. 46)

## 6. A Note on Comedy

If Jan Steen did not rely on the stage for inspiration in painting, as a 'Dutch Molière', the customs and manners of his contemporaries, it would indeed be strange if he had remained entirely aloof from contemporary comedy; for comedy is so intimately linked up with his portrayals of stupidly cunning peasants and bourgeois who ape the fine manners of their betters.

The fact that in the 18th century a scene with three figures in the Bute collection was looked upon as an illustration to Bredero's *Lucelle* cannot be disregarded.[1] The fashionable pair of lovers with the onloocker, whose presence is distasteful to them, corresponds exactly with Bredero's presentation and recalls Buytewech, who frequently depicted themes from Bredero.[2]

Moreover, some of Jan Steen's paintings, for which there is now no documentary evidence for their connection with the stage, speak so clearly the language of comedy, that they should not be passed over without mention. This is especially true of the "Seller of Poultry" in the Rasch collection (Pl. 6d)[3], a supposition which is supported by the familiar setting—the gate of the town with the little church beyond. The scene is so full of incident that more is obviously taking place than the settlement of an every-day bargain. A number of figures having nothing to do with the selling are expressive of such clearly defined emotions that the representation is not unlikely derived from a comedy. Actually the seller of poultry frequently appears in contemporary literature, in the form either of cheat or of cheated. A title like "A play about Master Kackadoris and a deaf woman who sells eggs"[4] must link up with the Rasch picture. A woman selling eggs also figures in a farce of the Hague Rederijker Kamer[5] as the antagonist of a quack, as in the "play" and apparently in Jan Steen's picture. Exceptionally enough, in the Hague farce, the quack, who is a great egg sucker, is for once put upon himself. Steen's characters may well be the counterparts of the four persons in the play, a "peasant with a stick in his hand," a woman "bringing eggs to market in a basket," and the quack master Hoon (Sneer) with his wife. Moreover, there is in the work of Jan Steen the same joy over the defrauding of the fraud. A sort of pendant to the Rasch picture is a picture exhibited at Winchester

(273)

---

[1] HdG No. 70 "Ascanius and Lucilla," sold by auction in Haarlem in 1749. HdG No. 87 mentions "The Story of Arent Pieter Ghijsen," which seems to be related to a poem of the same Bredero.

[2] One of Buytewech's finest etchings is the title-page of Bredero's play *Lucelle* (III, 3), published in 1616. Cf. J. G. van Gelder in *Oud Holland*, XLVIII, 1931, p. 57. Moreover Buytewech's sketch was used for another title-page—Bredero's collected plays—and in medallions surrounding it are scenes from each of his comedies. Cf. J. J. de Gelder, *Honderd Teekeningen van Oude Meesters in het Prentenkabinet der Rijks-*

*universiteit te Leiden*, p. 17, fig. 12.—A drawing of the Koenigs Collection (cf. *Oud Holland*, XLVII, 1930, p. 191) and a picture in the Rijksmuseum in Amsterdam (*Oud Holland*, XLIII, 1926, p. 97) show figures and decoration under the influence of the stage.

[3] *Suppl.* No. 746, now in the possession of De Boer to whom I am indebted for the photograph.

[4] *Cat. Lett.*, No. 7152. Printed in Amsterdam in 1634.

[5] N. van der Laan, *Rederijkerspelen naar een handschrift der Bibliotheek van het Leidsche Gemeentearchief*, 1932, pp. XVII, 93-117.

in 1938,[1] where a condescending housewife bargains with a poultry seller; and this episode also takes place in front of the familiar gate of the town with the view of a little chapel behind it.

With the appearance of the wandering actors from Italy, France and England on the 17th century stage—and also in contemporary paintings[2]— the activity of the Rederijkers more or less comes to an end. Thanks to a very persistent tradition, many "kamers" remained in existence for centuries, but their influence on the theatre, no less than on painting, had gone. Among the many Dutch painters who were drawn to the stage, from Quast and Buytewech to Naiveu and Cornelis Troost, none had greater genius than Jan Steen. He has handed down to us the best picture of the stage and the actors of his day, and only a realisation of this will make clear what otherwise is difficult to understand in his work.

[1] Lord Mottistone Coll., Winchester Exhibition 1938, No. 77.

[2] In the pictures of Gerrit Berkheijde, e.g., inscriptions sometimes point to the influence of Italian comedy. Cf. Sale Dr. A. Hommel, Zürich 19.8.1909 and Vermeulen, Amsterdam. In Naiveu's pictures also stages are often set up in the streets with figures of the Commedia Italiana; cf. "Harlequinade near one of the Gates of Leyden" in the Rijksmuseum, Amsterdam.

(274)

# DARK CHAMBER AND LIGHT-FILLED ROOM: VERMEER AND THE CAMERA OBSCURA

## CHARLES SEYMOUR, JR.

## I

For over thirty years the literature on Vermeer of Delft has included first hints, then suggestions and, finally, all but direct statements that Vermeer used the forerunner of the modern photographic camera, the camera obscura, as an aid in making his paintings. Although Wilenski in the late 1920's put much more emphasis on the use of mirrors than on the camera obscura, he pointed to certain effects (distorted enlargement in foreground objects, for example) which can be observed in photographs and noted as "perhaps one of the ironies of art history that with a Kodak any child might now produce by accident a composition that a great artist like Vermeer had to use all his ingenuity . . . to achieve."[1] More penetrating was Hyatt Mayor's discussion in 1946 of the evidence favoring Vermeer's use of a mechanical aid; here he spoke not only of distortion in size of near objects, but of the tonality of Vermeer's color which he "blended as perfectly as the ground glass of a camera" and of the highlights on foreground objects which "break up into dots like globules of halation swimming on a ground glass."[2] To the objection that the camera's image is inverted, Mayor opposed the historically valid possibility of using either a second lens or else a mirror within the camera at a 45 degree angle to right the image. And he cited one record at least in the form of a tradition known to s'Gravesande in the eighteenth century that several earlier Dutch painters had studied and imitated, in their paintings, the effect of the camera obscura and its manner of showing nature.[3] About ten years ago Lawrence Gowing set the artist quite apart from his contemporaries both on the count of his poetic richness of content and indifference to convention in drawing and modeling. The summary of several pages of close analysis is brief but quite definite: "The technical part of it is plain. It is likely Vermeer made use of the camera obscura."[4] How did Vermeer acquire the necessary technical knowledge in optics? Gowing suggested the help of Vermeer's fellow citizen in Delft, Anthony van Leeuwenhoek, who in addition to his fame as designer, grinder and user of lenses, is also recorded as the executor of Vermeer's estate.

Against this accumulating body of opinion, it is well to record the position of the Dutch scholar Swillens, who in connection with his ingenious reconstructions of the interiors, lighting and studio props in Vermeer's paintings steadfastly refused to see the necessity of supposing the artist used any optical aids, either mirrors or the camera obscura.[5] There are today probably a great many others who instinctively, or for reasons of aesthetic principle concerned with the nature of art in European painting as a whole, would like to concur in this view.

(275)

1. R. H. Wilenski, *An Introduction to Dutch Art*, New York, 1928, pp. 284-286.

2. A. Hyatt Mayor, "The Photographic Eye," *Bulletin of the Metropolitan Museum of Art*, 1946, pp. 15-26. See also R. Huyghe, "Vermeer et Proust," *L'Amour de l'art*, XVII, 1936, p. 13. Huyghe writes of "cette touche prodigieusement juste mais fondue et comme anonyme, posée en gouttelettes qui s'étalent, dédaigneuses des petitesses de la précision, et qui de près, on l'a trop peu remarqué, donne l'impression d'un léger flou d'une image imparfaitement 'au point'; par là sa technique est à l'opposé des realistes strictes comme Dou, Netscher ou Metsu." The evidence which will be outlined in the present paper will follow only in part Huyghe's perceptive analysis of Vermeer's brushwork; actually it can be shown to be the opposite of "dédaigneuse des petitesses de la précision." See also A. Blum, *Vermeer et Thoré-Burger*, Geneva, 1945, p. 61.

3. Quoted from C. A. Jombert, *Méthode pour apprendre le dessein*, Paris, 1755, p. 139.

4. L. Gowing, *Vermeer*, Glasgow, n.d., New York, 1953, pp. 19-20, 23.

5. P. T. A. Swillens, "Een perspectivische Studie over de Schilderijen van Johannes Vermeer van Delft," *Oude Kunst*, VII, 1929/1930, p. 153; *Vermeer*, Utrecht-Brussels, 1950, pp. 76-77.

The utilitarian appeal of the optical device and the corollary of aesthetic suspicion were both characteristic of the early interest shown in the camera obscura in Vermeer's own century. In his well-known letter to Bacon describing Kepler's use of a "dark chamber" tent and telescopic lens to draw a "landskip," Sir Thomas Wotton reported that Kepler himself had said that he had made his drawing "non tamquam Pictor, sed tamquam Mathematicus." He added that he thought that there might be made good use of the device "for Chorography: For otherwise, to make Landskips by it were illiberall; though surely no painter can do them so precisely."[6] The letter is dated in December, 1620. In 1646 Athanasius Kircher described Kepler's method in its application to parastatic images received in an *instrumentum mesopticum* and projected through the lenses of a solar telescope.[7] Sanderson in 1658 repeated, textually, Wotton's description of the "draught of a Landskip mathematical."[8] In 1668 the Royal Society was shown a portable viewing camera by Robert Hooke, who according to the minutes of the meeting, produced an "optical experiment, whereby the representation of objects in a dark room furnished with a lens is made applicable to painting, so as to exhibit and draw in colours the face of a man or any other object as big as the life." After some changes, made largely to right the image, it was reported that "Mr. Hooke produced again his darkened box improved so that it was now proper for the hand to draw a picture conveniently by a metalline speculum and a movable bottom, whereby the picture appeared both erect and direct."[9] The experimental use of the device not only for painting but for portraiture rather than landscape in 1668 is striking. Kircher's book was reprinted in Amsterdam in 1671. And in 1685 several models of the portable camera obscura as well as the solar telescope for projection within a darkened room were illustrated in Zahn's popular optical treatise published in Strasbourg.[10] By then the novelty had worn off, and probably to some extent also the earlier prejudice against using the device for artistic purposes; it is otherwise difficult to understand why the various models of a viewing box were published at this time. Nature herself was now praised as a higher artist; on a scroll under Zahn's figure xx which represented a portable camera obscura were written the following lines:

(276)

> *Cedit Naturae ars pictrix, dum pulcherius Arte*
> *Hic Natura suis ludit imaginibus.*

There is a great deal of the history of the development of the viewing camera and its application to art still to be explored and unraveled, in particular the relationships in the seventeenth century between such experimental milieux as Rome and Paris and England and Holland. Until this aspect of the topic is made much clearer, the evidence for Vermeer's use of the device must remain fragmentary and perhaps more than necessarily circumstantial. I am still hopeful that such a larger study will be undertaken.[11] I am presenting in this paper a preliminary study

---

6. *Reliquiae Wottoniae*, London, 1651, pp. 413-414. Kepler's experimentation with the camera obscura is in part reported in his *Dioptrice*, Augsburg, 1611.

7. Athanasias Kircher, *Ars magna lucis et umbrae*, Rome, 1646, p. 812; Amsterdam edition of 1671, pp. 713-714; *Utilitatem quoque maximam praestabat haec machina. Si enim sylvarum, collium, montium, camporumque cum fluviis et aquis ruderibusque projectiones, hominum quoque et animalium effigies ad vivum delineandae forent, machinam* [sic] *eis obvertebat: et ecce nullo prorsus negotio et summa voluptate intra concavii medi cubi latera exhibita dictarum rerum simulcra in charta se depingenda offerebat ita ad vivum, ut quilibet quantumvis etiam pictoriae ars imperitus imaginum effegies vel ad invidiam exprimere posset. . . .* The edition of 1671 adds the following: *Intellexi Parisiis non ita pridem similem machinam sub forma sedili gestatoris confectam esse, quamque magno pretio divendat; sed uti a me scribunt et passim fatentur totam inventionis, suae rationem ex hac a nobis descripta machina desumpsisse.* Kircher's apparatus as of 1646 is reproduced from the Bibliothèque Nationale example of the first edition in Fig. 13 of this article.

8. W. Sanderson, *Graphice*, London, 1658.

9. See R. T. Gunther, *Early Science in Oxford*, Oxford, 1930, VI, 1, pp. 366-367, 696; VII, 2, pp. 755-756. Boyle had also become interested in the camera obscura: R. Boyle, *Of the Systemmatical or Cosmicall Qualities of Things*, Oxford, 1671, p. 18.

10. R. Zahn, *Oculus artificialis teledioptricus sive telescopium*, Strasbourg, 1685; Nuremberg, 1701, pp. 125-126 (both editions); p. 178 (1685 edition), 174 (1701 edition); 180-183 (1685 edition), 177-179 (1701 edition); 186-188 (1685 edition), 181-183 (1701 edition). In describing the portable camera obscura, or *cubiculus obscurus* [sic] Zahn termed it *idea vera oculi et typus visionis*.

11. The topic is broad enough for a doctoral dissertation; the philosophical as well as technical implications would amply repay deeper study.

of only a very limited aspect of the broader and more complicated question involving not only the style and chronology of Vermeer's oeuvre, but the deep-lying implications for the relation of seventeenth century painting to the philosophy of nature. My purpose is simply to look more closely at the hypothesis that Vermeer did in fact make use of the camera obscura for some of his paintings and to scrutinize that hypothesis primarily in the light of two small pictures now in the National Gallery of Art, the *Girl in the Red Hat* (Mellon Collection) and the *Girl with the Flute* (Widener Collection). What I have to say here is in the nature of a report on some of the results of a testing procedure begun at the National Gallery of Art soon after World War II and carried on intermittently as opportunity arose since.[12]

## II

The point of entry into the problem was selected as those dots of heavily loaded pigment (the famous *pointillés*) which have been so much noticed by critics and in some cases are so reminiscent, in Hyatt Mayor's words, of "globules of halation swimming on a ground glass." Enlargement of details of several of Vermeer's paintings, including the *View of Delft* in The Hague, shows this effect.[13] The highlights spread into small circles, and in such images the solidity of the form of a barge for example is disintegrated in a way that is very close to the well-known effect of circles (or discs) of confusion in optical or photographic terms. This effect results when a pencil of light reflected as a point from an object in nature passes through a lens and is not resolved, or "brought into focus" on a plane set up on the image side of the lens. In order to paint this optical phenomenon Vermeer must have seen it, and it must be assumed that he could not have seen it with direct vision, for this is a phenomenon of refracted light. This leads to a further assumption: the apparatus which formed the image was archaic, for otherwise the points of light in the middle plane would have been resolved and we would not have the record of the discs of confusion in the painting. Either the apparatus could have been adjusted, but for some reason difficult to imagine was not adjusted, or else it was incapable of adjustment.

(277)

The latter alternative seems to be the one which must be chosen. From a preliminary study of early viewing camera obscuras it would seem that their flexibility was limited and that they possessed a number of inherent disadvantages. The focal length of the lens generally used appears to have been unduly short according to the norm of modern photographic usage. The image transmitted by a single lens was inverted; to right it, complications arose in transmitting light if a second lens or a mirror were used for the purpose, as the record of Hooke's experiment mentioned earlier clearly shows. Moreover, maximum depth of field was as a practical matter impossible to achieve because if the lens were stopped down to increase the depth of the field, so much light was kept out that the image became too dark to see, far less to work from. There is little early evidence of this problem, but if it was still true of a later period, as can be ascertained through nineteenth century viewing cameras, it is reasonable to suppose that it was true of Vermeer's time. In other words, the discs of confusion that occur in Vermeer's painting that would result from poor depth

12. I would like to express here my thanks to Mr. John Walker, Director of the National Gallery of Art for encouragement in beginning this study while I was still a curator in the Gallery, and for permission to reproduce here the remarkable photographs taken by the Gallery Photographer, Mr. Henry Beville. My thanks go also to the Smithsonian Institution for the loan of apparatus and to the Library of Congress for the loan of books. I am indebted to M. Jurgis Baltrusaitis for advice and help in the crucial middle stages of my study and to M. Jacques Guignard of the Bibliothèque Nationale for invaluable aid in locating printed source material in Paris and The Hague. In America I am equally indebted to Mr. Hyatt Mayor of the Metropolitan Museum, Professor Heinrich Schwartz of Wesleyan and Mr. Beaumont Newhall, Director of the Eastman Institute in Rochester. My thanks go particularly to Peter Bunnell, a special student at Yale, and to my colleagues George Kubler and Egbert Haverkamp-Begemann for advice in revision. Most of this material has been presented in the form of lectures or shorter papers before the College Art Association, at the National Gallery of Art, at Harvard University and Connecticut College.

13. This effect has been noted before. See the comment in Gowing, *Vermeer*, pp. 128-130; ill. pl. 32.

of field in a seventeenth century apparatus are more to be expected than not, overwhelmingly so in fact.

It is conceivable that only by the use of a camera obscura would Vermeer have been able to achieve the remarkably casual effect of exactness in the middle distance of the *View of Delft*. The view itself seems to have been seen from the window of an upper room of a house across the water from the port proper. It is not necessary to assume a complex apparatus. Seventeenth century texts speak of using a telescope with one lens removed for the lens part of the apparatus, and the viewing chamber could have been a darkened upper room of the house. Of all Vermeer's extant pictures the Mauritshuis *View of Delft* most closely conforms in program to the run of seventeenth century texts dealing with the possibilities in using the camera obscura. They most often stress its usefulness in depicting large stretches of nature in panoramic or "chorographic" views. Vermeer's view of his city should properly be termed a panorama.

These same texts do not suggest as subject matter, until Hooke's Royal Society experiment in 1668, what we most often think of when the name Vermeer is mentioned. That is the small, light-filled room with one or two motionless figures silently preoccupied with some common object of interest or meditation. A question now arises which needs some answer. How, by what means, over what transition, and with what purpose did Vermeer adapt the long-distance viewing program of the camera obscura to so much closer a vantage point?

I do not think that a full and truly convincing answer to that question can yet be given. But a beginning may be made. It is obvious that as an optical aid the camera obscura, relatively minor distortions aside, performed automatically a reduction of a view of the tri-dimensional "natural" world to a two-dimensional image which could be traced or otherwise imitated without much recourse to a complex mathematical perspective construction. We know very little of the kind of mental equipment or systematic knowledge that Vermeer may have possessed with regard to the perspective systems of his time. We tend to forget that to some minds mathematics may be difficult. In this connection it is worth noting that Vermeer's early phase of figure composition does not show any trace of the telltale "discs of confusion" noted in the *View of Delft*. These compositions, moreover, are hardly evidence of any great power in arranging figures in a unified space prescribed by Renaissance perspective. The Dresden *Procuress* dated 1656 betrays some trouble in this regard, for the space from the observer's point of view is split.[14] If the picture is divided into two equal parts this becomes rather startlingly apparent. One looks *up*, past a cloak hanging on a chair, toward the man at the left. But on the contrary one looks *down* toward the plane of the table in front of the woman at the right. The effect is the more startling if we remember Vermeer's later perfectly unified interior spaces, rendered with faultless perspective, inhabited by personages presented from a constant vantage point, surely and effortlessly, and the whole capable of extraordinarily precise measurement, as Swillens' reconstructions have shown. These later paintings are also for the most part noticeably smaller than those of the early phase.

I would propose as a first step that the paintings which are most crucial in tracing this progression in Vermeer's art are the two very small panels (only some nine inches high) which are now reunited as a pair in the National Gallery of Art in Washington (Figs. 1, 2).

One of these, in the Mellon Collection, represents a young woman in a large red hat, draped in a toga-like swathe of velvet against a tapestry background. She leans one elbow over the back of a chair with familiar lion-headed finials, of which one is visible in the full light in the right foreground on a plane somewhat closer to us than the bulk of the figure.[15] A vastly enlarged

(278)

14. See again Gowing, *Vermeer*, pls. 4-5, who relates the composition to Barent Fabritius (p. 86).
15. The *Girl in the Red Hat* measures 9 1/16″ x 7 3/16″. The *Girl with the Flute* is about the same in width but is only 7 7/8″ high. As indicated below it should be mentally restored to the same length as the *Girl in the Red Hat*. The pose of the girl is varied in a remarkable way between the two panels. In the *Girl in the Red Hat* the model was placed

detail of this finial (Fig. 6) shows a form which is all but completely disintegrated in "discs of confusion." Here is presented an opportunity to test whether the effect really can be interpreted as faulty focus by determining if it can be reproduced under the conditions of an early camera obscura.

The procedure was as follows: A nineteenth century viewing camera obscura was borrowed from the scientific and artistic collection of the Smithsonian Institution with a set of early, uncorrected lenses. Allowing for a little less than optimum depth of field in this instrument and placing it about two and one-half feet from a lion's head (in metal) on a Renaissance chair from the Widener Collection it was found that much the same effect could be obtained (Fig. 3). The same kind of effect can be achieved from photography of ornament in polished wood (Figs. 4 and 5). The discs and merging of discs along certain continuous ridges or planes follow almost precisely the same pattern as a comparison will show (Fig. 6). It was found that using the viewing camera obscura as a photographic camera did not give the image as it was viewed; this last image and others to follow were therefore photographed in a modern camera adjusted to fit these special conditions. Next a piece of velvet was draped on the chair to fill the space which the figure of a girl would have filled and a piece of tapestry was placed behind (Fig. 3). It was found that the depth of field could be defined as short; sharp focus could be gradually reached about a foot behind the lion's head. This setup was viewed and photographed also in a polished metal mirror, with not much change (Fig. 8). This point will be important to remember later.

If we now return to the *Girl in the Red Hat*, this time in an enlargement of the head and drapery on the shoulder, it is apparent that very much the same optical effects are present (Figs. 9, 10). The discs about the mouth become sensibly smaller as the plane of the face recedes, and the fuzzy textures in the foreground ultimately come to an extraordinarily sharp edge in the further edge of the collar which is on a plane just beyond the head. The brush is not working at random; rather, given the extent of this enlargement, it adheres with extraordinary fidelity to the system which the photographic reconstruction of the spatial situation called for. The areas are not determined by linear outlines but by light and shade juxtaposed in an orderly way. The order is not that of direct vision; it is that prescribed by an image projected through a lens.

(279)

The effects in the pendant piece of the same girl (perhaps the artist's young wife) in fancy costume, this time in a kind of exotic conical hat, were found to conform (Fig. 11). Very much the same effects are to be found as well in the Louvre *Lace Maker* which is only slightly larger, but is on canvas and not on panel. One point of interest in connection with the *Girl with a Flute* of the National Gallery of Art here shown: the lower portions have obviously suffered and the panel was at some time cut down. If restored as here to the same length as that of the *Girl in the Red Hat*, it shows the continuation of a plane probably of a table in the foreground (Fig. 1).[16] This detail is important for an answer to the next question: What kind of apparatus could Vermeer have used and how did he use it?

In these small, close-up interior views we must suppose a portable box-apparatus. Here is a difficulty. No such apparatus of Vermeer's period is thought to exist, at least in its original form. The information obtainable at the Leyden Museum of Natural Science is, or was in 1954, quite negative.

There is no certainty as to when the box-apparatus was first put to use. In Athanasius Kircher's

on a high stool of some sort and the chair was pushed into the table in such a way that the lion-head finials were brought immediately next to the edge; the model used the back of the chair as an arm rest. The view is therefore slightly upward (as on the left side of the Dresden *Procuress*) so that the underside of the red hat is partially visible. In the *Girl with the Flute* the model was posed sitting normally at the end

of the table in the chair; in this case the view is more direct although part of the figure is clipped at the right.

16. The change in effect of spaciousness in the panel is most noticeable when the addition is made on the lower edge, as illustrated. The evidence of cutting in the original panel is on the lower edge, not the top.

*Ars magna lucis et umbrae* of 1646, there is a verbal description and illustration of a *cubiculum* with two lenses like a pair of human eyes and made of "Mexican" wood, for reasons which at present I am unable to explain. During the ensuing years the size of the *cubiculum* was reduced, as in Zahn's *Oculus artificialis* of 1685 (Figs. 12-14).

The illustration in Fig. 14 is crudely drawn but easily understood. The lens is held in a projecting piece which seems capable of lengthening or shortening to some limited extent. From the lens the image is projected in inverted form onto a stiff plane of oiled vellum or paper. This inverted image is then thrown on to a tilted plane mirror in the back of the box and righted. It can then be observed directly in the mirror or projected once again to oiled vellum on a moveable end piece. This machine is not too cumbersome, about three feet in length by about one and one-quarter in height. It can be moved easily, needs no special stand, and one can trace directly from the viewing opening the image of what one chooses to train the objective on to. This apparatus represents an improvement in convenience, but not in optical principle, over examples published earlier in the century. Something like it could well have been constructed by an ingenious man in the later 1650's or 1660's in Delft, where Anthony van Leeuwenhoek was turning out week by week far more delicate optical apparatus in the form of telescopes and microscopes.

It is now perhaps possible to imagine Vermeer at work with a box-apparatus, perhaps not exactly like this one, but of this general type. For the two panels in the National Gallery he must have placed it on the large table which appears over and over again in his paintings. The view of these paintings as in the Dresden *Procuress* of 1656 is close to the subject. Depth of field at such close quarters is more difficult to achieve than ever, hence the unusually prominent discs of confusion in the foreground of the *Girl in the Red Hat*. At this early experimental stage with the instrument he follows the image it provides very closely. He not only merely traces his composition from the viewing rectangle, he also uses a panel to paint on so that he may perhaps more easily and safely handle it to compare what he is painting with the camera obscura's image; the processes of painting and viewing are thus virtually fused into one.

The two small paintings in Washington, with the Frick Collection *Girl Interrupted at Music*, are exceptional in all of Vermeer's oeuvre because they are on panel. They are also unusually small. Their shape and dimensions correspond almost exactly to the dimensions of the viewing rectangle as we can reconstruct them from Zahn's apparatus. With the Louvre canvas, which is only slightly larger, they have another unique property (shared only by the Kenwood *Guitar Player*): the light comes from the right rather than the left. It is generally felt, and probably rightly so, that the windows of Vermeer's studio-room faced the street and the light came in from the left. As he placed his model for these three pictures, this could well have been true. But if we suppose the use of a righting mirror in the apparatus, the direction of light in the righted image would necessarily have to change with the mirror-image—from left as transmitted by the lens to right as viewed from the mirror. Finally, if one goes over Swillens' reconstructions, two features stand out. One is the unusual repetition of the angle of vision, which corresponds to a moderately short focal length lens, and the other is the level of the vanishing point and viewing point, which frequently corresponds neither to the eye of a standing man nor of a man sitting on a chair or stool. It does in such cases (Figs. 16-20) correspond to a point about eight inches higher than a table, at a level with the sills of the windows. This height would fit the height of a lens in an apparatus like the one I have illustrated in Fig. 14 if it were placed on a table. This height interestingly enough also corresponds precisely to that found in conventional Dutch perspective treatises (see Fig. 15).[17] The constancy of the height of the vanishing point in so many of the paintings is an

(280)

17. For example Hondius' treatise much used apparently in Holland, of which I reproduce the lowest diagram of pl. 33 in my Fig. 15. The height of the vanishing-point is indicated by the detail of the detached human eye.

indication that for a time the viewing camera was the starting point even after the first experimental stage. Ironically but also seriously enough, the careful reconstructions drawn by Swillens to prove Vermeer's mastery of academic perspective-construction can be used in support of the camera obscura thesis.

## III

In summary: the sources for the evidence presented here in preliminary form in support of the idea that Vermeer did in fact make use of the camera obscura are of two categories. The first kind is internal, drawn from observation of effects in the paintings themselves; it is open to confirmation by recreating, to a considerable extent, the effects of modern devices in analogy with the apparatus believed to have existed in the seventeenth century. The second kind is to be found in the optical lore and treatises on dioptrics and perspective of the seventeenth century; these help to define the limits of probability in the problem of historical reconstruction. A confrontation of admittedly still incomplete findings from both kinds of sources suggests that Vermeer's apparatus was of two models. The *View of Delft* would seem from both its size and panoramic character to have been painted in part from a parastatic projection onto a whitened wall or paper in a darkened room; it was thus in what might be called the chorographic or Keplerian mode. The two small panels in the National Gallery of Art would seem to have been painted from images formed in a portable *cubiculum*, as Kircher had called it, in the mode experimentally presented to no less a body than the Royal Society by Robert Hooke within the time span of Vermeer's own activity as a painter. Whether the "scientific" experiment preceded the "artistic" application is not known; all one can say now is that the account of Hooke's presentation suggests that the *cubiculum* had already been experimented with by painters.

It is my feeling that there are no extant paintings which would better fit the role of first experiments in Vermeer's use of the *cubiculum* than the two small Washington panels. They are on wood, which would facilitate their handling during the process of painting; they are of a remarkably small format, which closely approximates the size of the image to be deduced from Zahn's seventeenth century model; and in the case of the *Girl in the Red Hat*, there is additional evidence that the panel had already been used for the beginning, at least, of a conventional small-scale head-and-shoulders portrait of a bearded man before Vermeer used it for the painting of the girl. A tie-in with an established genre is here provided, and a certain continuity in Vermeer's thinking in connection with tradition and the uses of the camera obscura is suggested.

The Washington paintings, though of differing provenience, were evidently intended as a pair. They seem to be neither slice-of-life household scenes nor cryptic poetic meditations on the themes of *Vanitas*, Love, or Music that have been isolated and analyzed particularly by Gowing. They are, if anything, rather slightly disguised costume pieces with an air of improvisation. It is most likely that they are to be identified with the two pictures listed as a pair in the famous Auction Catalogue of 1696 which appear under the numbers 39 and 40 at 17 florins each.[18] The preceding item at almost exactly double the price, or 36 florins, is described as "A half-length in antique costume, particularly artistic." Number 39 is described simply as "Another such Vermeer" and number 40 as "A companion piece to the same." The "half-length in antique costume" I would suggest is not The Hague *Girl*, as De Vries thought, but the Arenberg-Wrightsman *Girl*.[19] The "antique costume" for the latter is explainable by the toga-like velvet covering the shoulders.[20] If this identification is acceptable, it throws light on the subject matter of the Washington panels. In the *Girl in the Red Hat* a similar toga-like velvet covering appears which in 1696 was

(281)

---

18. See Gowing, *Vermeer*, p. 139 n. 105.
19. Illustrated in Gowing, *Vermeer*, pl. 41.
20. It is possible that the Dutch phrase should be translated

"old-fashioned" rather than "antique," as Egbert Haverkamp-Begemann tells me. This is apparently the sense in which it was read by Swillens and Gowing.

interpreted as "antique costume." In the *Girl with the Flute* the striped conical hat which Van Thienen had suggested might have been a studio prop brought from the Orient may be interpreted as a parallel to Attic women's headgear of classical times as seen for example in Tanagra figurines. The relatively low price of the pair of paintings is explainable by their small size, according to the criterion established by Nicholson.

In most chronologies of Vermeer's paintings the two National Gallery of Art panels are situated rather late, as belonging stylistically in what is believed to be either the last or else the penultimate group.[21] On the surface it would seem that there is nothing except their high quality and assurance of touch that would seem to justify so late a place in the classification of Vermeer's oeuvre. This is a matter which deserves more study. I certainly am in no position to pass judgment on the often conflicting theories concerning the chronology of Vermeer's painting, nor is it the purpose of this paper to do so. But a word on this topic may be a pertinent part of this preliminary report.

From the point of view of the logic of the painter's development in relation to his use of the camera obscura, the National Gallery of Art pair of panels should come fairly early in Vermeer's developed, "high" period, that is probably closer to 1660 than 1665. They appear to represent the experimental breakthrough into the uncannily perfected solution of his earlier problems in representing a unified space according to a one-point perspective system. The need for a mechanical aid to produce such unified effects is made evident in part by the Dresden *Procuress* of 1656 as pointed out on an earlier page. After one experimental phase with the "chamber" camera obscura to which the *View of Delft* points with some insistence, Vermeer then seems to have proceeded to a second experimental phase with the *cubiculum* apparatus which was required for those more characteristic interior scenes in which he was becoming interested as a rival to De Hooch. The *Girl in the Red Hat* and the *Girl with the Flute* in subject matter, format, and scale appear to be a prelude to more ambitious compositions and to be still very much involved with the "vision" of the *oculus artificialis*, as Zahn called the camera obscura. Gradually Vermeer would have become more adept at enlarging the drawings traced from the viewing aperture in the camera obscura and bolder in posing the figure or figures of his compositions until the relatively large scale of the Dresden *Procuress* was once more regained in such a canvas as the *Allegory of Painting* in Vienna, in which as an aid to the enlargement from the first tracing a more orthodox perspective system was apparently also used.[22] In the Vienna picture, as in other large-scale paintings which are generally classified as late, the treatment of the tapestry curtain in the foreground retains as lucid points of heavy impasto the memory of the discs of confusion that he had first observed and trusted in his viewing and tracing apparatus.

Such an outline of Vermeer's development may encounter technical difficulties of which I am not aware. Aesthetically, it seems to me as valid as any other theory so far published and for that reason may warrant a place here. One of the obvious dangers that investigations of mechanical aids, such as the camera obscura, face in art history is that the genuine artistic impulses and aims of the painter may be lost to view while the pseudo-scientific connections and gadgetry lore are played up. An exception in this case is the relationship to the prehistory of photography, which here seems quite real and a valid topic for further serious study. Indeed, it may seem even more understandable that Vermeer's rediscovery in the mid-nineteenth century by Thoré-Burger should have been due to a photographically trained eye.

There are a number of ways to frame certain larger questions which inevitably come to mind. One is to look forward from the seventeenth century to the nineteenth as suggested in the pre-

(282)

---

21. The exception is W. R. Valentiner who in 1930 placed the *Girl in the Red Hat* at about 1658.

22. See K. Hultén, "Zu Vermeers Atelierbild," *Konsthistorisch Tidschrift*, VIII, 1949, pp. 90-98.

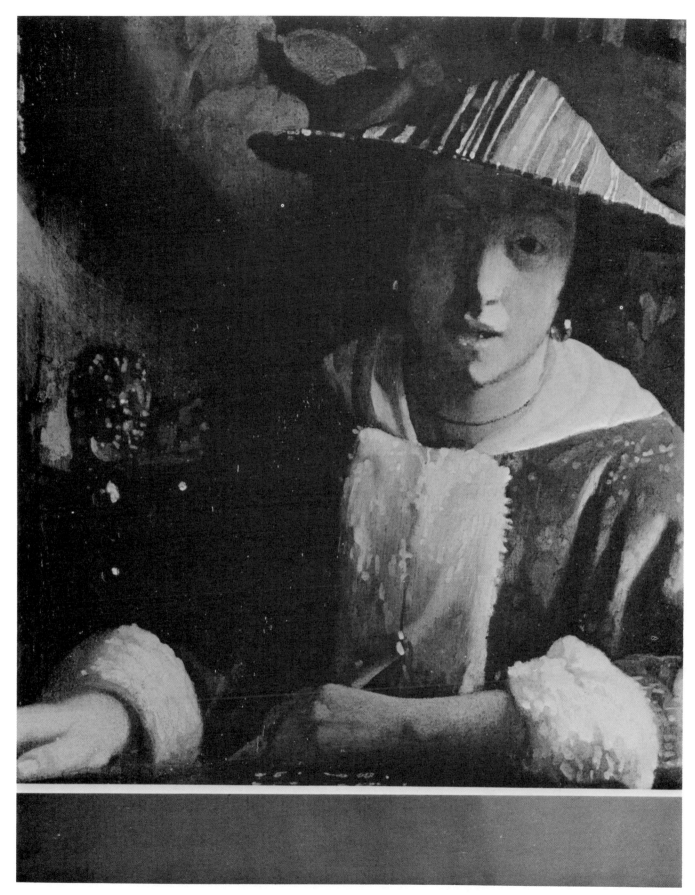

1. Vermeer, *Girl with a Flute*. Washington, D.C., National Gallery of Art
(Widener Collection). The bottom has been added to in order to bring the
picture to the same height as its presumed companion (see Fig. 2)

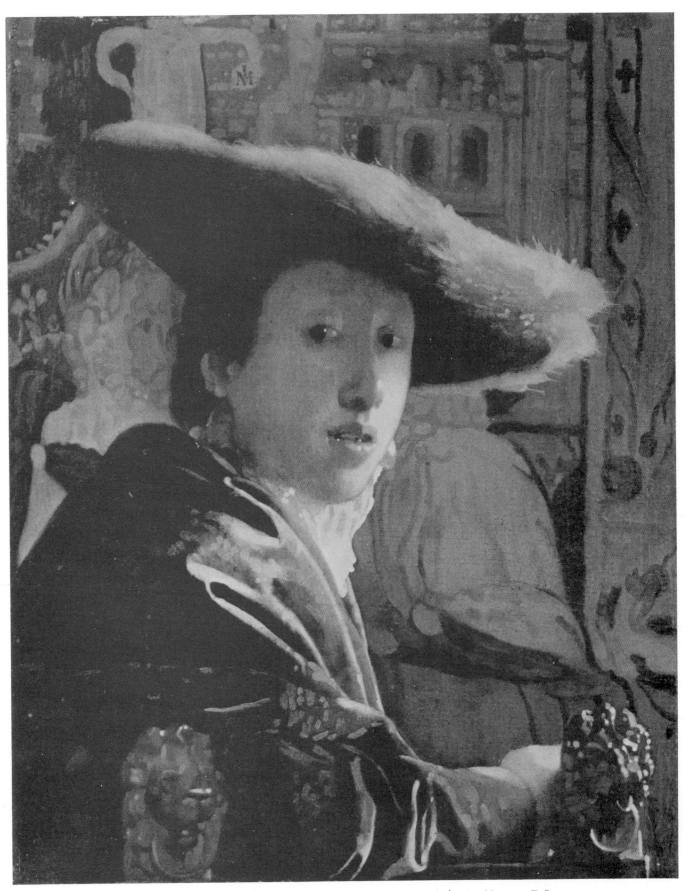

2. Vermeer, *Girl in the Red Hat* (approximately actual size). Washington, D.C.,
National Gallery of Art (Mellon Collection)

3. Photograph of setup of elements in Vermeer's painting opposite (lion's head finial, velvet drapery, tapestry background) with sharpened focus on middle ground only
(photo: Henry Beville, National Gallery of Art)

4. Carved wood ornament, in focus (photo: Emidio DeCusati, Yale Art Gallery)

5. Carved wood ornament of Fig. 4, out of focus with points of highlights spread to discs of confusion (photo: Emidio DeCusati)

6. Enlarged detail of lion's-head finial from Vermeer's *Girl in the Red Hat* (photo: Henry Beville)

7. Reconstruction of optical effect of Fig. 6 with a modern camera (photo: Henry Beville)

8. Elements in analogy to those in Vermeer's *Girl in the Red Hat* photographed in reconstruction of the effects in Vermeer's painting after reflection in a polished metal mirror (photo: Henry Beville)

9. Detail, much enlarged, of Vermeer's *Girl in the Red Hat* (photo: Henry Beville)

11. Detail, much enlarged, of Vermeer's *Girl with a Flute* (photo: Henry Beville)

10. Detail, much enlarged, of Vermeer's *Girl in the Red Hat* (photo: Henry Beville)

12. Viewing camera obscura of the XVII century, showing developed *cubiculum* with two objectives in analogy to human vision (from Zahn, *Oculus artificialis teleodiopticus sive telescopium*, 1685 ed.) (Courtesy Bibliothèque Nationale, Paris)

13. Viewing camera obscura of the XVII century, showing primitive *cubiculum* with two objectives (from Kircher, *Ars magna lucis et umbrae*, 1646 ed.) (Courtesy Bibliothèque Nationale, Paris)

14. Viewing camera of the XVII century, developed type (from Zahn, *Oculus artificialis*, 1701 ed.) (Courtesy Library of Congress, Washington, D.C.)

15. Perspective model, showing height of viewing-point in relation to the surface of a table (from Hondius, *Institutio artis perspectivae*, The Hague, 1692, first publ. 1647) (Courtesy Bibliothèque Nationale, Paris)

17. Reconstruction of the height of the viewing-point and the angle of vision in Vermeer's *Allegory of Faith*, New York, Metropolitan Museum of Art (after Swillens)

19. Reconstruction of the height of the viewing-point and the angle of vision in Vermeer's *Allegory of Painting*, Vienna, Kunsthistorisches Museum (after Swillens)

20. Reconstruction of the height of the viewing-point and the angle of vision in Vermeer's *Lady at Virginals*, London, National Gallery (after Swillens)

16. Reconstruction of the height of the viewing-point and the angle of vision in Vermeer's *Concert*, Boston, Isabella Stewart Gardner Collection (after Swillens)

18. Reconstruction of the height of the viewing-point and the angle of vision in Vermeer's *Letter*, Amsterdam, Rijksmuseum (after Swillens)

ceding paragraph. Another is to turn back to the Renaissance with its conception of a unified spatial field and Leonardo's documented experiments with an "artificial eye."[23] The term "chiaroscuro" as coined by Leonardo da Vinci is no more nor less than a Renaissance foreshadowing of Kircher's title, *Ars magna lucis et umbrae*. In the theoretical background are three concepts characteristic of the seventeenth century, but all with Renaissance roots: 1) the expansion of "natural philosophy," 2) the concept of nature as both work of art and artist, and 3) the ennoblement of the so-called mechanical arts by mechanizing organic functions. In Cartesian terms the visual perception of the world of nature is dominated by light, and the most faithful instrument for discerning and recording those perceptions, as far as purely sensory accuracy goes, is necessarily in Descartes' logic mechanical: *oculus artificialis*. If painting of the seventeenth century may in most of its varied modes be called a search for visual truth, the mechanical eye had theoretically a place to fill and a role to play. Yet after the neoclassical episode of the eighteenth century in Dutch art the peculiar effects of naturalism achieved by the camera obscura might well have seemed forced and paradoxically "unnatural." This is precisely the process hinted at by s'Gravesande who ultimately decried the "falsity" of effect in the work of some earlier Dutch artists who, as he stated, had used the camera obscura. Nevertheless s'Gravesande had earlier admitted freely the advantages presented by the camera obscura for drawing and composing.[24]

In the eyes of seventeenth century theoreticians and practitioners of painting there could be as well a fundamental falsity in the forcing of free forms of natural appearances into the straitjacket of elaborate perspective-constructions by means of mathematics. It is appropriate to recall here as a final point the warfare, related to perspective developments in Holland, between Mathematicians and Anti-Mathematicians in Paris in the 1660's. Against the geometers Bosse and Desargues rang out the uncompromising voice of a practicing painter such as Grégoire Huret, who claimed that

(291)

> La géometrie n'a aucun pouvoir en la portraiture de tous les animaux, arbres, fleurs, paysages et autres sujets compris de superficies courbés irrégulièrement. . . . Car qui sera celui qui osera prétendre en l'art de portraiture s'il croit tout ce que ledit Sieur Bosse a dit dans ses traités . . . qu'il faut premièrement sçavoir parfaitement la géometrie, puisqu'il faut portraire et peindre après le naturel et sans remuer la prunelle de l'oeil, et que de plus, il ne faut pas dessiner les objets comme l'oeil les voit, mais qu'il faut en trouver les infinis points d'apparences sur le tableau par des infinis aplombs et élévations géometrales . . .[25]

With such ideas about the nature of art and the nature of artistic vision in the air, there should be small wonder that an automatic device in analogy to the human eye might have found favor with some painters. The more conscientious observers of nature such painters were, as Huret's passionate language emphatically suggests, the more likely they were to find a use for the mechanical device. Logic and emotion were here to be found in a complementary relationship. Not too long after Vermeer's death, these two complementary aspects came to be considered as separate. But in Vermeer's developed painting, more obviously than in that of any of his Dutch contemporaries they appeared together as integral parts of human experience. I think that the means by which they were brought together into the focus of the painter's eye was the dark chamber trained on the light-filled room.

YALE UNIVERSITY

23. These experiments were seemingly not known, however, until some three centuries after Leonardo's death.

24. G. J. s'Gravesande, *Essai sur la perspective*, Ch. VIII: Amsterdam edition of 1774, pp. 62ff.

25. G. Huret, *Optique de portraiture et peinture en deux parties*, Paris, 1670 (repeats thesis of short tract published in April, 1665).